Exploring Photography

EXPLORING PHOTOGRAPHY

by
Fern Kennedy

PRENTICE-HALL
Englewood Cliffs, New Jersey 07632

AMPHOTO
Garden City, New York 11530

Dedicated to
My husband, Wesley W. Kennedy
and our daughter, Linda.

Their help, cooperation, and encouragement
made this book possible.

Preface

This book is planned to help you explore and understand the basic techniques used to make a picture from seeing the subject to finishing the photograph for display. Photographers differ on what is basic information or even the most desirable procedures. Over the years the ones presented in this set of books have been effective with and appreciated by my students.

Your own application of the information given will build a foundation on which to base an appreciation of and further study in photography. Whether it is to be only a hobby, an aid in your life's work or a career, a bonus for you will be a new awareness of beauty and potential pictures where you were not previously conscious of either.

Study and evaluate pictures made by others to improve your own work, crystallize your opinions as to likes and dislikes and to stimulate further exploration of methods and procedures. Above all, enjoy photography as you study, capture pictures and create in the darkroom.

The Author

Acknowledgments

Acknowledgments and appreciation are extended:

For the courtesy of manufacturers and/or distributors of camera and photographic equipment who supplied the photographs so credited.

To *Popular Photography* for the prints of the disassembled camera of Chapter 1 as indicated.

To C. Norman Dickison for the cartoons.

To my present and former students for their many negatives, proofs and slides submitted for unlimited use to illustrate techniques and problems. Many of the photographs were made to meet specific needs. Those negatives or slides used for prints are credited but thanks go also for those not utilized. The bas relief and solarized illustrations were furnished by the photographers. All others, except those credited to the magazine and manufacturers, were printed by the author.

To R. W. Olson, GAF Graphic Arts Division Manufacturer's Representative, and his wife, Bernice, for their many consultations on illustrations in color and black and white both half and continuous tone work.

To Zola Helen Ross, Creative Writing Instructor, and members of her class for their counsel, constant encouragement and critique and to Gordon Durr for special helps.

To my present and past assistant instructors, Jane Flanders and Norman A. Krebbs for their encouragement and consultations on this project.

To my first photography instructor, Ernest Fortescue, for his suggestions on preparation of the photographs in special areas.

To my husband, Wesley W. Kennedy, for all of the line drawings, his critique and unfaltering faith.

To my daughter, Linda S. Kennedy, for typing and retyping all of the manuscript plus modeling many hours to illustrate the camera care and how-to-do darkroom procedures.

To those neighbors, friends and relatives, both the very young and the older, who have so graciously modeled for the illustrations.

Table of Contents

PREFACE

ACKNOWLEDGMENTS

CHAPTER 1

Care and Handling of the Camera	13
Guides for Camera Care	13
Theft Prevention	23

CHAPTER 2

Camera Operation	27
How the Camera Works	27
Kinds of Camera	27
Using the Camera	32
Steps to Follow to Make a Picture	43

CHAPTER 3

Black and White Film Developing	45
Equipment	45
Chemicals	48
Mix the Chemicals	49
Load the Film in the Tank	51
Develop the Film	58
The Negative	64
Negative Defects	66
File, Index and Store Negatives	73

CHAPTER 4

Processing Color Films	78
Negative Color Film Processing	78
Positive Color Film Processing	78
Mounting	81
Transparency Defects	90
Indexing and Storing	95

CHAPTER 5

The Contact Print or Proof	97
Equipment	97
Papers	102
Equipment to Process the Print	105
Chemicals	107
Mixing the Chemicals	109
Tray Arrangement	109

Assemble the Negative and the Contact Paper 110
Expose the Contact Paper 110
Develop the Print 112
To Make the Final Contact Print 115
Wash the Prints 118
Dry the Print 118

CHAPTER 6

Enlarging 122
Equipment for Enlarging Black and White Negatives 122
Chemicals to Process Enlargements 128
Enlarging Papers 128
Arrangement of Equipment 129
Check the Equipment 130
Choose and Prepare Negative 130
The Procedure for Enlarging 131
Evaluate the Print 138
Bleaching Techniques 155
Spotting the Print 160
Other Techniques 162
Display 165

CHAPTER 7

Guides to Composition 169
Center of Interest 169
Arrangement of a Number of Subjects 175
Lines, Divisions and Contours 179
Influence of Format 186
Space for Subject to Move 186
Repetition of Lines, Design, Color 189
Limitation 189
Foregrounds and Backgrounds 195
Perspective and/or Orientation 195
Variety and Contrast 198
Portraiture 198

CHAPTER 8

Light 202
Source of Light 202
Characteristics of Light 203
Intensity 203
Contrast 203
Color 204
Direction of Lighting 208
Front lighting 212
Sidelighting 217
Backlighting 220
Top lighting 221
Low or Bottom lighting 223

CHAPTER 9

Understand the Camera 225
Film and Picture Sizes 225
Viewing Systems 227
Viewfinders 227
Parallax 229
Information in the Viewfinder 231
Parallax Correction 231
Etched Squares 231
Exposure Indicator 232
Focusing Devices 232
ASA and DIN 235
Shutters 236
Flash Settings 245

CHAPTER 10

The Camera Lens 246
Functions of the Lens 246
Materials and Construction 246
Focal Length 247
Control of Light by the Lens 248
Lens Automation 254
Normal, Wide-Angle, Telephoto and Zoom Lenses 255
Choice of Focal Length 256
Accessories for Magnification of Images 258
Extenders or Converters 258
Close-up lenses 259
Steps in Making a Picture with a Close-up Lens 261
Tubes and Bellows 262
Reverse Adapters 264
Macrophotography, Photomicrography, Microphotography 265

CHAPTER 11

Depth of Field 266
What is Depth of Field? 266
Factors that Affect Depth of Field 268
Acceptable Sharpness 270
The Depth of Field Scale 273
Ways to Utilize the Depth of Field Scale 276
Choice of Depth of Field 276
Hyperfocal Distance 276
Zone Focusing 277
Forefocusing 278
Focusing for Close-up Photography with Accessories 280
Control of Depth of Field on the Automatic Adjustable Camera 280

CHAPTER 12

Exposure 282
 Methods of Choosing Exposure 282
 Light Meter Care 284
 Purpose of the Light Meter 284
 Kinds of Light Meters 286
 Incident Versus Reflected Light Meters 286
 Power for Light Meters 289
 Light Meter Angle of Acceptance 290
 Light Meter Scales 291
 How to Make an Exposure Reading 293
 Choosing the Exposure Combination 300
 Multiple Exposure 301

CHAPTER 13

Flash Photography 304
 The Expendable Flash Lamp and Flashguns 304
 Flash Lamps 306
 Electronic Flash 310
 Care of the Electronic Flash 312
 Exposure Calculation for Flash 313
 Guide Numbers 314
 Techniques to Improve Flash Pictures 316
 Troubleshooting Flash Failures 324

CHAPTER 14

Films 327
 Care and Handling of Film 327
 Film Selection 330
 Classes of Films 330
 Classification by Packaging 331
 Black and White or Color 331
 Negative Films 332
 Positive Films 334
 Speed of Films 336
 Using the ASA Scale 339
 Specialized Films 342
 Summary, Selection of Films 344

CHAPTER 15

Filters 346
 Filter Materials 346
 Exposure Compensation 348
 Filter Choice 349
 The Polarizing Filter 351
 Neutral Density Filters (ND) 356
 Filters for Black and White Film 357
 Filters for Color Film 358

Warming Filters 360
 Filters to Match Light to Film Sensitivity 363
 Filters for Mood 364
Flares from Metal 365
Correction of Transparencies 365
 Make Custom Highlight Filters 366

CHAPTER 16

Goals for Photography 368
To Meet the Cost of Supplies 368
To Meet the Expense of Equipment 369
Is Travel Necessary? 372
Ways to Use Pictures 373
 Slide Shows 374
 Print Displays 379
 Display in Newspapers and Magazines 380
Fields for Photography 382

APPENDIX I

How To 387
Section A: Score a Transparency or Print (10 points) 387
 Score a Transparency or Print (5 points) 387
Section B: Convert to Another Scale 388
Section C: Mount a Photograph for Wall Display 388
 Supplies and Equipment to Mount a Print 392
 Mount and Mat Board 393
 Cutting Tools 393
 Adhesives 394
Section D: How to Make 395
 Reflectors 396
 Ground Level Camera Support 397
 Gadget Apron 398
 Darkbox 400
 A Light Box 401
 Emergency or Temporary Light Boxes 402
 Slide Duplicator 402
 Borderless Easel 404
 Bean Bag Support for Camera and Lens 405
 Star Pattern 406
 Level the Camera 406,
Section E: Choosing Equipment 408
 The Camera 409
 Camera Accessories 411
 Darkroom Equipment 413

APPENDIX II

Glossary of Photographic Terms 419

INDEX

CHAPTER 1

Care and Handling of the Camera

Today's adjustable camera is an expensive and delicate instrument. The sturdy metal (or plastic) body protects many tiny and intricate components that have been carefully aligned and interconnected (Fig. 1-1). For the camera to function properly, these components must be kept in their exact positions. The length of trouble-free service for a camera depends on the care taken in handling and storing it as well as on its design and manufacture. Actually, there is no great mystery to proper care when one understands the parts that are damaged most easily and how to protect them. All cameras, from the most to the least expensive, benefit from careful handling and storage.

GUIDES FOR CAMERA CARE

1. *Keep fingers off the lens at all times* (Fig. 1-2). Protect all glass surfaces of a camera from fingerprints. The most expensive part of a camera is the lens because of (*a*) the very fine grade of glass used and (*b*) the precise work of grinding, polishing, and assembling required to produce a lens that yields a sharp image on film. To avoid internal reflections, the surfaces of all better lenses are coated with a relatively soft transparent material. The natural oils and acids secreted by the human skin eat through this coating if fingerprints are allowed to remain on the glass. If fingerprints should get on any of the glass surfaces, clean immediately. Follow directions given in Guide 8.

 Any marring of the coating or the surfaces of the lens will soften focus. The picture will be less distinct than it would be had the lens not been damaged.

2. *Set the camera down carefully.* Treat it as carefully as a fine watch. Handle the camera so gently that there is no sound as it is placed on or against other objects. Jars, shocks, and vibrations can work units out of alignment and loosen screws. The vibrations of an airplane can loosen screws sufficiently that lenses will fall apart when removed from the case. The shutter and other parts are equally vulnerable. Foam-lined gadget bags reduce damage from vibration.

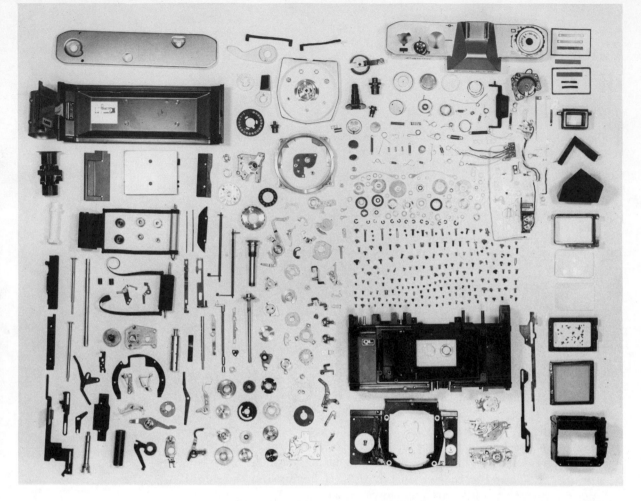

1-1A The number and size of the parts of a Canon Pellix QL, typical of many fine adjustable cameras, indicate the need for careful handling.

3. *Keep lint, dust, and sand off all parts of the camera.* Lint and dust are enemies of the camera and the picture. Sand will totally ruin the camera. Inside the camera, dust and lint can prevent mechanical parts from functioning (Fig. 1-3). Sand will enter seemingly impossible places and damage the mechanism beyond repair if not properly cleaned before the camera is operated.

Static electricity is developed as the film is advanced through the camera, causing dust and lint to be attracted to the film's surface. This results in dark or black specks or splotches on the

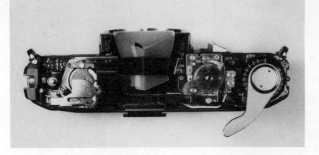

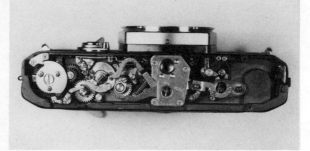

1-1B With the top plate removed, a portion of the Canon Pellix QL parts shown in position.

1-1C More of the assembly of the Canon Pellix QL is visible with the bottom plate removed.

finished pictures. Inside the camera, watch for chips of film that break off and may cause the same problems or interfere with the mechanism. Check the camera for dust, lint, and film chips each time film is loaded.

Dust and lint on the lens do not show in the picture as such but cause a picture to be less sharp. Sand and dust scratch the lens and its coating to degrade the quality of pictures. In some camera lenses, plastic is used instead of glass. Plastic is even more easily scratched than glass.

4. *Never swing the camera at the end of the neck strap or other attachment* (Fig. 1-4). The centrifugal force involved can be disastrous to finely balanced parts because parts of the mechanism shift out of place.

5. *Store the camera in dry, moderate temperature areas.* This guide applies any time the camera is not in use.

The dashboard or rear window ledge of the automobile keeps the equipment readily available for use (Figs. 1-5, 6), but this practice is extremely hazardous for camera, film, and passengers. First, sun shining through glass increases temperature severely. High temperatures thin the camera oil so that it runs into areas that must never have oil. In turn, there will *not* be oil in the parts that require lubrication. Metal parts may expand sufficiently to cause problems when the camera is used. Second, excessive heat causes film quality to deteriorate rapidly. Color films are particularly subject to shift in color rendition if they get too hot. Third, loose objects continue to move forward with the same velocity at which they have been traveling when a car is suddenly stopped, as in a collision. Imagine the deadly effect of any object as heavy as a camera, traveling at fifty (or seventy) miles an hour, striking a person on the back of the head or neck!

1-2 A quick way to lose lens sharpness.

1-3 Clean the interior of the camera, each time film is changed to get spotless pictures and to guard against malfunction. Do not disassemble the camera to clean it.

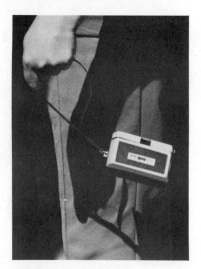

1-4 Camera owners who swing their equipment can cause repair or replacement costs.

The glove compartment of a car is a veritable oven in warm weather, and not good for camera storage (Fig. 1-7).

In the home, office, or school, care must be taken not to choose areas near heat pipes or in sunshine (Fig. 1-8). Basement storage should be chosen only if it is a *dry* area.

Too cold temperatures, zero Fahrenheit and below, affect the proper operation of the camera. Film becomes very brittle and may break or tear as it is advanced through the camera. Static electricity is increased and can result in miniature flashes inside the camera that cause flares on the film. Advance the film slowly to reduce the chance of either problem (Fig. 1-9).

Oil used in moderate or hot climates congeals in extremely cold temperatures. The camera mechanism will be sluggish, if it works at all; thus giving different exposures from those the photographer expects. This sluggishness may be evident even above zero.

To determine the shutter action of a camera in extreme cold, before it is encountered, make two exposures on color slide film at each of the marked shutter speeds. Keep careful records. Place the camera, loaded with film, in the family freezer for several hours. Repeat the same pictures under the same light conditions at the same exposures. It may be necessary to return the camera to the freezer several times to keep it cold while making the last series of pictures. After the two sets of exposures are completed and the film has been processed, carefully compare density and color saturation.

If the camera is to have extensive use in severe cold, the original oil can be replaced with a lighter grade lubricant by a competent repairman. Some methods of camera handling keep it warmer than the outside air. With the camera in its everready case, take it to

1-5 Film and cameras depreciate rapidly in sunlight.

1-6 The worst possible place to carry photographic equipment. Danger to the camera, film, and most of all, the auto's passengers.

1-7 Glove compartments get extremely warm!

bed or into the sleeping bag at night. In the daytime, carry the camera inside the coat as close to body heat as is practical. Remove the camera to take the picture and immediately return the camera to the sheltered area.

When one returns from the very cold out-of-doors to the warmth of a building, moisture may condense on the lens. If the whole camera is allowed to warm to room temperature before taking any pictures, the condensation will disappear and the pictures will be sharper.

6. *Do not use undue force in operating any camera* (Fig. 1-10). This can cause severe damage. If more than normal pressure is required,

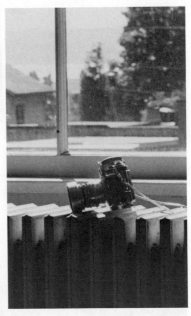

1-9 A cold dry night and a photographer in a hurry caused the main static electrical flash in the vertical white area on the left and the less intense lines in the other areas.

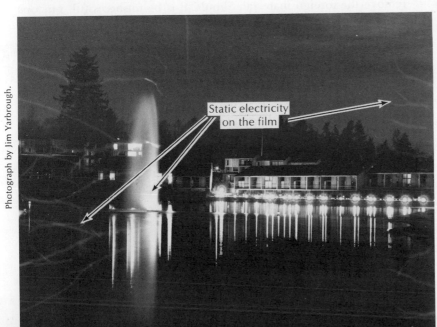

Static electricity
on the film

Photograph by Jim Yarbrough.

1-8 Check temperature and humidity of home storage areas, too. Closets near furnaces or dampness in basement cupboards damage equipment and opened film.

1-10

something is wrong. Find the problem and correct it rather than forcing the part to move. A camera repairman may be needed.

7. *Avoid touching the pressure plate with fingers* (Fig. 1-11). Acids in skin secretions on the fingers cause tiny rust spots. Rough areas on the pressure plate of cameras that use film without a paper backing (35mm and 220 films) will scratch the acetate film base. Such scratches probably will show in the finished picture.

8. *Use camera lens tissues for cleaning glass surfaces.* Handkerchiefs, facial and eyeglass tissues, and shirttails (Fig. 1-12) are much too coarse for the soft coatings and glass used in cameras. Inexpensive lens tissues made especially for camera lenses are available at most camera counters. A pack of tissues stored in a dust-free envelope should be kept in the gadget bag.

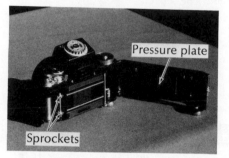

Pressure plate

Sprockets

1-11 Protect the pressure plate from all abrasions or anything that may cause roughness to prevent scratches on the film.

To use lens tissues, tear a sheet in half and roll the two pieces together so that the torn edges can be used as a brush (Figs. 1-13–15). *Never* rub a lens with the tissue. Any dust on the lens would then scratch the surface. Instead, if brushing is not sufficient, breathe onto the glass surface. If the lens is cooler than the breath, this gives a very thin coating of distilled water. Brushing may then remove the foreign material. Should this be unsuccessful, put one drop and *only one drop* of liquid camera lens cleaner on the brush tip of the tissue (Fig. 1-16). *Never put lens cleaner directly on the lens.* Brush the dampened tissue gently over the lens surface. Roll a fresh tissue brush to wipe off the lens cleaner.

An excellent method of removing loose dust from all parts of the camera is to blow it off with clean air under pressure (Figs. 1-17, 18). A jeweler's plastic hand blower or a baby's rubber ear syringe can be used. The jeweler's blower is the more effective because the nozzle isn't prone to change direction as it is squeezed. Products such as Omit or Airsweep, which are clean, sterile air in a pressurized can, are used to remove dust particles from all photographic equipment and materials.

1-12 Only *clean* tissues made specifically for cleaning lenses of cameras, microscopes, and binoculars should be used.

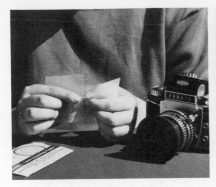 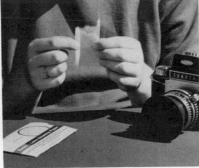

1-13 Tear the tissue in half.

1-14 Lay the two pieces together and roll to form a brush.

1-15 Brush, don't rub!

Brushes will clean dust from the lens and other parts of the camera. A camel's hair brush in a lipstick-like case is often recommended. Another brush that works well neutralizes static electricity and thus aids in picking up the dust. All brushes must be kept clean. In using them, the biggest danger lies in the tendency of the user to brush across the hand or fingers, picking up skin secretions and then wiping these onto the lens surface. Brushes can become reservoirs of dust to be scattered onto the brushed surfaces if the brushes are not kept clean. To clean, wash in mild soap and water, rinse and air dry in a dust-free area.

9. *Use plastic bags to protect against moisture, sand, and dust.* The camera can be used in relative safety in rainy weather if a clear plastic bag is slipped over the camera with the lens shade removed (Fig. 1-19). Let the lens come about midway of the side of the bag.

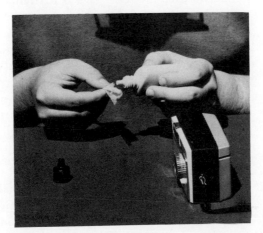

1-16 If necessary, use special lens cleaner on the tissue, *never directly on the lens.* Wipe off all residue cautiously.

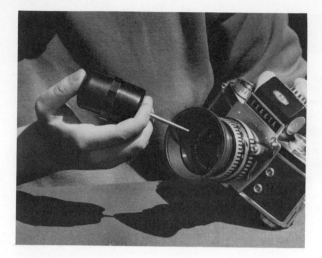

1-17 Plastic handblowers blow all loose particles off with no possible danger to the lens.

1-18 Clean air under pressure is effective for cleaning the camera interior.

1-19 Protect the camera from moisture in rain or snow with new, unused plastic food bags. These are best with the single-lens reflex cameras that focus through the lens. (Chapter 9, Understand the Camera.) Cut out the plastic over the lens when the lens hood is screwed in place.

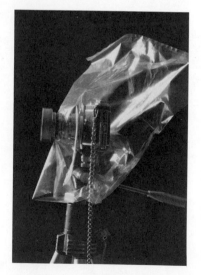

Screw the lens shade in place over the plastic bag to anchor it to the camera. At the same time the lens hood usually will cut out the plastic over the lens. If the plastic does not cut out, a pen knife will easily do it. Beware of scratching the lens with the knife blade! The lens shade helps to protect the lens. If the plastic bag chosen is an appropriate size, one can reach up under the bag to handle controls. Raise the lower edge of the back of the plastic bag to use the viewfinder but be sure the plastic does not get in front of the lens while the picture is taken.

A haze filter, skylight filter, or clear glass filter can give protection for the lens. This is particularly advisable in driving rain or blowing sand. No exposure compensation is required for either of these filters (Chapter 15, Filters).

In humid climates, it is wise to store a packet or bag of silica gel with the camera gear in a closed plastic bag or airtight container. Silica gel is a desiccant, which absorbs moisture, thereby drying surrounding air. When the silica gel becomes saturated, renew it for reuse by drying it in a warm oven.

10. *Never set a camera down in sand!* Should this happen, a competent repairman must clean the camera before it is used.

11. *Do not get the camera wet* (Fig. 1-20). Of course, exceptions to this guide are the cameras built specifically for underwater photography. Should other cameras be immersed accidentally, even partially, remove the film. When the immersion is for a short time,

1-20

the film may not be damaged, if processed within a day or so. If the water *is not salt water*, dry the camera carefully with clean towels. At the earliest possible time, preferably the same day, have a competent repairman inspect it and further dry it out, oil it, and do whatever additional work is necessary.

If the camera has been dropped into *salt water*, the procedure varies a bit. Remove the film as before, with a view to saving those pictures already taken. Dry the camera wherever water can be

detected without disassembling the camera. If water is not apparent inside, close the camera. If water has entered the inside, then leave it open. Immerse the whole camera in fresh water, in and out several times in rapid succession. Dry with a fresh, clean towel. Run, don't walk, to the nearest knowledgeable repairman! Many photographers do not consider a camera exposed to a salt water bath worth salvaging. Certainly, it is questionable. Repair charges compared with the value of the camera and the amount of water penetration are the points to consider in making the decision. The honest appraisal of the repairman is the best guide.

12. *Use a styrofoam ice chest as an insulated, inexpensive carrier for the camera and film in the auto, camper, or boat.* Never leave assorted equipment and supplies loose in the trunk of the car. There is too much danger of damage (Fig. 1-21). All of it should be stored in a gadget bag, which can then be stored in the chest (Figs. 1-22, 23). This will both moderate extreme temperatures and reduce vibration damage. The chest has other advantages, too, as camera gear storage, explained in the following section.

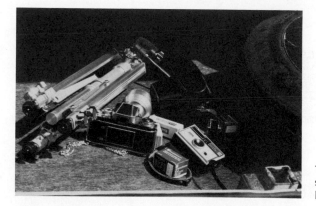

1-21 This photographic equipment is out of sight but not out of danger with the trunk lid closed.

1-22 Insulated picnic containers offer a safer, compact storage area for equipment and film in the car, camper, or boat.

1-23 Inexpensive web straps with D-rings secure the cooler without latches.

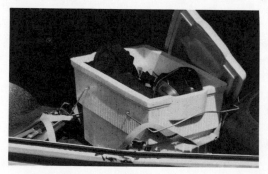

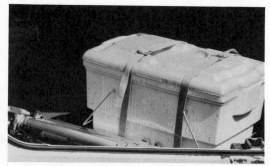

THEFT PREVENTION

Cameras and their accessories are often stolen. The major causes are:

1. Their common availability. Many people carry and use cameras.

2. The relatively high value in a compact, easily hidden package.

3. Carelessness of owners. Many photographers, both amateur and professional, all but hand the would-be thief their equipment.

4. The willingness of many purchasers and pawn shops to assume the person who is selling to be the rightful owner.

By following a few basic practices, photographers can reduce the chances of loss by theft, and perhaps may even recover stolen articles.

1. *Record brand name, model identification, and serial number of each piece of equipment as it is acquired.* Purchase price is helpful in evaluating loss. File this list in a safe place to aid in proving ownership and identifying items lost. In filing insurance claims, it is almost impossible to recall each article that was in a gadget bag without such a list.

2. *Insurance can protect against monetary loss.* Separate policies covering the camera and accessories or riders attached to household insurance protect against accident to the equipment as well as theft. The charges for this coverage vary but should be considered if the investment is sufficient to justify the cost.

3. *The owner's name, address, and telephone number should be on each piece of equipment,* if possible. Many times photographers walk off and leave items. It is often probable that the finder would be glad to return them if there were any way to identify the owner.

Permanent markings can be made with an electric vibrator tool that engraves identifying marks into the metal (Fig. 1-24). The disadvantage of this practice is the possibility of a later desire to trade or sell the equipment or of address change.

Embossed plastic tape labels can be used on the bottom of the camera and the post of the tripod (Fig. 1-25). The labels can be removed without damage and do serve to identify equipment for the honest finder. The gummed printed name and address labels used commonly for return addresses on envelopes can be stuck to the interior of the camera, in back of the area in which the spool of film fits. This will not damage the film nor interfere with camera operation in any way. Again, it is easily removed but can serve the person who wishes to return the object to the owner.

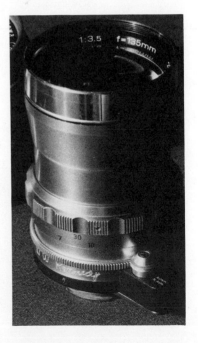

1-24 The owner's name engraved on each piece of photographic equipment is not easily removed from lost or stolen items.

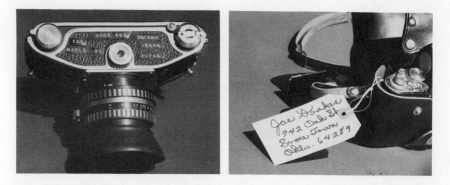

1-25 Removable plastic tape identifies equipment for the honest finder.

1-26 An inexpensive manila tag is superior to no identification.

Some photographers resort to manila tags attached by string to the larger items (Fig. 1-26).

4. *Lock the auto, camper, trailer, or boat when it is left* even for a short time. People seeking such items canvass unlocked vehicles and boats near restaurants, motels, hotels, marinas, and boat docks as well as sporting events, parks, and sightseeing stops. Often the camera owner is several miles on his way before discovering his loss. He may never be sure just where his property was taken or lost. Locked doors will discourage many thieves, though certainly not all of them. The determined, less adept thief will use a brick or rock to break a window if it is obvious there are worthwhile items within. Even relatively inexpensive cameras have been stolen by these methods. This leads to the next recommended practice.

5. *Keep camera gear out of sight when it is not being used.* This applies to the auto, boat, and home. Cameras, gadget bags, and tripods should never be obvious to the passerby (Fig. 1-27). Each immediately alerts the individual to the possibility of additional loot. The styrofoam ice chest (no ice, please!) suggested in guide 12 for care of cameras is an excellent disguise for most camera equipment even in a station wagon (Fig. 1-28). If it is stored in the trunk, the styrofoam aids in control of high temperature. Trunk interiors can be very hot! If possible, it is better to keep the foam container in the passenger section. A blanket or coat can hide the tripod. If these suggestions are not practical, small opaque plastic garbage bags hide and protect the camera (Fig. 1-29).

Dishonest casual visitors, door-to-door salesmen, and repairmen often use these activities as schemes to spot worthwhile prospects for later calls when the occupant isn't home. Indeed, some will pick up

1-27 Even though doors may be locked, this display is an open invitation to theft.

1-28 Cover tripods. Tripods in particular alert the would-be thief to the possibility of additional profitable items.

items on their first call. Using that styrofoam chest for camera gear storage at home may mislead this type of operator, too.

6. *In crowds or at sporting events, keep a hand on the camera at all times.* This means that the camera hanging from a neck strap should be in front of and not in back of the person (Fig. 1-30). In a crowd, cameras or gadget bags slung on the back are an open invitation for someone with a razor sharp knife or snippers to leave the owner with only a strap. By the time the owner can turn around to identify him, the culprit is lost in the crowd.

At sporting events, keeping a hand on the camera is equally important. A camera on the seat beside the owner is in dire danger. At a high peak of excitement, a fellow spectator can grab it without being observed by anyone. By the time calm is restored after the exciting play, the thief is well on his way to the exit. Should he be caught as he is picking it up, he likely will pretend to be fascinated by the lovely camera and hand it to the owner expressing admiration for his choice.

Do not leave a camera on the beach to care for itself while you go swimming. Even keeping one's eye on it doesn't help when the thief has a head start on a crowded beach.

7. *Beware of lockers and unattended offices for temporary storage.* All are dangerous places for camera gear.

A show of genuine concern at all times for photographic gear aids in discouraging the would-be thief. Even so, the most careful photographer may become the victim of theft in spite of all precautions.

8. *In case of loss by theft, notify law enforcement agencies immediately.* Furnish a complete list of lost equipment, descriptions, serial

1-29 A clean white garbage bag hides the camera, provides some heat reflection, and keeps the equipment available.

numbers, and identifying marks to the police. All area pawnbrokers and stores that sell used cameras and accessories likely to be approached by the thief should be given a copy of the list.

Sometimes, this procedure results in recovery of the items. If not, this is the time that money spent for insurance looks like an excellent investment.

These simple, common-sense suggestions for camera care, handling, and storage are neither difficult nor expensive. Following them prolongs the life of the equipment. Failure to do so can cost money in repairs, lack of quality, or even loss of potentially important pictures that may never be possible again.

Above all, beware of do-it-yourself repairs to expensive camera gear. Do not try to recondition, oil, or otherwise service the camera. Too often the inexpensive approach only adds to the final expense, or even, perhaps, causes the equipment to be damaged beyond repair. A reliable camera repairman or the manufacturer are the only ones that should take the camera apart for more than the surface cleaning suggested in this chapter.

REFERENCES FOR FURTHER READING

Goldberg, Norman: "How to Keep Your Equipment in Shape," *Popular Photography,* Vol. 67, No. 6, December, 1970, pp. 84f.

———— "Static Marks on Film," *Popular Photography,* Vol. 68, No. 4, April, 1971, pp. 94f.

Keppler, Herbert: "How Long Should Cameras Last?" *Modern Photography,* Vol. 33, No. 6, June, 1969, pp. 60f.

———— "The Art of Complaining About Equipment," *Modern Photography,* Vol. 33, No. 7, July, 1969, pp. 113f.

Matzkin, Myron A.: "Why Cameras Break," *Modern Photography,* Vol. 32, No. 2, February, 1968, pp. 54f.

McLeod, Frank, #83628: "I Stole Cameras for a Living," *Modern Photography,* Vol. 26, No. 2, February, 1962, pp. 88f.

Roalman, A. R.: "What Photographers Should Know About Insurance," *U.S. Camera,* Vol. 31, No. 6, June, 1968, pp. 72f.

Woolley, A. E.: *Traveling with Your Camera,* New York, Amphoto, 1965.

1-30 Which method is best for the camera? Why?

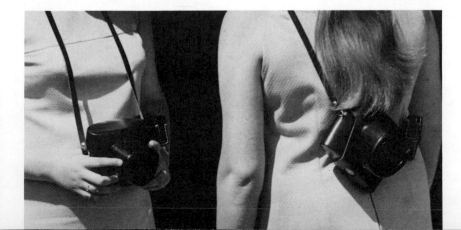

CHAPTER 2

Camera Operation

People interested in photography are anxious to make pictures. One can make pictures without a full knowledge of camera mechanics. Individuals with very little idea of how a camera actually works take pictures every day. It is necessary, however, to know how to operate a camera if pictures are to be successful.

Cameras vary in their appearance and operation, but all cameras have five parts in common. These are a viewfinder, a shutter, a shutter release, a lens and a lighttight case for the film (Fig. 2-1). Film is a transparent acetate coated on one side with chemicals, called the emulsion, which is sensitive to light and on which the photographic image is recorded.

HOW THE CAMERA WORKS

The photographer looks into the viewfinder to frame the picture; that is, he chooses what to include in the picture at the time of exposure. He opens the shutter for a given time by pressing the shutter release. A shutter is somewhat like a shade on a window. The shade is raised and then pulled down again. The camera shutter opens and closes automatically in most operations. During the period it is open, the light from the subject passes through the lens and onto the emulsion to form a latent image. If one could look at the film without further exposing it to light, there would be no obvious change. An attempt to look would erase all of the image because too much light would strike the film. When the entire roll has been exposed, the film is processed in appropriate chemicals that convert the latent images into permanent, visible pictures. The quality and success of the pictures depend on the basic photographic principles explored in this book.

KINDS OF CAMERAS

There are many ways to classify cameras. To be considered at this point of discussion are the controls and adjustments possible and whether they are automatic or manual. The dividing lines are not clear-cut because of the many variations in different brands and models.

1. *The simple box camera,* classified as nonadjustable, generally has no adjustments either automatic or manual. However, many

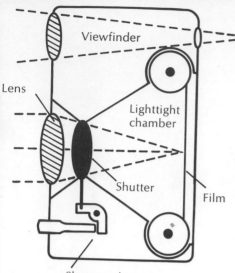

2-1 Basic camera parts.

Viewfinder

Lens

Lighttight chamber

Shutter

Film

Shutter release

do change to a slower shutter speed when a flashlamp is inserted, whether it is a new or an expended one. Do not allow a used flashlamp that requires a battery to remain in the camera over an extended time. A short can occur that would exhaust the battery. Box cameras are easy to operate and can make good pictures within the limits of the average situation in daylight, or with flash indoors, or at night at camera-to-subject distances of seven to ten feet. A number of nonadjustable cameras are illustrated in Fig. 2-2.

2. *The automatically adjustable cameras vary widely.* Some of these offer absolutely no possible control by the operator even though they are adjustable. Others are elaborate and may allow considerable control by special settings. Starting with the least control possible, the first adjustment will usually be the focus. The scale may show only an outline of a person, of three persons, and of a mountain to represent distances (Fig. 2-3). There

Instamatic 124, courtesy of Eastman Kodak

Instamatic 134, courtesy of Eastman Kodak

Instamatic 44, courtesy of Eastman Kodak

Instamatic 174, courtesy of Eastman Kodak

Instamatic 314, courtesy of Eastman Kodak

Instamatic X-15, courtesy of Eastman Kodak

2-2A A few of the nonadjustable cameras which change to a slower shutter speed when a flash lamp is inserted.

2-2B Some of the nonadjustable cameras that can be focused approximately.
Vitessa 126 CS, courtesy of Zeiss Ikon-Voigtlander of America
Instamatic X-35, courtesy of Eastman Kodak

SIMPLE FOCUSING GUIDE

2-3 Distances are estimated. Guide may be on the lens and/or in the viewfinder.

3' to 5' 6' to 10' 15' to ∞

may be a numbered scale to indicate feet and/or meters (Fig. 2-4). Or the operator may have to estimate the distance from camera to subject and set the scale accordingly (Fig. 2-5). All better cameras have a focusing device. Various types are discussed more fully in Chapter 9, Understand the Camera. Readers with a focusing device on their equipment may wish to study that section of the text at this point.

If the shutter speeds can be controlled, one of the following series of notations will be found on the camera. Most common

2-4 The numbers to the left of "ft" indicate focused distance in feet. The numbers to the left of "m" indicate meters. A meter is slightly more than three times the length of a foot. A distance scale may have less or more numbers than shown here.

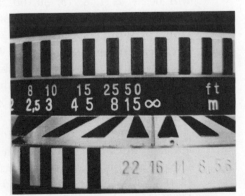

Anscomatic 626, courtesy of GAF

Contaflex 126, courtesy of Zeiss Ikon-Voigtlander of America Inc.

Olympus Quickmatic 600, courtesy of Ponder and Best, Inc.

Olympus-35 EC, courtesy of Ponder and Best, Inc.

Vitessa 126S, courtesy of Zeiss Ikon-Voigtlander of America Inc.

Konica C35, courtesy of Konica Camera Corp.

2-5 Some cameras which are automatically adjustable and can be focused by estimating the distance to the subject.

will be: 1, 2, 4, 8, 15, 30, 60, 125, 250, and 500. Some older cameras have: 1, 2, 5, 10, 25, 50, 100, 300, and 500. In either group of shutter speeds, there will be variations from camera to camera in the range covered. Each of these numbers refers to fractions of a second that the shutter is open when the dial or ring is set on that particular numeral and the shutter is released. Thus, 2 is 1/2 second, 30 is 1/30 second, 500 is 1/500 second, and so on (Fig. 2-6).

Some automatic cameras allow the photographer to set the lens apertures and still remain automatic. The lens aperture settings are indicated by a series of numbers: 2.8, 4, 5.6, 8, 11, 16 (Fig. 2-7). These are referred to as f/stops and are written, f/2.8, f/4, and so on. The scale varies in range from lens to lens

Instamatic X-90, courtesy of Eastman Kodak

Instamatic 714, courtesy of Eastman Kodak

Instamatic 814, courtesy of Eastman Kodak

2-6 Some automatic adjustable cameras that can be focused and offer shutter speed control.

because some will provide possible larger and/or smaller comparative apertures than the ones listed.

If the camera has a footage scale, an aperture adjustment, and choice of shutter speeds, it may be the camera can be taken off automatic and set manually when desired or for special problems (Fig. 2-8).

3. *Manually adjustable cameras,* also, vary in the adjustments possible. The series of symbols and/or numbers will be the same as those just outlined for the automatic adjustable. The completely manually adjustable cameras require the photographer to select and to make each adjustment to properly operate the equipment.

It is surprising how quickly one can learn to make the adjustments. If available, study the operating manual or pamphlet that came with the camera. Many manufacturers publish hard-cover manuals that explain the operation of a number of models. Such books are available

2-7 Identify the aperture scale by the sequence of numbers, which may be fewer or more in settings than on this lens.

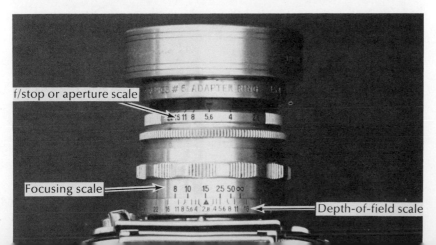

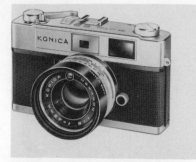

Konica Auto S2, courtesy of Konica Camera Corp.

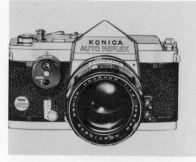

Konica Auto Reflex, courtesy of Konica Camera Corp.

Olympus-35 SP, courtesy of Ponder and Best, Inc.

2-8A Some automatic adjustable cameras that can be set to override the automation and be operated manually for greater flexibility.

2-8B (Opposite page, and top of next page) A few adjustable cameras which are operated manually. They do have automatic features but do not set aperture and/or shutter speed without manual adjustment.

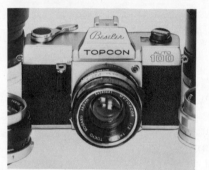

Beseler Topcon Auto 100, courtesy of Beseler Photo Marketing Co. Inc.

Vitessa 500SE, courtesy of Zeiss Ikon-Voigtlander of America, Inc.

in libraries, at camera stores, or in used book stores. The instructions that come with film are excellent guides, too.

Without film in the camera refer to the manual and practice operation of the camera as though making a picture, step by step right through tripping the shutter release. Do this until the operation is easy. NOTE: Some cameras will not operate without film. In that case, buy the cheapest available to fit the camera. Carefully mark the practice film to avoid accidental use as good film. It can be used as practice film in loading developing tank reels later in the course.

USING THE CAMERA

Regardless of the type or kind of camera used, certain procedures improve the photographer's chance of success. Practice saves films and pictures!

1. *Hold the camera still when taking a picture.* Shutter speeds can vary from several hours to one five-hundredth (1/500) of a second and faster. Obviously, camera shake is more of a problem at five seconds than one five-hundredth (1/500) of a second.

Alpa 10d, courtesy of Karl Heitz, Inc.

Icarex 35S, courtesy of Zeiss Ikon-Voigtlander of America, Inc.

Kowa Set R2, courtesy of Kowa American Corp.

Mamiya/Sekor 1000 DTL, courtesy of Ponder and Best, Inc.

Miranda Sensomat, courtesy of Allied Impex Corp.

Miranda Sensorex, courtesy of Allied Impex Corp.

Nikon F, courtesy of Gilbert, Felix and Sharf, Inc.

Nikkormat, courtesy of Gilbert, Felix and Sharf, Inc.

Pentax Spotmatic, courtesy of Honeywell, Inc. Photograph by Birlauf and Steen, Inc.

Hanimex Praktica Super TL, courtesy of Hanimex (USA), Inc.

Rolleiflex SL26, courtesy of Honeywell, Inc. Photograph by Birlauf and Steen, Inc.

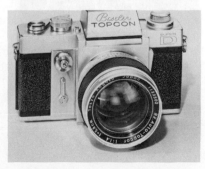

Topcon Super D, courtesy of Beseler Photo Marketing Co., Inc.

Vitessa 1000 SR, courtesy of Zeiss Ikon-Voigtlander of America, Inc.

Mamiya C330, courtesy of Gilbert, Felix and Sharf, Inc.

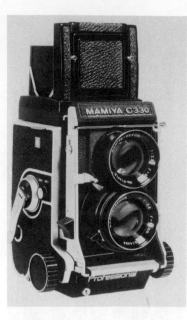

2-9 Tripods reduce chance of camera movement when film is exposed. The cable release aids camera steadiness.

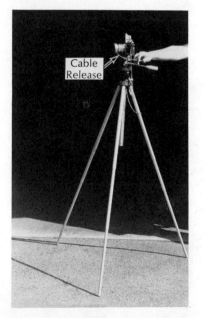

Cable Release

Methods that prevent camera movement will depend on the particular camera used, its viewfinder, the subject, its location, and the light intensity.

a. *Use of a sturdy tripod* set on a solid floor or ground is the best possible method (Fig. 2-9). Before the course is finished, pictures are assigned that require the use of a tripod or an adequate substitute. Clamppods and unipods are some that can be used effectively (Fig. 2-10). Not everyone has a tripod, nor do many people wish to use one *all* the time. In some areas, a tripod is forbidden. In other situations, there is no firm surface on which to set it (Fig. 2-11).

Handholding the camera is practical at 1/125 of a second and faster for most equipment in common use. Some people can handhold successfully at slower speeds.

b. *The photographer must make his body steady* if he is to handhold his camera. This does not mean to stand rigid. Body tenseness increases the chance of camera movement. Relax but do not slump. Stand with the feet comfortably apart, the body weight more on one foot, with the other foot serving as a brace (Fig. 2-12).

The elbows should be against the body for most viewing positions (Fig. 2-13). During the instant of exposure, when the shutter release is tripped, the careful photographer holds his

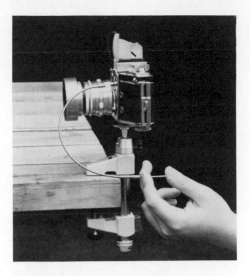

2-10 Various other methods of steadying the camera are possible with clamppods. This one will screw into a log, board, or post and three miniature legs make it a tripod. Legs and screw are conveniently stored in the clamp back post. The ball and socket head pivots 360° horizontally and 90° vertically as the clamppod is attached here.

2-11 Drawn by C. Norman Dickison.

2-12 (Bottom, left) One foot slightly ahead of the other steadies the body during film exposure.

2-13 (Bottom, right) Elbows against the body give additional stability.

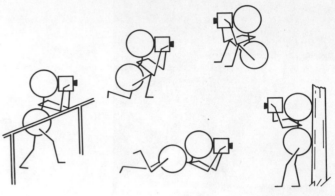

2-14 Numerous methods can be used to steady the camera.

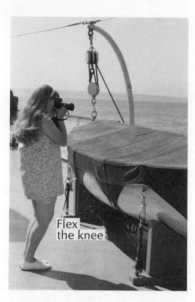

2-15 Vibrations of the ferry's engines are reduced with the flexed knees. What is wrong with the placement of the feet?

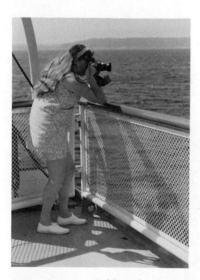

2-16 Danger of blurred or soft-focus images.

breath. When vibrations need not be considered, lean against a door casing, a wall, a post, or a tree to avoid movement for the slower shutter speeds. Other ways to steady the camera are illustrated (Fig. 2-14).

On a moving vehicle such as a boat, ferry, or plane, bend the knees slightly to reduce the tendency of the vehicle's vibrations to telegraph through the body to the camera (Fig. 2-15). Do not brace the elbows on an armrest or table in the plane or boat (Fig 2-16).

c. *A camera with an eye-level viewfinder* is held close to the eye to frame the picture (Fig 2-13). Be sure that a fingertip does not extend over the camera lens (Fig. 2-17). Firmly brace both hands and the camera against the face, one finger on the shutter release. This can be done in numerous ways. They vary with the shape and weight of the camera, the position of its controls, the contours of the photographer's face, and his own preferences. Another factor to consider is whether he wears eyeglasses (Fig. 2-18).

d. *A camera with a waist-level viewfinder* is held at waist level and looked into from the top (Fig. 2-19). If the camera has a neck strap, it can be used to steady the camera. With the strap around the neck, adjust the strap to a length that allows comfortable viewing. Put one hand on each side of the camera, one finger on the shutter release. Push down on the camera until the strap is taut.

The camera with a waist-level viewfinder can be held upside down at arm's length above the head to frame the picture (Fig.

2-17 The photographer sees the picture but won't get it with the finger over the lens. The viewfinder is separate from the taking lens. This occurs especially with small cameras and larger hands.

2-18A Experiment to find the most comfortable yet secure method to avoid possible camera movement.

2-18B Eyeglasses, their size, thickness, and shape, influence methods that are effective to steady the camera.

2-19). This method is useful in crowds to take a picture above others' heads or over a high fence. The head leaning back will tighten the strap to help in avoiding camera movement. Sometimes, the camera is held at arm's length, horizontally, to take a picture around an obstruction (Fig. 2-19). The taut strap serves as a brace in this way, too.

e. *Press the shutter release gently.* The camera shutter will go no faster or slower than the speed at which it is set. Those trained to shoot a gun properly know that the trigger is squeezed with gradually increased pressure to avoid changing the aim. Few cameras are equipped to squeeze the shutter release but, as with a gun, controlled increased pressure reduces the danger of movement.

f. *Use a cable release when the camera is on a tripod* for additional stability on long exposures (Figs. 2-9, 10). This is flexible cable that may be from five inches to thirty or more feet in length. A release on one end activates a plunger at the end attached to the camera's shutter release. Shorter cable releases up to two feet long may be either cloth covered or metal sheathed. Longer cables are of rubber tubing for air pressure (pneumatic) releases

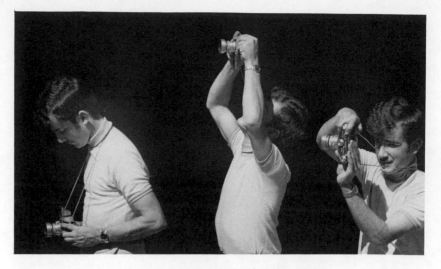

2-19 Three different ways the waist-level viewfinder can be used. Use the neck strap to adjust to correct distance from the eyes and to reduce camera movement.

activated by rubber bulbs. The metal- or cloth-covered cable releases with locking devices permit the shutter to be locked open for several seconds or even hours if desired. When using a cable release, always keep it flexed (curved), not straight and tight, to avoid camera movement.

2. *Load and unload film in the camera correctly.* Film is packaged in numerous sizes and containers (Fig. 2-20). Buy film to fit the camera. Some cameras have printed on them the size film required. Load and unload roll and 35mm films in a shady place, not in bright sunlight. The more sensitive the film, the more subdued the light should be. Check camera operating manual for exact procedure. General directions are:

 a. The 126 film cartridge is the simplest to put in the camera.

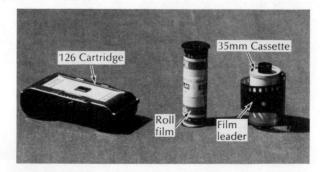

126 Cartridge
35mm Cassette
Roll film
Film leader

2-20 Three film packages.

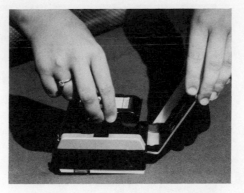

2-21 The 126, termed "Instamatic" film, simply drops into the camera.

(i) Subdued light is never amiss for loading or unloading any film. Drop the cartridge in place and close the camera back (Fig. 2-21).

(ii) Advance the film until numeral "1" appears in the window in the back of the camera. After each picture is made, advance the next number into the window.

(iii) When all of the roll has been exposed, advance until no paper can be seen in the window.

(iv) Open the camera and remove the cartridge.

b. Roll film is on metal or plastic spools. The film has a paper backing that protects the film from light if kept tightly rolled. There is sufficient paper to load the camera so that the film is not exposed to light. Have the camera in shade to load and unload the film.

(i) Open the camera back.

(ii) Inside the camera is a take-up spool, the one previously emptied. Shift this to the take-up position (Fig. 2-22) and put the new spool in the now empty place.

(iii) Completely remove the paper seal from the new roll of film (Fig. 2-23).

(iv) Thread the paper leader into position and into the take-up spool. The slot holds the paper leader to pull the film through when the film advance knob or crank is turned (Fig. 2-24). Turn the film advance to make sure the film is moving properly. Cameras with automatic frame stops have the starting point marked on the frame. The starting arrow or line on the film must be aligned with this point (Fig. 2-25).

(v) Close the camera back and lock.

(vi) Turn to the first frame. On many cameras, the film is properly advanced to the first frame when the number "1"

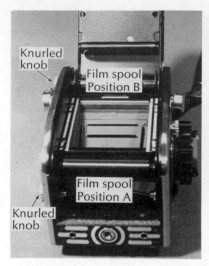

2-22 Pull the knurled knob at the end of the spool to remove it, then pull out on the knob that will be at the end when the spool is in its new position.

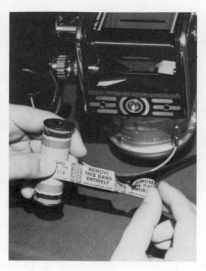

2-23 Be sure to remove and discard the strip of paper seal!

2-24 The new spool of film has been put in position, the paper backing pulled up and threaded through the take-up spool.

2-25 The arrow is aligned with the dot on the adjacent side of the camera.

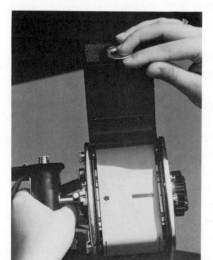

appears in the red window. Other cameras have an automatic stop at the first frame and all subsequent frames.

(vii) When all frames are exposed, with the *camera still closed*, roll the paper backing the rest of the way onto the take-up spool.

(viii) Open the camera, remove the roll, fold under the end of the paper backing. Seal the end with the gummed paper that is in position on the end of the paper backing. The roll must be opened only in a *completely dark room* when ready for processing.

c. 35mm film is fastened onto a spool inside a metal cassette. There is no paper backing. The leader, a narrowed section of film, extends through a nearly lighttight slit in the cassette. Film should be loaded in a shaded area. Cameras vary in the actual mechanics of film loading, but the basic procedure is:

(i) Open camera back.

(ii) To insert the cassette in the camera, look for a knob, usually knurled (ridges on edge to make it easier to grasp and turn), with an extension into the camera (Fig. 2-26). The extension fits into the center of the cassette. Pull out on the knob. Drop the cassette into position. Push the knurled knob back into place with a twisting motion to seat properly.

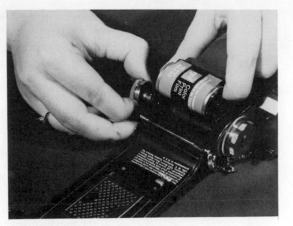

2-26 The knurled knob is pulled out to permit the film cassette to drop into the camera.

(iii) A take-up spool is on the opposite side of the camera. It may or may not be detachable. Pull the leader out of the cassette just enough to slip onto the take-up spool, fasten or attach (Fig. 2-27).

(iv) Start the film advance. Be sure the film moves properly. The sprocket wheel should engage in the sprocket holes of the film (Fig. 2-28). Some photographers, in an attempt to get 22 or 23 exposures on a 20-exposure roll, do not advance the film to be sure the sprockets are adequately engaged. This is false economy. Sooner or later a whole roll is lost because it was not properly attached and advanced before the camera was closed.

(v) Close the camera back. Advance two frames. On many

2-27 The manner in which the film is attached to the take-up spool varies from camera to camera. This one slips under the curved metal. Be sure it is securely gripped or fastened to be certain it advances, to avoid loss of time, money, and pictures.

2-28 If the sprockets, shown under thumb and forefinger on left, are not properly oriented in the sprocket holes, the film may not feed as it should.

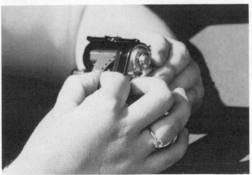

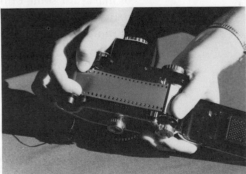

cameras the shutter will have to be cocked and the shutter release tripped before the film will advance. Cocking a shutter prepares it for the photographer to trip the shutter release. Some are cocked when the film is advanced. Others require a separate cocking operation. Check the camera's operating manual for directions. When the film has been advanced two frames, the film exposed in loading the camera has been rolled onto the take-up spool. If the frame counter is not automatic, it should be set at this time. The camera is ready to take pictures.

(vi) When all frames are exposed, the film will not advance further. *Do not open the camera!* Rewind the film into the cassette. There is a release button, lever setting, or other mechanism to release the lock on the film and allow it to change direction. Press or position the mechanism as needed, then turn a crank or knurled knob to pull the film back into the cassette. When all film is completely rewound, less pressure is required to operate the rewind mechanism.

(vii) Open the back of the camera. To remove the cassette, pull the knob out and lift the cassette. If the leader is not all the way in the cassette, turn the spool by the extension on the end. Pull the leader all the way inside to prevent an error in reloading and double exposing the roll. Open the cassette *only* in a *completely dark room* when ready to process.

3. *Set the ASA on light meters and camera.* The 126 film cartridges set the ASA automatically when they are dropped into place in the camera. Adjustable cameras that use roll or 35mm films and have light meters in or on them, automatic or manual, require the ASA be set correctly. The ASA dial or scale has numbers in sequence, thus: 25, 32, 40, 50, 64, 80, 100, 125, 160, 200. The dial may use dots or marks for some of the numbers: 25 – – 50 – – 100 – – 200. There may be other numbers in the series and use dots for this last series of numbers listed (Figs. 2-29, 30).

Some cameras have ASA dials that serve only as reminders for the correct ASA of the film in the camera. They exert no control, whatever.

At this point this text will not cover the use of the separate hand meter. The reader should follow instructions with the film on exposure settings (lens apertures and shutter speeds) until he studies Chapter 9, Understand the Camera. The pictures assigned for the first few rolls in the *Student Project Book* do not require the ability to read light meters, if directions with the film are followed.

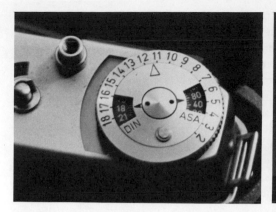 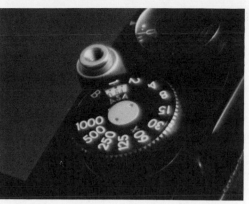

2-29 Different numbers of the ASA scale are shown on this scale from the one in Fig. 2-30.

2-30 Compare numbers on this ASA scale with those in Fig. 2-29. They represent the same series of numbers.

If the reader has explored the camera sufficiently as this chapter and the operating manual were studied, he may be ready to expose his first roll of film. Should he not feel sure, he should practice further with the empty camera.

STEPS TO FOLLOW TO MAKE A PICTURE

1. *Clean camera,* inside and out.
2. *Set the film ASA on the automatically adjustable camera.*
 a. 126 film cartridge sets it automatically.
 b. 35mm and roll film must be set on the ASA scale by the photographer.
3. *Set the ASA on the light meter for manually adjustable camera,* if a light meter is used.
4. *Choose the subject to photograph.*
 a. Study the subject from different distances and angles. Pictures have to be *seen* before they can be made. The kind of camera is unimportant for this part of the picture making.
 b. Check backgrounds. The camera sees everything.
 c. Look through the viewfinder to frame, that is, to decide exactly what to include in the picture.
5. *Decide on exposure* (shutter speed and lens aperture or *f*/stop). (Note for each picture in logbook.)
 a. Box cameras have only one exposure possible, except or unless a spent flashbulb is inserted. This may change the shutter speed. (If camera's manual does not tell the shutter speed, the camera dealer's literature does.)

 b. Automatic adjustable, even if not controllable, either in the viewfinder or on the camera exterior, may show the f/stop and shutter speed used. If controllable, both will show somewhere on the camera. Note for each picture in logbook all information shown.

 c. Manually adjustable camera exposure may be determined by
 (i) Paper packed with film or on paper backing on the roll film, that was noted when film was loaded.
 (ii) With a shutter speed suggested by the instructor, the light meter that may be on the camera can give the student the correct f/stop.
 (iii) A meter reading by the instructor.

6. *Focus,* if the camera has adjustable focus.

7. *Recheck all settings* to be sure they are as planned.

8. *Reframe in the viewfinder.*
 a. Hold camera level.
 b. Include only that desired.

9. *Hold camera still and trip shutter release.*

10. *Advance the film* to the next frame.
 a. If another picture is to be made soon. On many cameras, when the film is advanced the mechanism cocks the shutter. The tension puts strain on the shutter spring if it is left cocked for several days at a time repeatedly through the years. Film is prone to curl. It stays flatter on the roll to give sharper focused pictures if not pulled into position and allowed to cup up for several days or weeks between pictures.
 b. If the camera has no double exposure control to prevent taking one or more pictures on the same frame, then it is best to advance film immediately.

11. *Note anything in the logbook that might have affected the picture.*

12. *Go back to step 5 for each picture* until roll is finished.

13. *Remove the film* from the camera.

Now that the pictures have been *seen,* the shutter release tripped twelve (or twenty or thirty-six) times, and the film removed from the camera, it is called "exposed film." It is time to explore film processing to change those invisible latent images into visible ones.

CHAPTER 3

Black and White Film Developing

Care must be used when developing film to produce the best possible results, but the procedure is not complicated. Little special equipment is required and can be quite inexpensive. A darkroom is not imperative; the kitchen sink is adequate. The cost of chemicals is reasonable, within range of the budgets of most beginnning photographers. This can be the start of exciting experiences!

The terms most generally used are "develop" for negative film (used in most black-and-white photography) and "process" for positive color film (used for slides).

EQUIPMENT

The following equipment is needed for film developing:

1. A *daylight tank* with an appropriate size reel (Fig. 3-1). A daylight tank is a lighttight container that protects the film from light while the chemicals are poured on and off the film in a normally lighted room. Most, though not all, daylight tanks must be loaded in total darkness.

 For the beginner, the plastic daylight tanks (Figs. 3-2–4) are adequate and least expensive. Most plastic reels which are sold with the tank adjust from the width required for 35mm or Instamatic cartridge films (the same width) up to that of the 620 and 120 films. The FR Special (Fig. 3-2) is a plastic daylight tank that, with the insertion of a center dividing flange to separate the two rolls of film, can develop two rolls of 35mm at one time. The Yankee tank (Fig. 3-3) adjusts to fit several different widths. The Jobo tank (Fig. 3-4) takes two reels of 35mm film. This is a time saver, especially with processing color slide films. Most of the plastic reels accept any length of film up to the 36-exposure roll.

 The stainless steel tank (Fig. 3-5), while more costly, is easier to clean and dry. It is practically indestructible under normal usage. Different size tanks are available for developing various numbers of reels at one time.

 The stainless steel reels are purchased separately to fit the film

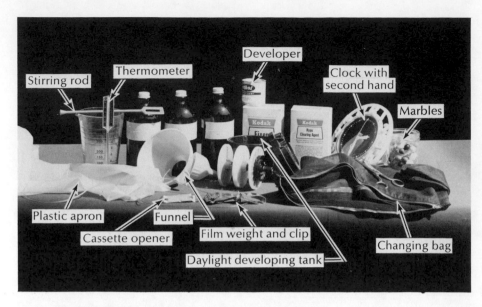

3-1 Supplies and equipment to process black and white film.

3-2 The FR Special Daylight tank shown in Fig. 3-1 is assembled and the thermometer inserted in the top, a convenient method to be sure of temperature of the chemicals. The reel adjusts to different size films.

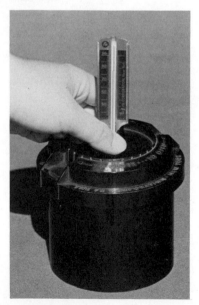

sizes used. In the 35mm sizes, the reels are made to accept the 20-exposure and the 36-exposure lengths of film. There is no advantage to the shorter length reel. The 36-exposure length gives maximum versatility.

2. A *completely dark place* to load film onto the reel and into the tank. A closet or bathroom often can be totally darkened. Another completely dark area which can be used is a changing bag (Fig. 3-1). It is made of two layers of black cloth, the inner one rubberized. At one end, the bag may be opened by a zipper in each layer of cloth. The opposite end of the bag has two sleevelike extensions with elastic at the outer ends. The bags are available at camera stores. The price varies with the size and kind of fabric used. The cotton is cheaper than the nylon in the same size (Appendix I-13).

3. A *thermometer* (Fig. 3-1), to check temperature of the water used for mixing the chemicals, to aid in regulating the temperature of the chemicals and rinse water during the developing procedures. The stainless steel shanked thermometer is the most durable. The cost varies with the model and brand purchased. A reliable and satisfactory one, the FR, is among the less expensive ones. The Weston dial model is several times more costly but is considered by professionals as the very best.

4. A *pint graduate* (Fig. 3-1), clearly marked in ounces, to measure and mix chemicals. This can be an inexpensive glass pint measure

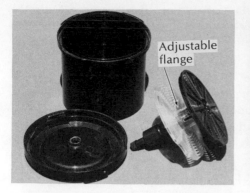

3-3 The Yankee daylight tank processes no more than one roll of film at a time but adjusts to take several widths. There are a number of other brands made that operate similarly.

3-4 The Jobo tank adjusts to various single roll film widths or takes two rolls of 35mm film at one time. The center flange is sold with the tank.

from the kitchen or one of the tapered plastic or glass graduates made specifically for the photographic trade. The chemicals dissolve quicker in the tapered ones because the stirring is more effective. The cost is nominal.

5. A *glass rod* or *plastic paddle* (Fig. 3-1) for stirring chemicals. The paddle dissolves the chemicals more quickly.

6. Appropriate sized *bottles of brown plastic or glass* with tight caps for storing chemicals (Fig. 3-1). Camera stores sell brown plastic bottles made for this purpose. Drugstores and beauty salons discard glass bottles that are excellent. Before storing chemicals in them, all bottles should be washed with hot water and detergent, then rinsed well until all odors and foam are absent. Developers deteriorate if exposed to light or air; therefore, use brown bottles

3-5 Stainless steel tanks and reels are durable. The plastic lid is less likely to leak as the tank is agitated.

or store them in a dark place or do both if convenient. Only the developers need this protection. The number and size of the bottles depend on the particular developer chosen and the quantity mixed at one time.

7. *Plastic funnel* (Fig. 3-1) to aid in pouring chemicals into the bottles. One funnel on the market is made in two sections so that a filter may be inserted. In addition, it offers two different size openings, should a larger-mouthed container be used. Another model available has a built-in screen for straining all chemicals that pass through the funnel.

8. *Small size marbles* (Fig. 3-1) to fill the developer chemical to the very top of the bottles, if glass or nonflexible bottles are used. This prevents deterioration due to exposure to air left in a bottle. Plastic bottles can be squeezed until the solutions come to the top and then tightly capped to protect from air. Small marbles of the type commonly used to play Chinese Checkers will go in most glass bottles of a pint or larger. When a sufficient number have been dropped into the chemicals to raise the liquid to the very top, screw on the cap securely. Only the developer storage requires the removal of all air.

9. *Clock* or *timer* (Fig. 3-1) preferably with a sweep second hand, that can be set or watched for exact minutes.

10. *Film clips and weights* (Fig. 3-1) to hold the film on a line or rod to dry and to hold the film straight. Metal and plastic clips are available. Plastic or wood clothespins of the spring clip variety can be substituted satisfactorily. One clothespin holds the top of the film and two are used as a weight on the bottom.

11. *Photographic sponge* or a *squeegee* to wipe water from wet film. A *soft* sponge kept immaculately clean can be used. A new automobile windshield wiper blade substitutes for a squeegee.

12. *Plastic or rubber apron* (Fig. 3-1) to protect garments or the photographer from chemical spatters or spills that cause holes and stains. Aprons may be of the disposable plastic type or the more durable plastic or rubber ones that can be washed in a washing machine.

CHEMICALS

The following chemicals are used in film developing:

1. *Developer* (Fig. 3-1), which develops the latent image into a visible one. If the beginning student is learning photography in school, no doubt the instructor chooses the developer for the

whole class. For those working on their own, the choice of developer is confusing. In most situations, it is best to use the developer recommended by the manufacturer for the specific film to be developed.

Actually, any black-and-white negative developer will develop any black-and-white negative film, though no two give exactly the same results. One needs to work with one developer until he is familiar with what it does under varying circumstances, to form a basis for comparing the results with other developers.

There are dozens of ready-mixed liquids; chemicals combined, both liquid and dry, to be mixed; and formulas for mixing bulk individual ingredients. Some are reusable with the addition of replenisher after each use, or with additional time allowed for each time the developer is used. Others are called "one-shot" because they are discarded after a single use. Most developers are one-solution but some are two-solution. Kodak's D-76 and HC110 are popular. Plymouth's UFG, FR's X-100, and GAF's Hyfinol are other widely used developers.

2. *Fixing bath* (Fig. 3-1), commonly called "hypo" because its principal chemical is sodium hyposulphite. It fixes (stabilizes) the image and clears (dissolves) those chemicals unaffected by light. Fixers, too, come in various forms and with varying ingredients but are fewer in number than the developing chemicals. An economical and suggested place to start is with the crystalline dry form containing hardener. It is mixed with water.

3. *Hypo neutralizer*, may also be called hypo eliminator or clearing solution (Fig. 3-1). This is an optional chemical which changes the chemical form of the fixer for easier removal of the hypo from the film. This saves both water and time spent in washing. The neutralizer is found in camera stores in a dry and in a liquid form to be mixed or diluted with water.

4. *The wetting solution*, also an optional chemical, used after washing to reduce danger of water spots on the film. Wetting solutions are sold under various brand names, usually in a concentrated liquid to be diluted with water.

MIX THE CHEMICALS

The procedure for mixing chemicals is:

1. Collect the necessary bottles, measuring and mixing equipment, and the chemicals near a source of water (Fig. 3-6).
 a. Wash thoroughly all bottles and equipment.

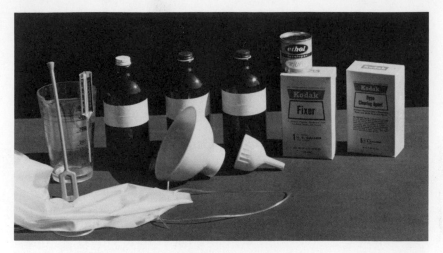

3-6 Assemble these items for mixing chemicals, not necessarily the same brands.

 b. Label the bottles with the names of the chemicals to be stored in them. Masking tape marked with a waterproof felt pen makes durable, inexpensive labels. The label should show the concentration (or dilution) and the date mixed. If the bottles have been used previously for photo chemicals, use them to store the same type of chemicals to reduce the danger of contamination.
 c. Line up the bottles in the order the chemicals are to be mixed. Line up the chemicals in a corresponding order. If the developer is mixed first, then the hypo, the risk of contamination is decreased.
2. Carefully read all directions for mixing the chemicals. Then read them again, step-by-step, as the mixing progresses. Respect the warning for handling the materials. The manufacturer knows the dangers. Temperature suggestions or limitations are important, too.
3. Do's and don'ts of mixing chemicals:
 a. Do mix by stirring in a glass, plastic, or stainless steel mixing vessel of a size convenient for the amount being mixed. Never use metal other than stainless steel with photographic chemicals.
 b. Don't mix by shaking the solutions in a bottle or jar unless directions specifically say to do so. If the bottles are shaken, the chemicals are aerated and, especially the developers, start deteriorating before they are even all dissolved.
 c. Do empty *all* of the chemical from the manufacturer's container. Chemical left in the bottom of an envelope or carton will change the strength of the mixed formula from that intended by the manufacturer.

d. *Do* wash the mixing utensils, stirring rod, and funnel after each solution is bottled by rinsing with five complete changes of water. Detergents or soap are not necessary.

e. *Don't* splatter chemicals, mixed or unmixed, on surrounding surfaces. This avoids stains and shortens clean-up time, and more important, eliminates another possible contamination problem.

f. *Do* keep the direction for use of each chemical solution until it is used or discarded.

LOAD THE FILM IN THE TANK

With the chemicals mixed and the equipment collected for developing film, the next step is loading the film in the daylight tank. Practice will make this easy. Use a roll of discarded film or purchase the cheapest film possible in the size used. Dealers often sell outdated film at a big discount. Either black and white or color will serve.

With the practice film, load the film on the reel in a lighted area until the film goes on without buckling, smoothly curved in the spiral grooves of the reel. With eyes closed, go through the procedure again. Then, still with the practice roll, do it in the area that will be used for loading, darkroom or changing bag.

This is the procedure for loading film:

1. *Wash hands with soap* to remove oils and acids from the skin to reduce the chance of fingerprints on the film. A still better way is to wear white cotton gloves made for handling films.

2. *Check adjustable reels* to be sure they are spaced *exactly* for the film width to be loaded. This precaution will save frustration in the dark because otherwise the film will not feed correctly.

3. *Turn out all lights* in the darkroom; or put film, tank, reel or reels, and tank lid (scissors, tool, or board for opening 35mm cassette) in the changing bag (Fig. 3-7). Zip it up. Put one hand in each sleeve (Fig. 3-8).

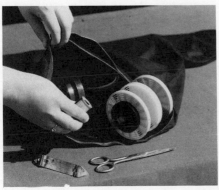
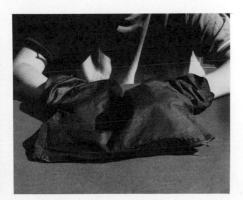

3-7 Items needed to load 35mm film in the tank. Instamatic cartridges and roll film do not need the bottle opener.

3-8 Zip the changing bag shut and insert the hands through the sleeves.

4. *Open film cartridge, cassette, or roll.* Film that is to be developed must be opened only in a totally dark area.

 a. Instamatic cartridge: Grasp the two rounded ends of the cartridge, one in each hand. Give a strong twist with each hand in opposite directions to break the cartridge open (Fig. 3-9). The film is rolled up in the larger end. Lift it out by the ends of the roll (Fig. 3-10). Roll paper backing to the film end (Fig. 3-11). Roll the film separate from the paper backing to taped end.

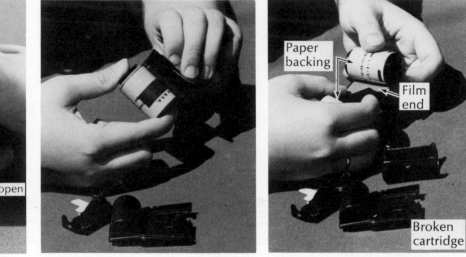

3-9 Give the ends of the cartridge a sharp, hard twist to break it open in total darkness.

3-10 Pick up the roll by the ends.

3-11 Roll the paper backing to the point the film starts. Now follow directions for roll film, Figs. 3–12C, D.

 b. Roll film: Cut or tear the gummed paper seal. Roll the end of the paper back until the fingers contact the end of the film (Fig. 3-12).

 c. 35mm cassettes: The end caps of Eastman Kodak cassettes are crimped to prevent their being used again. A pop bottle opener or similar tool is required to pry upwards on the rim of the cap on the flat end of the cassettes (Fig. 3-13). Do this at two or three points around the edge until the cap flips off. Drop the spool of film from the cassette into the hand. Use scissors to cut off the film leader to give a straight edge on the end of the film. To cut in the correct place, place left thumb and forefinger at the first full width of the film. Lay the scissors against the thumb and finger as a guide for the cut. On 36-exposure rolls the leader must all be cut off in order to have space on

3-12A Break paper seal on exposed film in total darkness.

3-12B Roll paper backing to start of film.

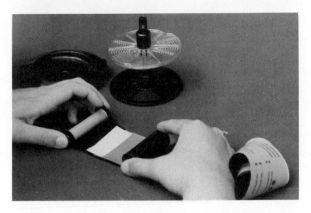

3-12C Remove tape that holds film in place and roll film separately from paper to the opposite end.

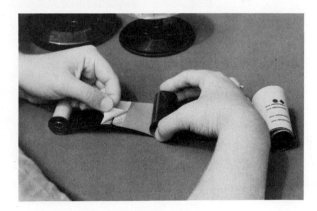

3-12D Peel tape from film. Remove all glue from the film.

the reel for all of the film (Fig. 3-14). Load the film onto the reel directly from the spool.

The GAF cassettes can be opened in the same manner as the Kodak but it does ruin the cassettes for reuse. Many people, who buy bulk film, open the GAF cassettes so that they can be used again. To do this, press or strike the spool extension end (Fig. 3-15) sharply on a solid surface to pop off the cap on the opposite end. This can mar a table top or cut through the changing bag fabric. Use a small board to protect these surfaces.

5. *To load film on reels* (directions are for right-handed loading).

 a. Stainless steel reels: Lay the reel on its edge on a table (Fig. 3-16). If the reel has the wire extension, hold it at the top and pointed

3-13 In total darkness, open the 35mm cassette.

3-14 (Above) Put thumb and forefinger at beginning of the leader. Lay the scissors blade against the finger and thumb. Cut.

3-15 (Right) Strike the extension end on a board as the opposite end is squeezed to release the pressure and pop off the top.

away. Cup the film end between the thumb and forefinger of the right hand. Slip the film into the fold of metal or under the spring at the center post. If the reel has a sharp point midway between the spirals (Fig. 3-17), press the film onto the point to puncture the film and thus anchor the end. If no device is furnished for anchoring, hold the film at the center with the thumb and forefinger of the left hand on the outside of the reel. Turn the reel counterclockwise while keeping the film slightly cupped

3-16 If the reel has the extension wire, place it at the top and pointed away. Not all reels have the extension wire.

3-17 Cup the film between the thumb and forefinger, insert to the center, bend over the sharp point to puncture, and anchor the film. Some reels hook the film under a spring instead.

3-18 Turn reel counterclockwise, cup film between thumb and forefinger, both of which rest on the reel edge as it is rotated.

between the thumb and two fingers of the right hand. Let the thumb and forefinger rest on the outside rim of the reel to guide the film (Fig. 3-18). When all of the film has been transferred to the reel except that held by tape to the film spool, lift the tape from the film. Check to be sure no adhesive remains on the film before the last bit is rolled into place. Do this by running the thumb and finger, one on each side, over the last one-half inch of the film. Rub any clinging adhesive off. No paper is on the 35mm but there is tape to hold the film to the spool.

b. The plastic reel with an upper flange that turns on the center post one-sixth of a turn: Trim the starting corners of the film to round them (Fig. 3-19). Hold the reel, with the spindle pointing into the right palm, an inch or so above the film roll lying on the table. Load from the outside toward the center. Start the end of the film into the outside spiral. Place the thumbs on edge

3-19 The Yankee tank and other similar models with movable reels on a center spindle feed the film from the outside edge. Round the two film corners slightly to prevent them from catching in the reel.

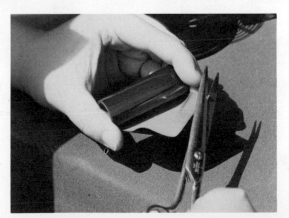

of the film at the depression on the rims of the reel. First turn the upper flange away, while the right thumb holds the film. The film is allowed to slip under the left thumb. Then, hold film with the left thumb while right hand turns the upper reel back to starting position (Fig. 3-20). Alternate these two movements until all of the film is on the reel. Remove tape from the end of the rolls.

If the reel is wet when it is necessary to load it, immerse reel and film in clean water and load as though both were dry.

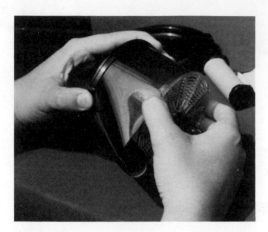

3-20A Hold one thumb down tight on one edge while turning the reel to its limit (about one-sixth of the circumference) to push the film in.

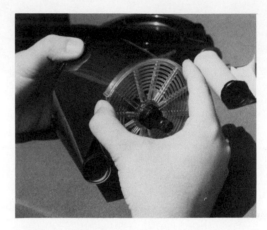

3-20B Release the first thumb held down and hold the film in place with the other thumb while the reel is returned to its original position. Alternate these two movements.

3-20C The film is all on the reel.

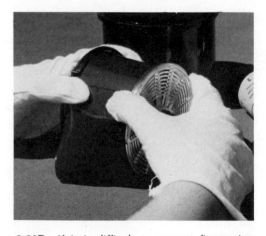

3-20D If it is difficult to prevent fingerprints on the film, use white cotton gauze gloves available at camera stores.

Drop reel into tank and put on the lid (Fig. 3-21).

c. The plastic reel with both flanges stationary: Lay the reel on edge on the table with the top of spindle pointing toward the operator. Thread the film of the reel from the center out to the edge. With the right hand, cup the film and insert to center. Press with left thumb on to the metal point to anchor the film. Do this fairly close to the edge of the film on the Instamatic cartridge and on roll film to avoid damaging a picture. The 35mm has more allowance between the end of the roll and the picture.

With the film anchored, keep the film cupped with the right hand, the thumb and forefinger, at the same time riding on the edge of the reels to guide the film (Fig. 3-22). When the film is down to the spool, remove the tape as suggested under the stainless steel reels in "a".

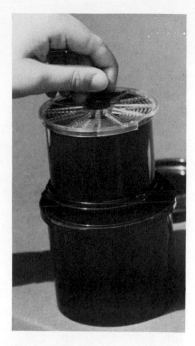

3-20E Drop the loaded reel in the tank. If it is agitated by twirling the center spindle, do so to be sure it moves freely. Put on the lid and twirl the center spindle again. If it moves easily, turn on the lights. If not, check position of film, reel and lid.

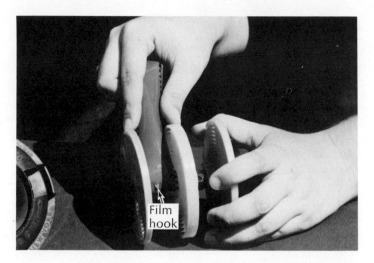

Film hook

3-22 To hook the film, hold the end firmly immediately in front of the hook with one thumb and pull the film against the point of metal with the other hand.

6. *Place reels in the tank.*
 a. The wire extension, if there is one, should be on the bottom as the reels are dropped into the stainless steel tanks (Fig. 3-23).
 b. Plastic reels should turn freely in the tank when the top of the spindle is twisted, if the tank has a spindle.

7. *Put on the tank lid.* Turn the plastic caps to locked position on the plastic tanks. Twist the spindle of the plastic tanks to be sure it still turns freely. If not, recheck it, until it does.

3-21 When the lid is locked in position on the tank, room lights may be used.

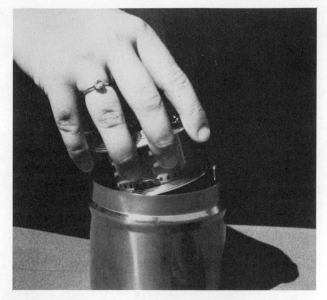

3-23 If the reel has an extension wire, place it *down* in the tank.

3-24 If you are not ready to pour in the chemicals, label the tank.

8. *Turn on the lights* or take the tank out of the changing bag.

9. *If the film is not to be developed immediately,* run a strip of masking tape up the side, over the top and down onto the other side. Label with the kind of film and its ASA (Fig. 3-24). If this precaution is not followed, sooner or later a loaded tank will be opened and the film inside will be ruined by the exposure to light.

DEVELOP THE FILM

1. *Check the developer for sediment.* If the developer is in brown glass bottles, tip the bottle sideways and hold it up to a good light. If the developer is in plastic bottles, pour into a glass graduate and check. If you see *anything* floating, filter the solution.

2. *Measure correct amount of each chemical.* Insufficient solution will not cover the film. Too much chemical will overflow the tank, thus waste solutions (Fig. 3-25).

AMOUNT OF CHEMICALS REQUIRED

Reel size	No. of rolls in the tank	Amount
126—35mm	1	8 oz.
	2	16 "
	4	32 "
127	1	11 "
120—620	1	14 "
	2	32 "

3-25 *Note:* Some tanks may require more liquid to cover the reel. These amounts are sufficient in most tanks.

3. *Bring all chemicals to the temperature recommended* by the manufacturer for the developer for the best results. Set all the bottles of solution in water up to their shoulders. The water should be five to ten degrees warmer or cooler than the desired temperature (Fig. 3-26). The solution nearest the bottle may register different from the center temperature, so tip the bottle upside down slowly once or twice to mix before checking. Wash the thermometer before inserting it in each solution.

3-26 The size of the container will determine temperature variance of the surrounding water from the desired chemical temperature.

4. Line the solutions up in the order to be used. Check labels to be sure correct dilutions are in each bottle.
 a. Developer.
 b. Fixer (hypo).
 c. Hypo clearing agent.
 d. Wetting solution.

5. *Read, again, all directions* for the particular developer being used. Especially, check:
 a. Recommended temperature.
 b. Duration and frequency of agitation.
 c. Time that the solution should be on the film.

6. *Check temperatures in all bottles.*

7. *When solutions are at the correct temperature,* pour the developer into the tank through the top of the lid (Fig. 3-27). Tip the stainless steel tank to aid the flow of chemicals (Fig. 3-28). The plastic tanks should set level.

3-27 (Left) Pour the chemicals in through the tank top.

3-28A (Bottom, left) Some stainless steel tanks have a division partition in the top so they may be left flat to pour in the chemicals.

3-28B (Bottom, right) Tip the tank to let the air escape for faster fill and more even development.

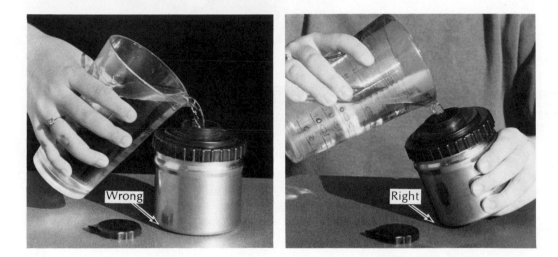

Wrong

Right

8. *Start timing* the instant all of the developer is in the tank. Put the small cap on the stainless steel tank.

9. *Tap the tank two or three times* on the table or sink surface to dislodge any air bubbles that may have formed on the film.

10. *Agitate the stainless steel tank* or the Jobo tank by alternately turning it over to the right, then to the left (Fig. 3-29). The *Yankee type and the FR plastic tanks* are agitated by turning the center spindle. Turn the spindle *clockwise* on the FR, *counterclockwise* on the Yankee type reel (Fig. 3-30). Agitate for the time and intervals recommended by the manufacturer of the developer. Two

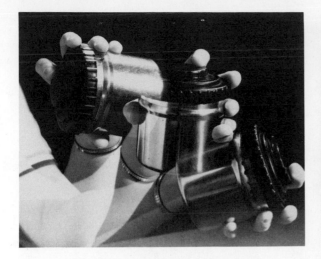

3-29 Agitate constantly the first 15 seconds in the developer, then for five seconds at 30-second intervals unless instructions with the developer state otherwise. Lack of agitation reduces contrast and causes uneven developing. Too much agitation increases contrast. Establish consistent rate and spacing of agitation.

3-30 Turn the center spindle at regular intervals as stated in Fig. 3-29.

or three minutes before the end of the time, start preparing water so the temperature will be stabilized close to that of the developer for step 12.

11. *Pour out the developer* when the time recommended by the manufacturer has elapsed. **Do not remove the tank lid!** Remove the *small* center lid from the stainless steel tank. Leave the plastic tank lids in place. Pour the solutions from the top of the stainless steel tank (Fig. 3-31). Use the side lip to pour solutions from the plastic tanks (Fig. 3-32). If the solutions are to be reused, they should be poured back into the bottles via the funnel. During the next step, add replenisher to the developer, remove air, cap both bottles.

12. *Wash with running water* at the temperature of the developer. Water should flow into the top of the lid as the chemicals did. Start timing when the water starts overflowing from the tank. Wash for one minute. The water stops the developing. Pour out the water with the *lid still on the tank*.

13. *Pour in the fixer (hypo)*. Agitate for five seconds every thirty seconds. At the end of three minutes, remove the tank lid. At this stage light will not affect the image. Lift the reel to inspect

 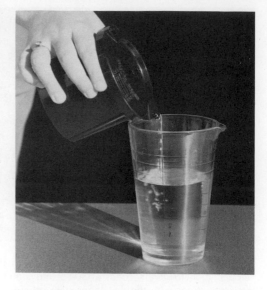

3-31 Pour off the chemicals rapidly to avoid uneven and excess development. Water stops developing.

3-32 Change solutions quickly to stop developing. Water must go into tank immediately.

the film. If the film is milky and opaque, the film is not yet cleared. If it has cleared, return the film to the fixer for three more minutes for a total of six minutes. If the film is not clear, return to the fixer and check at one-minute intervals until it has cleared. Note the total time it took for the film to clear. Leave the film in the fixer for that much additional time. Do not fix over the time required because to do so bleaches out detail. The time required for clearing varies with the kind of film and the amount of film that has been put through the hypo. The hypo should be discarded when the total fixing time requires over twelve minutes. Some photographers use new fixer each time. Using hypo after it is exhausted causes brown stains on the negative. The chemicals are not expensive enough to risk stains on even one negative.

14. *Wash two minutes in running water* that is within plus or minus five degrees of the temperature of the developer. Leave the tank lid off. If the hypo clearing agent is not used, continue washing for thirty minutes in all. If the hypo clearing agent is used, pour off the water.

15. *Pour in the hypo clearing agent* for the time indicated in the directions with the chemicals. This will be approximately two minutes. Agitate continuously.

16. *Pour off the hypo clearing agent* into the bottle for reuse. Note the capacity of its recommended use and keep count on the bottle label of the amount of film put through it. Discard when the limit of its recommended capacity is reached.

17. *Wash under running water* with the film still in the tank for the time suggested in the directions with the chemicals. This, probably, will be five minutes. Pour out the water.

18. *Pour on the wetting agent* and agitate for the recommended time. Bubbles are formed in pouring the agent on the film. If the roll is lifted through the bubbles, they may leave a residue. This danger is reduced if one pours the chemicals off rapidly.

19. *Hang the film to dry* with film clips or clothespins from a line or rod, in a dry, dustfree area. The film should not be dried at over 110°F. Do not dry in sunlight. *Wipe film down with a dampened, squeezed-almost-dry sponge* to remove the water that may be on both sides of the film or wipe with a clean squeegee.

20. When the film is dry, remove from hangers. Cut between negatives in lengths appropriate for the envelope or storage system used. **Handle film by the edges** (Fig. 3-33). Fingerprints damage film! Avoid scratches. They can be caused by dust or grit on surfaces where the negatives are laid or by the corners of the film striking the emulsion.

In summary, the previous twenty items of instruction can be stated:

1. Develop film at time and temperature recommended by the manufacturer of the developer.
2. Wash in running water one minute.
3. Fix for twice the time required to clear the film.

3-33 Film must be handled carefully to make quality prints.

4. Wash in running water for two minutes.
5. Use hypo neutralizer for two minutes.
6. Wash for ten minutes.
7. Use wetting solution for one minute.
8. Hang to dry.
9. File and index.

THE NEGATIVE

Photographers anxiously inspect their negatives when they pull them from the hypo because the success of the black and white print depends on the quality of the negative. The lightest portions of the subject will be the darkest areas of the negative.

Photographers critically read their negatives when they are dry. What do they want to see? For most subjects, they want negatives that have normal density, contrast, and good definition, without stains, scratches, or spots.

Density refers to the darkness or lightness of grays in the negative, usually expressed as "normal," dense," or "thin." A test is to be barely able to read newsprint through the darkest areas of the negative under a good reading light. This is a difficult one to use with negatives of the 35mm size or smaller. Another check on density is to see detail in both the highlights of the subject (dark portions of the negative) and the shadows of the subjects (light portions of the negative). Exposure of the film builds the density of the negative (Figs. 3-34–36).

3-34A A negative of normal density shows detail in both highlights and shadows.

3-34B The print then records that detail.

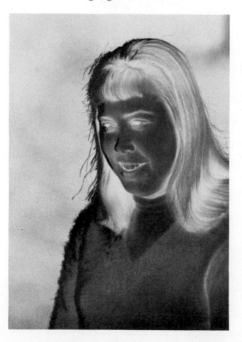

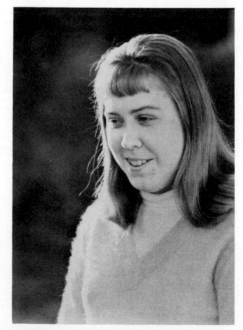

3-35A The too dense negative blocks detail in light areas of the subject. Contrast is lowered.

3-35B When the dense negative is printed to bring in shadowed area detail, the highlights lack definition. Contrast is lower.

3-36A The thin negative may show some detail in the shadowed areas of the subject but has insufficient contrast.

3-36B If the thin negative shows no detail or insufficient detail, it certainly will not print well.

Contrast is the variation between the darkest and lightest parts of the picture. Detail is best registered if there are many shades of gray between the darkest and lightest areas. While a wide range of gray tones is usually the goal for most subjects, the better *print* will have some totally black portions and some stark white highlights. This does not require totally black and totally clear areas in the negative. The contrast in the printing paper yields this if the contrast range of the negative is moderate. Development of the negative builds contrast.

Definition refers to the amount and sharpness of detail. Those factors affecting definition are choice of film, contrast, lens sharpness, accuracy of focus, control of depth of field, movement of subject, and steadiness of the camera during the exposure.

NEGATIVE DEFECTS

1. **Totally black roll of developed film.**
 a. *Causes*: Whole roll of film was exposed to light. The roll may have been improperly handled in loading or unloading the camera or when put in the developing tank. Camera back may not have been properly closed. Shutter speed dial set on "T" for entire roll. Shutter stuck in open position. Lid removed from developing tank during processing before the fixer bath. Roll of film used for practice loading of camera or tank.
 b. *Prevention*: Check camera settings carefully. Close camera back and lock in place. Mark practice rolls to avoid their being used.
 c. *Salvage*: None.

2. **Black frames** (normal negative size), with narrow, clear strips between frames.
 a. *Causes*: Overexposure of the frame in the camera. ASA setting wrong, smaller number than it should have been. Turned aperture ring instead of focusing ring when focusing. Failed to close down a nonautomatic lens. Shutter set on full seconds instead of fractions of a second. This is possible especially when readings are taken with a separate meter. Failed to take lens off automatic when shutter was set at "T" or when non-automatic tubes or bellows separate camera from automatic lens in close-up photography. Shutter set on "T" but used as though on "B." (Chapter 9, Understand the Camera.)
 b. *Prevention*: Recheck all camera settings before tripping the shutter. Be sure of equipment's degree of automation and the effects.
 c. *Salvage*: None.

3. **Dark streaks or areas in the negative** that were not a part of subject. This is termed "fogged."
 a. *Causes:* Flare of light struck that part of the film (Fig. 3-37). Film left without protection or loaded in the camera in strong light. Faster films are subject to this problem, especially. Light source struck the lens, particularly easy to happen with back-, side-, or top lighting. (Chapter 8, Light.) Reflection from a bright object in or near the subject. Camera back not completely closed. Defective camera that either leaks light or has a bright interior spot or edge that flares light. Static electricity flare may occur as film is advanced in extreme cold or as tape is removed from film in loading developing tank reels.
 b. *Prevention:* Keep film in closed lighttight containers when not in the camera. Load camera in subdued light. Check for light striking lens, especially with back-, side-, and top lighting. Use a lens hood for *all* photography! Added protection may be necessary in some cases. Close camera back and lock in place. Check camera for bright areas on interior and at front of lens. Apply flat black paint to eliminate bright spots on camera.

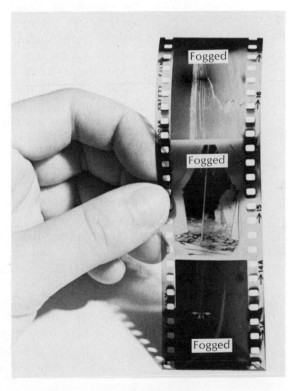

3-37 The fogged areas on this strip of negatives appear to have occurred when the camera was opened momentarily in a not too strong light while the film was on the takeup spool.

 c. Salvage: If flare is minor, it may be burned-in when the print is made.

 4. **Clear Film.**

 a. Causes: Severe underexposure or error in developing. Whole roll clear on a 35mm film indicates improper developing; first two or three frames black and rest clear indicates the film did not go through the camera or the lens cap was left on for whole roll. For cartridge or roll films, there is no difference in appearance between leaving on the lens cap, film not advancing through the camera, and/or improper developing. Light meter inaccurate because of improper handling. Flashgun failed or camera not synched for type of flash or shutter speed used. With improper developing, the developer could have been wrong dilution, or exhausted; fixer used before or instead of developer; or insufficient chemical to cover upper roll in a 2-roll tank. Individual clear frames may have occurred because aperture ring was turned instead of focusing ring, automatic lens not reopened after having been taken off automatic and closed down. Attempted picture in low light level beyond capabilities of camera and film. Needed a time exposure instead of fractional seconds.

 b. Prevention: Be especially careful that film is advancing correctly before the camera back is closed. Label all chemicals plainly, store appropriately, date, and keep track of the capacity. Check and double check each chemical before putting it into the tank. Be sure there is sufficient chemical to cover all film. Check light meter readings against another meter that gives appropriate readings or against film direction sheet. If they are within one-half to one-third stop, this is acceptable. Check shutter and aperture settings carefully before making the picture. Review instructions with camera and flash on its use. (Chapter 13, Flash Photography.)

 c. Salvage: Impossible, but save, clean and unscratched, for neutral density filters for color slides that are slightly overexposed.

 5. **Dark specks on negative.**

 a. Causes: Dust and/or chemical sediments on the negative. Sediment in the solutions or dust on the negative during the time it is drying or in handling or storing.

 b. Prevention: Filter chemicals before developing films; dry, handle, and store film in a dustfree area.

 c. Salvage: Wipe film with a lintfree cloth dampened with film cleaner. If dust is imbedded in the emulsion, soak the film in developer (film will not develop further but emulsion will

be softened) and *carefully* remove the foreign matter. Continue through the regular routine of chemicals, wash and dry the film. The print can be spotted. (Chapter 6, Enlarging.)

6. **Light flecks in the dark areas.**
 a. *Causes:* Dust or other particles were on the film in the camera. Airbells formed *on* the emulsion when the developer was poured in so that the chemicals could not act on the emulsion.
 b. *Prevention:* Clean camera interior each time it is reloaded with film. The film is electromagnetic and any dust on the emulsion side causes white images on the developed negative. Tap the developing tank on the table or sink surface to dislodge the airbells as soon as the solution is poured in the tank.
 c. *Salvage:* Larger negatives may be retouched. The print can be spot bleached with care. (Chapter 6, Enlarging.)

7. **Pinholes in the emulsion.**
 a. *Causes:* Airbells formed on the film emulsion in the developer because of insufficient agitation. A particular hazard when the solution is poured into the tank rather than having the film immersed in the chemicals. The air prevents the chemical action; when the film is cleared, tiny clear areas are left on the film. Too strong acid solution for the shortstop. A bit of acid gets beneath the emulsion to react with the alkaline developer and forms a bubble of gas that expands and bursts.
 b. *Prevention:* Tap the tank sharply on the table a time or two immediately after the developer is poured into the tank. Agitate sufficiently. Use a full minute water wash same temperature as developer instead of shortstop after the developer.
 c. *Salvage:* Careful retouching on larger negative; spot bleaching on the print is possible. (Chapter 6, Enlarging.)

8. **Milky (when wet) dark or opaque splotches with no detail** (Fig. 3-38).
 a. *Causes:* Areas are undeveloped and uncleared. Crimped, out-of-round loading of the film on the reel caused one layer of film to touch another, which prevented the chemical action on the emulsion in these spots.
 b. *Prevention:* Be sure the film follows the curvature of the grooves of the reel in smooth rounds.
 c. *Salvage:* None.

9. **Brown stains or entire film in brown tones.**
 a. *Causes:* Insufficient time in fixer, exhausted fixer, insufficient agitation in the fixer or fixer did not cover the film.
 b. *Prevention:* Use fresh fixer each time; or carefully note the time it takes the film to clear and then leave it in for a total

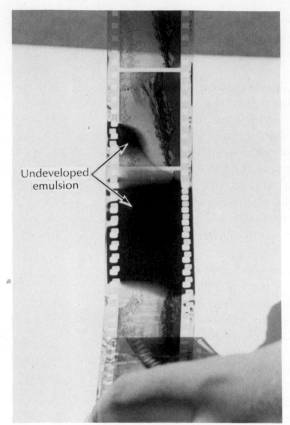

Undeveloped emulsion

Negative courtesy of Mark McCann.

3-38 Careless loading of the film on the reel permitted one ring of the film to touch another in the undeveloped emulsion area.

of twice that time and discard when time is excessive. Be sure film is fully submerged and agitate at regular intervals.

 c. *Salvage:* Return to fresh fixer for additional time and continue regular wash. This may not change the brown spots but will keep the image from deteriorating further. It may be printable.

10. **Light areas with no detail** on otherwise satisfactory negative.

 a. *Causes:* Finger, part of camera case, the cable release or other object was in front of the camera lens. Fence or grill close to the lens can create an out-of-focus light pattern on negatives.

 b. *Prevention:* Be more careful of the location of offending articles in relation to the lens during the exposure of the film.

 c. *Salvage:* None.

11. **Coarse grain.**

 a. *Causes:* Film's emulsion is primary factor. Generally speaking, faster films have coarser grain. Wide range of temperature during processing is believed by some photographers to in-

3-39A The greatly enlarged section of negative accentuates the coarse grain of underexposed and overdeveloped film to give the sandy appearance (Kodak's Tri-X exposed at ASA 4000, processed in UFG, 9 minutes at 70°F.

3-39B The positive print made from the negative illustrates extreme grain.

crease grain. Choice of developer has some effect. Degree of exposure and developing affects grain (Fig. 3-39).

b. *Prevention:* Choose a slower film, keep chemicals and wash temperatures close, use a fine-grain developer with optimum exposure.

c. *Salvage:* Control degree of enlargement, exploit the grain, and/or preflash print paper from back to fog very lightly.

12. **Too high contrast,** too few gray tones between very dark and very light tones (Fig. 3-40).

a. *Causes:* Overdevelopment because of too warm developer, too long development, too strong developer, too much agitation in developer, or use of a high-contrast developer. High-contrast film, subject, or light.

b. *Prevention:* Control developing process as indicated by choice of film and developer and following recommended use. If the light is of high contrast, try for a reflector, use a fill light, or wait for the light to change. If none of these is practical, then overexpose and underdevelop the whole roll of film. The degree of overexposure and underdevelopment depends on the amount of change required plus the choice of film and developer. To overexpose, the ASA can be changed to a lower number.

3-40 These exposures were made in high-contrast light on high-contrast film (Kodak's High Contrast Copy Film processed in high-contrast developer, Kodak's D-19, according to manufacturer's directions).

 c. Salvage: Print on soft (low-contrast) paper or use filter on multicontrast paper. Use low-contrast paper developer. Reduce negative with Farmer's Reducer following directions with the chemicals.

13. **Too low contrast.** Nothing dark or light, all middle grays (Fig. 3-41).

 a. Causes: Low-contrast film, subject, or light. Underdevelopment because of too cool developer, insufficient time in the developer, too weak dilution, exhausted developer, too little agitation, or use of a low-contrast developer.

 b. Prevention: Use higher contrast lighting or wait for light to change. Choose a film and/or developer with higher contrast. Underexpose and overdevelop to build contrast. The degree of underexposure and overdevelopment depends on the amount of change desired as well as choice of film and developer. To underexpose, the ASA can be changed to a higher number.

 c. Salvage: Print on harder (higher contrast) paper or use a filter on multicontrast paper to heighten contrast. Make the best print possible, then intensify the negative and try again.

14. **Mosaic pattern of fine lines.** This is termed "reticulation."

3-41 Normal exposure on a very foggy, hazy day, with normal developing, yields mostly middle grays. Makes a low-contrast mood picture with some subjects.

 a. *Causes:* Too warm chemicals or wash or drastic temperature change between steps. The emulsion swelled excessively, then contracted to leave fine hairlines.

 b. *Prevention:* Keep chemicals at appropriate temperatures within a narrow range.

 c. *Salvage:* The pattern may be used. Some photographers purposely reticulate for special effects.

15. **All-over fog not from exposure to light.**

 a. *Causes:* Outdated film or film that has been too hot shows this type fog.

 b. *Prevention:* Use only fresh film and protect it from heat at all times.

 c. *Salvage:* Use high-contrast paper or a high-contrast filter with multicontrast paper in printing.

FILE, INDEX, AND STORE NEGATIVES

Fine negatives are damaged by careless handling and/or storage so that they cannot be used to make quality prints. Inadequate filing and in-

dexing systems, temporarily and sometimes permanently, lose valuable negatives.

To avoid these problems:

1. Wash hands before working with negatives.

2. Work in dustfree areas. Lay negatives only on clean surfaces.

3. Handle negatives by the edges to avoid fingerprints on the picture area. The acids and oils secreted by the skin will, in time, eat through the emulsions if fingerprints are allowed to remain, thus causing permanent damage. Liquid film cleaner, available at camera stores, will remove the fingerprints if used soon after the occurrence.

 Inexpensive white cotton gloves can be purchased at photographic supply stores. The gloves are made especially for handling films, and used extensively by professionals in handling movie films and color transparencies (slides) (Fig. 3-42).

4. Save all printable negatives. Often, the failures can be used creatively in combination with one or more other negatives to make effective pictures. It is impossible for a photographer to anticipate all the possibilities for the negative that lacks vital elements. Index as to content and store so that when the occasion arises, the negative will be available.

5. For storage, slip negatives into acetate, plastic, glassine, or paper envelopes made especially for the purpose (Fig. 3-43). They can be purchased at camera stores, too. Correspondence mailing envelopes alone should not be used because the glue may gather moisture, ooze, and damage the negative. However, if the negatives are enclosed in clean cellophane or plastic to protect them, regular mail-

3-42 White cotton gauze gloves prevent fingerprints, both before and after processing films.

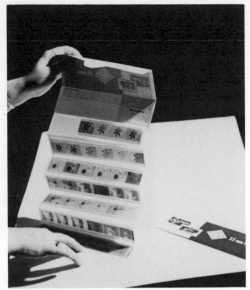

3-43A Accordion cellophane negative holders are available for all size films.

3-43B Glassine accordion negative holders are also available for all size films.

3-43C Glassine envelopes are available for all size films.

ing envelopes can be used (Fig. 3-44). Always store negatives *flat*, never in a roll. The emulsion gradually hardens and may crack or break when unrolled.

6. Devise a system of numbering, classifying, or indexing, and storing that aids in locating a specific negative quickly. 35mm negatives

3-44A Negatives laid on 12-inch-wide clear plastic food wrap double the length of their combined width. Fold over the ends to cover all negatives. Then fold one strip over the other from both outside strips to only one strip width.

3-44B Fold over the end portions to make a dust-proof, moisture-proof, scratch-proof, easily accessible package.

3-44C Slip into an inexpensive long business envelope or even a used one. Note on the envelope printing and any special film processing notations. Store all the envelopes in a shoe box or with the proof sheets. The glued flap of the envelope could be fastened permanently to the proof sheet if desired.

are often indexed by roll numbers because multiple negatives are stored in one envelope or even the whole roll in one acetate holder. 2¼ x 2¼ negatives can be stored separately or in strips of two or three and, also, in full rolls.

Indexing systems should be simple as possible to be effective. They must be adapted to the storage device that is chosen, the photographer's specialties and preferences.

7. Store negatives in a dry, cool place. In humid climates, silica gel can be used to protect from excess moisture. The silica gel must be dried periodically to keep it effective.

The reader working in black-and-white photography may wish to skip the next chapter and go on to Chapter 5, The Contact Print or Proof.

The reader interested in color film will want to study the next chapter, Color Film Processing, to explore the causes of problems in slides even though he does not process his own film.

REFERENCES FOR FURTHER READING

Adams, Ansel: *The Negative* (Basic Photo Series), New York, Morgan and Morgan, 1968.

Carroll, John S.: *Amphoto Black-and-White Processing Data Book*, New York, Amphoto, 1972.

Goldberg, Norman: "Scratching: a How-to-Undo It Guide," *Popular Photography*, Vol. 68, No. 1, January, 1971, pp. 42f.

Kennedy, Cora Wright: "Reticulation: Take It or Leave It," *Popular Photography*, Vol. 62, No. 3, March, 1968, p. 11f.

Kodak Customer Service Pamphlet No. AJ-30, *Push-Processing Kodak Black and White Films*, Consumer Markets Division, Eastman Kodak Company, Rochester, New York.

The Print, Life Library of Photography, New York, Time-Life Books, 1970, "How to Develop the Negative."

Jonas, Paul: *Manual of Darkroom Procedures and Techniques*, 4th ed., New York, Amphoto, 1972.

Kramer, Arthur: "Film Developer Roundup," *Modern Photography*, Vol. 35, No. 2, February, 1971, pp. 64f.

Miller, Thomas, and Wyatt Brummitt: *This is Photography*, Garden City, New York, Garden City Books, 1959, Chaps. 6 and 9.

Neblette, C. B.: *Photography, Its Materials and Processes*, New York, Van Nostrand Co., Inc., 1962, Chaps. 16 and 17.

Rhode, Robert B., and Floyd H. McCall: *Introduction to Photography*, New York, The Macmillan Company, 1965, Chap. 12.

Sussman, Aaron: *Amateur Photographer's Handbook*, New York, Thomas Y. Crowell Co., 1965, Chap. 14.

CHAPTER 4

Processing Color Films

Many photographers believe they secure more consistent color quality at home than is obtained in commercial laboratories. There is not the problem of films lost or missent, which happens occasionally in commercial processing. The processors replace the film but there is no possible way to replace lost pictures. Home processing offers the opportunity, in necessary situations, to compromise on exposure. This is compensated in developing time.

The chemicals are sold in kits ready for final mixing and use. For most satisfactory results, the kit of chemicals should be made especially for the particular color film. There are kits that can be used with several different negative color films but those for positive color films must be matched to the film for which they were made.

NEGATIVE COLOR FILM PROCESSING

Negative color films (used for prints) can be developed in the home darkroom or at the kitchen sink with exactly the same equipment and techniques required for black and white films. Before starting to develop color negative, a study of the previous chapter will be helpful.

More solutions are involved in some of the processes; thus more bottles are required. The Kodak C-22 kit has five chemical solutions which can be used for Kodacolor and also for GAF's Color Print Film. The Unicolor kit has only three chemical solutions for any color negative film and also includes chemicals for color printing.

Color films require careful monitoring of solution and wash temperatures, especially in the developer, to provide accurate color renditions. Otherwise, negative color developing is just as simple as for black-and-white negative films. Follow directions with the particular kit of chemicals used. Negative defects, causes, and prevention will be similar to black and white negative defects. One difference is that in printing color, there are no multiple contrast controls as with black and white.

POSITIVE COLOR FILM PROCESSING

Positive color film (slides or transparencies) with the color couplers in the solutions require more exacting controls of the process than is

possible at home. For this reason, rigidly regulated laboratory equipment is necessary for the Dynachromes and Kodachromes. Films with the color couplers in the emulsion can be home processed. Agfachrome, GAF's Anscochromes, and Kodak's Ektachromes are included in this group.

As with black and white film, a darkroom is not needed. The kitchen sink is fine as a work area. A changing bag is suitable for loading the film in the tank (Figs. 3-7, 8). (Also refer to Fig. I-13.)

Chemical kits are available for each of three kinds of color positive film, Agfachrome, Anscochromes, and Ektachromes. Since Agfachrome is sold only with processing included, there is little incentive for doing it at home unless there is immediate need for the pictures or special procedures are required. The other two films offer savings in both money and elapsed time between the time the picture is taken and the results are seen. Additionally, there is opportunity to vary developing times from normal if desirable. Beyond the need for careful surveillance of temperatures and time, either process is as easy as black and white, though more time is involved. The processed film is dried and then mounted as slides.

More bottles are needed in both Ektachrome and Anscochrome processing than with the black and white. At this writing, Anscochrome uses eight solutions and the Ektachromes vary with the kit (Figs. 4-1, 2). The E-4 kit has nine solutions, the E-3 kit fewer. The E-4 kit utilizes chemical reversal (changing the negative image to a positive image) while the E-3 and the Anscochrome kits use a second exposure to reverse. This is accomplished by exposing the film to light just before the color developer is poured into the tank. The film is left on the reel and light is shined through the ends of the reel (Fig. 4-3). The light may be of any kind. GAF recommends a fluorescent light because it is cooler, which avoids the danger of overheating the film during the second exposure.

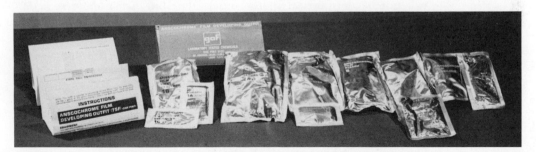

4-1 GAF's Anscochrome kit processes six 20-exposure rolls of film. The chemicals retain their strength after mixing and first use for two weeks with proper storage: cool, dark and airfree, especially for the developers.

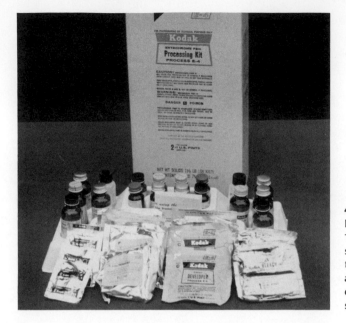

4-2 Kodak's E-4 kit for processing Ektachrome film is divided into two 1-pint mixes. Each pint will process six 20-exposure rolls of film within two weeks from the time of mixing and first use. The developers require airfree, cool, and dark storage

The directions with the kits are detailed and easily followed. Precautions suggested in the previous chapter for mixing of black and white chemicals apply to preparing color chemicals. The temperature of the two developers affects the color in the Anscochrome. Control of temperature within plus or minus $\frac{1}{2}°F$ is necessary to avoid a color shift. The same limited tolerance is required for the first developer on the Ektachromes. The wash and other chemical solutions have an acceptable variation of five degrees. Time and agitation are important, especially in the first developer. Except for this, split-second exactness is not required but no step should be lengthened unduly. A few seconds or even a minute over the recommended times will not be detrimental in the other steps but *never shorten to less time* than the directions indicate. The suggestions on mixing procedure are essentially the same as for black and white films.

Particularly the reversal step must not be hurried when accomplished by reexposure to light. There is no possibility of overreversal but the film definitely can be reversed insufficiently. Watch for overheating if fluorescent lights are not used. Rotate the reel in a semicircle to let the light penetrate all areas of the film. At this point, the image is visible but no color is evident. After the color developer, the film appears to have lost all the image. Don't panic! Color will appear later but may be very different, especially on the Ektachromes, from that expected. Proceed with the rest of the steps. Do not wipe the film

4-3 Reversing or reexposure to light is needed with the Anscochrome and E-3 (for Ektachromes) kits. Move the reel in a circular motion for a full minute on each end to be sure of complete reversal.

down. The emulsion is exceedingly soft. Handle with care. When the film has dried, the color can be evaluated, but not before!

Film ASA can be raised (pushed) on home-processed color film. The whole roll must be exposed at the same ASA. There is an increase in time for the first developer and the developer's capacity is reduced somewhat. The recommended ASA speeds and adjustments in developer time are indicated in Fig. 4-4. Expect slightly more grain, higher contrast, less latitude, and some color shift in pushed film. With careful meter readings, these are still at very acceptable levels. Pushing the film ASA enables pictures to be made that would otherwise be unobtainable (Chapter 14, Films).

MOUNTING

When the film is dry, if it curls and does not lie flat in the mount, roll the strip of film, before cutting, emulsion side out, for six to twelve hours. This flattens the film very well. Slip the rolled up film inside a plastic sandwich bag or enclose in plastic wrap to protect from dust for this period. Avoid fingerprints on the film. The acids and oils secreted will eat through the emulsion to permanently damage it. White cotton gloves eliminate the problem of fingerprints.

TIMES FOR COLOR FILMS IN THE FIRST DEVELOPER AT VARIOUS EXPOSURE INDEXES

Film	Temperature of developer	Normal E.I.	One stop over	One stop under	Two stops under
Agfachromes	Color Shift:	None	Magenta	Green	Greener
	75°	E.I. 64 13 min.	E.I. 32 11 min.	E.I. 125 16 min.	E.I. 250 NR 19 min.
GAF Anscochromes	Color Shift:	None	Cool	Warm	Warmer
64	75°	E.I. 64 12 min.	E.I. 32 8 min.	E.I. 125 18 min.	E.I. 250 NR 25 min.
100	75°	E.I. 100 12 min.	E.I. 50 8 min.	E.I. 200 18 min.	E.I. 400 NR 25 min.
200	75°	E.I. 200 12 min.	E.I. 100 8 min.	E.I. 400 18 min.	E.I. 800 NR 25 min.
500	75°	E.I. 500 12 min.	E.I. 250 8 min.	E.I. 1000 18 min.	E.I. 2000 NR 25 min.
Kodak Ektachromes	Color Shift:	None	Blue-Magenta	Yellow-green	More yellow-green
X					
E-4 at	85°	E.I. 64 7 min.	E.I. 32 4¼ min.	E.I. 125 8 min.	E.I. 250 10½ min.
E-3 at	70°	10 min.	7 min.	13½ min.	17½ min.
Daylight High Speed					
E-4 at	85°	E.I. 160 7 min.	E.I. 80 4¼ min.	E.I. 320 8 min.	E.I. 640 NR 10½ min.
E-3 at	70°	10 min.	7 min.	13½ min.	17½ min.
High Speed, Tungsten					
E-4 at	85°	E.I. 125 7 min.	E.I. 64 4¼ min.	E.I. 250 8 min.	E.I. 500 NR 10½ min.
E-3 at	70°	10 min.	7 min.	13½ min.	17½ min.

NR = Not Recommended

4-4 Positive color films can be pushed (exposed at a higher ASA) if desirable. Extra time is required in the first developer solution. The developer solution capacity is reduced.

Cardboard, plastic, metal, and/or glass mounts may be used. The least expensive are the flat cardboard mounts which are heat sealed. The laundry iron, set on rayon, can furnish the heat. Use a firm surface, not the padded ironing board, for mounting. Cut the film on the black frame lines, lay into the blocked-out depression of the mount, emulsion (dull) side down (Figs. 4-5–7). Fold the hinged side over and

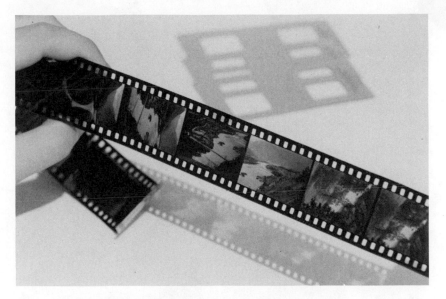

4-5A The narrow black lines separate the frames.

4-5B Cut the film on the frame lines.

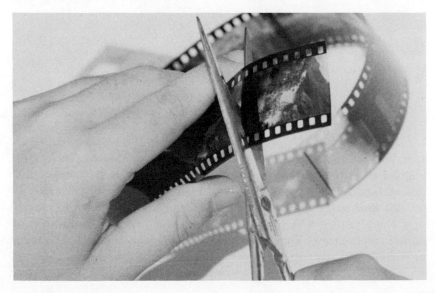

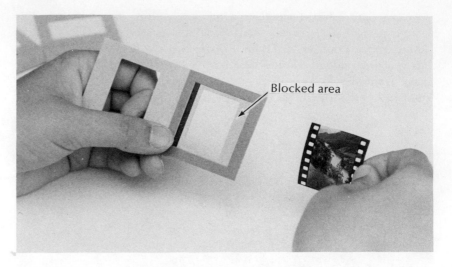

Blocked area

4-6 Put film in blocked area, emulsion (dull) side down.

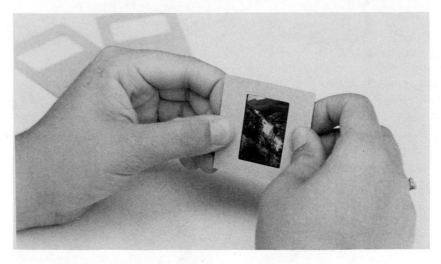

4-7 Fold other half of mount over, check for straight alignment.

spot seal with the iron (Fig. 4-8). Check to see that the picture is aligned correctly within the mount frame. If not, break the spot seal and realign. When it is properly placed within the frame of the mount, seal all four edges with the iron but do not allow the iron to extend over the film (Fig. 4-9). Turn the mount over and heat press all four borders on the back. This is necessary to prevent warping of the mount as it cools. Write or stamp address and name of the photographer on

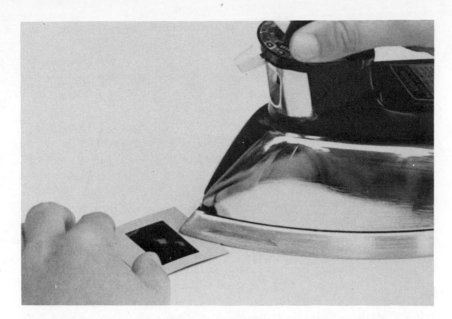

4-8 Spot seal the mount and recheck alignment.

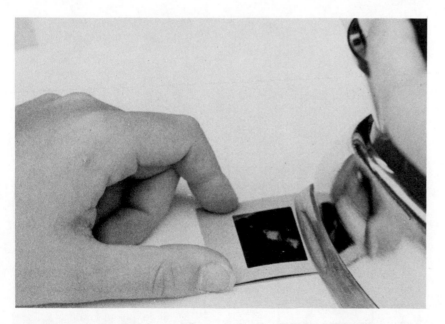

4-9 When film is placed correctly, seal all edges, front and back, to avoid a warped mount.

the mount, identify subject, and list any other data desired (Fig. 4-10). Put a thumbprint in the lower left corner of the mount as the picture is viewed in its correct position. The thumbprint can be a round dot made by pen or pencil. A pencil eraser touched to a stamp pad works well, too. This is a universal marking used to place the slide correctly in the projector tray.

For glass mounting, ultra thin glass cut especially for this purpose is used. Opaque masks frame the picture in the standard glass mount. Some glass mounts have a metal frame that holds the whole assembly in place. The most common and an excellent method to hold the combination together is by silver or gold tape, Polyester Film Tape No. 850 in the ⅜-inch width manufactured by 3M Company. The cement on the tape does not become sticky from projector heat as many others do.

Wash the glass in detergent, rinse, and dry so that it is spotlessly clean. Remove the slide from the original mount (Figs. 4-11, 12). Anchor the transparency in the opaque masks with a ¼″ strip of the tape (Fig. 4-13). Identify the slide on the mask with owner's name and address, date, subject, and thumbprint. Check the alignment in the mask (Fig. 4-14). Lay glass on both sides of the mask. Check for lint and dust over a light box with a magnifying glass before proceeding further.

Hold the sandwich together firmly as it is centered on the tape (Fig. 4-15). Fold tape up onto the glass (Figs. 4-16, 17). Mitre the corner of tape with a sharp razor blade (Fig. 4-18).

4-10 Finders can return lost slides promptly if the name and address is plainly written, stamped, or glued to each and every mount.

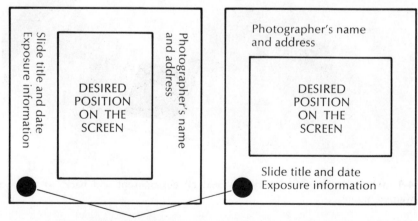

"Thumb Prints"

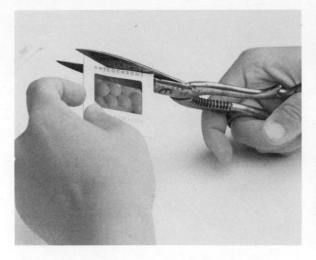

4-11 Cut cardboard mounts midway of the wide border. Plastic mounts can be split apart on the edges with a sharp blade or cut as desired.

4-12 Peel back the mount from the cut edge and lift out the transparency.

Tape

4-13 Lay the film in the mask, carefully align and tape in place with a sliver of the polyester tape (never cellophane tape).

4-14 Fold mask over and check placement. Label mask with information suggested in Fig. 4-10. Check and clean off any dust or lint on the transparency.

4-15 Set the sandwich midway on a strip of tape so that the end of the tape will not be at a corner.

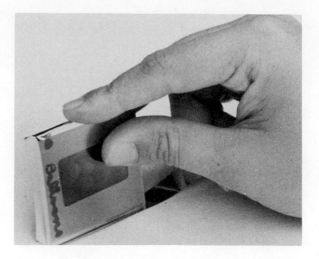

4-16 Rotate the sandwich on the tape, carefully centering it crosswise.

4-17 Press the edges down firmly at the sides, but not the corners. Overlap the ends ¼ inch.

4-18 Mitre the tape corners with a sharp single-edge razor blade or utility knife.

35mm MOUNTS AND MASKS

4-19 Use odd shapes sparingly. Several companies offer varied masks and mounts. Gem-Mounts and Gem-Masks Co., Box 630 Times Square Station, New York, New York 10036, probably has the largest variety.

4-20 This system numbers each slide consecutively, uses a cross card index file, and keys outstanding slides with various colors on the mount edges with a felt pen.

TRANSPARENCY DEFECTS

1. **Slide with picture but too pale or too light.**
 a. *Causes:* Overexposure in the camera or overdevelopment in processing. In the camera: Light meter inaccurate because of exhausted batteries or overexposure to light; ASA setting in error; error in meter reading; failure to close down the non-automatic lens or the automatic lens when set on manual; failure to set the automatic lens on manual for a time exposure or when used with nonautomatic bellows or tubes. In the processing: First developer too warm, overagitation, or overextended development.
 b. *Prevention:* Check light meter accuracy at regular intervals, keep an extra set of fresh batteries available (store in refrigerator), avoid exposing light meter to direct sunlight or leaving it uncovered for long periods with power. Check ASA setting and methods of taking a meter reading. (Chapter 12, Exposure.) Be sure of degree of automation of equipment and proper operation when set on manual. (Chapter 9, Understand the Camera.)
 c. *Salvage:* Neutral density filters can be combined with the slide, sandwich style, in the mount. (Chapter 15, Filters.)

2. **Whole roll or several frames of clear or yellow-orange film with no images.**
 a. *Causes:* Overexposure to light. Roll may have been improperly handled in light while loading or unloading the camera, or in the loading of the processing tank. The lid of the tank may have been removed before processing reached the proper step. Camera back may not have been closed. Shutter speed set on "T" for entire roll. Shutter stuck in open position. The roll of film may have been the one used for practice loading of camera or tank.
 b. *Prevention:* Load camera in subdued light, close back, and lock in position. Load processing tank in complete darkness, mark tank, and leave lid closed until processing directions say it can be removed. Check empty camera to see that shutter is performing correctly. Check shutter settings. Mark practice film to avoid its being used by mistake.
 c. *Salvage:* Not possible. Keep for color tints to mount sandwich style to alter color of otherwise good slides. (Chapter 15, Filters.)

3. **Clear or orange-yellow frames** (narrow black strips between frames).
 a. *Causes:* Overexposure to light. Wrong ASA setting. Camera's

lens aperture and/or shutter speed incorrectly set. Possibly on "T" or "B". Automatic lens not taken off automatic and closed down manually when nonautomatic bellows or tubes were used for close-ups. Aperture ring turned instead of focusing ring when camera was focused. Shutter set on "T" but operated as though on "B".

b. *Prevention:* Recheck all camera settings before tripping the shutter. Be sure of equipment's automation and the effects of each. (Chapter 9, Understand the Camera and Chapter 10, The Camera Lens.)

c. *Salvage:* None.

4. **Orange or yellow streaks or areas in the picture** that were not a part of the subject. The film is fogged.

a. *Causes:* A flare of light struck that part of the film. Often the first frame of 35mm is fogged in loading. Use this frame to photograph the name and address of the photographer to avoid loss of the film at the processors. Film left without protection or loaded in the camera in strong light. Faster films are particularly subject to this problem. Nonreflected light (direct from the source) struck the lens. This happens particularly with back-, side-, or top lighting. (Chapter 8, Light.) Reflection from the subject. Camera back not completely closed. Defective camera, either leaks light or has a bright edge or spot inside the camera or in front of the lens.

b. *Prevention:* Keep film in closed, lighttight containers when not in the camera. Load camera in subdued light. Check for light striking the lens, especially with back-, side- and top lighting. Use a lens hood for *all* photography. Additional protection may sometimes be required. Check camera interior and lens for bright spots. Paint with flat black paint any probable reflective areas.

c. *Salvage:* None.

5. **Black or very dark roll of film and/or individual frame.**

a. *Causes:* Severely underexposed. Whole roll black with no image indicates improper loading so that the film failed to go through the camera. Wrong ASA number used, meter misread, or camera set on shutter speed of fractions of a second when it should have been a time exposure of several seconds. Light meter inaccurate because of improper handling. Improper processing. Individual frames may have occurred because aperture ring was turned instead of focusing ring. Automatic lens not reopened after having been on manual and closed down. Picture attempted in low light level beyond the capabilities of camera and film.

 b. Prevention: Be very sure film is advancing properly before the camera back is closed. Set the correct ASA number on camera and/or meter. Understand the readings on the light meter. Check the light meter for malfunction. Light meters can become fatigued. (See "Care of Light Meter" in Chapter 12, Exposure.) Learn the exposure that can be successful in low light levels or use a sensitive exposure meter. Film ASA can be pushed with special processing. The whole roll is involved (Fig. 4-4).

 c. Salvage: If image is present but underexposed, as much as two stops can be gained by immersing the Ektachrome slide in Colorbrite, a product of Special Products Lab., Chicago, Ill.

6. **Dark spots or globs that were not a part of the subject,** and are raised areas in the emulsion.

 a. Causes: Dust or dirt on the slide, sediment or undissolved chemicals in the solutions that is embedded in the emulsion. Dust settled on the film while drying.

 b. Prevention: Filter chemicals before using, even freshly mixed chemicals, especially the two developers. Dry, handle, and store film in dustfree areas.

 c. Salvage: Use plastic hand blower for all loose dust. Film cleaner applied with a clean, soft, lintfree cloth may be used if necessary but this should be used sparingly. Foreign matter imbedded in the emulsion cannot be removed successfully.

7. **Dark spots or semi-square areas which were not a part of the subject,** but do not show as stuck or raised areas in the emulsion.

 a. Causes: Film chips, dust, or lint inside the camera that were on the film in the camera.

 b. Prevention: Clean the camera interior with the hand blower each time the film is loaded.

 c. Salvage: None.

8. **Irregular dark areas or pattern of sprocket holes** across the film.

 a. Causes: Irregular dark areas are caused by faulty loading of the film reel so that one layer of film was in contact with another layer, which prevented the chemicals from reaching those dark portions. Sprocket hole images indicate the same problem but these occur chiefly in commercial processing.

 b. Prevention: Work for smoother loading of the film on the reel. Nothing the consumer can do in commercial processing except ask for a refund of film and processing costs.

 c. Salvage: None.

9. **Blue shadow areas.**

 a. Causes: Lack of proper proportion of chemicals.

 b. Prevention: Manufacturer's containers, especially in the color developer, must be completely emptied to the point of rinsing with a part of the water to be sure *all* of the chemicals are in the solution.

 c. Salvage: May be able to mount a color tint with the slide to reduce the blue or use a projection filter.

10. **Dark, out-of-focus areas** that are not a part of the subject.

 a. Causes: Camera case, fingers, cable release, or other objects in front of the taking lens.

 b. Prevention: Keep the area near and around the lens clear of such objects. The lens hood aids in this respect.

 c. Salvage: None, except to crop out those areas when possible. See Number 16 of this series.

11. **All-over blue cast to slide.**

 a. Causes: Tungsten film used in daylight. Invisible ultraviolet light rays such as found at high altitudes; subject has chemical whiteners (used on wedding gowns, wedding cakes, and many fabrics) that are accented with ultraviolet light of the electronic flash. Daylight has a blue cast just before dawn and just after sunset. Developer was too cool.

 b. Prevention: Use orange filter on tungsten film for daylight and electronic or blue flashlamps. (Chapter 15, Filters.) Use daylight film instead of tungsten film. (Chapter 14, Films.) An ultraviolet filter, slightly yellow, reduces the blues. (Chapter 15, Filters.) Use skylight filter on pictures made late evening or early morning. (Chapter 15, Filters.) Keep chemicals at proper temperature.

 c. Salvage: Sandwich in a gelatin or a piece of film with a warm tone with the blue slide.

12. **All-over yellow-orange or red cast to the picture.**

 a. Causes: Daylight film used with candle, tungsten, or other nonwhite light. Picture taken late afternoon before blue tones occur or early morning just at sunrise. Developers were too warm.

 b. Prevention: With tungsten light and daylight film use a blue filter on the camera lens. Keep processing solutions at correct temperatures.

 c. Salvage: Sandwich gelatin or clear piece of film with a cool tint to correct or exploit the effect, which is very often done intentionally.

13. **All-over unpleasant green cast** to whole roll of slides.

 a. Causes: Film is outdated or has been exposed to heat. Fluorescent light source also gives a green cast.

b. *Prevention:* Store film unopened in a plastic bag or closed moisture-proof container in the refrigerator or freezer. Remove from the refrigerator an hour or more, and from the freezer three hours or more, before opening. Keep film in cool area during transport. Process as soon as possible after exposing. Beware of outdated film. Use fluorescent filters on lens to match the film. (Chapter 15, Filters.)

c. *Salvage:* Mount a gelatin tint such as Addacolor, Tint-a-slide, or clear frames of color film that have tints sandwich style with the slide. The overexposed clear portions of Ektachrome-X are perfect for correcting the fluorescent light with daylight film.

14. **Mosaic pattern of fine clear lines** throughout the roll, termed "reticulation."

a. *Causes:* Solutions or wash too warm. The emulsion swelled excessively, then shrank as it dried to make miniature hairline cracks. Each film has its own peculiar pattern of reticulation.

b. *Prevention:* Monitor temperatures more carefully. Check thermometer for accuracy.

c. *Salvage:* None. The reticulation can be and often is exploited for its effect. Perhaps it may have an added bonus for the slides.

15. **Negative-like images especially in shadows** and particularly in dark pictures.

a. *Causes:* Insufficient reversal in processing.

b. *Prevention:* Use open or transparent reels for processing color film and allow plenty of time in the reversal of second exposure step. Expose both ends of the reel to light for even a full minute but do not let the film become too warm from the heat of the lamp. It can cause reticulation or even losing part of the emulsion from softening.

c. *Salvage:* None.

16. **Areas of the slide need cropping.**

a. *Causes:* Lack of careful composing in the viewfinder before the shutter release was tripped. Inability to get closer to the subject for a myriad of possible reasons. Lack of time to compose. Shape of subject not easily composed in the format of the frame.

b. *Prevention:* Attention to best possible composition in the viewfinder is best of all.

c. *Salvage:* A number of companies make masks and mounts with numerous shapes and sizes of openings that can be used with either the square 126 or 35mm slides. The camera stores stock a few standard sizes which can be used. A company with a great

many types is Heindl Masks 'N' Mounts, 200 St. Paul Street, Rochester, New York 14604.

INDEXING AND STORING

The mounted slides should be indexed and stored for their protection. Colors of transparencies are not absolutely stable and they need a cool, dark, dry, dustfree place of storage. Mildew will attack the emulsion in overly warm and/or damp areas.

Projector slide trays are satisfactory if they are dust tight but this is bulky storage that the enthusiastic photographer soon finds consumes too much space.

Only the best slides should ever be projected for guests. There are many that are less than guest quality which still have meaning for the photographer or members of his family. Do not discard the less desirable but save them for private showings. There are many instances where a slide alone has little merit but becomes an excellent supplement when combined with one, two, or even three others in a composite or sandwich. Many a salon slide has been assembled this way. It is impossible to foresee all the possibilities, so all slides should be saved. There are enameled metal boxes or trays that will hold from 600 to 750 cardboard-mounted slides (less if in glass or metal mounts) (Fig. 4-20). The sections within the boxes take twenty to twenty-five slides each. These boxes provide a space in the lid for indexing.

Early establishment of a simple, efficient indexing system saves much frustration later when the collection of slides becomes voluminous. There are numerous methods used to index slides. Each individual needs to design the indexing system which is most effective for his type of photography. Too many slides are stored and never used. Consider forming them into shows that effectively teach, entertain, or accomplish other worthwhile benefit. (Chapter 16, Goals for Photography.)

REFERENCES FOR FURTHER READING

Bomback, E. S.: *Manual of Colour Photography*, 2nd ed., New York, Amphoto, 1972.

Carroll, John S.: *Amphoto Color Film & Color Processing Data Book*, New York, Amphoto, 1972.

Eastman Kodak: *Kodak Color Dataguide*, R-19, *Kodak Color Films* E-77, Eastman Kodak, Rochester, New York.

Edelson, Mike: "E-4 Replaces E-2," *U.S. Camera*, Vol. 30, No. 10, October, 1967.

Excell, Raymond: "Color in the Kitchen Sink;" *U.S. Camera*, Vol. 30, No. 7, July, 1967.

Life Library of Photography: *Color*, "For Best Color, Home Processing," pp. 170f.; *Techniques of Color*, pp. 101f.; "Shooting Color Early or Late, Rain or Shine," p. 80, New York, Time-Life Books, 1970.

Nichols, Gordon W.: "Color Processing—A Different Point of View," Peterson's Photographic Magazine, Vol. 1, No. 6, October 1972, p. 35f.

Pierce, Bill: "Be a Copy Cat," *Popular Photography*, Vol. 64, No. 4, April, 1969, pp. 71f.

———"How to Get Pushy with Color," *Popular Photography*, Vol. 61, No. 7, July, 1967, pp. 92f.

Reid, Giorgina: "Getting Started in Color Printing for $100," *Popular Photography*, Vol. 67. No. 6, December, 1970, pp. 90f.

Rothschild, Norman: "Copy Correct and Crop Your Color Slides,"

———"Texturize Your Color Slides," *Popular Photography*, Vol. 66, No. 1, January, 1970, pp. 75f. and 86f.

Scully, Ed: "Rescue Your Slides," *Modern Photography*, Vol. 33, No. 7, July, 1969, pp. 86f.

Thomson, C. Leslie: *Color Films*, 5th ed., London, Focal Press, 1971.

CHAPTER 5

The Contact
Print or Proof

When compared to the subject photographed, the negative has the dark and light areas reversed. For this reason, it is easier to decide which negatives should or can be satisfactorily made into large pictures, if they are first made into small prints called "proofs." They are more economical and usually supply the answer. Sometimes, the proofs will be as large as the picture desired.

Contact proofs, which are the exact size of the negatives, are usually adequate for the 2¼ x 2¼ films. A full roll of 35mm and 126 negatives may be contact proofed on one 8 x 10 sheet of paper (Fig. 5-1). This is an aid for some systems of filing and indexing. Many photographers proof 35mm film by enlarging two or three times the negative size. This reduces the chance of error in a decision on whether to enlarge still more. If a 4 x 5 enlarger is available, nine 35mm negatives can be enlarged onto an 8 x 10 sheet of paper (Fig. 5-2). This method of proofing will be possible after studying Chapter 6, Enlarging.

A contact print is made in a darkroom. The negative is laid in direct contact with the photosensitive paper. The paper is exposed to the required amount of light through the negative, developed and fixed in the appropriate chemicals, then washed and dried.

The exposure of the paper to light through the negative can be done in one of several ways. The method used depends on the available equipment, the paper supply, and the preference of the operator.

EQUIPMENT

Equipment that can be utilized (only one of the following listings is required, Fig. 5-3):

1. *Print frames* have glass laid in a frame of wood, plastic, or metal. A safelight is required to assemble the negatives, paper, and removable, felt-lined opaque back with a spring-pressure fastener (Figs. 5-3—7). The light for the exposure can be an ordinary room light with switch control or an enlarger light.

2. *Easels with guides* hold the strips of negatives in place over a sheet of photosensitive paper to proof multiple negatives in one

5-1 The 36-exposure roll or less of 35mm film, the 20-exposure roll of 126 film, and the 12-exposure 2¼ x 2¼ roll can be contact printed on one 8 x 10 sheet of paper.

5-2 35mm proofs enlarged, nine at a time with a 4 x 5 enlarger.

5-3 Equipment and chemicals needed to contact print or proof.

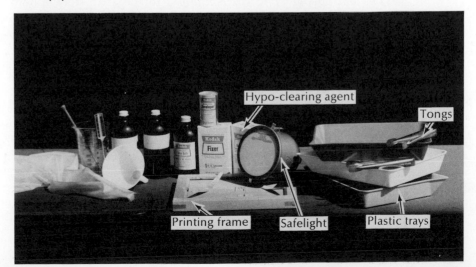

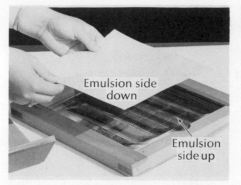

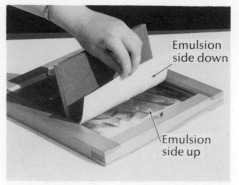

5-4 Spread negatives on the glass and lay photosensitive paper on top, emulsion to emulsion.

5-5 Place the felt-lined back on top of the paper.

5-6 Press the springs down and twist into place to hold the emulsions of negative and paper in firm contact.

5-7 Expose to light of sufficient intensity.

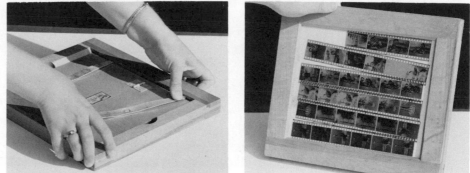

operation. The exposure light source can be the same as with the print frame (Figs. 5-8–10).

3. *The optically clear plastic containers* for negative storage hold the negatives in place for contact printing (Fig. 5-11). Exposure light source is the same as number 1 and 2.

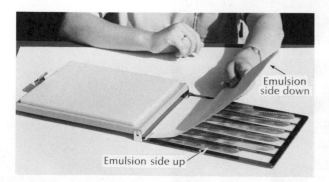

5-8 Contact proof printers may fit only one size negative or be adaptable to different sizes. Arrange paper and negatives emulsion to emulsion.

5-9 Lock the glass top into position.

5-10 Expose to the appropriate amount of light.

5-11A Negatives can be stored and contact printed in acetate holders.

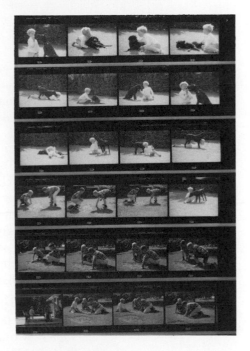

5-11B A proof sheet made with the acetate negative holder of 5-11A. Proofs are not as sharp because negative and paper are not in firm contact.

4. *Contact printers* made especially for the purpose are available in numerous sizes and designs to take one or several negatives at one time. Inside the printer is always the light for the exposure and often a safelight to use in assembling the negatives and paper (Figs. 5-12, 13). A safelight is a lamp of a color to which the paper emulsion is not sensitive.

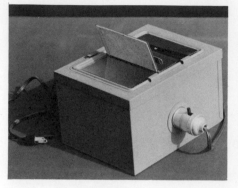

5-12 Contact printers may be of metal (this one is), plastic, or wood.

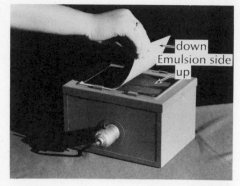

5-13 Lay negatives on top of the glass emulsion side up, then paper emulsion down, and finally spring the cover springs into place for firm contact. The printer lamp exposes the paper.

5. *A print frame* can be improvised with an enlarging easel and a piece of plate glass to hold paper and negatives in place. A foam cushion aids in giving closer contact. Use either the enlarger light or room light with a switch control for the exposure.

PAPERS

The two general classes of photosensitive papers are: Contact paper and enlarging paper. Contact paper reacts to light more slowly than enlarging paper; therefore, *if the source of light is in the contact printer* or is a room light, *a contact paper must be chosen.* If the enlarger is used as a light source, an enlarging paper is better. Within both groups of papers there is variation in the speed with which they react to light. Other differences are:

1. *Weights:* Light, single, medium, and double.
2. *Contrast:* 0 through 6.
3. *Tones:* Warm, neutral, and cool.
4. *Surfaces:* Matte, semi-matte, glossy.
5. *Textures:* Smooth, silk, tweed, velvet, pebbled, and numerous others.

The most common weight classifications, in reference to the thickness and weight of the paper stock, are single and double weight. Some contact papers are designated as light and medium weight. Double weight paper is the more expensive and often the best choice; but for proofs, single weight is adequate, unless the filing system used would benefit from the heavier paper. Light weight is lighter stock than single, medium weight lighter than double weight.

Many, but not all, kinds of photosensitive papers are manufactured in different contrast grades, designated by numbers 0 through 6. The No. 2 paper is considered normal contrast and when used with a normal contrast negative gives a pleasing variation in gray tones with some very dark and some white (Fig. 5-14). Papers numbered below 2 are referred to as "soft papers" because they yield a wider variety of gray tones, with no very black or very white tones when the print is made from a normal contrast negative (Fig. 5-15). Numbers 3 to 6, called "hard papers," give progressively higher contrast and with a normal negative yield fewer gray tones up to almost only black and white (Figs. 5-16, 17). In actual use, normal contrast papers vary from one manufacturer to another in the amount of contrast they give. The result is that one manufacturer's No. 2 paper may give the contrast of another's No. 3 paper and so on through the series (Fig. 5-18). The developer, also, can affect print contrast.

For the proof, a normal contrast paper is best for the normal negative, softer paper for higher-contrast negatives, and harder paper for the low-contrast negative. Since exposures may be mixed on one roll, if they are to be proofed on one sheet of paper, use one of normal

5-14 A normal negative printed on normal contrast paper (Grade 2, Agfa Brovira). Notice wide range of gray intensities.

5-15 A normal negative printed on a soft paper (Grade 1, Agfa Brovira). Observe lack of pure whites and blacks. Paper works well for the too-high-contrast negative.

Photographed by Hazen M. Hyland.

Photographed by Hazen M. Hyland.

5-16 The same normal negative printed on a hard paper (Grade 4, Agfa Brovira) gives higher contrast, whiter whites, darker shadows. For a lower contrast negative or a thin negative, this grade is fine.

5-17 Above, right, the hardest paper made (Grade 6, Agfa Borvira) reduces the normal negative to black and white with scarcely any gray tones between. This is an excellent paper for a very low contrast or a thin negative.

5-18 Right, Grade 1 Kodabromide yields a different contrast than the same grade in Agfa Brovira.

contrast. With final prints, either contact or enlarged, the desired effect plus the contrast of the negative will determine the contrast grade that is needed.

The other ways that papers vary are not particularly important for proofs. Often papers left over from other projects are suitable. If a new paper is to be purchased, a good choice is a neutral white, glossy, No. 2 paper in single weight or in light weight.

EQUIPMENT TO PROCESS THE PRINT

Equipment for print developing (Fig. 5-3):

1. Safelight.
2. Three to five trays for the chemicals.
3. Thermometer (same one used in film development).
4. Two pairs of tongs.
5. Timer.
6. Print washer.
7. Print dryer.

For some papers, a dark red bulb screwed into an ordinary electrical socket is sufficient for a safelight. Other papers require a fixture with an orange filter, while still others require a green filter (Fig. 5-3). Directions with the paper indicate the kind needed. Safelights should be at least three, preferably four or more, feet away from the photosensitive papers at all times.

Trays are available in plastic (Fig. 5-3), enameled metal, hard rubber, fiberglass, and stainless steel, named in order of their relative durability and cost for any given size. For the beginner in photography the plastic trays are certainly adequate. With reasonable care they last for years. Plastic trays must not be dropped (they crack) or exposed to heat (they warp or melt). The enameled trays will chip in use when carelessly handled and must not be used thereafter. The fiberglass and stainless steel are so expensive that they probably aren't justified unless heavy usage over many years is anticipated. The smallest size tray will handle a print up to and including 4 x 5. Other sizes are appropriate for prints that are 5 x 7, 8 x 10, 11 x 14, and 16 x 20. For best agitation and circulation, use the size next larger than the paper.

A disadvantage of this size difference is the larger amount of chemicals necessary to fill the tray to a depth that will cover the prints. Paper developer is discarded after each printing session. For this reason, it may be well to consider the number of prints to be put through the chemicals at one time to decide which size is best for the beginner.

Tongs are made of plastic, rubber-tipped bamboo, and stainless steel. All are adequate. The cost of the stainless steel is reasonable and they will outlast many pairs of either of the others (Fig. 5-3). Tongs are used to transfer the prints from one tray of solution to another and to agitate the prints in the chemicals. One pair is used only in the developer, the other is reserved for use in the shortstop and hypo.

Many photographers utilize fingers instead of tongs but the practice is questionable.

1. Danger of contamination of the chemicals is increased. Even if one hand is kept for the developer, the other for the shortstop and hypo, there is danger of fingerprints of chemicals on the emulsion of fresh paper when it is removed from the box and placed in the easel.
2. The chemicals cause stains on the hands, especially around the nails. The stains are difficult to remove.
3. Many people are or become allergic to one or several of the chemicals if they put their hands in the solutions. Otherwise they might have no difficulty. Once the allergy is developed, they cannot get near a darkroom without trouble.

Some method of timing the exposure in seconds is needed. Counting "one thousand one, one thousand two, one thousand three" and so on at a moderate speed can be done effectively. Each three words make approximately one second. A timer can be a clock or watch with a sweep second hand or a wind-up timer with a buzzer. More desirable is a darkroom timer that connects to power plus an outlet for the contact printer light or the enlarger. The timer automatically cuts off the light at the preset time (Fig. 5-19).

A print washer can be as simple as changing water in a tray every five minutes for the duration of the washing period, with intermittent

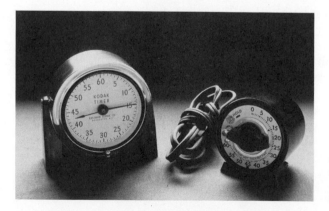

5-19 A wind-up buzzer timer (left) and an inexpensive electric timer (right) that cuts off power to the light at a preset time.

agitation between changes. The kitchen sink will serve, if the water flowing from the faucet falls into a jar or glass to prevent the force of the water from damaging the emulsion of the prints. A more efficient washer that is quite inexpensive is the De Hypo washer, which is a rubber drain to fit over the sink drain to prevent the print floating over and stopping the drain. The washer connects a rubber hose to the faucet to let the force of the water expend itself in circulation around the sink (Fig. 5-20). There are numerous other devices available that are still more efficient and some are many times more expensive.

A print dryer may be a blotter pad, a blotter roll, a reversible electric dryer that can dry prints on both sides or a many times more expensive drum dryer with thermostat (Fig. 5-21). The blotter roll and blotter book give a semi-matte finish on glossy paper. The electric dryer yields either a semi-matte or glossy finish on glossy papers.

The blotter book requires weights to hold it and the prints flat and up to several days to dry. The blotter roll is an effective, relatively inexpensive dryer for matte prints. With good care, it will dry many prints very economically, usually overnight. This can be speeded up if it is set over a hot air register or attached to a hair dryer (Fig. 5-21B).

CHEMICALS

Chemicals for developing or processing black and white prints are (Fig. 5-3):

1. Developer.
2. Shortstop.
3. Fixer.
4. Hypo neutralizer (optional).

5-20A The washer prevents prints stopping the drain and provides water circulation without danger to the prints.

5-20B Dehypo washer in use in kitchen sink. Turn prints face down to avoid chance of floating above the water surface. Prints are shown face up here to more easily identify them against the white sink.

5-21A The blotter roll dries prints overnight without buckling. The electric dryer performs best at low settings.

5-21B A hair dryer speeds up blotter roll's work. Stuff a bath towel in the center and prop the end up to force the air evenly through the corrugations of the blotter roll. Too much heat causes uneven drying and buckled prints.

There are numerous black and white paper developers on the market, though not nearly so many as there are for films. Developers for papers vary, principally in the amount of contrast and the tone (cold blacks or warm blacks of varying degrees on different papers) that they yield. Tone is discussed further in Chapter 6, Enlarging. Developers in both concentrated liquid and powder forms are available. Personal taste for tone and contrast for the particular subject matter will determine the kind to use eventually. A good place to start is with a neutral or a cold tone, normal contrast paper developer. Kodak's Dektol is a popular one.

To stop the further development of the print use shortstop, dilute acetic acid. It is sold in concentrated solution. Several brands on the market are offered with a color indicator to make it obvious when the shortstop is exhausted. This eliminates the necessity of keeping count of the number of prints that have been put through the solution or as some photographers do, discarding it when the acid smell disappears.

Fixer for printing is the same dilution as that used for film but once it has been used on paper, it should *never* be used for film. The fixer with hardener gives slower action but it hardens the emulsion so that it is not so easily damaged by tong marks and the corners of the other prints. There are a few techniques in which the prints should be fixed without hardener but except for these particular procedures, it is beneficial to have fixer with hardener.

MIXING THE CHEMICALS

The procedure for mixing the chemicals for prints is the same as for the film. The same utensils are used. Avoid contamination of one chemical with another, label the bottles, and follow directions on the package for temperature and dilution. Store the developer in brown bottles that are filled to the top and tightly stoppered or use plastic bottles that can be squeezed to remove the air. Keep in a cool place, not in a refrigerator. Most photographers mix shortstop to the correct dilution in the amount required at the time it is needed.

TRAY ARRANGEMENT

The chemicals and trays should be kept away from the contact printer and/or enlarger. If the trays will fit in the sink, this is ideal. If they will not fit in the sink, set them on a separate table. Label each tray with the chemical that will be used in that tray. Line them up in the order to be used (Fig. 5-22).

Fill the first tray at least one-half inch deep with paper developer in the proper dilution. Put shortstop, properly diluted according to package directions, in the second tray. This should be one inch deep in all but 4 x 5 and 5 x 7 trays. They usually are shallower and one-half inch may be best to avoid spilling it over the rims of the trays.

The third tray is filled with fixer (hypo) to a depth of one-half inch in the two smaller sizes, at least three-fourths of an inch in all of the larger sizes.

A fourth tray can be utilized as a second hypo bath. This procedure provides stability of the image as well as maximum use of the hypo solutions. When the maximum number of prints have gone through the first hypo solution, discard it. Use the solution in the fourth tray as the first hypo bath because it is not yet exhausted since it was the second bath. Start a new solution in the fourth tray.

5-22 Tray arrangement to process prints.

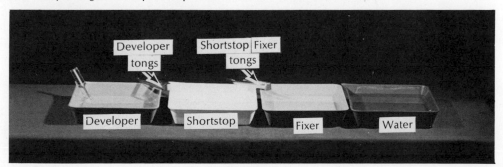

When the prints have been sufficiently fixed, it is preferable to slip the prints from the hypo into a running water bath at about 68°F. If this is not practical, then put the prints into a fifth tray filled with water at the same temperature. If the water in the tray is changed every fifteen to twenty minutes of the printing session, the hypo will be more efficiently washed out of the print during the washing period.

Mark one pair of tongs for developer and place it across the corner of that tray. Mark the other pair for hypo and shortstop and lay on the shortstop tray.

ASSEMBLE THE NEGATIVE AND THE CONTACT PAPER

Turn on the safelight. Turn out the room light. Remove only one sheet of photosensitive paper from the package or safe box at a time. Whenever a sheet is removed, the container must be reclosed completely to avoid exposing or fogging the rest of the paper. Fogging causes the paper to darken all over fogged area when it is developed (Fig. 5-23).

Follow the directions with the equipment that is being used or the instructions beneath the illustrations in this chapter (Figs. 5-4–14). To have the finished print as the photographer saw the subject left to right, the emulsion (dull) side of the negative faces the emulsion side of the paper. Glossy paper emulsion has a sheen that is easy to see under the safelight. With matte-finished paper it is a bit more difficult to distinguish which side of the paper is coated with the emulsion. The emulsion causes the edges of the paper to cup or curve toward the emulsion side.

EXPOSE THE CONTACT PAPER

The amount of time given in the exposure of the photosensitive paper through the negative controls much of the quality in the finished print. The ideal time will be determined by:

1. Speed of the paper's emulsion.
2. Density of the negative.
3. Intensity of the exposure light.

To get choice prints, the exposure should be one that requires at least ninety seconds, preferably two minutes, to develop fully in a standard dilution of developer. A test strip is used to decide the best exposure. There are several ways this can be done.

One of the easiest methods is to lay a Kodak Projection Scale on the negative over a 4 x 5 piece of photosensitive paper (Fig. 5-24). The scale must be between the exposure light and the paper, either above

5-23A The paper box was left partially open, which fogged the print.

Photographed by Linda S. Kennedy.

5-23B A print made with the same negative with the print paper box kept tightly closed between paper removals.

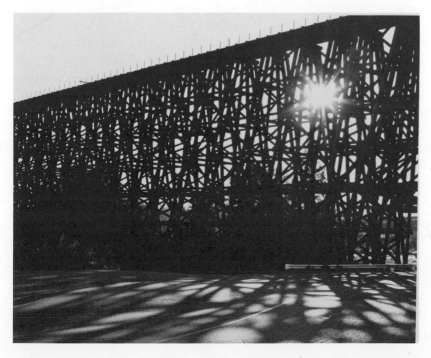

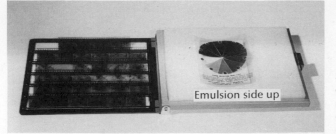

Emulsion side up

5-24 Kodak's projection scale laid over a piece of 4 x 5 photosensitive paper. Close the proof printer and expose to light source for exactly one minute.

or below the negatives, depending on the equipment used to make the contact print.

Turn on the exposure light for exactly sixty seconds.

DEVELOP THE PRINT

1. Remove the paper and slip it into the developer solution, emulsion side up (Fig. 5-25). With a pair of tongs, press the paper down to be sure it is all wet. Start timing for a two-minute development. Flip the print over, emulsion side down. Agitate constantly, either by gently lifting one edge of the tray or grasping the print with the tongs by a corner or side then moving it continuously. Lift the print by one corner to drain for the last fifteen seconds of the developing time (Fig. 5-26).

2. Drop the print face down into the shortstop without getting the tongs in the solution (Fig. 5-27). Take the second pair of tongs and press the print into the solution and agitate for seven or eight seconds. Drain (Fig. 5-28).

3. Slide the print into the fixer face down (Figs. 5-29, 30). For a test print, the room light can be turned on to inspect the print after one minute. For other than test prints, it is better to wait until it has been in the fixer for two minutes. The number in the wedge that is best indicates the number of seconds to expose the print to duplicate that result (Fig. 5-31).

If the whole test print is too dark, or with no visible image in the dark, the cause may be one of the following:

1. Exposed too long to the light used for the exposure.
2. Exposure light was too bright. Reduce the amount of light by installing a lower wattage lamp or by being further from the light for the exposure.
3. The negatives and projection scale were not between the paper and the exposure lamp.

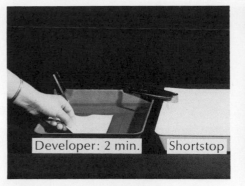

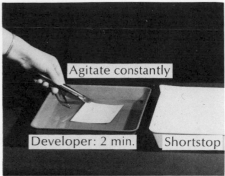

5-25A Slip the exposed paper into the developer, emulsion side up, to be sure it all gets under the surface of the solution without air bubbles.

5-25B Turn paper emulsion side down and agitate constantly. The print is turned to avoid possible fogging from the safelight.

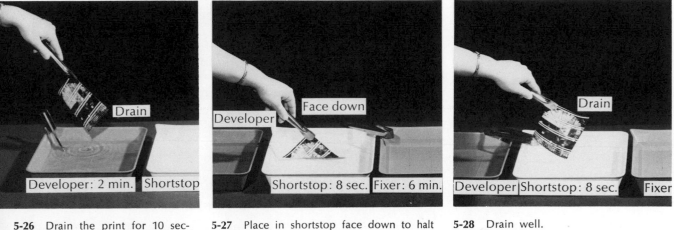

5-26 Drain the print for 10 seconds or so to keep developer in tray and to prolong life of shortstop.

5-27 Place in shortstop face down to halt developing.

5-28 Drain well.

5-29A Place print face down in fixer. Room lights on after two minutes. Agitate intermittently during the six minutes.

5-29B Drain well to save fixer.

5-30 Change water in the tray every twenty minutes until ready to wash prints.

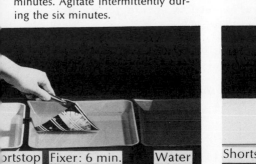

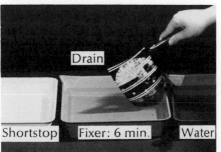

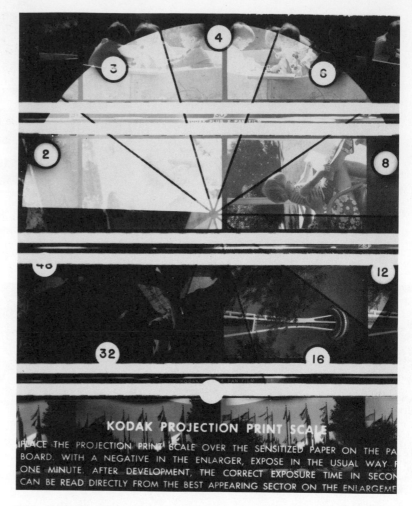

5-31 With this test print, 8 seconds seems a bit light, 16 seconds too dark. The 12-second wedge is not visible in its entirety but this was the time used for exposure on Fig. 5-1.

4. Used enlarging paper when contact paper should have been used.
5. Paper fogged. That is, it was exposed by opening or leaving the package open while the room light was on.

Should all the sections be too light, or lack any image at all, the cause may be:

1. Insufficient time for the exposure to the light.
2. Light not strong enough. Move closer to the light or use a higher wattage lamp.

3. Emulsion side of paper turned away from the exposure light.
4. Exposure light filtered with the red filter on the enlarger or safelight was mistakenly used for the exposure.
5. Contact paper was chosen when enlarging paper should be used.
6. Print was put first into the hypo, instead of into the developer.

TO MAKE THE FINAL CONTACT PRINT

To make the final contact print, assemble the negatives and paper, and expose for the time indicated by the test print. The developing and agitation is the same as for the test print. The print should be left in the fixer for a total of six to eight minutes. If two baths of fixer are used, the print should be in each one-half of the time, with agitation every thirty seconds or so. Be sure the prints do not stick together or lie so flat on the bottom that there is no change in solution on the face of the print.

Turn the print upside down to be sure it does not surface and thus become partially uncovered in the solution. Should this occur before the print is sufficiently fixed, it causes yellow to brown spots or areas. Lack of enough time in the hypo bath, exhausted hypo, or both will cause inadequate fixing. In time the print will turn yellow, even brown, though it looks all right when it is taken from the hypo.

Drain the print well before shifting it from one tray to another. If this is not done, the chemicals are lost for use in the tray in which they belonged, and at the same time either dilute or neutralize the chemicals in the following trays. Do not move the prints (or tongs) in reverse order into the developer. Any contamination with shortstop or hypo ruins the developer.

When contact printing multiple negatives on one piece of paper, the variation in negative density causes some prints to be too dark, others too light, while most may be just right. Proofs do not have to be the very best possible print quality, but they must show sufficient detail for one to be able to judge their potential (Fig. 5-32).

Two ways to cope with this difference in density are:

1. Use varying exposure times on one sheet of paper.
 a. Expose the whole group for the time required for the thinnest negative, the lightest ones on the printing frame.
 b. Cover all of the thin negatives with pieces of black paper or cardboard cut to negative size.
 c. Expose the uncovered ones with enough *additional* time to make those with average density print well.
 d. Cover entirely all but the darkest negatives with black papers.
 e. Expose with sufficient *extra* time to bring in the detail. Develop and proceed as with any contact print (Fig. 5-33).

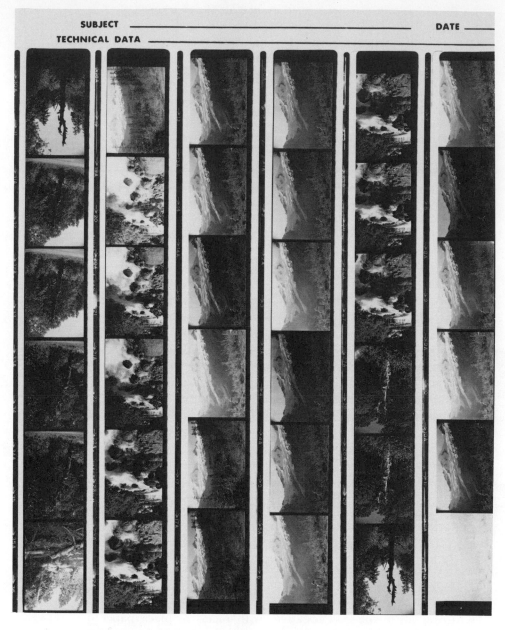

5-32 The very light frame in the lower right corner shows insufficient detail to determine picture possibilities.

5-33 The corner frame was then exposed four times that for the rest of the sheet by covering all the other frames with black cardboard.

2. Print three contact sheets of the same negatives.
 a. Expose one sheet for the thinnest negatives.
 b. Expose a second sheet for the average negatives.
 c. Expose a third sheet for the darkest negatives.
 d. Develop and dry all three sheets of contact prints.
 e. Cut the needed prints from two sheets and glue in place on the third sheet to give a complete record of all negatives.

The first method is certainly more economical in time and paper.

WASH THE PRINTS

When the printing session is finished, the prints are washed. The timing starts *after* the last print is added. If a hypo neutralizer is to be used, a two- or three-minute wash is sufficient at this stage. Move the prints about so that two or more do not stick together. If hypo neutralizer is not used, the wash must continue for one hour.

All washers should be checked at regular intervals (or not left at all) to be sure that prints are not sticking together; that prints are not face up above the surface of the water; that they are not stuck against the side of the sink or tub; and that bubbles of air are not forming on the prints. Any one of these retard the washing effects. Continually pulling the bottom print to the top in succession helps to assure good washing. If they are first all turned face down, then all face up alternately, it assures water rinsing over each print. Inadequate washing causes a print to fade in time.

When hypo neutralizer is used, after the two- or three-minute wash, the prints should be lifted from the water, one by one, drained, and slipped face down into a tray of neutralizer. When all are in, keep agitating them for the time required according to directions with the chemicals used. Continuously move the bottom print to the top during the entire time to agitate. Usually, two minutes for single weight papers and three minutes for double weight papers is required. When both weights are being processed together, the longer time is used for all. Return to the wash for the time required for the paper weight used. Ten minutes for single weight and twenty for double weight or mixed loads is normal. The same precaution explained in the one-hour wash should be followed.

DRY THE PRINT

Follow the directions for drying the print given with the equipment being used or the directions under the illustrations in this chapter. Trying to dry the print too fast is likely to cause buckling and/or oyster shelling (Fig. 5-34–41).

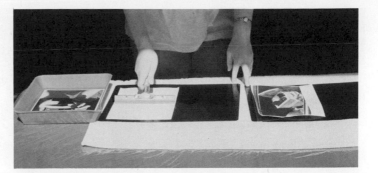

5-34A Regardless of method of drying, squeegee or roll excess water off both sides of the print.

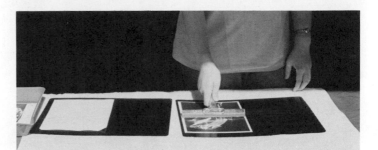

5-34B Lay glass or ferrotype plates on a bath towel to absorb moisture as it is pulled off the print.

Linen surface

5-35 Start at the center part of the blotter roll to lay the prints emulsion side against the linen surface. Open only the width necessary to get the print in place.

5-36 Spreading the rolls too far apart breaks the linen side of the roll, which mars the prints that may lay over that section. Squeegeeing the print avoids stains. Properly handled, a blotter roll will dry thousands of prints.

5-37 Soak prints in Pakosol or other similar solution after the wash to improve gloss and to aid separation from the dryer surface, which must be kept immaculately clean without scratches. Squeegee the print on both sides.

5-38 To gloss, lay the print emulsion to the ferrotype surface.

5-39 Squeegee again to press out all air and to make direct contact between the two surfaces. Close the dryer canvas and do not remove until the print loosens entirely from the surface.

5-40 To dry matte finish prints or glossy paper to a semi-matte finish, lay the print emulsion side up. Pakosol bath is not required for either matte or semi-matte finish.

5-41 Close the canvas cover over the print until it is dry. After the prints are removed, if they are weighted flat for 24 hours or so, they are not so likely to curl. Placing them in a blotter roll for 24 hours flattens them permanently.

Contact prints can be used as a guide for deciding about enlarging at any stage after it is in the hypo. When dry and indexed, they can be stored with the negatives to give instant information as to what is in the picture.

A *good* contact print is adequate for many uses. Examples are the student notebook and the family album. An enlarged print of a good negative can be very exciting to do and shows much more detail.

CHAPTER 6

Enlarging

An effective enlargement of a favorite negative thrills every photographer. Much of the creative artistry is accomplished in this step of making a picture. The photographer who enlarges his own pictures becomes aware of the limitations and the versatility of the negative and understands the multitude of possibilities that are involved. No two people visualize a finished print in exactly the same way. The photographer who completes the entire procedure conveys his own creative taste in the finished work.

EQUIPMENT FOR ENLARGING BLACK AND WHITE NEGATIVES

Equipment used can vary substantially, but minimum requirements are:

1. An enlarger to project and enlarge the negative image onto the photosensitive enlarging paper (Fig. 6-1).
2. An easel to hold the enlarging paper flat and in place during the exposure (Fig. 6-2).

Courtesy of Beseler Photo Marketing Co., Inc.

6-1 Beseler 23C enlarger.

3. Three to five trays of a size suitable for the dimensions of the prints (Fig. 5-3).
4. Device for washing the prints (Fig. 5-20).
5. Print dryer (Fig. 5-21).
6. Tongs for handling prints in the chemicals (Fig. 5-3).
7. Thermometer for regulating temperature of the chemicals (Fig. 5-3).
8. Safelight with a filter for paper to be used (Fig. 5-3).

Desirable equipment that aids in control of the results, thus saving paper and time, are:

9. Timer to control the exposure time.
10. Projection scale for establishing desired exposure.
11. Paper cutter to cut papers to desired sizes for test prints and other varied formats.
12. Magnifier focusing device for sharpest focusing.
13. Filters to control contrast on particular papers.
14. Blower and liquid film cleaner to clean negatives and negative carrier.

6-2 Speed Easel is nonadjustable and made in numerous standard sizes.

There are other desirable devices that are time and paper savers, discussed in the Appendix under "Choosing Equipment."

Enlargers vary in their features but all have certain basic and necessary parts (Fig. 6-3):

1. Easel base to which the support post is attached.
2. Support post to hold the enlarger mechanism in place.
3. Lamp head which encloses the light used for the exposure of the enlarging paper through the negative.
4. Negative carrier (holder) to keep the negative in position.
5. Adjustable bellows to give a lighttight space to provide for varied distances between the negative and lens and thus focus the negative on the paper.
6. Lens to enlarge the negative image onto the enlarging paper and to control the intensity of the light during the exposure.

The enlarger mechanism is moved up and down on the support post to make varying degrees of magnification. The further the negative is moved from the paper, the larger the print that is possible. Some enlargers are made to pivot on the base so that the image may be projected onto the floor for a still larger print than can be obtained at the enlarger base. Some can also project horizontally onto a wall for mural size enlargements.

Lamp heads may have a fluorescent circle tube lamp, called a cold light, or they may use an incandescent opal lamp made especially for the purpose. The incandescent lamps generate more heat and with

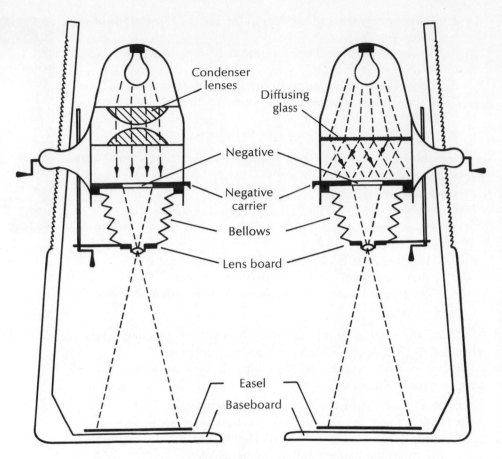

6-3 Basic parts of two types of enlargers.

extended exposure times can cause the film to expand or buckle, referred to as popping. When turned on, the cold light has a warm-up period that varies in light output. Exposure control is difficult. Some photographers leave the cold light turned on constantly during the printing session and use the red filter, mounted beneath the lens, to control exposure time.

Of those enlargers with incandescent lamps, there are two principal types (Fig. 6-3):

1. The condenser enlarger directs the light through a pair of condenser lenses through the negative and lens onto the print paper. For a normal contrast print, this enlarger requires a negative with less contrast. If other factors are equal, it gives a sharper image, but scratches and dust on the negative or negative carrier glass also reproduce sharp.

2. The diffuser enlarger reflects the light in all directions from the lamp head interior through a sheet of opal glass (diffuser) through the negative and lens onto the enlarging paper. This arrangement minimizes negative flaws such as scratches and dust particles. For a normal contrast print, the diffuser enlarger requires a negative of higher contrast than does the condenser type. There are numerous combinations of these two general types.

Negative carriers vary in their design. They are made to fit each size negative. The carriers hold the negative in a flat plane. Some are glassless, others have glass on one side or both sides of the negatives. Those without glass have the advantage of having only two sides of the negative to keep free of dust, scratches, and fingerprints instead of six surfaces as with a double glass carrier. A warped negative or one that pops from the heat of the enlarger lamp can provide a problem that is easiest solved with glass on both sides. Some enlargers will accept only one size negative, others can use several sizes with a carrier made for each size or negative masks to be used for smaller negatives.

The bellows, between the lens board and the negative carrier, contracts or expands as the operator moves the lens up and down to focus the negative image on the easel and serves to contain the enlarger light.

The quality of the enlarger lens affects the sharpness of the print. Regardless of the sharpness of the negative, a poor quality lens cannot transfer that sharpness to the print. If the focal length of the lens is appropriate for the negative size, usually a 16 x 20 print will be possible on the baseboard. Most enlargers can project images on the floor or a wall for still larger prints.

A 50mm (2″) lens is normally used with a 35mm negative.

A 75mm (3″) lens is normally used with a 2¼ x 2¼ negative.

An 80mm to 90mm (3½″) lens is normally used with a 2¼ x 3¼ negative.

Enlarging lenses have diaphragms, leaves of metal that overlap to reduce the light on the easel. These opening are calculated and compare to the f/stops or apertures on the camera lens, except that they do not usually open as wide and may not close down as small. They may start at f/4.5 and continue on as 5.6, 8, 11, and 16. They may go on to 22 or 32 or even further on the longer focal length lenses. The image is focused with the lens open at the widest aperture, which would be the smallest number on the scale. The lens is closed down to a smaller aperture (larger number) for the enlargement exposure.

Easels to hold the enlarging paper in place should be quite heavy to prevent their being inadvertently shifted as the paper is inserted. There are easels of many designs (Figs. 6-2, 4, 5). Some have multiple size slots to fit the standard sized papers. These usually have a place

for an 8 x 10 paper on one side with the several other sizes on the reverse side. It provides for a standard size white border on each print (Fig. 6-4).

There are easels with provision for adjusting the print size to odd dimensions with standard border size on two sides (Fig. 6-5). Varied width of the white border from ⅛″ to ¾″ with the dimensions of the picture area flexible are features of still other easels. Some are borderless easels. One can make borderless easels quite simply. See the Appendix.

An 8 x 10 easel with adjustable leaves on two sides is certainly adequate for the beginner. It allows for flexibility of size and format from wallet to the standard 8 x 10 picture.

6-4A The Airequipt easel provides multiple size openings in one piece of equipment. This hinged side holds 8 x 10 paper.

6-4B The other side is made for 5 x 7, 4 x 5 and 2¼ x 2¼ papers.

6-5 The LPL easel blades adjust to print in any size format desired within the limits of the exterior dimensions. Width of borders may be varied.

The trays for processing the prints should be a size larger than the paper, if feasible, to allow for better agitation. This was discussed more fully in the chapter on contact printing.

Print washers were covered in the chapter on contact printing.

The print dryer, tongs, and thermometer are used in the same manner with enlargements as with contact prints. Manufacturer's notations with the paper give the correct safelight filter.

Timers may be the same one used for contact printing. With enlarging, it is desirable to have accurate, repeatable exposures so the timers that cut off the lamp at the preset time work especially well. Gra Lab and Time-O-Lite are two popular brands (Fig. 6-6).

The projection scale is used in enlarging as in contact printing (Fig. 6-7). In lieu of a projection scale, multiple exposures on one print can be made (Fig. 6-11).

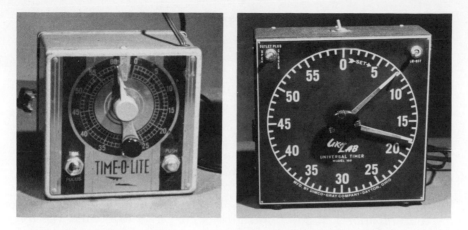

6-6 Time-O-Lite cuts off the enlarger light and resets the needle at preset time up to periods of 60 seconds, convenient for making multiple prints at one setting or manipulating the print for repeated equal periods of time. The GraLab sets from one second to one hour but requires manual setting for each period whether repetitious or not. Especially convenient for film and print processing.

After the negative image is framed on the easel in the desired dimensions and is in fairly good focus, a magnifier focusing device aids to get the sharpest focus possible. Many photographers find them indispensible.

Several manufacturers make papers on which contrast is altered with a filter placed between the light and the paper. It may be above or below the negative (Fig. 6-8). The set of filters saves the photographer stocking so many different contrast papers. Variable contrast papers have other advantages in the printing process that are further discussed under papers in this chapter.

KODAK PROJECTION PRINT SCALE

PLACE THE PROJECTION PRINT SCALE OVER THE SENSITIZED PAPER ON THE PAPER BOARD. WITH A NEGATIVE IN THE ENLARGER, EXPOSE IN THE USUAL WAY FOR ONE MINUTE. AFTER DEVELOPMENT, THE CORRECT EXPOSURE TIME IN SECONDS CAN BE READ DIRECTLY FRTIM THE BEST APPEARING SECTOR ON THE ENLARGEMENT.

Made by EASTMAN KODAK COMPANY, ROCHESTER, N.Y., U.S.A.

6-7 The Kodak Projection Print scale gives 10 different exposures on one piece of 4 x 5 paper to reduce time needed to decide the best exposure. Lay the scale in the most critical area of the print.

6-8 Kodak's filters are mounted below the enlarger lens with the plastic holder sold with the kit. Durst filters are used above the lens in the Durst enlarger. Both accomplish the same contrast changes.

CHEMICALS TO PROCESS ENLARGEMENTS

All paper developers will develop all black and white papers but may yield differences in tone and in contrast. Tone refers to the color of the blacks, which may be cool or bluish, warm or brownish, olive or greenish, or neutral. The subject matter and the photographer's taste determine which is best. Portraits of people are usually done in warm tones, while snow scenes or water scenes may be in the cold tones, yet often the reverse of these is effective. The beginning photographer will not wish to stock a lot of variations, either in paper or developer, so a neutral-toned, normal contrast developer is the best choice.

The other chemicals used for contact prints are, also, used for enlargements. The major concerns in chemicals should be to prevent contamination and not to use them beyond their capacities. The cost per print is nominal. To use them when they should be replaced is false economy because they yield inferior prints, wasting both paper and time.

Toners are available that will change the tone of many of the papers, though not all. With these, one can range from just slightly warm blacks to brown tones or to very warm browns. There are blue toners that can be used in the same manner. These may be preferable to purchasing multiple tone developers or different toned papers if the desired effect is achieved.

ENLARGING PAPERS

Enlarging papers vary in numerous ways. The principal variations are:

1. The degree of contrast produced, called "grades."
2. The weight of the stock paper on which the emulsion is coated.
3. Tones, sometimes referred to as tints.
4. Surfaces.
5. Textures.
6. Speed of reaction to light.

Contrast grades are rated from 1 through 6. As with contact papers, not all contrast grades are available with all the other variations. No. 2 grade is considered normal contrast; however, a No. 2 grade from one manufacturer may more nearly match another's No. 3 grade. A No. 6 in one brand of paper may have more contrast than another brand in that same grade. The one that is best for any given picture will depend on:

1. The contrast desired in the final picture.
2. The contrast of the negative.
3. The contrast that the paper developer yields.
4. The type of enlarger used to print the picture.

If it is practical from the standpoint of the other pictures taken on any given roll, it is desirable to produce negatives that require a No. 2 paper. The negative is the first and most desirable place to start contrast control. When varying degrees of contrast in subject matter and/ or lighting are taken on one roll, it may be necessary to resort to different contrast grades of paper to achieve the desired results. The photographer is not always successful in producing the hoped-for contrast on an important negative. Again, the different grades may be the answer.

Several manufacturers, as mentioned before in this chapter, produce enlarging papers that can yield different contrasts by means of filters between the light source and the paper. They are referred to as variable or multiple contrast papers. Contrast grades No. 1 to No. 4 are available by this method (Fig. 6-8). This has the advantage of not only reducing the stock of paper required for different contrast printing but it allows different contrast printing areas within one picture. This is particularly advantageous when a large portion of the picture is in subdued light but another important area is in contrasting light, with detail desired in both. The mechanics of this operation will be explained in a later part of this chapter, points 8 and 9 under "Evaluate the Print." Without a filter, the papers yield a normal contrast picture with a normal contrast negative.

In most, if not all, multiple contrast papers, the degree of contrast that can be achieved with filters is not as great as with the graded papers, especially those that go up to No. 6.

Tones without special toning solutions vary with the paper and the developer that is used. A warm-toned paper or a cream-toned paper will give warmer blacks with a warm-toned developer than with a cool-toned developer. Often it requires a careful inspection to discern the subtle differences in the tones.

At the time of this writing, several manufacturers are producing papers that print in tones of blue, green, orange, red, and yellow which require no special chemicals. On these, the total blacks are black with the lighter tones taking on the colors of the paper. These give different effects from the regular black and white papers that are toned with special chemicals.

ARRANGEMENT OF EQUIPMENT

Not every photographer is fortunate enough to have a room that can be used exclusively for a darkroom. Bathrooms, closets, kitchens, and utility rooms often are used as satisfactory darkrooms. The primary qualifications are that all light and dust can be excluded, that there be a way of getting electric power for a safelight and the enlarger, plus

enough room for the trays with the chemicals. It is desirable to have some means of bringing in fresh air and exhausting chemical fumes. A small exhaust fan on an exterior wall is suitable.

Arrange the equipment and supplies for efficient operation. If possible, the dry area should be on the opposite side of the room from the wet chemicals and washing equipment. The operations can be either from left or right as best suits the photographer or the room. The dry side should be set up with the paper supply first, the enlarger with the easel on the baseboard, followed by the timer if one is used. The wet side starts with the tray containing the developer, then the shortstop, the hypo, the second hypo bath if one is used, followed by the tray of fresh water or the print washer in operation.

All chemicals, especially the developer, should be at 68°F. Variations can cause undesirable results. In hotter areas, set the trays of chemicals in larger trays of water to which may be added an ice cube occasionally. A small aquarium heater with thermostat controls the temperature in colder situations. The tray may be set on a heating pad, such as used in the sickroom, to keep the desired temperature.

The tongs should be labeled or marked and laid on the corner of the tray in which they are to be used as indicated in the previous chapter under "Equipment to Process the Print" and "Tray Arrangement".

CHECK THE EQUIPMENT

Household vacuum cleaners are effective dust collectors for the darkroom in general. Clean dust from all parts. Especially, be sure all dust and fingerprints are off the negative carriers, particularly if they are glass. The jeweler's hand blower removes the dust. Fingerprints need to be washed off with a soft, lintless cloth moistened in water, then polished with a dry cloth. Check the easel for dust. See that all equipment is in working order.

CHOOSE AND PREPARE THE NEGATIVE

From the contact prints or proofs, decide which negative to enlarge. Determine if the whole negative should be used. If a portion of the negative would be best eliminated, print the picture in a different proportion. This is called cropping. The negative is not altered. The undesirable part spills over the easel borders while the print is exposed. One method that is used to decide what to include or to crop in an enlargement is illustrated (Fig. 6-9). The cropped picture may eliminate distracting images or it may give the closer view of the principal subject.

6-9 Two L-shaped pieces of paper or cardboard laid over a print to be enlarged or contact printed, adjust to any proportion to help decide the areas best included or cropped out.

The creative photographer does not limit the dimensions of his prints to those of the standard size papers nor to the standard size negatives. Many times a negative can be more effective printed in a long narrow format, either vertical or horizontal. Other times, a square might be the better choice. Some negatives can be cropped in a number of formats, each giving a different effect.

Check the chosen negative for dust, water spots, and fingerprints. If any of these are found, clean the negative. Blow off the dust with the jeweler's plastic hand blower or with canned air in a spray can such as Omit or Airsweep. The *clean* camel's hair brush may be used though this may build static electricity to aggravate the problem. Fingerprints are best eliminated with liquid film cleaner used according to directions of the manufacturer. Fingerprints on the emulsion may have remained long enough to permanently damage the emulsion. In that event, that portion of the negative is ruined beyond repair. Remove water spots on the glossy (acetate) side of a negative by rubbing lightly with a slightly dampened spot of a soft lintless cloth, then polishing it dry with the dry area of the same cloth.

THE PROCEDURE FOR ENLARGING

The following steps will produce an effective enlargement:

1. Place the negative emulsion (dull) side down in the negative carrier. The lens reverses the image on the easel. If the horizontal negative is inserted with the top toward the operator, it will appear upright on the easel, making it easier to compose the picture on the easel. Do not pull the negatives through the negative carrier. This can scratch the negative.

2. Turn on the enlarger lamp. Against the light of the enlarger, recheck the negative for dust. Blow off any that is visible. Turn off the enlarger lamp.

3. Lower the enlarger head onto the negative carrier.

4. Insert a sheet of white paper in the easel, the same thickness and size as that to be used for the print. This can be a discarded print turned upside down to give a white surface for focusing. On the adjustable easels, set the adjustable blades to the size desired for the print.

5. Turn on the safelight. Turn out the room light.

6. Turn on the enlarger lamp. Place the easel so the negative image falls on the white paper. Open the lens to its widest aperture (brightest light).

7. Raise or lower the enlarger head, to give the approximate size image desired on the focusing paper. Raise the enlarger head to make the image larger, lower it for a smaller picture.

8. Focus by raising or lowering the lens. This will alter the image size to some extent. It may require finer adjusting of the height of the enlarger. The image must be refocused each time the enlarger is raised or lowered unless it has automatic focusing.

9. Frame the picture with the *easel edges*. The negative carrier edges give soft, indefinite margins on the print.

10. Close down the lens. The f/stop to which it should be closed varies and would be determined by a test strip or projection scale. Factors affecting the choice of f/stop are:
 a. The density of the negative.
 b. The intensity of the enlarger light, which depends on both the wattage of the lamp, the type of enlarger, and whether filters are used.
 c. The intensity of the light is reduced as the enlarger head is raised and increased as it is lowered.
 d. The speed of the paper used for the print.
 e. The necessity for time to manipulate the print by dodging or burning in.
 Try closing the lens down to f/11 for the first test strip.

11. Remove the paper that was used for focusing. Turn off the enlarger lamp.

12. From the package of unexposed enlarging paper, remove one 4 x 5 sheet (or cut an 8 x 10 sheet in two pieces, 5 x 8 or into four pieces, each 4 x 5). Keep only one piece of paper and replace the extra pieces in the package. Close it, lighttight.

13. Make a test strip by *one* of the two following methods:
 a. With a projection scale (Fig. 6-10):
 (i) Lay the projection scale on the emulsion side of the 4 x 5 sheet of paper.

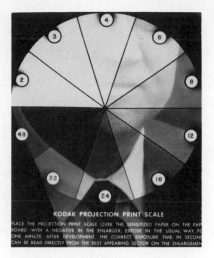

KODAK PROJECTION PRINT SCALE

PLACE THE PROJECTION PRINT SCALE OVER THE SENSITIZED PAPER ON THE PAP
BOARD WITH A NEGATIVE IN THE ENLARGER. EXPOSE IN THE USUAL WAY FO
ONE MINUTE. AFTER DEVELOPMENT, THE CORRECT EXPOSURE TIME IN SECOND
CAN BE READ DIRECTLY FROM THE BEST APPEARING SECTOR ON THE ENLARGEMEN

6-10 In the subject of this photograph, the skin tones, shirt, and coat are the most important areas. Sixteen seconds is a good guess for this particular negative, paper, and lens setting.

 (ii) Lay the combination paper and scale on the easel in the area of the main subject of the picture.

 (iii) If there is a red filter (most enlargers have one) turn it away so it is not between the enlarger light and the paper.

 (iv) Expose for 60 seconds. If the enlarger is connected to power through an automatic timer, it can be set to turn the enlarger off after 60 seconds of exposure.

b. Without a projection scale, use a piece of cardboard, preferably black, to mask off areas to make multiple exposures on one piece of paper (Fig. 6-11). If making a final print larger than 4 x 5, change the easel to a 4 x 5 size but do not change the enlarger in any way. It is necessary to have the paper held firmly for this procedure.

 (i) Place the 4 x 5 area in the main part of the picture. Let the rest of the picture fall where it will.

 (ii) Turn on the enlarger light for 5 seconds.

 (iii) Cover a strip along one edge, approximately $\frac{1}{5}$ of the paper, with the opaque paper. Turn on the enlarger lamp for another 5 seconds. The uncovered section now has had 10 seconds.

 (iv) Cover a wider strip, about $\frac{2}{5}$ths, including the one covered in (iii). Turn on the enlarger lamp for 10 seconds. The uncovered $\frac{3}{5}$ths now has had 20 seconds.

 (v) Cover still more with the opaque paper to make a total of $\frac{3}{5}$ths including all previous covered areas. Expose with the enlarger light for 20 seconds. The uncovered section now has received 40 seconds exposure.

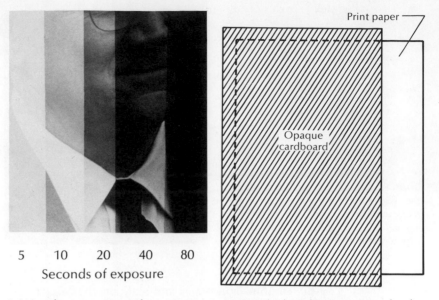

5 10 20 40 80

Seconds of exposure

6-11A The test strip with an opaque board gives five different exposures on one 4 x 5 piece of paper. The 10-second exposure is too light, the 20-second too dark. Midway between gives a more acceptable exposure.

6-11B The board is in position for the last 40-second exposure for a total of 80 seconds for the uncovered section. Timing can be varied to 5, 10, 15, 20, and 25 seconds with a 5-second exposure between each shift of the board.

(vi) Add another strip under the opaque paper to cover $\frac{4}{5}$ths of the paper and expose the remaining $\frac{1}{5}$ for 40 seconds. The last strip now has been exposed for 80 seconds.

(vii) An optional additional step is to lay the opaque paper in the opposite direction covering about half of the paper and expose for 40 seconds. The uncovered half then has exposures of 45, 50, 60, and 120 seconds. The covered half has 5, 10, 20, 40, and 80 seconds.

14. Set the timer for two minutes in the developer. Slide the exposed test strip in the developer, emulsion side up. Start the timer. With the tongs, grasp the edge of the paper and move it around in the tray until the whole surface is wet. Pick up the print by one corner and turn emulsion side down. Continue the agitation either by moving the print with the tongs or by gently raising and lowering one edge of the tray. Be sure the print does not stick to the bottom of the tray.

15. Lift the print by one corner and hold it diagonally to allow the developer to drain from the print for the last 15 seconds of the two minutes.

16. Drop the print emulsion side down into the shortstop without getting the tongs in the shortstop. Replace the developer tongs on the developer tray. Agitate the print with the second pair of tongs or by tipping the tray for 6 to 8 seconds. Lift by a corner and let drain.

17. Drop the print face down into the hypo. Agitate for one minute. Turn the print over and turn on the room light to inspect for the best exposure time.

 a. If the paper is totally white, check the red filter. Was it pushed to one side as it should have been? Perhaps the paper was emulsion side *down* on the easel. If so, no image will show on double weight paper.

 b. If all exposures are too dark, check the lens aperture. Was it closed down to $f/8$ or $f/11$? Try closing down to the smallest aperture and rerun another test strip in the same procedure.

 c. If there is an image but all sections are too light, check the lens aperture. Was it closed down to the largest number (smallest aperture)? If so, open it back to $f/5.6$ or $f/8$. Expose another test strip in the same manner. Was the paper emulsion side down away from the enlarger head? Some image will go through single weight paper, even from the back.

 d. If one section is too dark and the one next to it is too light for the desired result, then consider an exposure midway between the two.

18. Choose the best exposure time. Expose a second piece of 4 x 5 paper at the center of interest, without the projection scale or the opaque paper, for that time. Follow the same procedure in the chemicals as for the test strip. Allow exposure for at least 90 seconds developing time, preferably two minutes. For the problems involved in shorter times check Fig. 6-42.

19. If the check print is either too dark or too light, then study the test print further and choose the next most likely exposure time. Make additional check prints until a satisfactory exposure is found.

20. When a check print is the desired exposure, proceed to expose a full print for the same time. First replace the larger easel or adjust the easel to the original planned framing. Check carefully the alignment of the picture on the easel.

21. Follow the same times in the chemicals as for test and check prints, except that the full print should be left in the fixer for 6 to 10 minutes with agitation at one-minute intervals (Figs. 6-13–21). Yellow or brown spots on the print, as explained in Chapter 5, indicate hypo has not been in constant contact because the

6-12 Fifteen seconds on the check print proves an acceptable exposure. To increase or decrease time to gain optimum exposure, change time by one-fourth, one-third, one-half, double or triple. A two-second change in exposure on a four-second base changes density much more than two seconds on a 32-second base.

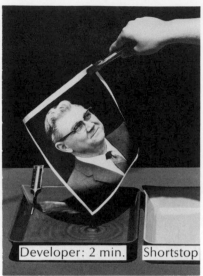

6-13 Slide the exposed paper into the developer face up. When paper is completely submerged, raise by the tongs and turn face down. Agitate constantly.

6-14 Lift with the tongs and drain for the last 15 seconds in the developer.

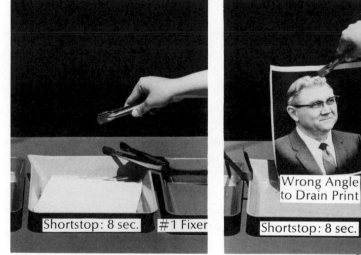

6-15 Drop into shortstop. Do not get the tongs in the solution. Face down position stops developing evenly on the whole print to avoid spotty density.

6-16 Agitate constantly for the entire time. Drain cornerwise.

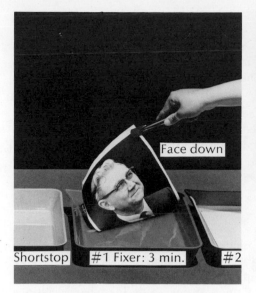

6-17 Be sure fixer is over the whole print. Agitate at least once every minute.

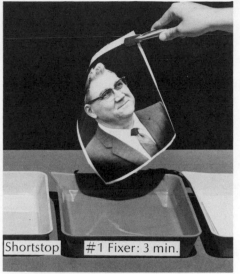

6-18 Drain well.

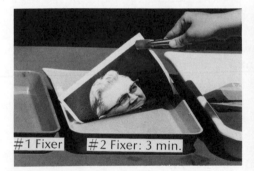

6-19 Submerge in #2 fixer and agitate once every minute.

6-21 Change water two or three times per hour until wash is started.

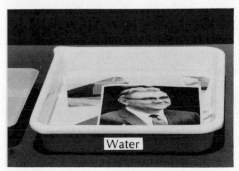

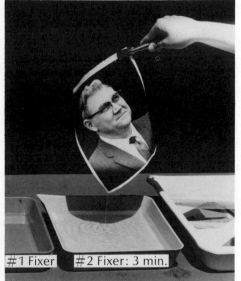

6-20 Drain well to save hypo and to prevent carryover into water.

prints have stuck together or to the bottom of the tray, or have floated to the top so that the emulsion is not exposed to the hypo. The normal room light can be used to evaluate the print when it has been in the hypo for two minutes. The print must be kept below the surface of the chemical if it is to be used as a permanent print.

22. The prints can lie in the tray of water or be washing until the printing session is finished. Then they are washed and dried in the same manner outlined for contact prints. All timing in the washes should start *after the last print is added*. Any loads of both double and single weight papers should be timed for double weight requirements.

EVALUATE THE PRINT

The first inspection of the full-sized print is for obvious flaws that may have occurred in the printing process, and to determine if more prints should be made in the same manner. If not, to decide what variations could yield improved pictures. Some of the faults that may be present and possible remedies are:

1. Whole picture is on the paper at an undesirable angle (Fig. 6-22). For future prints practice putting the paper in the easel until it is easily inserted squarely in place without shifting the position of the easel. For the individual print that is now off square, consider trimming the white border to an even, but narrower, border all around. When a print is mounted for display, the borders are usually eliminated. This is called "bleeding the print" (Fig. 6-23). It can be accomplished during the printing with a borderless easel, or the border can be cut after printing and processing the print.

2. Soft edges on the print are caused by letting the edge of the negative carrier form the border instead of the easel frame or blades. The lighted portion of the negative should always fall outside the easel framing. When every possible bit of negative is desirable, $\frac{1}{16}$th inch of light on the easel border will be sufficient to give a sharp print edge. In the process of cropping, it may be a great deal more than $\frac{1}{16}$ inch, which is entirely proper if it gives the format desired (Figs. 6-24, 25).

3. White specks or white wiggly lines scattered over the prints indicate that dust and/or lint is either on the negative or on the glass of the negative holder (Figs. 6-26A, B). Possibly dust in the air has settled on the paper during the exposure. Clean the darkroom, negative, and glass as outlined previously. For

6-22 Easel was improperly aligned with the projected negative.

6-23 Same negative used in Fig. 6-22 correctly aligned on the easel.

6-24 (Left) The principal subject seems too distant. He occupies too little of the print.

6-25 (Right) Cropped closer, there is still sufficient surroundings to tell the story.

Photographed by Sylvia Noel.

Photographed by Sylvia Noel.

6-26A The dust particles on the far left print are much too large and numerous to consider spotting. Be careful not to damage the negative as it is cleaned.

6-26B The near left print was made with the same negative as 6-26A after it was cleaned.

EVALUATE THE PRINT 139

the present print, spotting is the only solution. Every photographer, no matter how careful in printing he may be, finds it necessary to spot his prints to some extent. This is time-consuming, meticulous work, so every bit of extra care in the darkroom that can reduce the amount of spotting necessary is worthwhile. Spotting equipment, supplies, and techniques are explained later in this chapter.

4. Scratches on the negative back leave streaks of white or lighter gray. If the scratches are in the emulsion, they cause black streaks on the print. Scratches are caused by careless handling during processing or in storage (Figs. 6-27A, B). Spotting is the only hope for the present print if the streaks are white or a lighter gray. Should they be black on the print, then the lines will have to be bleached. Only a very good picture would merit the time involved. For future prints from the same negative a *very thin* coating of vaseline on the back of the negative that is scratched may obliterate or at least reduce it. Rub a bit of vaseline between the thumb and forefinger. Wipe them lightly on a tissue to absorb most of the vaseline, then apply what remains on the finger to the back of the negative. Print the picture (Fig. 6-28). After the print is made, clean the vaseline off the negative before returning it to the storage envelope.

5. A soft-focus print from a sharp negative can be caused by the enlarger light being on long enough that the heat expands the negative sufficiently to make it pop during the exposure. This is a problem especially with the glassless negative carrier. It may have occurred so that the negative was focused in popped

6-27A (Left) Scratch at right side of print is on the back of the negative.

6-27B Scratches on the emulsion of the negative print dark and cannot be eliminated without much time-consuming and meticulous effort.

Photographed by E. J. Goodwin.

6-28 A tiny smear of vaseline on the negative back prevented the scratch registering in the print. Clean with liquid film cleaner before the negative is stored.

6-29A Seldom will the easel be shifted this severely. More often and easily, just a general softening of the image is registered.

position but the exposure was made after it has cooled a bit, or vice versa. The remedy is to let the enlarger cool and then not leave it on long enough to cause the negative to pop. Install a lower wattage enlarger lamp, if popping occurs too frequently. Movement of the easel, the enlarger, or the table on which they rest also can cause soft focus (Fig. 6-29). Even walking across the floor during an exposure may cause a problem if the floor is not completely firm.

Inaccurate or careless focusing can cause soft focus. Focus with the lens opened to its brightest. Use a magnifier focusing aid, if necessary.

The lens installed on the enlarger with the wrong lensboard or with the lensboard upside down can make it impossible to focus sharply.

6. An underexposed (too light) print gives little or no detail in the highlights and limits the range of gray tones with no intense blacks, all of which are considered necessary for the normal picture (Figs. 6-30, 32). The degree of underexposure will, of course, determine the amount of adjustment in exposure time or lens aperture to give the result desired.

7. An overexposed (too dark) print also has a limited range of gray tones but in the reverse of underexposure shows no pure white or too few light tones and gives little or no detail in the shadowed areas (Figs. 6-31, 32). Reduction of printing time or closing down the lens to a smaller aperture (larger number) or both produce a lighter print. Again, the amount of adjustment necessary depends on the amount of change desired.

6-29B Another print illustrates the negative is sharp.

Photographed by E. J. Goodwin.

6-30 The 3-inch-high white mushroom is in approximately its natural values but the print lacks contrast range with little detail on the left. The exposure of the print paper under the enlarger (5 seconds) was insufficient.

6-31 Six times the exposure of Fig. 6-30 (30 seconds) gives too dark values with little detail on the right.

6-32 One-half the exposure of Fig. 6-31 (15 seconds) produces detail in both highlights and shadows with better range of dark to light gray tones. Exposure may be changed with time or with lens apertures alone or in combination.

8. One area prints out too dark while the major part of the picture is just right (Fig. 6-33). This can often be improved by dodging, that is, reducing the exposure for the too-dark area. Insert an opaque object between the negative and the paper for a portion of the overall exposure time. This may be done in a number of ways (Fig. 6-34).

 Black or opaque paper or cardboard can be cut in various shapes and mounted on holders made from wire coat hangers (Fig. 6-35). If the cut edges of the black paper are notched or cut with pinking shears, there is less danger of a discernible line at the dodged area. The dodging tool should be held above the paper with a constant movement to avoid an obvious shadow (Fig. 6-36). For areas near the border of the print, the photographer's fingers or his hand make versatile dodging tools.

9. Some areas print too light while the rest of the print is as desired (Fig. 6-37). Burning in or printing in (the terms are used interchangeably) is used extensively to bring up or intensify detail in light areas. These particular areas are given more exposure than the balance of the print by holding back

6-33A Candy would be entirely too dark if the background were printed to show less or no pattern.

6-33B The shadowed areas show insufficient detail when the sunlighted upper and near right portions are printed to show contours of the precast porcelain panels.

6-34A The background is exposed three times the overall while the principal subject was dodged with the largest dodging tool shown in Fig. 6-35.

6-34B Two pieces of cardboard, cut in the general contours but smaller than those areas shown on the print, were kept in constant movement above the dark portions to hold back light while the overall exposure was repeated twice. The sunlighted door on the lower level was dodged with the shadowed area.

6-35 Dodging tools made from black paper wrappings on enlarging print paper and coat hanger wire.

6-36 (Right) The areas dodged are blended with the surrounding areas without sharp lines if the tool is kept in constant circular motion in a horizontal and/or vertical direction.

6-37A The moon above Seattle's Space Needle is a blurred circle of light.

the light to all but that portion that is to be darkened (Figs. 6-38, 39). There are many ways this can be accomplished.

Sheets of black or opaque paper or cardboard with various shaped openings can be used effectively. The jagged or pinking sheared edges help disguise the borders of the burned-in areas. The sheet must be in constant motion to give shading into those areas with less exposure under the enlarger.

Probably the most used burning-in tools and certainly the most readily available are the darkroom worker's hands. The shape and size of openings that can be devised are unlimited. There must be constant movement to prevent obvious shading.

It is not unusual to do both burning and dodging in several different areas on one print. Ideally, a careful metering of the film exposure and appropriate developing reduces the need for dodging and burning-in.

10. If a good and clean negative produces mottled and/or streaked prints, one of the following may be the cause:
 a. Dirty glass negative carriers or condensers.
 b. Exhausted chemical solutions.
 c. Insufficient agitation of the chemicals (Figs. 6-40–43).
 d. Chemicals too warm (Figs. 6-41, 43).
 e. Overexposure under the enlarger, thus requiring the print to be pulled from the developer too quickly in order to prevent too dark a picture (Figs. 6-42, 43).
 Eliminate the cause and make another print.

6-37B Detail in the right side of this seascape is lost when the left portion is printed as desired.

BURNING-IN

6-39A The moon detail burned in with two hands folded to let a tiny circle of light from the enlarger give five times the overall exposure.

6-38 A hole cut in a cardboard burns in specific areas while the light is held back from the balance of the print. A tiny hole in a cardboard was used to burn in the focal length numeral in Figs. 1-24 and 10-2.

6-39B One hand held back light from the left side while the right side was given three times the overall exposure.

6-40 No agitation in the developer. Compare contrast, detail in highlights and shadow with properly agitated print of Fig. 6-43.

6-41 Developer at 80°F instead of recommended 68°F. Compare quality of print with Fig. 6-43.

6-42 Four times normal exposure decreased time to develop print with disastrous results. Compare with quality of Fig. 6-43.

6-43 Constant agitation in 68°F. Kodak's Dektol for a full 2 minutes produced a good quality print of Wendy on the dune buggy.

11. Unsatisfactory contrast for the subject matter or the effect desired can often be changed sufficiently for subsequent prints by using a different contrast paper or with contrast filter on multiple contrast paper (Figs. 6-44–50).

6-44 The contrast is too strong and print lacks desirable detail in highlights and shadows.

6-45 A Kodak No. 1 Polycontrast filter below the enlarger lens softens the contrast on Polycontrast paper to show more detail in highlights and shadows.

6-46 (Top right) A picture made on a hazy cloudy evening is muddy and flat with little sparkle when printed on normal paper.

6-47 (Center right) A No. 3 Polycontrast filter improved the contrast but print is still flat.

6-48 (Bottom right) A No. 4 Polycontrast filter livened up the picture much more.

6-49 A thin negative printed on No. 2 paper is flat with lack of contrast.

6-50 The same negative prints much better on No. 5 Kodabromide paper. The corners were burned in to hold the viewer's attention in the picture.

Sometimes the subject of a picture needs a certain degree of contrast in one area but this is not appropriate for the rest of the picture. Here the mulitple contrast paper controlled by filters can be most advantageous. The best filter for the major part of the picture could be used while the area that needs a different contrast is held back by dodging or a mask. Then the other filter can be installed, and the previously printed area protected while only the remaining area is printed with a different contrast. This is one effect that cannot be achieved with the graded papers in the printing process (Figs. 6-51, 52).

The graded papers, as mentioned earlier, give a higher *contrast* than the multiple contrast papers (Fig. 6-53).

12. If vignetting (corners of the print lighter) occurs with a normal negative, the cause can be improper condensers installed for the negative size being printed. Some enlargers (referred to as universal) require no change of condensers for larger negatives while others require additional or different condensers for various size negatives. The manufacturer's instruction booklet supplied with the equipment should disclose the appropriate condenser lenses for each negative size. Another common error that causes vignetting is too short a lens for the negative size.

6-51A The mountain is obscured by haze with much less contrast than the foreground when printed on a multicontrast paper with no filter.

6-51B When a Kodak Polycontrast No. 4 filter is used, the mountain is better, the foreground is too dark with excess contrast.

6-52 (a) The lower portion was dodged with a hand while the top was printed through a No. 4 filter for 15 seconds. (b) The left side was burned in for an additional 10 seconds. (c) The upper portion was held back with a hand while the lower two-thirds was printed with no filter for 5 seconds.

13. Objects within the picture that should be vertical or horizontal but are at a different angle may have been caused by:

a. Careless framing on the easel during the preparation for making the print (Fig. 6-54).

b. Camera held at an angle through carelessness during the film exposure (Fig. 6-55).

c. Camera held at an angle because of necessity. For example, a picture of a tall building taken from ground level or the camera turned down toward a subject. A wide-angle lens is prone to exaggerate this problem (Fig. 6-56).

For the first two causes, careful framing with the easel can usually correct the error (Figs. 6-57, 58).

Unavoidable convergence of lines (if the lines were extended they would meet) as in "c" can be compensated to some extent, and sometimes entirely corrected, by raising one side or one end of the easel to change the scale of enlargement on that edge (Figs. 6-59, 60). Some enlargers have a negative carrier that tips or the whole enlarger head may be angled. Some easels are especially made with tilting mechanism to aid in straightening the subject on the print.

6-53 Negative used in Figs. 6-49 and 6-50 printed with a No. 4 Polycontrast filter. Compare with Fig. 6-50 on grade No. 5 paper.

Photographed by Ramona Roth.

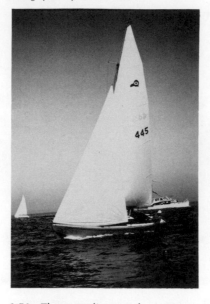

6-54 The waterline on horizons on seascapes should be level, which isn't true of this print.

6-55 The height of the subject plus a camera not held level caused the Jasper, Canada, totem pole to tip.

Photographed by Ramona Roth.

6-56 The terrain and presence of telephone and power poles with their lines required the subject to be photographed from a very low angle, which makes the church appear to slant backward.

6-57 The slanted waterline corrected by framing on the easel.

6-58 The tipped totem pole changed by careful framing plus the technique illustrated in Fig. 6-59.

6-59 (Left) Tip the easel to correct perspective errors from camera angle. The difference in the degree of enlarging and distance from the enlarging lamp requires burning in the print on the lower portions of the easel.

6-60 (Above) The apparent height of the church is changed but angle and perspective are corrected by the technique shown in Fig. 6-59.

All three methods of straightening the image will cause a loss of a wedge-shaped portion of the negative at two corners and along the edges from those corners.

There can be a problem of focusing in each of these situations. The best possibility of getting the whole print in sharp focus will be achieved if it is focused on an area two-thirds of the way up the sloping image from the lower edge of the tipped easel. Use the smallest aperture that is possible in exposing the print because this will give the greatest depth of field, which refers to the area that appears in sharp focus. Depth of field is explained in detail in the study of lenses in Chapter 11, Depth of Field. The same principles explained for camera lenses in that section apply to the enlarger lens.

14. Harsh, unflattering lines, especially in portraits of women, can be minimized by one of several techniques (Fig. 6-61).

 a. A layer or two of nylon stocking stretched over an embroidery hoop or mounted in a cardboard frame makes an excellent diffuser. It is kept in motion constantly during the exposure as it is held between the lens and the enlarging paper (Figs. 6-62, 63). For slightly sharper effects, a third or a half of the exposure time can be made without the diffuser. If it is desired to keep the eyes in sharper focus, small areas appropriately spaced can be cut out of the diffuser to let the eyes print at the sharpest possible focus with the negative while diffusing the balance of the portrait.

6-61 Several flaws are evident in this portrait: (*a*) Highlights in the necklace distract. (*b*) High contrast in skin tones is objectionable. (*c*) Reflections of the papers on the desk in the eyeglasses. (*d*) Highlights in the chairback and background objects.

6-62 This print was manipulated as follows: (*a*) One layer of sheer nylon hose on an embroidery hoop was moved constantly, during print exposure under the enlarger, to soften facial tones. (*b*) The background was given three times the overall exposure while the subject was dodged with the triangular tool shown in Fig. 6-35. (c) Spotted and shaded with Spotone, described further in this chapter.

6-63 Same techniques employed in Fig. 6-62 except two layers of nylon were used in the embroidery hoop, which softened lines still more.

The nylon in a frame can be laid over the enlarging paper to print texture on the print (Fig. 6-64).

 b. A cheap or a diffusing enlarger lens may be used instead of the ultra-sharp enlarger lens that is desired for most prints.

 c. Crumpled cellophane that has been smoothed out in one or several layers may be held beneath the lens and kept in constant motion to diffuse the image.

 d. Lens tissue or a fine thin woven fabric may be laid on top of the negative to print a texture with the subject.

 e. A thin sheer fabric can be stretched in a frame and laid on top of the enlarging paper. The fabric may be nylon netting, lace, or any chiffon type of fabric. It is not moved during the exposure so that the fabric texture prints quite visibly (Fig. 6-65).

 f. Textured screens and negatives are available though they are quite easily custom made by any photographer with close-up equipment. Make a negative of any fabric. Its texture and angle of light will determine the results (Fig. 6-66).

6-64 Stretch sheer nylon hose or other sheer fabric textures over the print paper on the enlarging easel for special effects.

6-65A Nylon net laid over the print paper produced a different appearance.

6-65B Nylon net laid over the negative in the negative carrier changes the portrait.

6-66 A commercial texture screen on top of the print paper gives another impression.

15. A portion of the picture is fine but other sections are undesirable and so placed that neither vertical nor horizontal cropping eliminates the objectionable area and preserves the good features. There are several ways this type of problem may be

approached. Some of the following methods are quite time-consuming and complicated, but for the picture that is valuable artistically, monetarily or sentimentally, they are worth consideration. (Certainly, the following listing does not include *all* the methods available.)

a. Intentionally vignetting the print is a simple method, if it is practical for the problem. The process is holding back the enlarger light from the paper, usually in a rounded or oval shape to make the picture gradually shade off into light gray or totally white. Portraits are often printed in this manner even when the backgrounds are not a problem (Fig. 6-67). This procedure is a version of dodging. The hands can be used as the dodging tool, if held in appropriate positions. There are devices made especially for this purpose (Figs. 6-68, 69).

6-68A The commercial vignetter can be adjusted to any desired opening shape. Openings cut in an opaque board could serve the same purpose. Hands make excellent vignetters.

6-68B A smaller opening in the vignetter is more quickly formed than on the cardboard.

6-67 The camera was too close to Derek, so distortion and soft focus are objectionable but the happy expression is worth saving.

b. It is sometimes possible to completely bleach unwanted details or to subdue them sufficiently to attain the result desired. To achieve a natural effect, it is necessary to work carefully and cautiously.

Bleaching is discussed in the latter portion of this chapter.

c. Flashing the paper before exposing it through the negative gives a darker gray or a black area on the part flashed. The

intensity of the darkening depends on the amount of exposure given in the flashing. (Figs. 6-70–72).

d. Negatives 2¼ x 2¼ and larger can be retouched. The technique requires practice to perfect but can be very satisfactory when done well. Some proficient photographers successfully retouch 35mm negatives but it is not a general practice. There are special books, pamphlets, leaflets, and classes given in retouching.

e. The paper negative process can be used to correct an unlimited number of faults. It is a time-consuming process but produces results that are attainable by no other method. It is also a challenging creative procedure.

The beginning photographer should not attempt to master on his first roll of film all of the printing techniques suggested in this chap-

6-69 The vignetted portrait diminishes the undesirable features of Fig. 6-67.

ter. He should understand where they can be used effectively and develop his skill as the need arises.

BLEACHING TECHNIQUES

There are many prints that can give more visual impact with a bit of judicious bleaching. Black spots or dark areas may need lightening, or highlights brightening to give desired accents. Undesirable back-

6-70 The pussy willow picture is ruined by the failure of the photographer to check backgrounds. Cropping or vignetting is a suitable solution.

6-71 Flash the print paper without a negative in the carrier. Protect the rest of the print from exposure with an opaque board.

6-72 Print paper was flashed in the upper right-hand corner before the negative was placed in the negative carrier.

grounds may need to be completely bleached to total white with careful application of bleaching solution (Figs. 6-73, 74). Contrast beyond the capabilities of the paper may be achieved (Fig. 6-75).

Patience, practice, and experimentation are the keys to perfecting bleaching techniques. Following is a list of equipment and supplies that can be used:

1. Cotton balls and the round applicator sticks that can be purchased at the drug counter combined to make varying size swabs or Q-tips; all are good for spot or selected area bleaching. Toothpicks, wood skewers, or other pointed wood sticks make good spot applicators. Water color brushes work. Do not use the same brush for spotting.
2. Tray of water for slowing bleach and reducing bleach before putting print into hypo.
3. Tray of hypo for stopping the bleaching action.
4. Tray for the bleaching solution if the whole print is to be bleached.
5. Bleaching chemicals (only one of the following listed):
 a. Potassium ferricyanide (granules).
 b. *Spot Off* (two liquid solution by the makers of Spotone).

Photographed by Ellen Boyd.　　Photographed by Jim Yarbrough.

6-73 (Above) The out-of-focus tree detracts from the rest of the subject. (Sometimes only a shadow needs lightening or a distracting spot needs to be removed.)

6-74A (Above right) A closer picture of Cameron alone may be desirable.

6-74B (Right) Enlarged and cropped print leaves conflicting areas. Bleaching can remove these.

Photographed by Jim Yarbrough.

6-75 A low-contrast light on a low-contrast subject and background presents a problem when processed with other pictures that require normal film processing. Printing with the highest-contrast filter fails to give needed separation in tones.

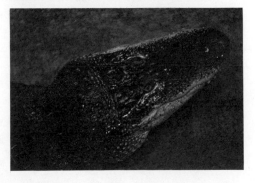

 c. Farmer's Reducer.
 d. Iodine and alcohol.
 6. Small quantity of wetting solution such as Photo-Flo to add to the bleach solution when needed.
 7. Blotters and/or small squares of sponges.

Each photographer eventually works out his own preferred methods of procedures in bleaching areas on a print. Unless the negative is available to make additional prints, never start the first experiments on an important print (Fig. 6-76).

The strength of the solution determines the rapidity of the bleaching. The knack of successful bleaching is to stop the action at precisely the right stage. For this reason, the beginner should start with a weak, slow-action solution. Since the manufacturer includes directions for the dilutions and working of Spot Off and Farmer's Reducer, the directions here will be principally concerned with the use of the ferricyanide. Actually, the techniques for bleaching with any of the bleaches are quite similar.

The solutions deteriorate rather rapidly after they are mixed, sometimes losing their bleaching effect in a few minutes. Only the amount to be used within a short time or on a particular print should be mixed at any time.

Most experienced photographers mix the ferricyanide crystals with water, judging the strength of the working solutions by the color. A good proportion for the beginner to start would be 1/8 teaspoon of ferricyanide to 1/2 cup water.

The print to be bleached can be taken from the fixer bath or may be one that has been completely processed and dried. A dry print should be resoaked in water for several minutes to prepare the emulsion for the bleach. If the print has been taken from the water wash, a few drops of fixer should be added to the bleach solution. The hypo extends the working life of the ferricyanide, sometimes up to thirty minutes. For the print coming from the fixer bath, it is unnecessary to add hypo to the bleaching solution. Adding a few drops of dilute wetting solution or detergent to the mixture prevents the liquid from beading or balling up in a heap when it is applied to the surface of the emulsion.

6-76 A cotton ball dipped in Potassium ferricyanide solution bleaches the large areas; Q-tips and brushes are used for smaller and more critical areas. Do not rub hard enough to damage the emulsion. Wash and slip into fixer often to avoid stains. Realize fixer too can bleach if left too long.

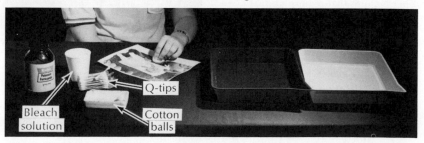

The print should be well-drained, squeegeed or blotted quite dry of any surface moisture with blotter or sponge. The bleach is then rubbed gently onto the desired areas with a nearly dry applicator of a size that makes it easiest to cover the desired area but not go beyond it. If a brush is used, wipe it repeatedly on the blotter or sponge before applying it to the print. The cotton applicators can be squeezed between the sponges or blotters or paper towels. After about five seconds, wash the area with running water for a few seconds and slip the whole print into hypo until all yellow stains disappear. Check under a good light. If bleaching is insufficient, repeat the procedure until the desired action occurs (Fig. 6-77, 78).

When the whole picture needs the contrast heightened, it is done in a tray with sufficient solution to cover the print well. Use constant agitation. Wash with running water and drop into the hypo every few seconds to prevent the process from going too far (Fig. 6-79).

If a large portion needs bleaching but a part does not, it is possible to use rubber cement to prevent action on that section. Simply spread the cement on the area to be protected. Let it dry until it does not feel sticky before proceeding. When the bleaching process is completed, rub the cement off with the fingers.

As one becomes more proficient, the bleach solution can be made stronger to speed up the whole process on any of these problems.

After all bleaching operations are finished, the print *must be treated to a regular hypo bath* of 8 to 10 minutes and then washed for one

Photographed by Ellen Boyd.

Photographed by Jim Yarbrough.

6-77 (Left) Bleached print eliminates objectionable portions.

6-78 (Above) Only Cameron and part of his carrier is left.

6-79 Details become much more visible. The eye was given additional help beyond the all-over bleach bath.

hour to prevent stains. If a hypo neutralizer is used, then follow the regular procedure of washing.

SPOTTING THE PRINT

To effectively spot a print produces the final finish that subdues or eliminates distracting white or light spots, lines, or highlights.

Spotting a print can be time-consuming but it is certainly not difficult. When done with care, spotting is practically undetectable on matte or semi-matte paper. The spot does have a dull appearance on a glossy print. The amount of spotting needed can be controlled best, as stressed earlier, with good housekeeping in and with the camera, in the darkroom and with the negative, to prevent spots and scratch marks on the print (Fig. 6-80).

6-80 Careful spotting of the print gives the final professional touch.

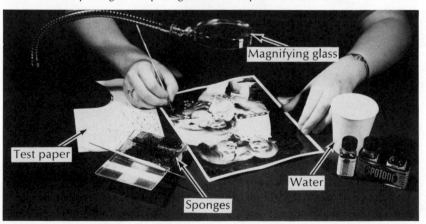

However, these are not the only areas that are spotted. Distracting highlights are often toned down or obliterated. These, too, often can be reduced at the time the picture is taken, with careful attention to backgrounds, highlights, and the kind and direction of lighting. However, with the most careful attention to details all along the way, nearly every enlarged print is improved with some spotting (Fig. 6-80).

Equipment and supplies used for spotting are:

1. Two or three fine-pointed sable brushes.
2. A small glass of water.
3. A good light, preferably daylight.
4. Spotting colors.
5. Small plastic box with a lid such as fishing lure cartons.
6. Four small squares of sponge to fit in each quarter of the plastic box. They should not quite touch each other if there are no partitions to separate them.
7. A magnifying glass is desirable.

The brushes should be sizes "0" to "00000." Different brands vary somewhat in sizing and the individual photographer develops his own preferences but it is agreed by all that they should be sharp pointed.

Any small container that holds an ounce or so is suitable for water.

The light should come from a direction that does not cause a glare from the print into the worker's eye and be strong enough to avoid eye strain. Matching tones and intensities of grays and blacks is easier with daylight, preferably north window light, than with artificial light.

Since printing papers vary in tone and developers also affect tones of the grays and blacks, it is necessary to have more than just a neutral black for spotting. The usual choices are a neutral black, a blue black, and a sepia (brown). Sometimes there is need for a greenish or olive black. These are all available in both liquid and dry form. One popular liquid brand, Spotone, has the first three colors named in a 3-bottle combination. The olive-black is sold separately. Kodak makes discs of dry color. It is easier to remove the Kodak colors should one make an error. The Spotone is more permanent but can be removed by soaking the print in clean water for thirty minutes or so and then drying as usual. This removes all of the spotting and one can start over.

The principal secrets of successful spotting are:

1. Work with an almost dry brush. Those who have difficulty with spotting glossy prints will find this technique works. Liquid should *never* be visible, as such, on the print. There are numerous methods used. An effective one is:

a. Shake a bottle of the Spotone.

b. Drop four to six drops onto one of the sponges in the plastic box.

c. Label (masking tape works well) on the lid directly above that sponge the color and number of the bottle.

d. Repeat b and c for each of the other Spotone colors.

e. Let the sponges air dry.

2. Dampen the brush in the water and lift color from the sponge with the moistened brush. Touch the brush to a piece of white blotter or, better yet, a discarded print on the same paper that is developed in the same developer. Check the tone and intensity of gray with the area to be spotted. **Never, Never** touch a print with a spotting brush until it has been tested on a blotter, white paper, or a discarded print. This must be done each time the brush is touched to the color. Start spotting in the darker areas first.

The intensity of the gray should always be less than the area surrounding the spot. When the test spot color is too dark, repeatedly brush with a twist to the brush to keep the point on the scrapped print or blotter. The color gradually lightens as the moisture is depleted. If the tone is too warm (brownish), pick up a bit of blue; test again. When the tone is too cool, warm it with a bit of sepia; test again.

For the photographer who confines his work to only a few papers, the colors can be premixed as outlined in the directions with the product. The mixed colors then can be applied to small sponges and dried. The moistened brush picks up the color and the mixing procedure is eliminated for each brushload.

3. To fill in white spots, dot with tiny spots. Work from the center out. Beware of the edges, they easily form a dark line around the spot. To fill in lines, scratches, or stray hairs on a portrait, dot, rather than drawing a line. For darkening a highlight, a small circular stroke works well.

4. Build up the spot by repeated applications. Let it dry between each one. If the practically dry brush is used, it takes only a few seconds for a spot to dry. This gives opportunity to check tone and intensity.

OTHER TECHNIQUES

Explore other creative and corrective procedures that can be used in printing. Some are:

1. Composite prints (Fig. 6-81).
2. Montage prints.

6-81 The larger seagull is on one negative, the smaller one and the dock on another, both taken on a very foggy morning. Negatives were printed separately on one sheet of paper.

3. Solarization, more appropriately termed Sabattier effect (Fig. 6-82).
4. Tone-line prints.
5. Bas relief (Fig. 6-83).
6. Contrast control by other methods:
 a. Increase contrast by using developer solutions stronger than normal.

Photographed and printed by E. J. Goodwin.

6-82 Prints or negatives may be exposed to light midway in developing; then the developing is completed to gain a partially reversed image commonly termed solarization.

Photographed and printed by George P. Horton.

6-83 A positive contact print was made on film. The positive and the negative were placed together, slightly off register, to make the bas relief print.

 b. Decrease contrast by diluting the developer solutions several times normal.

 c. Vary contrast between filter grades by use of the filter for only a portion of the exposure time.

 d. Intensify the print for increased contrast.

 e. Paper negative on high contrast grade.

 f. High contrast copy film.

7. Distortion created on the enlarging easel (Fig. 6-84).

8. Black and white enlargement from color slide via paper negative (Fig. 6-85).

9. Photograms (Fig. 6-86).

6-84 Enlarging paper attached to an uneven easel elongated Sandy.

6-85A The paper negative made from a color slide on regular (orthochromatic) enlarging paper. Panchromatic enlarging paper would give different gray values from this negative.

6-85B A positive made from the paper negative by contact printing in the printing frame.

6-85C Sometimes the paper negative is effective, too. This negative was made with an enlarger on regular enlarging paper from a color transparency.

DISPLAY

Except for the information learned in the process, enlarged pictures are of little value tossed in a drawer or stacked on a shelf. Time and money have been invested. The unsuccessful ones should be kept, along with notations of the procedure that caused the failure, to be used as reference. This can aid in preventing a repetition of the

6-86A A photogram is made without the camera. The subject was laid directly on the photosensitive paper on a foam base. Plate glass laid over the subject held it in close contact with the paper to give a relatively sharp image. It is not always desirable to press the subject flat. The paper was exposed to light, which may be from an enlarger or from some other source. The negative image may give the desired end result.

6-86B Or it may be contact printed in the printing frame to make a positive.

6-86C A 3-inch sprig of new leaves between glass in the 4 x 5 negative carrier produces this negative print.

6-86D Contact print yields a positive.

error. The mistakes should be displayed only in a teaching-learning situation.

Prepare the successful enlargement for display so it can be repeatedly enjoyed by the photographer and others. The display area may be on a wall at home, school, or in a salon; by publication in a newspaper, magazine, or book; or in an album.

Some of the methods of display preparation are explained in the Appendix. Choose an appropriate procedure and start a portfolio of successful prints for display.

Mastering only the mechanics of enlarging does not make a successful photographer. The composition or arrangement of the subject within the picture is vital to picture quality. The following chapter offers guides.

REFERENCES FOR FURTHER READING

Combs, Bob: "The Technique of W. Eugene Smith," *Camera 35*, Vol. 14, No. 3, April/May, 1970, pp. 42f.

Cornell, Jack: 'Controlled Solarization," *U.S. Camera*, Vol. 30, No. 9, September, 1967, pp. 46f.

Cornfield, Jim: "A Simple Method of Print Retouching, Part I," *Petersen's Photographic Magazine,* Vol. 1, No. 5, September, 1972, pp. 64f.

———"A Simple Method of Print Retouching, Part II," *Petersen's Photographic Magazine,* Vol. 1, No. 6, October, 1972, pp. 54f.

Croy, O. R.: *The Complete Art of Printing and Enlarging*, New York, Amphoto, 1970.

East Street Gallery: *"Procedures for Processing and Storing Black and White Photographs for Maximum Possible Permanence,"* East Street Gallery, Grinell, Iowa, no date.

Farber, Paul: "Blix It! Now Everyone Can Print Color," *Camera 35*, Vol. 13, No. 4, June/July, 1969, pp. 31f.

Floyd, Wayne: *ABC's of Developing, Printing and Enlarging*, New York, Amphoto, 1964.

Francekevich, Al: "Processing Tube for Murals," *Popular Photography,* Vol. 67, No. 1, July, 1970, pp. 20f.

Frazier, William: "Solarization Anyone?" *Camera 35*, Vol. 13, No. 6, October/November, 1969, pp. 10f.

Gibson, H. Lou: *Perfecting Your Enlarging*, New York, Amphoto, 1966.

Haffer, Virna: *Making Photograms*, New York, Hastings House, 1969.

Harrison, Howard: "Montage. The Exciting World of Multiple Imagery," *Camera 35*, Vol. 13, No. 4, June/July, 1969, pp. 25f.

Hattersley, Ralph: "Dark/Lighter/Bleached," *Popular Photography*, Vol. 65, No. 4, October, 1969, pp. 102f.

Kennedy, Cora Wright: "How to Bleach Without Blobs," *Popular Photography*, Vol. 67, No. 3, September, 1970, pp. 24f.

———"You Can't Print That—Or Can You?," *Popular Photography*, Vol. 64, No. 4, April 1968, pp. 74f.

———"How to Salvage Outdated Print Paper," *Popular Photography*, Vol. 66, No. 2, February, 1970, pp. 40f.

Kramer, Arthur: "Give Prints a Hand," *Modern Photography*, Vol. 32, No. 1, January, 1968, pp. 62f.

———"Processors," *Modern Photography*, Vol. 32, No. 12, July, 1968, pp. 96f.

Lerner, Norman: "With Onion Rings and Other Things" (photograms), *Camera 35*, Vol. 14, No. 4, June/July, pp. 46f.

Lootens, J. G.: *Lootens on Photographic Enlarging and Print Quality*, New York, Amphoto, 7th ed., 1967.

Satow, Y. Ernest: *35mm Negs and Prints: And How to Get the Most from Them*, New York, Amphoto, 1969.

Schultz, Mort: "Giant-Size Prints," *U.S. Camera*, Vol. 30, No. 4, April, 1967, pp. 54f.

Vestal, David: "Reginald Wickham" (tone-line processed prints), *Camera 35*, Vol. 14, No. 3, April/May, 1970, pp. 54f.

———"Are Your Prints Fading Away?," *Popular Photography*, Vol. 64, No. 4, April, 1969, pp. 67f.

West, Kitty: *Modern Retouching Manual*, New York, Amphoto, 1967.

Wolfman, Augustus: ". . . Use Ferricyanide for Overall or Local Reduction," *Modern Photography*, Vol. 33, No. 11, November, 1969, pp. 54f.

CHAPTER 7

Guides To Composition

The primary concern of this book to this point has been with the mechanics of taking and printing a picture. More is required to produce a picture with impact, that quality which causes viewers to pause, to look again and again. A picture must have interest.

Composition is a most important factor used to achieve impact and interest. Good composition directs the observer's attention to and supports the center of interest in a picture.

Three general qualities of good composition are:

1. The center of interest dominates the picture.
2. Balance is created by the arrangement of the subject matter within the area of the frame.
3. Limits are established by including only that which reinforces or contributes to the center of interest.

The ways in which people see pictures must be considered in attempting to give a picture these qualities. Most viewers' attention goes into a picture from the left or from the bottom, whichever has the stronger line or lead. The eyes follow lines or contours within the picture from left to right, as in reading. (It is possible, even probable, that people who use a language read from another direction may view pictures differently.) A bright spot, either light or bright color, in a dark area, or a dark place in a light field causes the eye to jump rather than travel to the object. Conscious effort is required to see the rest of the picture. If the point drawing the attention is the center of interest and occupies the major portion of the picture, the photographer has succeeded. When the bright spot is neither the center of interest, nor the support, the viewer is distracted (Figs. 7-1,2).

The "Rules of Composition" as they are often called are better termed "Guides to Composition" because this implies that they can be applied when they are effective. The guides aid the photographer in specific ways to give his pictures the three qualifications of good composition.

CENTER OF INTEREST

The center of interest can be placed at various locations within the frame, preferably *not* in the center for most subjects. Exceptions to

Photographed by Jim Yarbrough.

7-1A (Top) The lace demands attention, which severely detracts from that given to the principal center of interest.

7-1B (Top, right) The triangle of white shirt and line of cuff direct the eye to the face as they should, but the area beneath the arm reduces the viewer's concentration.

7-1C (Below) Light flares from the window in the eyeglasses detract.

7-2 (Below, right) When the lace is left out, the picture becomes stronger. Crop a part of Fig. 7-1B with a piece of paper. This technique is not practical for Fig. 7-1C.

Photographed by Hazen M. Hyland.

Photographed by Jim Yarbrough.

this are statues, cathedrals, mountains, and the sun in sunrises and sunsets, all of which are effectively placed in the center (Fig. 7-3). A method of determining the best placement of the principal object in a picture is a visual aid to mentally divide the scene in thirds, both across and up and down, whether the picture is a vertical, a horizontal, or a square (Fig. 7-4). The points at which the lines cross are choice locations for the center of interest and supporting materials. Point "1" is the most advantageous position for the most important area of the picture. If this isn't practical, "2" should be the next choice. Positions "3" and "4" are better than placing the object in the center of the picture other than for the type of subjects previously suggested. An easy way to remember this sequence is the "N" superimposed on the film format with the numbers at the ends of each straight line in reversed order. The reasons for this order of choice for the center of interest areas are:

1. Maximum use of the film is achieved at "1" because of the viewers' tendency to look at a picture from left to right. (Figs. 7-5–9).
2. With the principal subject at "3" or "4", the eye tends to hold in that area. Special effort is required to get into the rest of

7-3 The Space Needle at Seattle, Washington, is a subject suitable for center placement in the picture.

7-4 All formats are divided into thirds. The cross points become desirable areas for the principal center of interest. An "N" placed over the intersections and traced in reverse provides an easy method to remember the order for the choice of positions.

Photographed by Linda S. Kennedy.

Photographed by Linda S. Kennedy.

7-5 The largest light area is roughly in the "4" position. The eye is forced to jump across uninteresting areas to see the rest of the picture. The attention is led out of the view by the lines of light.

7-6 With the print reversed, the eye follows the lines of light into the picture, follows the columns and patterned ceiling to the light areas to the fountain, down and back along the floor design.

7-7 When the head is in the "3" position, the right half of the picture holds scarcely any interest. The tail and two feet in that area are just necessary appendages to complete the dog.

7-8 With the center of interest, the dog's mouth and eye, at "1", attention is guided to that point by the tail and all four legs.

7-9B The tiger's head at "4" stops the eye. The rest of the picture is just space.

7-9A The elephant's foot atop the post is quickly observed and the rest of the picture is of little consequence, wasted film.

the picture. Three-fourths of the picture is waste space if the center of interest dominates (Fig. 7-10).

3. With the principal subject in the center, the right half of the picture becomes a semi-waste space (Figs. 7-11, 12).
4. Informal balance is more interesting than formal balance (Figs. 7-12–14).
5. With overpowering subjects, as mentioned in the exceptions suitable for center placement, there is limited possibility of achieving balance if placed other than center.

Photographed by E. J. Goodwin.

Photographed by E. J. Goodwin.

7-10B As shown here the viewer is led to all sections of the picture. No particular area becomes waste space.

7-10A The body and legs lead the eye to the center of interest and the poor general condition of the ailing elephant is obvious.

7-11 The inside of the trumpet of the daffodil is definitely the center of interest. Except that the light petals against the dark background demand some attention, there is nothing else of value in the print.

COMPOSITIONAL BALANCE

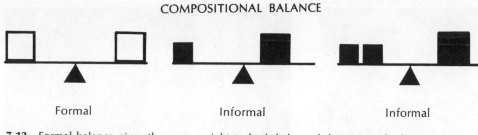

Formal Informal Informal

7-12 Formal balance gives the same weight to both halves of the picture both in subject matter and in darks and lights. For all practical purposes the right half is a mirror image of the left side. Informal balance may place the larger, darker or lighter subject nearer the center to balance a smaller, less weighty subject further away on the opposite side. Or the balance may come from two, three, or more small subjects on one side compared to the largest on the right.

Stonettes assembled by Linda S. Kennedy. Stonettes assembled by Linda S. Kennedy.

7-13 An example of informal balance of three subjects. Compare with the same objects in Fig. 7-14.

7-14 A typical example of less interesting arrangement in formal balance.

ARRANGEMENT OF A NUMBER OF SUBJECTS

Secondary or supporting objects should be placed at a diagonal point from the center of interest. For example, if the center of interest is at "1", an object of less importance that can lead the eye into the picture would be best at "4" (Fig. 7-15).

With more than one object, such as several flowers, use an uneven number. An even number is difficult to arrange in other than formal balance while an uneven number is more easily placed informally to lend greater interest (Figs. 7-16,17).

7-15 The highlights that make lines on the sandbox, the Humpty Dumpty toy, the truck, the shovel, and Jodi's arm lead us to the center of interest, her face.

7-16 The two daffodils really resolve into two pictures. Neither is dominant.

7-17 The three daisies offer informal balance with each observed from a different angle.

Let one subject dominate. If three persons are being photographed, change camera angle or place them to let one be most important. As is so commonly done, lining up all three to look at the camera produces three pictures in one (Fig. 7-18). The viewer is at a loss to decide where to look. If the heads are at different heights with the attention of two toward the third, the viewer is given a point to focus his attention, yet he will see all three (Fig. 7-19).

7-18 Groups of people in static formations present a record of physical features but little else.

7-19A Something of mutual interest tells more about the subjects but fails in this picure. Why?

7-19B The girls' interest in each other as well as origami is immediately evident.

Consider three flowers. Turn one full face, one a three-fourths view and one in profile. Another way would be to use a full blown blossom, a half-opened one, and a bud (Figs. 7-20,21).

With five apples, lay one on its side on top of three standing ones placed to show only one's full side. Partially peel, cut, or bite a piece from the fifth apple and place it to overlay one of the three standing apples.

7-20 The two Kolkwitzia amabilis buds and the one full-bloom blossom form an interesting combination.

7-21 Two full-blown Thalia daffodils with a partially opened one let the viewer see three aspects of the variety in one print.

Immovable objects in a row can be made more interesting by choice of angle to let each one become smaller than the preceding one. Those closest to the camera will appear largest. The repetition of similar but different sized lines adds interest (Fig. 7-22).

7-22A (Below) Repetition of the curves and columns each in different proportion gives depth and pattern.

7-22B (Right) Abstract design of dried hypo clearing solution crystals on a glass plate gives repetition and variety in design.

Photographed by Linda S. Kennedy.

Photographed and printed by George P. Horton.

LINES, DIVISION, CONTOURS

See and be aware of the effects of lines, divisions, and contours within the picture. Line directions affect composition and mood.

1. The vertical line signifies solemnity, dignity, and power. The Washington Monument, a church steeple, and the tall, erect, well-built man present this mood (Fig. 7-23).
2. The horizontal line provides a feeling of balance, quiet restfulness. The pastoral scene, a person lying on a beach, or an animal lying down suggest quietness (Fig. 7-24).
3. The diagonal line gives dynamic accents, a feeling of force, a potential of rising or falling as opposed to balance. The seesaw with one end on the ground and the slide on the children's playground are examples (Fig. 7-25).
4. A zigzag line shows energy being discharged and/or action. Examples are lightning during an electrical storm and the football player running with the ball (Fig. 7-26).
5. A curved line is graceful, with the "S" curve being the most interesting. The ballet dancer with body and arms in gentle curves and sweeping beaches along quiet water are samples often photographed to show graceful curved lines (Fig. 7-27).

Invisible, but suggested lines are often used. This technique is employed when a person is placed in the scenic, looking toward the principal subject in the picture. It can be used between people. Animals are effective for invisible line direction, too.

7-23 Waterfalls show power.

To establish these moods or feelings in a picture requires that the photographer study the subject to decide what he wishes to show. Usually there will be a combination of lines. It becomes a question of which ones are to dominate, to obtain balance while limiting the subject or subjects and thus determine the angle from which to photograph.

7-24 The polar bear stretched in nearly horizontal lines demonstrates restful repose.

7-25 The tilt of the sailboat's mast and the diagonal shroud lines portray action.

7-26 The zigzag lines of the ski poles, the skier's body, the skis, and the shadow all show action and energy being expended.

Lines extending to the edge of the picture on the lower half of the left side or from the left one-half of the bottom provide a lead-in that guides the viewer's attention into the picture. Avoid lines from the exact corner. A short distance either side of the lower left corner is excellent (Figs. 7-28,29).

Lead-in lines for the scenic may be shadows from the subject, a path or tracks of a person, an animal or a vehicle in snow, sand or dirt. The lead in may be a person or animal on the left looking into the scene to give the invisible line (Fig. 7-30). In portraits of people, consider a shoulder line to the face, a drape of the garment worn by the subject. There are innumerable ways to create or utilize existing lines as lead-ins.

Provide a stop for strong lines going out the top or the right side of the frame if at all possible. Lines extending to the right edge or to the top lead the eye of the viewer away from the picture. A "stop"

7-27A (Above) This composition illustrates a "C" curve with the beach line. Notice the reeds and grasses fill in the water where little detail of interest is otherwise registered.

7-27B (Right) The tree starts the line, which then follows the shore-line to complete the "S" curve.

7-28 The rope from the exact corner tends to give a less interesting lead-in than Fig. 7-29.

7-29 The lead-in line of the rope from the bottom gives a better entry into the picture than in Fig. 7-28.

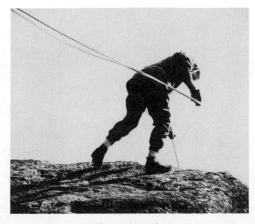

Photographed by Frank W. Shaver.

Photographed by Frank W. Shaver.

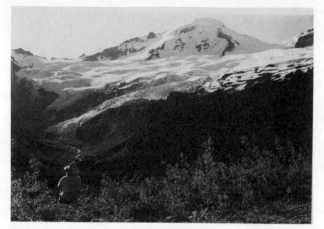

7-30 The rim of light on the person combined with the river moves the viewer's eye along the glacier and over the view of Mount Baker. Foreground subjects give perspective and a feeling of depth.

in this situation refers to a cross line or object to redirect the viewer back into the picture. Even a darkened or shadowed portion of the object can stop the eye (Figs. 7-31–33).

Tree branches on the right make an effective stop. A part of the tree with ground for it to grow should be included. Branches without a possible attachment are referred to as crocheting (lace) by some photographers and they consider this very undesirable (Figs. 7-34,35).

Archways, doorways, and buildings are good stops. Let the road or path disappear over or around the hill. The stream or river can be photographed at an angle to let it vanish around the bank.

7-31 The tree near the middle divides the view into two pictures. There is no base for the tree to grow, no stop to keep the eye from going out the top of the frame.

7-32 Back up wih the camera or tip it down a few degrees to give a base for the trees and shrubs. Some foreground interest for perspective and to unite the elements improves the results, even though the center tree still is not provided with a stop.

Photographed by Frank W. Shaver.

7-33A There is no lead-in from the left, except a small dim one from the bottom with a strong line out the right on the shoulder and arm. However, the cuff provides a stop for the hand and wrist.

7-33B With a change in the angle of light, composition is stronger to make a character study. The shadowed areas hold the attention within the portrait.

7-34 The tree acts as a stop for the bridge and as a place for the leaves to be attached, though the actual connection is not shown. The tree and shrubs have sufficient base to grow.

7-35 The willow leaves have no visible reason for being, even though they do break up an empty sky. Some foreground orientation with a tree trunk and ground could have saved the feeling they were hung from the sky or surreptitiously held in front of the camera.

LINES, DIVISIONS, CONTOURS 183

Photographed by Neil W. Momb.

7-36 The lines of the wire fence lead to the girl, who looks at the reflections, all directing the viewer's attention to the center of interest. The wires alone would lead the eye diagonally out of the picture without a stop.

Have a person sit on or stand by the fence at the right side of the picture (Fig. 7-36). Have him look at the center of interest, not at the camera. An animal can be used, too, as a stop for a fence.

Consider reversing the picture when printing or projecting, if it is impossible to provide a stop for a strong line out the right side. The lines leading out of the picture now become strong lead-in lines. Even turn pictures upside down if they are more effective (Fig. 7-37). Among pictures that can not be appropriately reversed are:

1. Well-known views that are to be used as record pictures, because it would disorient the viewer.
2. People with buttoned or lapped jackets and coats. Women's and girls' coats lap from right to left, men's and boys' overlay from left to right.
3. Activity or items that identify as right or left (Fig. 7-38). Pictures with printed or written signs or names.
4. Vehicles with steering wheels on a specific side.

Place lines that tend to divide a picture in a one-third, two-thirds proportion rather than half and half. This guide applies to all pictures, whether the format is vertical, horizontal, or square, and to all dividing lines whether they are diagonal, horizontal, or vertical.

A seascape would be an example for the application of this guide. If the horizon is placed in the halfway area, then each portion seems an independent picture with neither half lending support to the other part. The viewer should know immediately whether the photographer intended him to see the cloud formation or the pattern of the waves (Fig. 7-39). If the water consumes two-thirds of the picture, the waves are more important and the clouds are supplementary (Fig. 7-39). If

Photographed by Neil W. Momb.

7-37 The water reflection takes on an entirely different feeling when turned upside down. Turn the book around to see.

184 GUIDES TO COMPOSITION

7-38A With Jodi at the extreme left of the picture, the right half seems lost space.

7-38B The composition is greatly improved when the negative is reversed to print, but Jodi is shown left-handed, which is not true. For general display, this is not a particular disadvantage because many children are left-handed. If the picture is made specifically for parents or other relatives, they might properly object.

Photographed by Mark McCann.

7-39A (Above) With the horizon at the center area, there is conflict in deciding what the photographer wished the viewer to see.

7-39B (Right) With the division one-third, two-thirds, the water takes on more importance.

Photographed by Frank W. Shaver.

7-40 When the mast divides diagonally, there are two relatively even divisions, yet the right side does not have sufficient interest to merit half the print. Compare with Fig. 7-25.

the clouds occupy two-thirds, the water certainly is of less importance. Additional subjects may add to or even supersede the water and clouds; yet the horizon should be placed in the one-third, two-thirds position.

Vertical lines are best in a one-third, two-thirds division (Figs. 7-5,6). Informal balance can be achieved more easily. Diagonal lines, too, make it a half and half situation when they come into or out of the picture at a corner (Fig. 7-40). Shift the diagonal on the left away from the corner and provide a stop on any diagonal line going out of the picture on the right, to emphasize the principal subject (Fig. 7-25).

INFLUENCE OF FORMAT

The format affects the mood of the picture:

1. A rectangular, horizontal frame conveys a restful feeling. It is ideal for the peaceful, reposeful subject, such as landscapes and pastoral scenes.
2. A vertical rectangle emphasizes dignity and strength. It is appropriate for portraits of individual people, statues, tall buildings, stately trees, and mountains.
3. The square format portrays bulk or massiveness. It is suitable for the stocky, sturdy subject if the photographer wishes to accent this characteristic. For most pictures, the square format is the least interesting.

With the camera that takes a rectangular picture, the photographer must consider his subject before he photographs it to decide which format is most desirable. Especially, he needs to remember that he *can* turn the camera to make a vertical format. Beginning photographers often forget this can be changed when the picture is printed, also (Fig. 7-41). This versatility is one of the advantages of the square negative. It has the possibility of a rectangle (vertical or horizontal) or of a square format when the print is made.

If the subject needs a different format, either vertical or horizontal, the square *slide* (transparency) becomes a problem. For the square 126 film and 35mm color slide, there are available mounts and masks in various shapes and sizes to change the effect. (Chapter 4, Processing Color Film.) For the 2¼ x 2¼ square, there is little alternative.

SPACE FOR SUBJECT TO MOVE

Leave space in front of all live subjects and moving or movable vehicles and craft to provide apparent space for them to see and/or move. More space should be in front than behind to avoid the feeling the subject is moving out of the picture (Fig. 7-42). To judge

7-41 The animal's rapid movements did not permit a change to a vertical format but the print was made so. Color slide photographers can use the half-frame mounts available at camera stores.

the best proportion, determine in the viewfinder the point at which the subject appears to be going out rather than coming into the picture or is up against a blank wall. Leave at least a bit more space beyond that point in front of the object or person. It is a problem in proportion.

The subject in motion is relatively easy to frame if it is moving toward or away from the camera, perpendicular to the film plane (Fig. 7-43). When the movement is diagonal or parallel to the film plane,

Photographed by Mark McCann.

7-42 The magnificent animal seems to be leaving the area. Lay a paper across the right one-third to one-fourth of the picture to see a better frame.

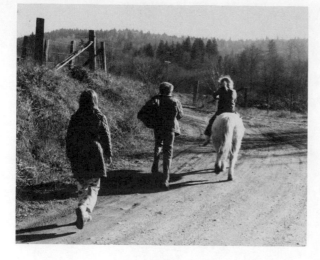

7-43 Movement away or towards the camera is not difficult to keep in desirable position in the frame.

framing is more difficult. Speed and near distance to the subject may add further complications. For these, consider panning the camera, which is moving the camera to follow the subject as the shutter is tripped. This is an excellent method of conveying a feeling of action because the background will be blurred from the camera movement and the subject will be sharp if focus and panning are well done (Fig. 7-44).

A relatively slow shutter speed of 1/30 or 1/60 of a second accents the background blur and thus suggests speed. The panning camera can be tripod mounted or hand held. In either event stand still and turn the body or tripod handle smoothly with just sufficient move-

7-44 The motorcycle on rough terrain registered blurred motion vertically as well as horizontally but the rider's face is sharp. Notice blurred background. Camera panned and shot at 1/15 second shutter speed.

ment to frame the subject as desired. Trip the shutter at the most opportune moment. Continue to pan as the shutter is tripped.

REPETITION OF LINE, DESIGN, COLOR

Repetition in line or design, gray tones or color can make a picture stronger and increase interest, or it can be monotonous. The result achieved depends on the way it is done. Repetition, skillfully executed, provides rhythm. If repetition gives different proportions of each line or color by angle of view, it often creates beautiful design (Fig. 7-45). Avoid approximately half and half of two colors or two gray tones in black and white photography. A varied proportion of one-third of one and two-thirds of the second is more interesting. A one-fourth, three-fourths proportion may be still better.

Fill the frame. Except for the occasional special mood picture, it is a waste of film to have extensive areas of blank sky, patternless water, or background areas that add neither atmosphere nor detail. If clouds or foreground objects are not available, lower the camera angle by tipping it downward to reduce the sky portion. Completely eliminate the sky, unless it is necessary for the picture. Reflections in water or foreground subjects will yield detail in water.

LIMITATION

Limit the surroundings and accent the center of interest. Simplify! This can be accomplished in one or a combination of several ways:

1. Physically move the camera closer to the subject.
2. Use a telephoto lens.
3. Utilize various close-up equipment for small subjects.
4. Crop in the printing process.
5. Crop the transparency with appropriate mount or mask.

Each of the methods has limits within which they will work; therefore, it is necessary to understand which ones can be used in a given situation.

The closest distance the camera may be to the subject is determined by various factors. Some are danger to the camera operator and/or his equipment, such as rough terrain, fire, water, traffic, people, wild or vicious animals; and of subject moving out of camera range, i.e. timid or self-conscious people, wild creatures. Barriers restrict the cameraman or use of the camera. Cliffs, bodies of water, mud, walls, fences, cages, and inaccessible space prevent the close approach to many subjects. Social restrictions of institutions and/or good taste are other obstacles. Courtrooms, museums, theatrical performances, and religious ceremonies have rules governing pictures taken within their

7-45 The similar subjects in the picture hung on the wall repeated in the balance of the print plus repetition in the background paneling, the piano keys, and the bars of music all provide a striking composition.

jurisdiction. If not, good taste should and often does restrict the closeness of the camera to the subject. With the versatility of cameras and film on the market today, there is no excuse for the rudeness of persons using flash, moving around during performances, and disturbing others in their enjoyment of or concentration on the program.

The nearest point at which the camera lens will focus further limits moving in close. It is impossible to get a sharp picture at eighteen inches with a lens that will give acceptable focus at no less than three feet, without the use of supplementary equipment. If the lens or camera does not have a focusing scale, most leaflets that come with cameras and/or lenses indicate the closest distance that is practical. Every camera owner should know the near limitation of his lens.

The possibility and amount of distortion that can be tolerated must be considered. Distortion occurs when the camera lens is too close to the subject. This causes the closest areas to appear abnormally large and sometimes yields a twisted appearance (Fig. 7-46). This may be a distinctive addition to one subject but totally unacceptable in another situation (Fig. 7-47).

Cameras and their lenses vary in the amount of distortion they produce at given distances. It depends on the focal length of the lens compared with the negative size. (Chapter 10, The Camera Lens.) Other factors involved are the depth of the subjects and the distance from lens to subject (Figs. 7-48,49). For the 35mm camera, there is a general rule in portraiture of people that a normal lens (45mm to 58mm) should not cover less than three-fourths of the height of a normal-sized adult in order to avoid the chance of distortion. Wide-angle lenses (shorter focal length) create unpleasant distortion more often than do longer focal length lenses, which are telephotos (Fig. 7-50).

More distortion is tolerated and may even be desired in pictures of animals or inanimate subjects. Architecture can be more striking often with some distortion in the picture.

Telephoto lenses are available for many cameras and offer opportunity to tighten the composition without being as close to the subject. Telephotos give a type of distortion, too, in that they compress distance perpendicular to the film plane until objects or people appear abnormally close together. A subject may be given a flattened appearance with a telephoto (Figs. 7-51,52). As with the different type distortion of the shorter lens, this may or may not be desirable.

Close-up photography can be accomplished with any camera for exciting results. Equipment varies with the type of camera and/or lens. The largest assortment is available for the single-lens reflex camera with interchangeable lenses. This is more fully explored in Chapter 10, The Camera Lens.

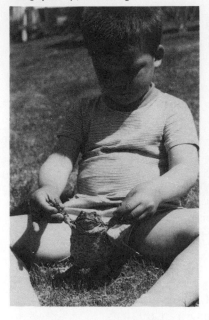

7-46 (Above) The hands, legs, and toad are overly large because the camera was so close to the subject.

7-47 (Right, top) The hands, face, and toad appear abnormally large while the feet and legs seem diminutive when the camera angle is changed. Even so, that is a *big* toad!

7-48 (Right, center) Another approach is used, but again distortion is present.

7-49 (Right, below) Camera distance is the same but the angle of view provides more pleasant proportions in the subject.

Photographed by Neil W. Momb.

7-50 An extreme wide-angle (Fish-eye) lens gave abnormal size and shape to Wendy's clogs, feet, and legs as well as the dune buggy. Compare with Fig. 6-43 taken with a telephoto lens.

A second chance to improve the composition is available when the enlargement is made by the way it is cropped. Often, this gives the opportunity, also, to make several pictures with very different moods and effects from one negative.

To decide where to crop a picture, study the contact print or enlargement. Cut two "L" shaped pieces of paper large enough to cover both dimensions of the print. Move the "L's" until they enclose the desired composition (Fig. 6-9).

To crop the transparency, there are multiple standard-size masks and mounts that may be used for the 35mm size and some are suitable for 126 slides. In severe cropping of 127 transparencies, the standard 126 or 35mm mounts can be used if they make the desired composition.

Dozens of formats, made especially for the 35mm slide, are available both in masks (for mounting between glass) and in cardboard mounts. With both the masks and mounts, the original mount that came from the processor is removed and the film remounted in the selected custom mount. (Chapter 4, Color Processing.) Another method of cropping can be used for the slide. The slide may be duplicated to the desired format with close-up equipment or photographed from a projected image on a white matte screen, preferably with a telephoto lens. Mat the print to cover undesirable portions or bleed the print. It is trimmed to better dimensions leaving no borders.

While stress has been on "moving in close," there most certainly are subjects for photographs that require much space surrounding

7-51 With a normal lens, the building in the background is hardly discernible and appears to be at considerable distance from the picnic shelter. Compare with Fig. 7-52.

7-52 A telephoto lens pulls the building up just a short distance beyond the same picnic table!

them to establish the mood the photographer may wish. Additionally, a subject may need a base on which to stand to avoid the feeling it may topple toward the viewer (Fig. 7-53). This guide applies to people also. It must be the photographer's decision to move in close or to provide a more distant perspective.

7-53A (Below) The Firebell tower at Port Townsend, Washington, has insufficient base for the height of the subject.

7-53B (Right) A vertical format gives sufficient base but the trees have no trunk or ground on which to grow. Moving the camera back further brought in power and telephone wires that would spoil the composition.

FOREGROUNDS AND BACKGROUNDS

Mess and clutter can be cleaned up if not too extensive. A change of camera angle up, down, or sideways can sometimes reduce its effect (Fig. 7-54). Consider throwing the objectionable area out of focus (Fig. 7-55). (Chapter 11, Depth of Field). Telephone and power lines and the support poles ruin many otherwise excellent pictures.

Foregrounds should usually be sharp. Backgrounds may range from sharp to so soft that they cannot be identified, as best suits the picture (Fig. 7-56). Mergers can be avoided by change of camera angle, moving the subject, and by depth-of-field control. Some mergers can be used advantageously to give emphasis to the picture (Fig. 7-57).

Lights and bright reflections from glass or metal objects sometimes may be used to guide the viewer's eye to the principal subject. In some cases, reflections can be subdued or eliminated by a polarizing filter. (Chapter 15, Filters.)

PERSPECTIVE AND/OR ORIENTATION

Foreground subjects can give perspective and orientation. A portion of an airplane wing, an engine pod, the stern, bow or boat railing, or a dock can orient the viewer as to the position of the camera. Beware of barriers that keep the observer from mentally getting to the picture. Boat railings offer visual security from falling overboard; however, don't let the boat railing follow a level horizontal line across the

7-53C Probably the best choice is the horizontal format with a good base for the tower and the trees.

7-54A The TV and surroundings detract from the subject, the child and dog.

7-54B A change of camera angle a few feet away simplifies the picture to strengthen the relationship of child and dog.

7-55A (Far left) The lens hood of a 135mm lens was centered over and against the crossbars of a chain link fence, but because it was so close to the camera, the wires are out of focus sufficiently to just give a slight shadow and blur. The longer the lens, the larger the aperture, and the more distant the focus, the less close-up areas affect the image.

7-55B When the picture is cropped to eliminate the more severely blurred areas, the fence is less noticeable. If the lens had been centered over an opening in the mesh, the blurring would have been still less distracting.

7-55C With the animal close to the fence there is no possibility of throwing the fence out of focus sufficiently to prevent its interference.

7-56 The background and foreground all in soft focus illustrates Mr. Pyle's hobby without intruding.

7-57A Common mergers are the telephone poles set atop people's heads. Here Candy seems to have both a shrub and a house resting precariously on her head. Compare with Fig. 6-33, taken no more than 20 feet away.

7-57B (Below right) This merger speaks for itself.

7-57C (Below) Another merger.

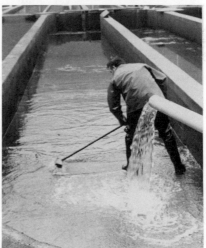

picture. Place the railing at an angle to lead into the view. A fence all the way across the front of a picture may stop the eye from getting into the view beyond. Provide an open gate, a stile, or place the fence at an angle so the observer feels he can get over or around the obstruction.

VARIETY AND CONTRAST

Variety and contrast are qualities of good pictures. Avoid busyness but have variety. Every photograph should contain:

1. Contrast in texture, something coarse and something fine.
2. Contrast in temperature, which is most easily obtained in color photography. Water is cool, fire is hot; snow is cool, sunshine warm. In color, the warm colors range from red-purple to yellow-green and the cool colors from green through blue-purples (Fig. 8-4). A small bit of warm color in an all cool color scene accents the cold and the reverse is true.
3. Contrast in light and dark gives accent to the picture. This can vary, according to the subject matter and desired mood, from very high contrast to very low. Contrast is essential in both black and white and color photography.

PORTRAITURE

Composition in portraiture of individual persons and animals uses more specific guides based on the points already covered. In making portraits of individuals, it helps to remember:

1. The eyes are the center of interest and should fall one-third of the vertical distance from the top of the picture (Figs. 7-58, 59).
2. There is a feeling of space for the subject to look, if the nose is about the center of the picture horizontally (Figs. 7-58, 59).
3. The camera is placed approximately eye level with the subject unless special effects are desired.
4. For portraits of individual persons, show only one ear with no more than a portion of the other ear.
5. Crop legs or arms, one-third or two-thirds of the way between hip and knee, knee and ankle, shoulder and elbow, or elbow and wrist, never at a joint or a halfway point.
6. If the wrist is included, have the whole hand in the picture. This same guide applies to the ankles and feet, except the feet must be given a base on which to stand.
7. Choose the most photogenic angle for the subject. Usually, people have one side that photographs better than the other.

7-58A Mary seems about to bump her nose. The eyes, the center of interest, are too low in the picture. She appears to almost slip out of view.

7-58B If it places the eyes and nose in more pleasing composition, do not hesitate to crop a portion of the head.

7-59A Suppose the photographer had hesitated because of the background. The moment would have been lost.

7-59B Cropped, the background is most unobtrusive, the picture strong.

7-59C The two make a sequence story of the photographer's son. Family pictures perhaps are treasured most of all.

They may or may not be aware of this. The photographer should observe the possibilities and proceed accordingly. If the subject should point out a defect, the photographer must take corrective action. Change the angle of camera or lighting to minimize the problem.

8. Create an air of alertness with the subject's body at a 45° angle to the camera, the face at another angle and the eyes looking in a third direction. Watch for too much white of the eyes in comparison to the darker portions. It is permissible to photograph ministers, priests, presidents, and comparable officials with the body squarely facing the camera.

9. Be alert for unattractive features or flaws and minimize them with make-up, by camera angle, or by direction of lighting. In black and white photography, filters can offer additional correction. Direction of lighting and use of filters are discussed in subsequent chapters. Some of the problems that camera angle can aid are:

 a. The long neck benefits from a slightly higher camera angle.
 b. A short neck is given apparent length with a lower camera angle.
 c. The thin face can be taken full face and lighting influences the results, too.
 d. The round face is flattered by a three-fourths or seven-eighths view, even a profile if there is not a double chin. Lighting must be considered.
 e. A Roman nose is less pronounced with a full face picture.
 f. The cosmetic companies sell several shades of products that can be used effectively in covering skin blemishes.
 g. The droopy eyelid or defective eye with an obvious flaw is less noticeable if posed away from the camera.

10. Some techniques that aid in good portraiture are:

 a. Anticipate and watch for characteristic facial expressions. The face and eyes are mobile. The camera captures only a fleeting instant. The mood created by a subject's expression can overcome many compositional faults. The best composition never compensates for an inappropriate expression.
 b. When photographing people, ask the subject to shift the body, head, hands, or feet into the desired position, but beware of unnatural or artificial placements. *Do not physically touch or move the subject into position.* To do so instantly creates stiffness, if not outright opposition. Even small children should be maneuvered by means of directions or toys, rather than twisted or turned by the mother

or others. Keep the atmosphere friendly and encouraging. The subject must be relaxed if a characteristic expression is to be achieved. Shooting a few frames that may be less than desirable, expression-wise, will sometimes help the subject to relax. Another ruse can be to continue conversation with the subject while apparently fiddling with equipment but all the time watching for the opportune moment.

 c. For the ham actor, the photographer can waste several frames until the subject tires of the game. An alternative is to use an empty camera until the subject is calm and then pick up a loaded camera or put in film.

It has been said in various ways throughout this chapter that spacing, timing, and lighting affect composition. The purpose of the photographer in making the picture, as well as the subject and its surroundings, will determine which guides can be applied effectively. *Never* miss taking a good picture just because the composition is less than perfect (Fig. 7-59).

As the reader makes pictures, critically studies his own and the photographs of others, the guides soon are used automatically to produce the desired results as he frames the subject in the viewfinder and trips the shutter release.

Previous chapters have indicated the photographer must "see" a picture before it will be successful. Not just look at it, but see it in the sense that he has a definite emotion concerning the subject. If the finished picture returns him to that mood, he has a good picture. When many other people feel the same sentiments, as they view the photograph, then he has a great picture.

The composition of every picture is most definitely affected by the direction of lighting which is explored in the following chapter.

REFERENCES FOR FURTHER READING

Falk, Edwin A. Sr., and Charles Abel: *Practical Portrait Photography for Home and Studio*, New York, Amphoto, 1967.

Feininger, Andreas: *Principles of Composition in Photography*, New York, Amphoto, 1972.

Jonas, Paul: *Guide to Photographic Composition*, New York, Amphoto, 1961.

Theisen, Earl: *Photographic Approach to People*, New York, Amphoto, 1966.

CHAPTER 8

Light

Light reflected from the subject to the light-sensitive film is the basis of photography; therefore, some light must be present to expose the film when the shutter is open. Explore light to understand the ways in which it affects the image in a picture.

SOURCE OF LIGHT

Light may be natural, as with the sun, the moon, and the stars. Artificial light is supplied by electrical devices such as mercury vapor lights, incandescent lamps or flashcubes, or by other sources such as natural gas lamps, gasoline or kerosene lanterns, even open flames such as candles, matches, or campfires.

Available, natural, and existing light are terms that are used interchangeably to indicate light situations which are normal for the locale, such as a room, a stage, or a gymnasium in which no additional lights are added specifically for picture-taking operations. When pictures are made by existing light, no flash is used.

Incident light is the light that falls on the subject, whether it shines directly from the light source or reflects onto the subject. In order for the eye to see or the camera to record the image, light must reflect from the subject to the eye or the light-sensitive chemicals on the film. If no light is reflected from the subject, there can be no picture unless the source of the light is the subject photographed, such as the lantern, the street lamp, or the moon.

Many a casual snapshooter with an adjustable camera fails to recognize the potential of his camera and so depends on only two sources of light, sunshine or flash lamps or cubes. It is true that low light levels limit the use of box cameras. Pictures can be taken with many automatic adjustable cameras without flash in much lower light levels than the owners realize. The manually adjustable camera will make a picture if there is *any light* (Fig. 8-1). It may not be the picture desired, but an image can be obtained. Often it is superior to one made with flash.

With the cameras and films available today, the knowledgeable photographer need never say, "There wasn't enough light to take a picture," or "There was too much light." His statements will be, "My camera (or film) would not take the picture at that light level," "My

equipment would not take the picture that I wanted," or "I over-exposed the picture."

CHARACTERISTICS OF LIGHT

The source of light is only one element to be considered. Other characteristics of light that affect the finished picture are:

1. Intensity
2. Contrast
3. Color

Intensity

Intensity of light can be defined as the brightness or quantity of light, which is measured with a light meter in units of candlelight power (foot-candles). Not all light meters give readings in foot-candles. Automatic built-in meters simply set automatically the shutter speed or aperture.

Contrast

Contrast of light is determined by:

1. The distribution of the light sources and their placement in relation to the subject. If lights from all sides are directed at the subject, the contrast will be low. With lights from only one side, light will be of higher contrast.
2. Diffusion materials between the light and the subject. Frosted glass, translucent plastic, fog, haze, and clouds are examples of substances that reduce contrast.
3. Reflective surfaces around the subject. White or light walls, pavements, stucco building, sand beaches, and snow reflect light to reduce contrast.

Contrast is easiest to evaluate if one looks at the shadows. Sharply defined, very dark shadows indicate high-contrast light. Soft or indistinct shadows indicate low-contrast light, called flat lighting.

Black and white film needs contrast to a greater degree than is required in color photography because the variation in gray tones is the way detail is shown. Color requires less contrast, in general, because different colors give separation of detail and too much contrast changes color in the shadows and in the highlights.

To estimate the contrast effect on film, photographers close one eye and squint the other. This eliminates many of the shades that the eye normally sees and approximates the film's capacity to record. Film varies widely in this respect, so familiarity with the individual film improves the picture-taker's ability to estimate the final result.

8-1 The candle provided the only light.

Images which are dark overall with only a small portion in light tones are low-key pictures. Those with all light tones except for the principal point of interest are high-key. Any picture can be printed very light or dark under the enlarger, or overexposed or underexposed on positive films, but this is not the technique usually employed for high-key or low-key work. The subject and the light along with the exposure and printing are all teamed for the most effective results. Usually rather light-tone subjects are flat lighted if the high-key picture is desired. The darker subjects are illuminated with higher contrast with special highlights on the center of interest (Fig. 8-2).

Color

Light is made up of the visible spectral colors: violet, blue, green, yellow, orange, and red (Fig. 8-3). Of these, red, blue, and green are the principal colors. The varying proportions of these three make all colors of light from the distinct blue of the mercury vapor light to the yellow-orange of the sodium vapor lamp. In between these two extremes are the white light of the midday sun and the many shades of yellow of incandescent lamps (Fig. 8-4A). Then there is the rosy glow just before sunset followed a few minutes later with the gray-blues of after sunset.

Because the human eye compensates a great deal, the casual observer is not aware of the extent of variations in the color of light. The common assumption is that all light is white. This, as can be

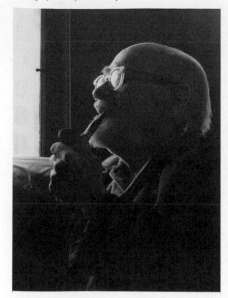

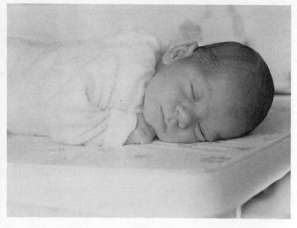

8-2A (Left) Low key is principally dark tones with a small proportion of light tones.

8-2B (Above) High key is very light tones with a bit of dark for contrast.

quite easily seen, is far from the truth. At night, look out the window to compare the mercury vapor street lamp with the incandescent light in the neighbor's window; or at midday turn on an incandescent light and look from it to the out-of-doors light and back again.

Since neither the film nor camera has a brain to aid it in compensating, photographers must understand how to get the results they wish. Black and white film offers less problem in this area because its images are in shades of gray. Primarily, with black and white, it is only a question of degree of sensitivity of the film to the various colors. Most black and white films in general use are sensitive to all colors, and so present minimum concern.

REFRACTION OF DAYLIGHT

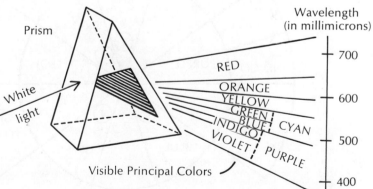

8-3A White light breaks up into these visible spectral colors when it shines through a prism.

Some basic knowledge of the control of the color of light is imperative for the color photographer to forecast results.

Color films are made more or less sensitive to blue to make these adjustments. It is necessary for the manufacturer and the photographer to have some common basis of comparison to balance the film for the light. The scale, called color temperature, is measured in degrees Kelvin (°K). This does not refer to an actual temperature, as temperature of atmosphere or liquids, but to the method by which the scale was devised. The °K is based on the color glow of metal at various degrees plus 273°. As metal is heated it first glows red, then orange, yellow, white, and finally blue at its hottest.

The color temperatures of some of the light sources commonly used for photography are:

	°Kelvin
Clear blue sky	9000
Electronic flash (varies with the brand and/or model)	6500
Blue flashlamps	6000
Sunlight (10:00 A.M. to 2:00 P.M.)	5500
Photoflood lights	3400
Studio floodlights	3200
Household incandescent lamps (vary with wattage)	2700
Candlelight	1900

Visible Spectral Colors

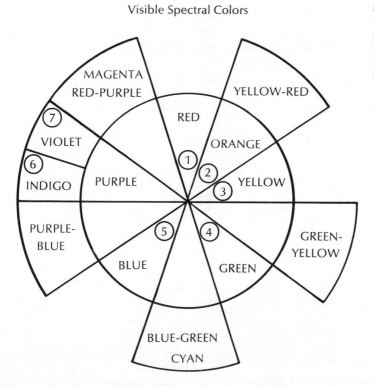

8-3B The relationship of the colors one to another are easier to understand when placed on a color wheel. In color photography, magenta, cyan, and yellow are the principal colors used in the subtractive system. Red, green, and blue are the principal colors used in the additive system.

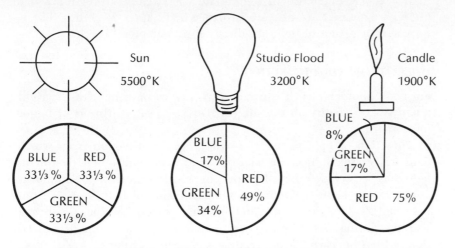

8-4A Light varies widely in color content. These are three representative samples.

8-4B Visualize the complementary wedges rotated around the color wheel. Colors opposite each other are complements; in equal quantities they make gray or white light. Split complements in equal parts make white also. The warm colors and cool colors are shown in relation to the color wheel of Fig. 8-3B.

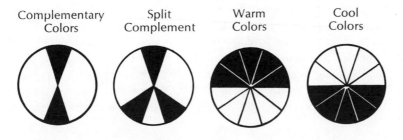

The lights with lower °K readings are termed warmer. Those lights with higher readings are called cooler (Fig. 8-4). These, obviously, are exactly opposite of the actual temperatures.

A color temperature meter is used to identify color temperature when very precise color control is needed. The color meter is an expensive piece of equipment and seldom used by the casual photographer. However, by being aware of the color temperatures of basic lighting situations, and the color temperatures for which film is balanced, the knowledgeable photographer does know what to expect or

how to compensate. Normally, the human eye is not sensitive to less than a 200°K difference in light. The color temperatures for which films are balanced are discussed further in Chapter 14, Films. Filters for correcting color of light are discussed in Chapter 15, Filters.

DIRECTION OF LIGHTING

For good photography, it is not enough just to have light of the right quantity and quality on the subject. Direction of lighting is of major importance.

Direction of lighting refers to the angle or direction from which light strikes the subject in relation to camera position. Direction of light has a very definite effect on the resultant picture. Commonly used terms to identify the main source direction of light are: (1) front lighting, (2) sidelighting, (3) backlighting, (4) top lighting, (5) low or bottom lighting. Let it be said at this point, there is no one *best* direction of lighting; each has it advantages and disadvantages.

Front lighting occurs when the principal light on the subject is from a source at or behind the camera position. A picture taken with a flash on the camera is front lighted. The same is true of a picture taken in sunlight when the sun is behind the photographer. Shadows in the front-lighted picture fall away from the camera and beyond the subject (Figs. 8-5–10).

Sidelighting is the term used when the main light strikes the side of the subject as viewed from the camera position. Shadows fall away from the subject on the side opposite the source of light (Figs. 8-11–16).

In backlighting the primary light shines toward the camera position from behind the subject being photographed. Often, this is referred to as rim lighting because of the halo effect. Shadows fall between the subject and the camera (Figs. 8-17–22). Notice that Fig. 8-17 is a floor pattern. If the primary light source is much brighter than lighting or

FRONT LIGHTING

8-5 Light strikes the subject from the same direction the camera takes the picture.

8-6 Photoflood front-lighted styrofoam shows no more depth or form than would white pieces of paper cut in these shapes.

8-7 Front-lighted lily lacks depth and modeling. The green leaf scarcely shows.

8-8 Flash front-lighted Sandy throws distracting shadow on background.

8-9 Sunshine front light yields a poor portrait of Carol.

8-10 (Far right) Without the darker stains in the recessed areas, the driftwood modeling would be lost entirely with sunshine front light.

SIDELIGHTING

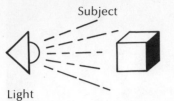

Subject

Light

Camera

8-11 Sidelight comes at right angles to the camera lens.

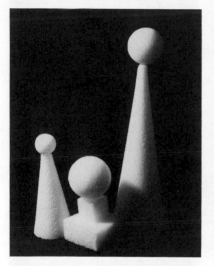

8-12 Sidelight gives form and texture.

8-13 Form, depth, and texture are increased with sidelight. The leaf is more evident.

Driftwood sculpture by Ruth Arnold.

8-14 Depth of the chest is portrayed as well as texture and modeling with sidelight.

8-15 (Far left) While texture and depth are recorded, the sidelight shadows detract severely.

8-16 (Left) New aspects of the driftwood are shown with sidelight.

BACKLIGHTING

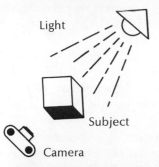

Light

Subject

Camera

8-17 Backlight shines toward the camera.

8-18 Roundness, depth, and rim light combine to show conformation. What causes the center cone to be lighter?

8-19 Photoflood backlight (plastic lighting on translucent subjects) shows texture or veining within the petals.

Driftwood sculpture by Ruth Arnold.

8-20 Flash backlight with a reflector accents Sandy still differently.

8-21 (Far left) Sunshine backlight with reflector gives modeling without harshness for Carol.

8-22 (Left) Sunlight back of the driftwood with a reflector provides modeling of different surfaces.

reflected light from other directions, it will be a higher contrast picture. High contrast means there will be very dark areas and very light areas with few in-between gray tones. If of sufficiently high contrast, the subject will go in complete silhouette (Fig. 8-29).

Top lighting refers to a light source above the subject so that the light is most concentrated on the top of the subject. Shadows fall immediately below the objects involved in the picture. A picture taken at midday in the sunlight would demonstrate this type of lighting (Figs. 8-23–28).

Low or bottom lighting, like the other terms, is self-explanatory. The primary light comes from very low or below the subject. Objects on a glass table or counter with the light source directly below would demonstrate bottom lighting. Figs. 8-30–33 illustrate low front lighting.

Forty-five degree lighting is a term applied to the light source that is halfway between side and front lighting and above the subject at a 45° angle.

A combination of two of these terms may be needed to describe the lighting direction used in a picture. If the sun were high in the sky and at the same time to one side of the view, it would be a combination of top and side lighting. Other combinations might be low front lighting, low backlighting, top front lighting, low sidelighting, 45° front lighting or 45° backlighting.

Simply learning terms used in describing directions of light is of limited value. Comparison of different directions of light on the same subject shows the effects each produces. It is exciting to experiment with direction of light on favorite subjects. Frequent reference to the illustrations will aid in understanding.

Front lighting

The advantages of front lighting are:

1. Front lighting seldom produces lens flare. Lens flare is caused by light striking the camera lens directly, causing a foggy or smoky appearance on part or all of the picture. With color film, lens flare may range from a white flare to yellow, orange-red blurs. The image on film is produced by light reflected from the subject, not by light from its source.
2. Attaching a flash to the camera may be the simplest way to get light onto the subject in low light levels. Flash is often used in candid or action photography inside buildings or at night.
3. In portraiture of people, front lighting tends to broaden the thin long face, which may be more flattering.
4. Front lighting of portraits lessens skin blemishes such as wrinkles, pimples, or pits caused by acne. Front lighting tends to flatten out any texture or modeling. The extremely high

Sunlight

Camera

Subject

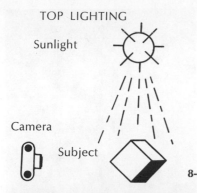

8-23 Light above the subject.

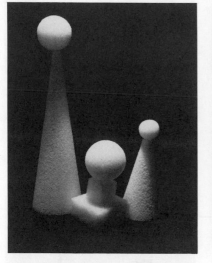

8-24 The styrofoam shows texture and quite different dimensions.

8-25 Compare the top-lighted lily with its other lightings. Which is best?

Driftwood sculpture by Ruth Arnold.

8-26 Electronic flash top light varies in its effects from any of the previous pictures of Sandy. Choose the most interesting.

8-27 (Far left) Sunshine top lighting causes contrasting dark shadows that are most unflattering for many subjects, especially people.

8-28 (Left) Top light diminishes much of the fine artistry of this driftwood. Which direction of light shows it best?

8-29 Backlight without a reflector; compare with Fig. 8-20.

8-30 Low front light shows other modeling. Compare with the effects of other directions of light.

8-31 Sandy's shadow adds nothing to the picture with low front light.

Driftwood sculpture by Ruth Arnold.

8-32 Photographers can lose friends fast with low front light portraits.

8-33 Many details on the driftwood are lost with low light.

nose would appear less high with front lighting if taken full face toward the camera. Bald heads or thin hair are accented less with front lighting.

Problems with front lighting are:

1. There is little or no modeling (contour or texture) detail. In other words, it reduces or eliminates the feeling of depth in subject matter. Modeling or texture is desirable when photographing many subjects from the tiniest flowerlet to the majestic mountain.
2. Flash is effective for only limited distances. This distance depends on several factors, namely, speed of film (Chapter 14, Films), flash output, reflective characteristics of surroundings, and amount of existing or available light. (Chapter 13, Flash.)
3. In color portraiture of people or animals, lighting from the front may produce red eyes caused by light reflecting from the inside (retina) of the eye. Red eye occurs most frequently in flash photography.
4. Flares in eyeglasses are another similar problem that can be distracting.
5. Front lighting often causes the subject, people or animals, to squint in sunlight (Fig. 8-9) or blink in a natural reaction to flash. Both give undesirable effects.
6. Lighting from the front can cause the subject's shadows to fall on backgrounds. Often, background shadows detract from the picture (Fig. 8-8).
7. The photographer's own shadows may be thrown on foreground, an unattractive feature (Fig. 8-34).

Solutions to the problems of front lighting are (first, consider whether another direction of lighting is possible):

1. If flash is necessary, can it be raised above the camera by means of an extension cord between flash and camera? Six inches can help. Two or three feet off the camera improves the texture and modeling still more. The amount of improvement depends on the area covered in the picture. (Chapter 13, Flash.)
2. When using flash, consider aiming it at a reflective surface such as a light ceiling, a light wall, or other similar area. The light from the reflective surface lights the subject. This is called bounce flash. It then becomes diffused top lighting if a ceiling is used. A wall may cause it to be a 45° lighting half way between side and front lighting. In these two instances, a flashgun with a tilting head or off the camera with extension cord is necessary. Another technique that improves the flash-on-camera

8-34 The photographer's shadow in front lighting is seldom effective in a picture.

picture is to work without the reflector on the flash. This is called "bare bulb." All these procedures call for different exposures, explained more fully in Chapter 13, Flash Photography.

3. Red eye and eyeglass flare can be avoided by the methods outlined in "1" and "2" above. If these are not practical for the situation, have the subject look away from the camera during the exposure.

4. Shadows on the background are avoided by moving the subject away from the background if there is sufficient room for maneuvering. Raise the flash above the camera to reduce shadow on background.

5. The photographer's own shadow on the foreground can sometimes be eliminated by changing camera angle, that is, framing above the shadows. Change of angle, to right or left, may aid. If the camera is on a support (tripod, wall, or other stable object), delayed shutter release allows the photographer to move out of the picture area while the picture is taken. (Chapter 9, Understand the Camera.)

6. For nonmovable subjects in daylight, consider a different time of day to improve the lighting.

Sidelighting

The advantages of sidelighting are:

1. Texture and modeling are emphasized (Figs. 8-12–16). The word *modeling*, as used here, refers to the appearance of three dimensions showing roundness and conformation. Shadows cast with sidelighting show modeling. In a high percentage of pictures, this is desirable. The lily and the driftwood are examples of subjects that need maximum modeling. Carol's portrait would be better with less modeling (Fig. 8-15).
2. Sidelight gives a feeling of a third dimension to all subjects that have depth. With many subjects, it is superior to other directions of lighting because of this characteristic.
3. Light from the side is often used in portraits of men to emphasize strength or ruggedness.

The problems with sidelighting are:

1. Deep shadows created by sidelight may be of too high contrast, which accents undesirable texture or causes loss of detail in shadowed areas. This is especially true of color pictures. Extreme contrast may be a problem in many subjects of black and white photography (Fig. 8-15).
2. Texture or too extreme modeling on babies, children, and women is unflattering. Sidelight accents age lines severely. Acne or scars are accentuated by sidelighting and detract from the individual portrait.
3. With sidelighting people or animals still have difficulty avoiding squinting or blinking (Fig. 8-15).
4. Lens flare occurs if special care is not observed.
5. The choice of exposure for the subject matter requires careful consideration.

The solutions to the problems of sidelighting are:

1. Photographing shadowed portion of faces of women and girls aids in subduing unflattering lines. If all of the face seen in the viewfinder is in shadow, it may be good. Soft diffused light such as one finds on hazy, cloudy days or in shade gives more desirable results (Fig. 8-35). Definite light direction is still visible. Color portraits of both flowers and women benefit with less contrast in lighting. A skylight filter improves skin tones for color photography in shade. Filtering is usually unnecessary for black and white portraits of people.
2. Fill light reduces contrast effectively. Fill light is a term used to describe light added to supplement the main source light.

8-35 Pleasant modeling occurs with the subject in shade. Direction of light is still important. Which lighting is best for Carol?

The fill light is directed to soften or lighten but not to totally eliminate the shadows. The main or prime source of light remains the strongest. The fill may be from a reflector (Fig. 8-36) or any artificial light such as photofloods or flash (Fig. 8-37). The reflector may already exist, such as an exterior stucco wall, paving, water, a sand beach, interior light walls, or white drapes. Other reflectors can be a projector screen, a white umbrella, a newspaper, white cardboard, crumpled aluminum foil, or commercial reflectors especially made for the purpose. A white or light shirt or dress worn by the photographer can act as an effective reflector for close-up photography on flowers

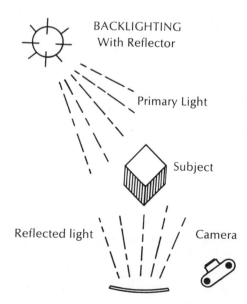

BACKLIGHTING
With Reflector

Primary Light

Subject

Reflected light Camera

8-36 The reflector picks up the light from the source and sends it back into the shadowed areas if placed or held to do so.

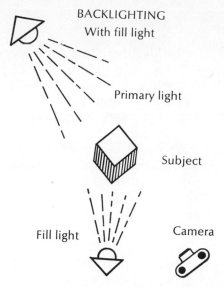

BACKLIGHTING
With fill light

Primary light

Subject

Fill light

Camera

8-37 Any supplementary light source can be used to open up the shadows but it must be weaker than the primary light if the direction of light is to be maintained.

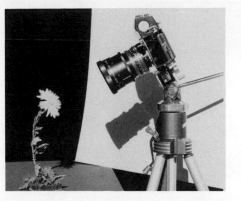

8-38 The reflector is used effectively with either side- or backlighting.

or a child. A crumpled aluminum reflector produces a stronger reflection. A white cardboard is used as a reflector in Fig. 8-38. Instructions for making the reflector used for Figs. 8-20–22 are in Appendix I. When artificial light is used, a lamp with lower intensity than the main light may be added to soften the shadows. A lamp of the same intensity can be used if put at a greater distance than the main one. Flash, on or off the camera, softens shadows when sunlight is the main source of light and is called fill-flash. (Chapter 13, Flash Photography.)

3. A lens hood or shade attached to the lens aids in preventing lens flare. In fact, lens hoods are almost mandatory for side-lighted photography. A lens hood *on the lens* is advisable for *all* pictures. Even with a lens hood, it is wise when taking side-lighted pictures to check to be sure the light is not striking the lens directly. If no lens shade is on the camera, the photographer should take the precaution, on all sidelighted pictures, of stepping into the shade of a building, a car, a tree, or having someone hold a hat, cardboard, or other object in such a manner as to cast a shadow on the lens but not be included in the picture area. If one can frame the picture with a doorway, archway, overhanging cliff, or other available device, the frame can shade and also serve as an effective frame of the picture as discussed in Chapter 7, Guides to Composition.

Photographed by Suzanne D. Nancarrow.

8-39 Backlighted teasel head is dramatic in silhouette.

Backlighting

The advantages of backlighting are:

1. The rims of light produced by backlighting the subject separate the subject from the background (Figs. 8-18,20,21,22,29).
2. Backlighting gives a feeling of depth to a picture, because it separates objects from the background. Pictures made on a cloudy hazy day, while they may be in much lower contrast, show this quality also.
3. Backlighting on translucent subjects such as flowers or glassware is sometimes termed plastic lighting. Internal veining or texture shown by backlighting can add interest in the final picture (Fig. 8-19).
4. Shadows in foreground can give interesting lines leading into the composition (Fig. 8-18).
5. Without fill light or reflected light, strong backlighting makes a high-contrast picture with a dramatic quality that can add impact (Fig. 8-39).
6. There is no danger of squinting against light by people or animals being photographed with backlighting.

Photographers need to train their eyes to see the backlighted picture. One theory for this is that it is not comfortable to look against the light; therefore, many an exciting and dramatic picture is never seen. To those who have not discovered the magic of backlighting, there is a whole new world of beauty to be discovered. The first step is to see and then to photograph the backlighted picture.

Backlighting problems are:

1. Backlighting may produce too high contrast in instances where this may not be desirable (Fig. 8-29).
2. Serious danger of lens flare exists with bright backlighting.
3. Determining best exposure is sometimes difficult.

Solutions to the problems of backlighting are:

1. For high contrast, fill flash can lighten the shadows. (Chapter 13, Flash.) Reflectors, either existing or temporary, can soften contrast, if used to fill the darker areas (Figs. 8-19–22). Cropping in the viewfinder to eliminate most of the background highlight area before tripping the shutter release is an effective way to retain the backlighting effect but reduce the apparent contrast. In this instance, the meter reading definitely would be taken from the shadowed areas for calculating exposure (Fig. 8-40).
2. Lens hoods prevent lens flare if the light source is sufficiently

8-40 Because detail was desired in the shadowed areas, the meter reading was calculated from the shadowed side of the photographer's hand for blond Elaine and black Ralph.

higher or lower than the camera angle. As in sidelighting, it is necessary to check the front of the lens to be sure the hood does shade the lens. If not, consider the possibility of letting the subject matter shield it. A tree trunk in the scenic, a portion of the building, a person, or an animal between the camera and the light can be effective. Protect the lens with an improvised shield that does not show in the picture as suggested in the discussion on sidelighting. A hat, a piece of cardboard, or even the photographer's hand can be a shield. As in sidelighting, an archway or doorway can become a frame for the picture while protecting from lens flare. Barn doors are used with the reflector flood or studio floodlights. In photographic terminology, barn doors are hinged metal flaps attached to the lamp that can be adjusted to limit the area covered by the light (Fig. 8-41).

3. To obtain a high-contrast picture in a backlighted scene, take the meter reading from the lightest area, for example, the sky in a sunset picture. The foreground objects then go into silhouette.

Top Lighting

The advantages of top lighting are:

1. Top lighting is excellent for photographing through glass such as an aquarium, a terrarium, or showcase merchandise. Top lighting avoids flares in the glass that often occur with front lighting (Fig. 8-42).

8-41 The Lowell barn doors slip over reflector lights to control light spread. There are numerous other types of barn doors. The lamp is in a Lowell light unit.

8-42A The fish were exposed with flash held above the aquarium.

8-42B Cut glass goblets with toplight show detail nicely without distracting flares. Bottom light would work well, too.

2. Top lighting may be effective when doing low-angle photography of an insect, a caterpillar or like creatures crawling across horizontal foliage, wire mesh, or screen.
3. Lighting from the top shows horizontal layers and texture across the face of the subject such as a vertical rock cliff.

The problems with top lighting are:

1. Eye sockets and other depressions of a person's face become too dark (Fig. 8-27).
2. Other facial features in portraiture are often accentuated out of proportion, such as the so-called Rudolph nose. This occurs when light spills over the face and strikes just the top of the nose (Fig. 8-43).
3. Bald heads should never be top- or backlighted unless they are to be accented excessively.
4. Lens flare is a distinct possibility with top lighting.

The solutions to the problems of top lighting are:

1. For a majority of subjects, the best solution is not to photograph in sunshine between the hours of 10:00 A.M. and 2:00 P.M. Move the subject to shaded areas, if at all possible.

8-43 The Rudolph nose caused by the light spilling over Carol's head indicates the photographer needs to be more observant before he trips the shutter.

2. If using artificial lights, change the position to alter angle of lighting.
3. Top lighting presents another instance where the lens hood is a necessity. Some other temporary material may be used to shade the lens in lieu of the lens shade.

Low and Bottom Lighting

The advantages of low or bottom lighting are:

1. Creates interesting pictures of glassware displayed on a glass table or shelves.
2. Creates a grotesque appearance or hints of intrigue in pictures of people when this is the purpose.
3. Lighted gardens frequently employ low or bottom lighting. These can be effectively photographed.
4. Texture on horizontal plane is accented by low lighting. An example would be the setting or rising sun across water or sand dunes.

The disadvantages of low and bottom lighting are:

1. Low lighting is never flattering in portraiture (Fig. 8-32).
2. Fortunately, relatively few subjects present opportunities for use of low lighting.

Solutions to the problems of low lighting:

1. For photographing people, choose another direction of lighting,

if at all possible. Should it be necessary to use low lighting, increase the distance between subject and light as much as possible to minimize the bizarre effect.

2. If low lighting is unavoidable, strong lights added at a higher position to fill shadows help to reduce undesirable effects.

In summary, the final choice of direction of lighting is determined by the photographer's desired picture and the possibilities. Certainly, some subjects are more effectively lighted from one direction than from another. Entirely different mood and atmosphere can be created with a change in lighting direction. This is one of the factors that makes photography so exciting and challenging. *Light direction can make or break the picture.* Every *good* photographer has to be aware and to know how to vary these effects when necessary or possible, in order to make successful pictures.

Questions to consider in deciding the best lighting for a photographic subject are:

1. Is maximum, moderate, or limited modeling or texture best?
2. Which lighting will best show perspective?
3. What are the possibilities in change of position of camera, subject, or light source?
4. In every situation, is there a *best* lighting solution?
5. Would making the picture at a different time of day improve lighting?
6. What areas will be highlighted with each of the possibilities?
7. If there is only one possibility and it is not the most desirable, can the disadvantages be subdued or modified during the developing and printing?
8. If the opportunity is now or never and the lighting not ideal, is it worth the cost of the film to try?

REFERENCES FOR FURTHER READING

Dunn, Phoebe: "On Better Family Pictures;" *Popular Photography*, Vol. 46, No. 12, December, 1959, pp. 64f.

Karsten, Kenneth: *Science of Electronic Flash Photography*, New York, Amphoto, 1968.

Murphy, Burt: *Complete Lighting Guide*, New York, Amphoto, 1965.

Nurnberg, W.: *Lighting for Photography*, New York, Amphoto, 1968.

———*Lighting for Portraiture*, New York, Amphoto, 1969.

Scully, Ed: "Floodlight: It's Simple and Controllable," "Spotlight: It's Dramatic and Inexpensive," "Strobe: It's Portable and Flexible," *Modern Photography*, Vol. 32, No. 1, January, 1968, pp. 72–77.

Waldman, Harry: "Simple Lighting to Make Her Beautiful" (a primer on flattery), *Camera 35*, Vol. 14, No. 3, April/May, 1970, p. 46f.

Woolley, Al: *Photographic Lighting*, New York, Amphoto, 1971.

CHAPTER 9

Understand
the Camera

Sophisticated cameras are expensive. Each feature of adjustment, auto-
mation, or flexibility adds to production costs and, in turn, to the
sales price. The photographer who does not exploit the full potential
of the camera's devices is not getting his money's worth. In addition, he
is missing much of the enjoyment to be found in photography. To
understand the possibilities, it is necessary to explore the kinds of
cameras.

Cameras are grouped in numerous ways. The size of the film used or
the maximum picture size that the camera yields is one·method. Other
ways of classifying cameras are based upon mechanical characteristics,
such as the viewing system, the light meter location, or the degree of
automation, which was discussed in Chapter 2, Camera Operation.

FILM AND PICTURE SIZES

Terms used to identify still camera sizes are:

1. Miniature or double frame, more commonly termed 35mm
 (135 film), which produces a negative or picture size of 24mm
 by 36mm (Fig. 9-1).
2. Subminiature, which includes cameras that use different size
 films and yield varied size negative or pictures, all smaller than
 the 35mm.
 a. Single frame, which also may be termed half frame, gives
 a negative approximately one half the size of the 35mm
 camera's picture. The half frame camera uses 135 film to
 yield twice the number of pictures per roll as the 35mm
 camera (Fig. 9-2).
 b. Other subminiatures use 16mm films to give pictures up to
 that width while the Tessina camera utilizes respooled
 35mm film to yield a negative smaller than the single frame
 camera but several times larger than the 16mm pictures
 (Fig. 9-3).
3. Instamatic cameras (126 cartridge) produce negatives one and
 one-eighth inch square (Fig. 9-4).

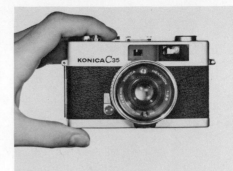

9-1 Miniature cameras are all of those cameras that utilize 35mm film and produce negatives or slides 1" × 1½" (24 × 36mm).

9-2 (Right) Half-frame (single-frame) cameras, less numerous, yield negatives or slides 1" × ¾" (24 × 18mm).

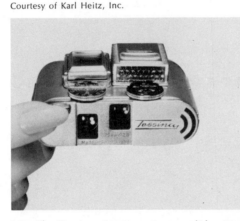

9-3 The Tessina gives negatives or slides 14 × 21mm, larger than other subminiatures exclusive of the half-frame cameras.

9-4 Cameras for 126 film are increasing in number rapidly.

4. 2¼ x 2¼ cameras (120 or 620 films) give pictures the size of their classification (Fig. 9-5).

5. 2¼ x 3¼ cameras (120 roll film or cut film) for pictures the size of their classification will not be discussed further in this book.

6. Press and view cameras (cut film in sizes from $2\frac{1}{4}$ x $3\frac{1}{4}$ to 11 x 14) are not covered in the text, because seldom will the beginner start with this type camera.

VIEWING SYSTEMS

Viewing systems are of three general types:

1. The simple viewfinder is located near the top of the camera with a small window in the back and one opposite in the front to give a miniature view of the area covered by the lens which reproduces the image on the film (Fig. 2-1).
2. The rangefinder viewfinder is located similarly to the simple viewfinder except that there is a device for accurate focusing included. The image is much smaller than the negative format.
3. The reflex viewfinder shows, by means of mirrors within the camera, the image covered by the taking lens in full negative or picture size. There are two types of reflex viewing: twin-lens and single-lens. With a twin-lens reflex (TLR) camera, the view is through the top lens, but the picture is taken through the bottom lens (Figs. 9-5A, 6). In single-lens reflex (SLR) cameras, the view is through the same lens that transmits the picture to the film (Fig. 9-5B, 7).

VIEWFINDERS

The primary function of the viewfinder is to show the area covered by the lens that takes the picture. In other words, and as explained earlier, the viewfinder is used to frame the picture.

There are two general classes of viewfinders that by their names indicate the position of the camera during the picture-taking process.

1. The waist-level viewfinder is held approximately at waist level or it may be held the same distance from the eyes, horizontally or above the head for viewing. The view is reversed from side to side with waist-level and overhead viewing. There is vertical reversing of the subject with the camera held vertically. The better cameras, with waist-level viewfinders, have a magnifier that can be flipped into place to have the camera closer to the eye, when this is desirable. Waist-level viewfinders are available and interchangeable with eye-level viewfinders on a few single-lens reflex cameras (Fig. 2-19).
2. Eye-level viewfinders permit the camera to be held to the eye. The viewing area may be a small fraction of and/or up to the exact size and always in the same dimensional proportion as the

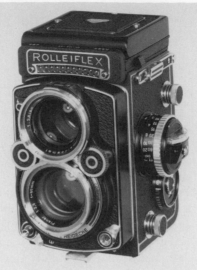

9-5A One twin-lens reflex camera.
While not numerous in brands, cameras of this type are very popular.

9-5B There is a limited but increasing
number of brands in the single-lens
reflex cameras that take 120 film.

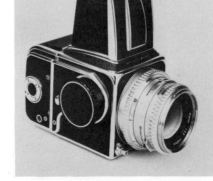

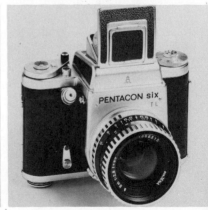

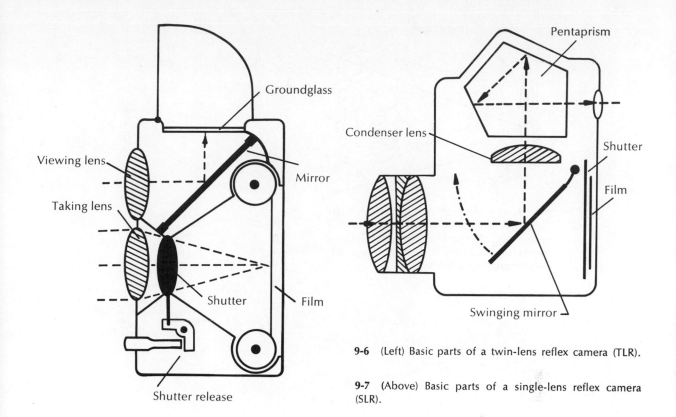

9-6 (Left) Basic parts of a twin-lens reflex camera (TLR).

9-7 (Above) Basic parts of a single-lens reflex camera (SLR).

film frame. The smaller-sized viewing areas are on the range-finder type cameras; the full frame on the reflex cameras. Normally, the viewfinder will closely frame the view the lens will take. If the viewfinder seems not to include the same area that the lens takes, it may be due to:

a. The photographer's eyeglasses prevent holding the camera close enough to the eye to see all four edges of the viewer.

b. Incorrect position of the camera's viewer in front of the eye. It is not centered so that all four edges of the frame are visible.

c. Parallax, which is discussed later in this chapter.

3. Wire frame and sportsfinders are used at eye level for fast operation on subjects some distance from the camera.

PARALLAX

Parallax can be a problem on all except SLR cameras and is caused by the difference in view between the viewfinder and the lens that transmits the image to the film (Figs. 9-8, 9).

PARALLAX

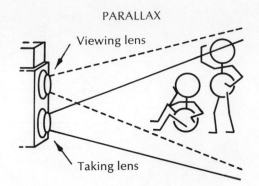

Viewing lens

Taking lens

9-8 Rangefinder and twin-lens reflex cameras present parallax problems at near distances. Not only are heads clipped, but viewfinders set off-center horizontally frame differently at close distances.

9-9 Drawn by C. Norman Dickison.

One can demonstrate for himself the problem quite easily if he will close one eye. With a forefinger held upright about six inches from the face, line the finger with a vertical edge such as a door jamb or a window casing several feet away. Without letting the finger move, close the open eye and open the closed eye. Repeat the procedure with a line that is two feet away.

The distance between the two eyes is comparable to the distance between the viewing lens and the taking lens except that the eyes are positioned horizontally and the lens and viewfinder are often vertically

placed. Many a head in a picture could have been saved if the photographer had been aware of the problem and how to correct it.

Most cameras are made to minimize the parallax problem on distant shots but it can be critical on pictures taken at ten feet and closer. Another variation occurs as one shifts from a horizontal to a vertical picture with the rectangular format. In this instance, one side of the picture will be cut off while the other side may include more than desired.

The photographer who is familiar with the problem and with his camera will allow extra space in the viewfinder on top of the horizontal view or the side (which side will depend on which way he turns the camera) of his vertical picture. The amount will vary with the individual camera and the distance from subject to camera. Some experimentation at different closer distances should solve the problem. If close-up lenses are added, the subject must be lined up very precisely with the taking lens to get exactly the desired picture. To do this, view the camera from the side or use a straight edge of a ruler or yardstick for sighting.

INFORMATION IN THE VIEWFINDER

Within the viewfinder area, there may be indicators besides the framing of the picture. These are:

1. Parallax correction on rangefinder type cameras and on some twin-lens reflex cameras.
2. Etched squares to aid in aligning the subject matter.
3. The exposure via a light meter either within, or outside, the camera but with the meter internally connected.
4. The focus of the lens.

Parallax Correction

A high percentage of cameras are parallax corrected. There is a line, usually a broken etched line within the viewfinder, that shifts as the camera lens is focused (Fig. 9-10). The view within the frame indicates the area included by the taking lens. The parallax correction must be ignored when close-up or portrait lenses are added. The subject matter is aligned, as with the non-parallax-corrected viewfinder. (Chapter 10, The Camera Lens.)

Etched Squares

Many of the larger format cameras, 2¼ x 2¼ and bigger, have etched ½-inch squares on the viewfinder glass to aid the photographer in aligning his subject matter vertically and/or horizontally in the picture.

9-10 The dotted frame line for parallax correction may completely encircle the area framed or be on only two sides.

Exposure Indicator

The exposure indicator within the viewfinder frame may be a simple floating needle that is to match into a "C" marking or with a straight line. Some cameras have warning signals for over- or underexposure. Those cameras with a spot meter will have some marking to indicate the part of the frame that is sensitive to the light. The photographer must consider where this spot or area is within his picture in taking the meter reading.

FOCUSING DEVICES

Focusing devices aid the photographer in adjusting the lens for the desired sharpness of the image on the film. Many of the devices are visible in the viewfinder; others are in a separate viewing window within the camera or attached to the outside of the camera. The attachment may be permanent or temporary.

The focusing devices are essentially an arrangement of mirrors that reflect the image onto the viewing glass. The viewing glass may have various grindings, etchings, or other special forms that may simplify the photographer's setting of the lens for desired focus.

Ground glass is used with waist-level viewfinders in reflex cameras. The focus of the lens is shifted by turning a knurled ring on the lens or a knurled knob or disk on the camera body. The image on the ground glass of the viewfinder shows the same blur or sharpness that will register on the film, except that the f/stop at which the picture is taken may give greater depth of field. (Chapter 11, Depth of Field.)

With all focusing devices, it is advisable when focusing the lens, to go past the point of sharp focus until there is slight blur and then turn back again to the point that is sharpest. This habit will help to assure sharpest focus.

The split-image rangefinder is used on many eye-level viewfinders, sometimes in a second window or attached to the outside of the camera. The split image is a center portion of the viewer within a circle that appears cut in half horizontally. If not focused properly, a vertical object, such as a tree trunk, appears in the split-image viewfinder as being cut across and out of alignment. When in focus, the trunk will show normal and uncut to record a sharp image on the film (Figs. 9-11, 12).

Another kind of rangefinder device gives a double image when the subject would be blurred to some degree on the film. When the lens is adjusted to show the single image in the rangefinder, the lens will transmit a sharp picture of that subject to the film (Fig. 9-13).

Variations and other kinds of viewing screens for focusing are the split-image rangefinder surrounded by ground glass. A rangefinder may be ringed by a ground-glass collar and the rest of the screen

9-11A Split-image rangefinders may have the split diagonal instead of horizontal as shown.

9-11B If the picture is made when the lens is focused as in Fig. 9-11A, the image will be out of focus as shown, without the circle and split as seen in the viewfinder.

9-12A When the viewfinder appears as it does here, the lens is focused.

9-12B A picture made with the rangefinder as shown in Fig. 9-12A, yields sharp focus of the subject.

9-13 Double image rangefinders show out-of-focus objects as in the shot at left; in-focus objects appear as in Fig. 9-12A. Results for the in-focus objects appear in Fig. 9-12B; out-of-focus are as in Fig. 9-11B.

appears scored with concentric circles referred to as a fresnel lens. Another type of center area is microprism focusing, which is a myriad of miniature prisms on the glass that breaks up the image until the lens is sharply focused. Then the subject appears whole and sharp on the microprism area. Some viewing screens have only ground glass. A center circle may be more finely ground for critical focus.

This by no means explains all of the focusing devices available but should give an idea of how some of the more common ones are used. Photographers differ in their preferences of focusing aids which, of course, accounts for the variety on the market.

Cameras equipped with focusing devices have a distance scale that is set automatically as the lens is focused. The scale is marked in feet and/or meters. An "M" indicates meters; an "F" indicates feet; the full words are on other scales (Fig. 2-4).

Since a meter is equal to 3.28 feet, it is important for the camera operator to know which scale he has. The numerals on either scale vary considerably from one lens to another. The last symbol will be for infinity and appears to be a figure "8" laid horizontally, thus ∞.

The point of focus may be anywhere on the scale, any distance between or on numbers, at the place the image in the viewfinder and the lens is focused.

For a camera without a focusing device but with a distance scale that affects lens focus, a separate rangefinder is available. These are convenient for persons who find it difficult to estimate distances. The rangefinders may be hand held or put in the accessory shoe on top of

the camera. Focus the rangefinder and set indicated distance on the camera's scale.

ASA AND DIN SCALES

Some explanation of the ASA and DIN scales is given in Chapter 2, Camera Operation (Figs. 2-29, 30). A more detailed review is in Chapter 14, Films.

At this point, in Understanding the Camera, the need is:

1. To recognize the scale. (Chapter 2, Camera Operation.)
2. To know how the scale or dial is set on the individual camera. The camera manual indicates this.
3. To know what effect, if any, the setting has on exposure control. Again, refer to the camera manual.

Only one scale, either the ASA or DIN, need be set. Often, this will automatically set the other, but whether it does or not is not important.

Some of the scales on cameras are simply reminder dials to tell the operator the emulsion speed of the film in the camera, if he has forgotten. On other cameras, the ASA setting is vital for correct exposure of the film, because it is one of the controls of the exposure of the film in the automatic camera and the light meter reading in the nonautomatic camera.

The ASA scale must be correctly set on hand-held light meters for appropriate exposure readings.

With automatic cameras everywhere, the question could be asked, "Why bother to control a camera manually when the automatic works fine?"

The automatic camera does have many advantages. It saves both time and film and because of its rapid operation can get important pictures that might be lost with a totally manual camera. In some situations, the automatic camera cannot get the desired picture that is possible with the camera used on manual control. In other instances, with the camera still on automatic, certain procedures in setting controls yield very different and often most creative results. Many of these possibilities become apparent as this and the next two chapters are studied. For the photographer who desires to do more than the casual record shot with the sun over his shoulder, it is necessary to explore and learn to use both automatic and manual controls.

To understand easily, the various settings and devices on cameras, the reader needs:

1. A camera that can be manually adjusted. There should be no film in the camera for the exploratory procedures of this chapter.

2. An operating manual, if possible, for the camera. Besides the booklet that comes with the camera, many manufacturers publish books that further detail the camera's features and how to use them. These books can be an excellent investment and sometimes can be found in used book collections at greatly reduced prices.

3. A piece of white paper 8½ x 11 on the table or desk in front of the camera. Use the paper to observe the shutter action through the open back of the camera and the lens. Remove the lens cap from the lens. Open the camera back or remove it, if detachable. Follow good camera handling practices. No fingers should touch any glass or the pressure plate.

SHUTTERS

The shutter is similar to a door that opens when the shutter release is tripped, then closes automatically on all timed exposures. Explore the shutter action and understand how it works.

Find the shutter speed control. It may be a dial, two dials (one for faster speeds and one for slower speeds), or it may be engraved on the ring of the lens or in some other area. On the newer cameras the shutter speed numbers vary considerably from those on older cameras. Later models will usually have a series of numbers, thus: 1, 2, 4, 8, 15, 30, 60, 125, 250, 500 and 1000. They may be more or less extensive than this list. The older cameras may have numbers such as: 10, 25, 50, 100, 200, 300 (Fig. 9-14). Here, too, there may be more or less numerals and they may vary even on these, but will have 25, 50, and 100.

All of these numbers refer to the time the shutter is open to let the light through the lens onto the film. The "1" refers to one second. All the other numbers listed above refer to one fractional part of a second, as ½ second, ¼ second, ⅛ second, and so on to 1/1000 of a second. Notice that on the newer cameras each succeeding number gives approximately one-half the time and each preceding number twice the time. The older cameras vary in comparison of previous and successive

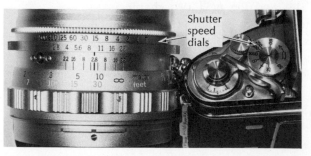

Shutter
speed
dials

9-14 Newer sequence of shutter speeds are on the left, older ones on the right.

speeds. Cameras, usually those with two dials, may give up to several full seconds of timed exposure. Some cameras with meters give readings in full seconds but do not time them. The photographer must manually open and close the shutter on "B" for the indicated time.

Set the shutter speed dial at 1/30 (or 1/25) second.

Always set shutter speeds at a specific mark. A setting between shutter speed marks can prevent the shutter from opening at all or may possibly damage the mechanism. At best, setting between speeds gives a questionable speed, probably the nearest one. For the very few cameras that can be set between shutter speeds, there are specific directions in the operating manual.

Cock the shutter. On some cameras it may be necessary to cock the shutter by turning the sprocket on which the film normally rides with the fingers. There are a few cameras that have to be cocked by advancing the film. If this should be true, use that practice roll of film suggested in the earlier chapter and remove it before the next step.

With the shutter cocked, hold the camera so that the lens is pointed toward the white paper on the desk. Look through the back of the camera (not the viewfinder) and through the lens as the shutter release is tripped. One should see a full circle of white paper for 1/30 (1/25) of a second.

Locate the shutter. There are three general locations for shutters. As a simplified explanation, the between-the-lens type, a series of overlapping, thin metal leaves that open and close as the release is tripped, may be mounted within the lens, between the front and back elements. Leaf shutters may be placed immediately behind the entire lens. A third location for shutters is in the focal plane, at the back of the camera, very close to the film plane (these are called, not surprisingly, focal plane shutters). They are curtains of either metal or rubberized cloth that travel horizontally or vertically (never both) across the film plane, exposing the film to the light.

Each type and location of shutter has both advantages and disadvantages. The focal plane shutter is considered more accurate at higher speeds and is a practical system for interchangeable lenses. The between-the-lens shutters have to be made within each interchangeable lens, thus adding to the cost. This makes them available for the professional or the individual willing to spend a great deal of money. Except for possibly one brand, behind-the-lens shutters are not made for cameras with through-the-lens viewing (SLR cameras) because the shutter interferes with the necessary mirror movement. The leaf shutters have some advantages in flash photography that will be covered more fully in the chapter on that subject.

Now, set the shutter speed at the slowest timed speed on the camera, perhaps one second. Cock the shutter. Watch, again, through the lens

from the back of the camera toward the white paper as the release is tripped. Follow the same procedure for the fastest shutter speed. It becomes immediately apparent that there is wide difference in the time the shutter is open (Fig. 9-15).

The exposure of the film is affected by both the lens aperture and the shutter speed. Assume that the camera is set with the appropriate lens aperture in combination with each shutter speed, to give the desired exposure, different effects would be achieved with the various shutter speeds in photographing action (Figs. 9-16–22).

Since the picture is being taken only for the time the shutter is open, only that instant is recorded. At 1/1000 of a second, motion would be more nearly stopped or frozen in the picture than at one second. In daylight photography, the completely automatic camera will choose a fast enough speed to satisfactorily freeze most movement. In lower light levels, it may be desirable to sacrifice something else in order to slow or stop the action. These are some of the places the automatic camera without manual control can fail to get the desired picture. On some automatic cameras, a full understanding of the controls that can be set might provide a better picture (Fig. 9-22). The reader's

GRAPHIC COMPARISON OF TIME

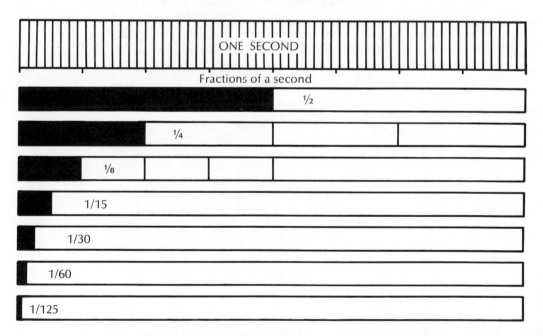

9-15 The solid black portions represent the time shutter is open at each indicated portion of a second.

SHUTTER SPEEDS TO STOP ACTION
(With normal lens)

SUBJECT IN MOTION	Miles per Hour	Camera to Subject (in feet)	DIRECTION OF TRAVEL ↕	✕	⟷
			Shutter Speed Required		
People Walking / Children Playing	5 to 10	15	1/250	1/250	1/500
		25	1/100	1/200	1/300
		50	1/25	1/50	1/100
Ballet Dancing / Fast Sports / Slow-moving Vehicles	20 to 30	15	1/500	1/1000	1/25 Pan
		25	1/250	1/500	1/1000
		50	1/125	1/250	1/500
		100	1/50	1/125	1/250
Fast-moving Vehicles	60 and over	25	1/500	1/1000	1/125 Pan
		50	1/250	1/500	1/1000
		100	1/125	1/250	1/500

9-16 These shutter speeds are suggested for the 35mm camera with a normal lens. Longer lenses (telephoto) need faster speeds at the same distances, speed, and direction of travel. Shorter lenses (wide angle) under the same set of circumstances will tolerate slower speeds.

own experiments with other situations will help to use the various shutter speeds effectively.

Factors that are considered in choice of the shutter speeds for stopping action or motion are:

1. The direction of the travel in relation to the camera position. Movement away from or towards the camera at right angles to the film plane can be stopped with slower shutter speeds than the same motion diagonally toward or away from the camera. The fastest shutter speeds are required for action that moves across the view, parallel to the film plane.
2. The distance between the subject and the camera. Action close to the camera requires a faster shutter speed than does the same movement at a greater distance.
3. The speed at which the action moves. The more rapid the move-

ment, the faster the shutter speed that will be needed to freeze the action.

4. The focal length of the lens affects the choice of shutter speeds also. Other things being equal, the wide-angle lens will not require as fast a shutter speed to stop the same motion as will a normal lens. Freezing action requires a still faster shutter speed with a telephoto lens. The increase is determined by the length of the lens.

Suggested speeds for a normal lens on a 35mm camera are indicated in Fig. 9-16. Other cameras and other lenses can require different speeds.

The exact instant of the release of the shutter makes a difference in the result with some types of motion. As the pole vaulter goes up and over, there is a split second before he starts downward that he is motionless and a relatively slow shutter speed could stop the action. Timing can be all important in stopping some ballet routines.

There is a possibility that some blur of motion is desirable. It can give interesting effects. This must be the photographer's decision (Figs. 9-17—25).

Cameras with a "B" and/or a "T" shutter setting have unlimited exposure times available, even several hours. These are called time ex-

9-17 At a shutter speed of 1/500 second, the water is frozen in place as it tumbles and splatters.

9-18 With a shutter speed of 1/25 second, flowing motion is evident. Air bubbles in the water reflect the sunlight to make the white streaks.

Photographed by Jim Yarbrough.

Photographed by Jim Yarbrough.

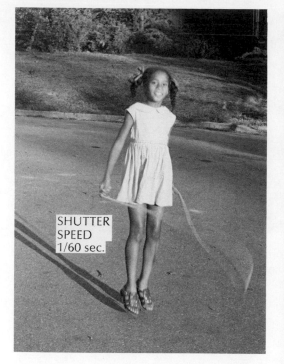

SHUTTER
SPEED
1/60 sec.

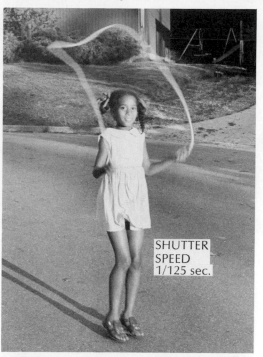

SHUTTER
SPEED
1/125 sec.

9-19 (Above) Marnita's jump rope all but disappears at 1/60 second shutter speed. Considerable blur is registered in her image.

9-20 (Above right) The jump rope is less blurred at 1/125 second and so is the jumper.

9-21 (Right) Marnita and her rope are very sharp at 1/1000 second.

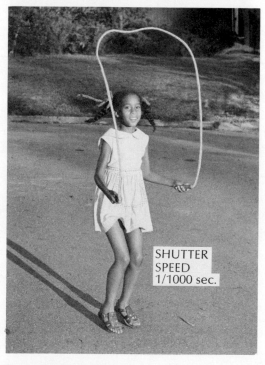

SHUTTER
SPEED
1/1000 sec.

Photographed by Jim Yarbrough.

9-22 The racing car was photographed at 1/1000 second with an automatic camera on which shutter speeds could be controlled.

9-23 Rushing water photographed at 1/8 second. This required two polarizing filters and bright sunshine. See Chapter 15, Filters, for techniques in using the polarizing filter.

9-24 The camera was panned at a shutter speed of 1/15 second. The camera follows the subject and the shutter is tripped with the camera still in motion to give the blurred background.

9-25 Photographed at 1/30 second while the camera was panned.

posures. The camera is operated differently with these two settings so it is important that the photographer understand which he is using. The "B" refers to the bulb at the end of a pneumatic cable release that was standard equipment for many years and is used in special situations today. *Do not confuse the "B" with any reference to a flash bulb!*

A camera with two speed dials may require each dial to be especially set for the shutter to operate as expected. Check the camera manual for any special instructions. For those with one speed dial, set the "B" the same as each of the other speeds.

Cock the shutter. Watch through the back of the camera as the shutter release is pressed and *held down* for the desired time. Release the pressure. The shutter closes. In other words, the shutter remains open as long as pressure is maintained on the release.

It is best to have the camera mounted on a sturdy tripod set on a solid surface for any time exposure. Even on a tripod there is danger of camera jiggle if the finger is used to hold down the shutter release. Use a locking cable release to avoid this problem (Fig. 2-9).

With "T" settings, the shutter opens when the release is pressed and remains open until the release is tripped a second time. Remember the "T" as *Trip Twice*. Some cameras, especially those with two speed dials, may require a dial be turned instead of the release being tripped a second time. Check the camera manual for instruction. A cable release is beneficial with this setting, too, but does not require a locking one.

Some automatic cameras have a "B" setting on the aperture rings. In these, the aperture is always at the widest opening when the camera is set at "B". While time exposures can be made for any length of time, there is no control of aperture.

Nonadjustable cameras may offer two speeds, usually 1/90 and 1/30 of a second. The slower speed is obtained anytime a flash bulb is inserted. It makes no difference whether the flash bulb is used or unused.

Many cameras provide for delayed shutter action, called a self-timer. This is sometimes indicated by a "V" setting on one side of the lens barrel. Other cameras have a lever on the body of the camera that makes a 1/4 or 1/2 turn. Check the camera manual for directions to operate the particular mechanism. Set the shutter for any timed shutter speed. Operate the delayed-action device. Watch through the back of the camera towards the white paper on the desk to observe the shutter action with the self-timer.

Delayed shutter action can be used for two purposes:

1. To allow the photographer to be in the picture; he has several seconds to get in place. Average time is about twelve seconds, but this time is variable on many cameras (Fig. 9-26).

9-26

2. To give time for the camera to steady itself following any vibrations that may have occurred in the process of tripping the shutter. For instance, if a camera is set on a table or window sill instead of mounted on a tripod, there could be some vibration involved in the pressure on the release. Even with the camera on a tripod and with a long telephoto lens, bellows, or other heavy accessories, there can be shake in the equipment from the operation of the shutter release. In either case, the danger is reduced with delayed shutter action.

For those cameras without a self-timer, there are delayed-action releases that can be attached to the cable release socket; another type that can be locked on the hand-end of the cable release. These offer a variety of time settings up to about twenty seconds. The devices are inexpensive.

FLASH SETTINGS

For different kinds of flash equipment, there are varying settings or mechanical controls. At this point in Understand the Camera, the principal need is to recognize the symbols as applying to flash. They are explored in more depth in Chapter 13, Flash Photography.

F or M is the setting used for most flashguns that use expendable flash lamps. The lamps are used once and discarded, or the flash cubes with four lamps are used an equal number of times and discarded.

FP indicates the correct setting for focal plane expendable flash lamps, appropriate for use on cameras with focal plane shutters.

X is used for electronic flash (used repeatedly, not discarded) and for some of the expendable flash lamps.

Check the camera manual for any settings or markings that have not been explained in this or preceding chapters, except those on or that control the lens proper, which are the concern of the following chapter.

REFERENCES FOR FURTHER READING

Keppler, Herbert: "A Concise Guide to Aches and Pains of SLR Finders," *Modern Photography*, Vol. 35, No. 4, April, 1970, pp. 16f.

CHAPTER 10

The Camera Lens

The most expensive and vital part of any camera is the lens. The fidelity or accuracy with which it records the subject is vital to picture excellence. The lens is only a tool, however. The photographer needs to understand the versatility and the limitations of each lens that he uses.

FUNCTIONS OF THE LENS

The lens has two principal functions:

1. To gather light rays reflected from the subject of the photograph and transmit these rays as an image to the film plane with the desired fidelity or accuracy and sharpness.
2. To control the amount of light that reaches the film and, when combined with the time the shutter is open, give the film the best exposure possible to yield desired detail in highlights and shadows and to provide best color saturation when color film is used.

In order to operate and to recognize the possible and impossible performances for an individual lens, it is necessary to further explore lenses and their characteristics.

MATERIALS AND CONSTRUCTION

For many years, all camera lenses were made of glass mounted in metal housings. More recently plastics have been used for both camera bodies and lenses by some manufacturers. There are both advantages and disadvantages with plastic as compared with the glass lens.

Nonadjustable camera lenses have a single piece of glass or plastic ground and polished to a shape that focuses reflected light rays onto the film plane. The lens will yield acceptably sharp prints in the sizes usually made from such equipment. Subjects at optimum distances from the camera can be moderately enlarged satisfactorily. More expensive camera lenses have multiple pieces of glass or plastic called

elements, each technically a lens. Even though a lens may have a number of elements, the whole is still referred to as a lens, singular form.

Each element of a lens is ground to a specific and precise curvature, then carefully polished to serve a particular purpose in focusing the light rays to correct distortions, called aberrations. These are caused by the physical action of the light rays within the lens. Different kinds of glass are combined to give other corrections. One is to bring all colors to a common focal plane, which results in a color-corrected lens to give a sharper image on the film. Because different colored light rays have different wave lengths, a color-corrected lens yields a sharper image of the subject regardless of whether the film is black and white or color.

Special coatings are used to reduce internal reflections within the glass. Each additional procedure adds to the cost of production but serves to improve the image sharpness on the film and thus to permit negatives and positives (slides) to be enlarged many times the original size of the film. The slightest image distortion on film is accentuated with enlarging.

Lens quality, however, is not determined by the number of elements, the kind of glass or coatings, but by the way the lens performs in actual operation. They can and do vary in the sharpness of image focused, contrast, and color cast. Sharpness is of the most concern to the beginning photographer. Differences in contrast and color are comparatively small but are of concern to the advanced amateur and the professional photographer.

In viewing a picture, people will tolerate less sharpness in a transparency projected on a screen than in an enlarged print. Sharpness or softness of image is a relative term. A picture that is acceptably sharp to one photographer may be totally unsatisfactory to another.

FOCAL LENGTH

All lenses are constructed to a specific focal length. Focal length is the distance between the optical center of the lens and the point at which the light rays reflected from an object at infinity will be sharply focused behind the lens (Fig. 10-1). Infinity, in photographic terms, extends to the stars and beyond. The focal length of the lens determines the near distance from the camera at which infinity begins. The longer the focal length, the further from the camera to the beginning of infinity.

The point or distance at which the lens focuses the image is the focal plane (Fig. 10-1). In cameras with adjustable focus, the film is held flat at this exact distance. In relation to cameras, the terms *film plane* and *focal plane* often are used interchangeably. They are the same only when the lens is focused at infinity. The focal length of

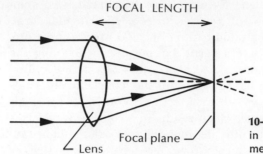

FOCAL LENGTH

10-1 Focal length may be expressed in inches, centimeters, or milli-meters.

Lens

Focal plane

lenses is usually expressed in centimeters or millimeters. Large view or portrait camera lenses are listed in inches.

The focal length of all better camera lenses is shown on the front of the lens. For example 5cm or 50mm (Fig. 10-2).

When a lens is moved further from the film plane than its focal length, images nearer than infinity will focus on the film. Each lens has its limitation on the closest distance it will fous without supplementary accessories. Lenses in nonadjustable-focus cameras are placed at a compromised distance from the film plane to give acceptably sharp focus for reasonably close subjects, while sufficient sharpness at infinity is maintained for the small print or snapshot. The limitation on near distance varies with the focal length of the lens. On small nonadjustable cameras the near distance is usually 3 to 3½ feet.

In cameras with adjustable focus, a mechanism is in the camera body or in the lens barrel for lengthening or shortening the lens-to-film plane distance. This variation permits the adjustable camera lens to be focused sharply on objects much closer to the camera than the nonadjustable lens of the same focal length. The adjustable camera also can be focused more sharply at infinity.

To see the change in film plane-to-lens distance, operate an adjustable focusing ring or knob while watching the lens from above. Though the lens shift is limited, it certainly can be observed. The shift in focus can be easily seen in the viewfinder of the single-lens reflex camera.

CONTROL OF LIGHT BY THE LENS

The lens controls the amount of light that can reach the film in the time the shutter is open by the effective lens diameter, which is the width of the opening in the camera lens. This will always remain the same in the nonadjustable camera lens. The adjustable lens may be varied or controlled automatically and/or manually, depending on the

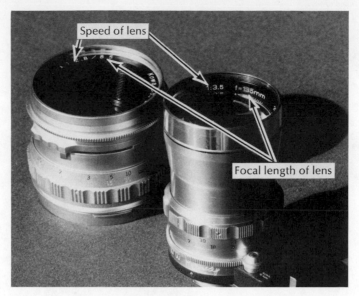

Speed of lens

Focal length of lens

10-2 Both lenses have the focal length expressed in millimeters though the mm is omitted on the Kowa lens.

individual camera and the particular lens. The aperture is changed by a series of overlapping hinged metal leaves that move to make a larger or smaller opening for light to pass through the lens. It is easier to understand if one looks at an adjustable camera lens.

Open the back of a camera that has a manually controlled lens or set the automatic lens on manual if this is mechanically possible. (For the totally automatic camera, the following procedure works on some cameras. Set the shutter speed on "B," trip the shutter, and hold down on the release long enough to make the desired observations on each aperture.) Look through the back of the camera toward a white paper on the desk as the aperture ring of the lens is turned from the largest to the smallest opening (Fig. 10-3). Compare the size of the apertures of a given f/stop on two or more lenses of different focal lengths (Fig. 10-4).

The variations in lens openings are termed f/stops, lens apertures, diaphragm settings, iris diaphragm openings, lens stops, f/numbers or some other combination of these terms. F/stops are indicated by a series of numbers that express the relationship or ratio of the apertures to the focal length of the lens and that are written as f/number or f:number (Fig. 10-5).

A lens with a maximum opening of one inch and a four-inch focal length has a ratio of 1 to 4, written either 1:4 or f/4. An eight inch focal length lens with an effective lens diameter of two inches is also f/4. A 50mm lens with a 25mm aperture is 1:2 or f/2. The speed of

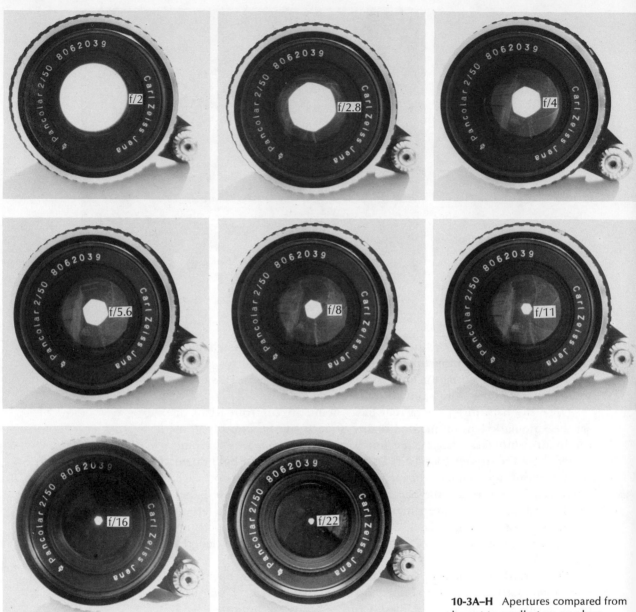

10-3A–H Apertures compared from largest to smallest on one lens.

any given lens is indicated by the *f*/stop at its widest aperture. A common question among photographers is, "How fast is your lens?" The answer may indicate that it is an *f*/2.8. If so, the widest aperture is divisible into the focal length 2.8 times, though the photographer

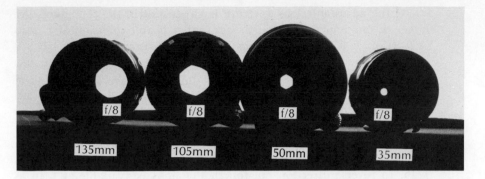

10-4 Shorter focal lenses have smaller apertures at *f*/8 than longer focal length lenses because the *f*/number expresses a ratio.

10-5 The focal length of the lens is divided into the equivalent of four of its own diameters in this drawing.

f/NUMBERING LENSES

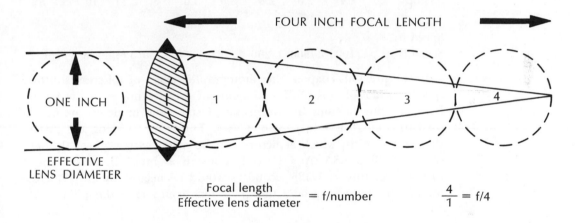

$$\frac{\text{Focal length}}{\text{Effective lens diameter}} = \text{f/number} \qquad \frac{4}{1} = \text{f/4}$$

does not calculate this. It is engraved on the front of the lens on all better cameras. The speed of the lens does not indicate a particular size opening but states a relationship between the focal length and the largest aperture.

The fixed aperture lens on simple cameras is about *f*/11. A few models have full-stop changes when a metal slide is shifted with larger or smaller openings in front of or behind the lens to change an *f*/11 to *f*/8, and possibly *f*/5.6. This type of lens cannot be set between *f*/numbers because there is solid metal between the different sized openings.

As the adjustable lens aperture is closed down, the f/numbers get larger. If one remembers that the f/number is an expression of a ratio or fraction, it is not so confusing. Certainly, ¼ is smaller than ½; ¹⁄₁₆ is smaller than ⅛. F/4 will let in less light than f/2, and f/16 less than f/8.

Except for the first two numbers on some lenses, the f/stop adjustment scales are marked in full stops. When the lens is closed down to the next succeeding number, there is only one-half as much light at a given shutter speed. The preceding stop gives twice as much light. Therefore, f/4 gives four times the light of f/8; f/8 four times that of f/16. In reverse direction one-fourth the light is available at f/16 as compared with f/8 (Fig. 10-6).

Since opening the lens aperture or closing it down changes the amount of light that reaches the film, this allows the shutter speed to be changed to vary the effects. For example, if the light level and film ASA is such that the right exposure is f/8 at 1/30 second, then any of the following combinations will give a similar exposure to the film:

F/stop	1.4	2.0	2.8	4.0	5.6	8	11	16	22	32
Shutter Speed in Seconds	1/1000	1/500	1/250	1/125	1/60	1/30	1/15	1/8	1/4	1/2

In the previous chapter, the photographic effect of different shutter speeds on motion was illustrated. Some of the advantages of the faster lenses are now obvious. The terms fast, faster, slow, or slower are often used in comparing the speed of lenses. The faster the lens, the lower the light level in which a picture can be made with a given shutter speed and film ASA. At f/1.4 only one-half as much light is needed to take a picture at 1/125 second as would be needed by an f/2 lens. Stated another way, where the f/1.4 lens could take the picture at

WHOLE STOP APERTURES

(With comparable square areas)

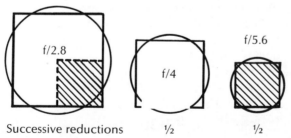

f/2.8

f/4

f/5.6

Successive reductions ½ ½

10-6 Square divisions of comparable circle areas graphically demonstrate the relation of one aperture to another.

1/125 second, the *f*/2 lens would require 1/60 second for the similar exposure.

As should be expected, for a given brand of lenses, focal length, and camera, the faster lens is considerably more expensive and a bit heavier and bulkier. Faster lenses require larger sized and, therefore, more expensive filters than do slower lenses. Usually, the faster lenses sacrifice a bit in sharpness. The choice between faster or slower lenses is a compromise between advantages and disadvantages, as is true of many areas in photography.

On all adjustable lenses, the apertures can be set at any place between the *f*/stops indicated on the scale. Some lenses have click stops which are felt and heard when the lens is adjusted to different apertures. The clicks are at half-stop and full-stop intervals. The diaphragm can be set anywhere on the *f*/stop scale that the photographer finds desirable, regardless of the click stops. Especially on color positive (slide) film, a one-third stop difference in exposure affects the color saturation and the effectiveness of the picture. Use and memorize one-third and one-half stops and be aware of their relationship to each other to help in keeping records of the exposures and in comparing results (Fig. 10-7).

Every adjustable lens has a certain range of apertures where it gives a sharper image on the film than at other openings. This is termed critical aperture. The manufacturers quite consistently establish this

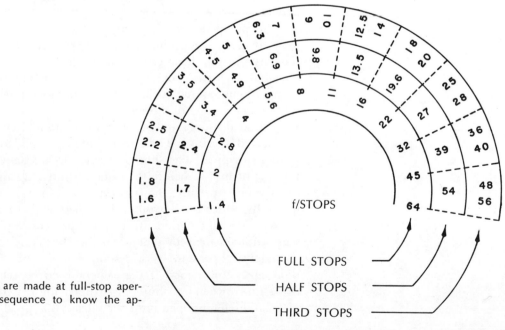

10-7 Not all pictures are made at full-stop apertures. Memorize the sequence to know the approximate *f*/stop used.

for each lens in the middle range of possible diaphragm settings. The area of critical aperture usually is one to two stops from the smallest aperture and three stops or so from widest lens opening. The sharpness of image does not refer to objects outside the depth of field, as explained in the following chapter.

LENS AUTOMATION

Various lenses for single-lens reflex cameras may operate quite differently. Because viewing, framing, and focusing are done through the lens, it is desirable to have the lens at its widest aperture to give the brightest field possible. This is especially important when operating in low light levels. However, only a small percentage of pictures are taken at the largest diaphragm opening. The lens is closed down to the chosen aperture before the shutter is released. It depends on the individual lens whether the closing down is done manually or automatically. The provisions or methods used are:

1. Click stops.
2. Preset.
3. Semi-automatic.
4. Automatic.

On lenses with click stops only, the operator first focuses, then closes down the lens manually as he looks at the f/stop scale, or counts the clicks to the desired stop while still framing the picture, all before he trips the shutter.

The preset lens may or may not have click stops. The f/stop is preset by a mechanical means which varies from brand to brand. When the lens is preset, the aperture ring is blocked or stopped at the selected opening. The lens is open for focusing and framing, then in one motion, without looking at the scale, the photographer turns the aperture control against the solid preset stop.

The semi-automatic lens, with or without click stops, is set for the preselected aperture. The lens is wide open and remains so until the shutter is tripped. The shutter release mechanism closes the lens down just a split instant before the camera shutter opens. To open the lens to its widest aperture, the lens (not the camera) needs to be recocked manually, which is the reason it is termed semi-automatic.

With the automatic lens, the same procedure is followed as for the semi-automatic, except that when the shutter is released the lens immediately reopens to its widest aperture. This feature needs to be thoroughly understood if the camera is to be set on "T". The lens closes down when the shutter is tripped the first time, opens immediately, and remains open until the release is tripped to close the shutter.

Any time the lens is set for less than the widest aperture, the picture will be given more exposure than was planned. The "B" setting does not present this problem because the continued pressure on the shutter release for the total exposure maintains the lens aperture setting.

If the automatic lens is made for a camera with a shutter setting of "T", there will be a device to take the lens off automatic so it may be manually set.

The automatic camera lens will be about double the cost of the same brand in a preset lens. The automatic lens works much more rapidly and will save many a picture unless and until the photographer becomes proficient at remembering to close down the nonautomatic lens. It can really be confusing, but not impossible, when one uses all four types of lenses! It is necessary to thoroughly understand the mechanics involved.

NORMAL, WIDE-ANGLE, TELEPHOTO AND ZOOM LENSES

Lenses are generally termed normal, wide-angle, and telephoto according to their focal length and the size of the camera on which they are used. The normal lens for a given camera is approximately the diagonal of the film frame or negative, but this is a very flexible rule. For example, consider the normal lenses for the 35mm camera and the 2¼ x 2¼ camera compared to their negative diagonals. The 35mm negative has a diagonal of just over 43mm; yet, a normal lens may range from 45mm to 58mm in focal length, with the 50mm probably the most popular. The diagonal of the 2¼ x 2¼ is just under 81mm and the accepted normal lens is 75mm, 80mm, or 85mm.

A lens of shorter focal length than normal is wide-angle. It covers a wider angle of view than the normal lens. A lens longer than normal is termed a telephoto and gives a narrower angle of view. There are indefinite divisions within the wide-angle and telephoto classes, also. For a 35mm camera, a 35mm focal length lens is a wide-angle; a 21mm is a very wide-angle; an 18mm lens is an extreme wide-angle. An 8mm lens is termed a "fish-eye." Telephotos are classed as moderate in the 75mm to 100mm range; medium long from 110 to 200mm; longer ones to 300mm. They are made in even longer lengths for the 35mm camera. Other size cameras that take interchangeable lenses offer similar assortments of variable lengths but are appropriately termed wide-angle and telephoto at different lengths than on the 35mm lens.

A lens is interchangeable when the whole lens assembly is removable from the camera body so another lens can be substituted. The two most popular methods of attaching interchangeable lenses are the threaded screw-in mount and the bayonet mount.

The interchangeable lenses for rangefinder cameras are more lim-

ited in their lengths with the most made for rangefinder cameras with focal-plane shutters. A separate viewfinder is substituted on top of the camera for the built-in viewfinder when a different length lens is attached.

The single-lens reflex cameras offer a much wider range of interchangeable lenses. Cameras without the focal-plane shutter are limited in the lengths of lenses offered. On some cameras a front portion of the lens is removed and another unit, termed a component lens, is substituted to give a different focal length.

Single-lens reflex cameras with focal plane shutters offer the largest assortment of interchangeable lenses, especially in the 35mm format. Telephotos as long as 1500mm are made for some 35mm cameras. Other sizes of cameras do not have so many lenses with so extensive a range in focal lengths, but there are numerous ones of both wide-angles and very long telephotos.

The image size on the film is changed in direct proportion to the change in focal length. If the focal length is doubled, the image size on the film is doubled when photographed from the same camera-to-subject distance. If the focal length is halved, then the image size is reduced by one half from the same camera position.

As the focal length is changed, the angle of field covered is changed. This is measured and expressed as the angle of field diagonally of the film frame (Fig. 10-8).

Zoom lenses are constructed so that focal length can be adjusted, offering an infinite range of magnification within the limits of the particular equipment. At any given focal length the zoom lenses do not give quite as sharp an image as do the individual telephoto lenses of the same focal length in the same quality range. Zoom lenses are heavier than the single focal length lens, somewhat more tiring, and difficult to hand hold. Even so, for many types of photography, the zooms are most satisfactory and offer some kinds of picture taking that are impossible to do with the regular telephoto lenses.

Besides the magnification and change in the angle of field covered, the various focal length lenses give different effects, referred to as distortion. This is not related to the aberrations sometimes found in lenses normally corrected in manufacture. The distortion peculiar to the different focal lengths can be used creatively or it can detract from the picture when improperly used. The photographer needs to be aware so he may avoid distortion when it is undesirable but use it when it will give accent or emphasis (Figs. 10-9–11).

CHOICE OF FOCAL LENGTH

The choice of the focal length for a particular photographic problem affects the results. The subject, problems, and goals determine which

DIAGONAL ANGLE OF VIEW OF LENSES ON 35MM CAMERAS

Focal Length of the Lens	Angle of View (lens focused at infinity)
21mm	92°
28mm	76°
35mm	64°
50mm	45°
105mm	23°
135mm	18°
200mm	12°
300mm	8°
500mm	5°

10-8

10-9 An extreme wide-angle (Fish-eye) lens on a 35mm camera produced this image. Note position of the tree branches and gravel bar.

10-10A A moderately long telephoto (135mm) gives a different image with the motorcycle and model in the same exact area. Where is the gravel bar now?

10-10B A 300mm lens narrows the stream and puts the tree branches all but in the model's face. Compare with the fish-eye view.

10-11 (Left) A normal lens view (58mm). Check comparative distances.

to use. For the 35mm camera owner, these very general suggestions may offer some guidance.

For interiors of moderate to small rooms, a 28mm wide-angle lens is practical. Portraits of individual people are effective with the 90mm to 105mm telephoto. Many photographers enjoy using a lens in this range as the normal one. The popular 135mm lens is actually a compromise between the 100mm lens and the longer 200mm length for the photographer who feels he wants to buy only one lens. A 200mm to a 400mm lens is excellent for wild animals and birds. The distance, size, timidity, or viciousness of the wildlife determines which is best. The 200mm is probably as long a lens as the average photographer can handhold. Because of the extreme magnification, long telephotos require much steadier support and shorter shutter speed than do the normal, wide-angle or more limited length telephoto lenses.

For photographers who do a great deal of close-up focusing, the macro lens which focuses as close as two and a half to four inches, and, also, to infinity can be used as a normal lens. A handicap is that the macro lenses are slower than most normal lenses, with an $f/2.8$ the fastest usually available. $F/3.5$ lenses are more common in this type.

ACCESSORIES FOR MAGNIFICATION OF IMAGES

Supplementary equipment is used to aid the camera lens in magnifying the image on the film or to focus at closer than normal subject to-camera distances. Accessories available for this purpose are:

1. Lens extenders or converters.
2. Close-up lenses.
3. Tubes.
4. Bellows.
5. Reverse adapters.

Extenders or Converters

There are numerous other names attached to this type of equipment but these are the ones more commonly used to identify supplementary lenses that are inserted between the camera and lens to lengthen the focal length of any interchangeable lens. Extenders may increase the focal length of any lens 1.5×, 2×, or 3×. Some converters may be set to give a 2×, 2.5×, or 3×. Others are available to zoom from 2× to 3×. They can be used in pairs to increase the focal length still more. The focusing distance scale of the camera lens remains correct. There is some loss in definition as compared with the same lens without the converter, but still image detail is maintained at acceptable levels in most instances. Lens speed is decreased. Two stops are lost with the 2×, two and one-half to three stops with the 3× converter. Cameras

with through-the-lens metering give the correct readings without special adjustments when extenders are used.

Extenders are lighter to carry, are much less expensive than telephotos, and can be used with any or all interchangeable lenses that fit the particular camera. Many converters retain the automatic features of both camera and lens. The versatility, cost, and convenience offered offset the slight loss in picture quality and lens speed for many photographers.

Close-up Lenses

While the very new student of photography may not be ready to try close-up photography at this point in his study, it is appropriate to become aware of devices that permit focusing closer than normal. The procedures involved with each type of close-up equipment can alert him in his choice of equipment.

Close-up lenses are easiest of all close-up equipment to use because they require no exposure compensation. Variously termed portrait or portra lenses, they are attached to the front of the camera lens in one of several ways. They may have a slip-on ring that relies on friction, screw into the front of the camera lens, or drop into an adapter ring that is fastened to the camera lens. Lenses and filters may be used in combination. The screw-in type of lens or filter just screws into the previous one all in one diameter each to fit a particular lens diameter. The drop-in lenses require retaining rings that screw into the adapter, which is purchased in a series size (4 to 9) to fit the specific lens.

Close-up lenses are designated as plus 1, plus 2, and on to plus 10. The higher the numeral, the closer to the camera lens that the subject can be focused. A plus 3 on a 50mm lens permits focusing a subject as close as 10 inches from the lens with an adjustable focus 35mm camera. A plus 10 close-up lens lets the same camera and normal lens focus on a subject four inches from the lens.

As many as three close-up lenses can be used in combination. The sum of their numerical titles equals their effect. A plus 2 and a plus 3 give the same size image as a plus 5. With a collection of four lenses, the plus 1, plus 2, plus 3 and plus 5, the complete range from 1 to 10 is possible. A plus 6 is the highest-numbered lens practical for the rangefinder and twin-lens reflex cameras. The full range is very usable with the 35mm SLR cameras because through-the-lens viewing simplifies framing and focusing.

For the SLR camera only, there is a zoom type of close-up lens being made by several manufacturers (Fig. 10-12). This lens attaches to the front of the camera lens by screwing it into a series 7 adapter ring. The variable strength lens is more expensive than an individual close-up lens but probably not as costly as purchasing the four sug-

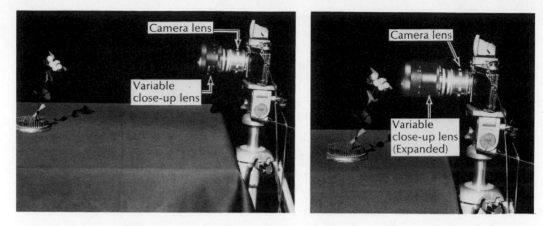

10-12A The snow berries are in focus at this distance with the variable close-up lens fully collapsed and mounted on a 50mm lens.

10-12B A snow berry is in focus at this distance with the variable close-up lens extended to its maximum and mounted on the same lens.

gested. A big advantage with the variable close-up lens is the infinite range from plus 1 to plus 10 in one piece of equipment without unscrewing and rescrewing the individual close-up lenses numerous times for covering various sized fields of subject matter.

Both the area covered by the lens and the depth of field (explained in the following chapter) are progressively less as the lens is moved closer to the subject. Careful and exact measuring is necessary with all rangefinder or twin-lens reflex cameras. The appropriate measurements are provided with close-up lenses by the manufacturer. Parallax correction is *not accurate* with close-up lenses added.

The twin-lens reflex viewfinder is accurate if the close-up lens is attached on the viewing lens while framing and then placed on the taking lens. Before the picture is made, the camera must be raised the exact distance between the horizontal center of the viewing and taking lens. Mark this distance on the tripod center post or use a device made for the purpose between the tripod and camera.

Tripods are required for rangefinder cameras for successful close-up photography unless a framing and measuring device is used. There is one made for Instamatic cameras and there may be others. The photographer can make his own framing and measuring device for a given camera and lens combination. Tripods are necessary for the twin-lens reflex camera to assure exact distance of rise when the camera is shifted from the viewing to the taking position. Tripods are a distinct aid with the single-lens reflex camera, too, especially when working with the higher numbered close-up lenses.

STEPS IN MAKING A PICTURE WITH A CLOSE-UP LENS

For the Rangefinder Camera:

1. Camera mounted on a tripod unless a framing device is attached to the camera.
2. Choose subject to photograph and arrange it.
3. Measure height and width of subject.
4. On the chart packed with the close-up lens, locate the dimension closest to those obtained in step 3, in the column that refers to the camera lens and negative size. To the left, the close-up lens that will cover that area will be indicated.
5. Attach the appropriate lenses to the camera lens, largest numbered one first, in decreasing order, with a filter last if it is needed. All lenses should be placed on the camera with the concave side toward the camera and the convex (bulging) side away from the camera toward the subject. Attach the lens hood!
6. Ignore the focusing viewfinder. Refer to the chart in "Footage Setting on Camera" column. Find the distance to focus horizontally from the subject dimensions. Focus the camera at this distance.
7. The "Inches from Subject to Close-up Lens" column gives exact distance that must be measured *accurately* from subject to close-up lens, not the lens hood or filter!
8. Framing in the viewfinder is useless. Frame by sighting along the lens above and to each side so that it is pointed at the exact center of the frame planned for the subject.
9. Recheck:
 a. Distance from close-up lens to subject.
 b. Distance lens is focused.
 c. Alignment of lens with subject.
10. Decide on correct exposure and shutter speed. Close-up lenses require no compensation. Compensate for filter if one is used.
11. Take the picture!

For the Single-lens Reflex Camera:

1. For most people, the camera on a tripod is mandatory when using more than a plus 5 close-up lens.
2. Choose subject and arrange it as desired.
3. Attach close-up lens or lenses to the camera lens with convex (bulging) side toward the subject. The highest numbered lens is put on first, then next highest. Filter, if one is used, is last. The lens hood is important on close-ups, too!

4. Frame the subject in the viewfinder. The depth of field at very close distances is extremely limited so that shifting the subject or the camera a very small fraction of an inch can throw the picture in or out of focus. A focusing rail such as the Proxiscope is a wonderful aid in this process. The Proxiscope is attached to the tripod and the camera to the Proxiscope. It is easier to make the minute change in framing to bring the subject in view and then to focus.

5. Numerals on the camera lens will not correspond to the camera-to-subject distance but *do use* the focusing ring for focus control. Ignore the depth-of-field scale. Use the depth-of-field previewing device, if the camera has one.

6. Decide on exposure. Close-up lenses require no compensation in exposure but most filters do. BTL meters will automatically do this. Set shutter speed and f/stop.

7. Take the picture!

Of additional interest to photographers is a one-half close-up lens with no glass in the opposite portion of the lens, so that one-half the picture may be made of a subject very close to the camera while the other half may show subjects at infinity. This split-field close-up lens is suitable for the SLR camera only. At present, the lens is available only in a plus ½, plus 1, plus 2, and plus 3 in series sizes 6 to 9 (Fig. 10-13). Others may appear soon.

Tubes and Bellows

Tubes and bellows are made only for SLR cameras with interchangeable lenses (Figs. 10-14, 15). Tubes and bellows serve as light traps to move the lens further from the film plane to permit focusing on subjects closer to the lens than is otherwise possible. In doing this, the image is enlarged on the film, even magnified beyond life size with sufficient extension of bellows and/or tubes. Both require exposure compensation. With BTL or TTL metering, this will be indicated automatically.

Tubes, sometimes called rings, are made of rigid metal in varying lengths that can be attached to the camera, to each other, and to the lens in the same manner the lens is attached to the camera. The longer the tube or series of tubes between the camera and lens, the closer the lens can be to the subject and still be focused, and the larger the image on the film. There are tubes made to give infinite or zoom adjustments within their limits. This type can save time in changing the tubes to have the right length when shifting to different size subjects. Tubes are generally considered more rigid than bellows. Some tubes are made to retain the automation of the lens when they are mounted together.

10-13A (Left) The split close-up lens on the barb permits a distant subject to be focused in combination.

10-13B (Above) The blurred area between the close-up and no-glass section is not as evident because of different placement.

Bellows offer a wide range of infinite flexibility in distance between the camera and lens and then in subject size on the film within the limits of the equipment. Bellows attach in the same manner that the lens attaches to the camera. Some bellows are made to keep the lens automatic. Double cable releases can be used for the nonautomatic bellows and tubes.

Tubes and bellows may be combined between the camera and lens and close-up lenses can be used on the front of the camera lens also, if necessary, to get as close to the subject as desired. There comes a point where the normal lens can prevent light getting to the subject when the subject is too close. Telephoto lenses, 100mm or 135mm, can be advantageous with such situations though they do give less magnification with the same bellows or tube extension.

Exposure compensation is determined by the camera-to-lens distance measured from the front of the camera to the back of the lens, where it attaches to the camera when in normal operation.

BTL meters automatically compensate and indicate the correct exposure as in normal operation. For the hand meter or meter on the camera, the problem is a bit more complex. (Chapter 12, Exposure.)

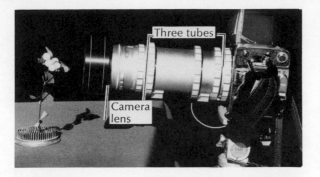

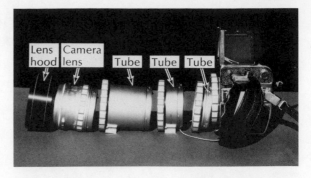

10-14A Three tubes, each a different length, are mounted behind the normal lens (85mm) on a 2¼ x 2¼ camera to photograph the snow berries at this distance. The tubes may be used singly, in pairs, or all together to provide a varied range of lens-to-subject distances.

10-14B The breakdown of the individual tubes and lens assembly. These tubes are automatic. They close down the lens to a preselected aperture when the shutter is tripped.

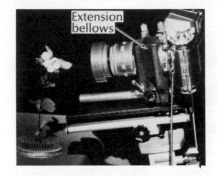

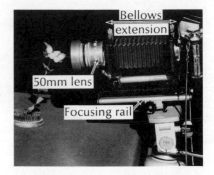

10-15A The collapsed bellows mounted between the 50mm lens and 35mm camera will photograph the entire group of snow berries at this distance.

10-15B When extended the same combination of equipment will photograph only one berry at this distance.

Reverse Adapters

Reverse adapters allow the lens on SLR cameras to be mounted in reverse position, which then permits closer lens-to-subject distance. This magnifies the subject in the film image. There is only a single specific magnification and limited subject-to-lens distance range for each focal length lens. There is a loss in lens speed. The reverse adapter is quite inexpensive and certainly less bulky and lighter to carry. Within its limitations, the results are excellent. No additional glass is added to degrade definition.

If bellows or tubes are inserted between the reversed lens and camera, then variable magnification and lens-to-subject distance are available.

MACROPHOTOGRAPHY, PHOTOMICROGRAPHY AND MICROPHOTOGRAPHY

When close-up equipment is used, the image on the film may be smaller up to a few times larger than the subject. This is termed macrophotography. Photographs taken through a microscope is photomicrography, sometimes incorrectly called microphotography, which is the recording of many documents or extensive printed material on very small sections of film.

In order to determine the best shutter speed and lens aperture combination for a given situation, it is important to understand depth of field, the subject of the following chapter.

REFERENCES FOR FURTHER READING

Arnold, Rus: "The F/Stop," *U.S. Camera,* Vol. 30, No. 4, April, 1967, pp. 40f.

Eastman Kodak: "Close-Up Pictures of Flowers and Other Small Objects using Kodak Instamatic and Brownie Star Cameras," pamphlet AB-11. Rochester, Eastman Kodak, 1966.

Cox, Arthur: *Photographic Optics,* New York, Amphoto, 14th ed., 1971.

Farber, Paul: "(Almost) All About Close-Up Photography," *Petersen's Photographic Magazine,* Vol. 1, No. 5, September, 1972, pp. 46f.

Gaunt, Leonard: *Lens Guide,* New York, Amphoto, 1972.

Neblette, C. B.: *Photography, Its Materials and Processes,* "Photographic Optics," Chapter 4, and "Photographic Lenses," Chapter 5, pp. 65f. Princeton, New Jersey, D. Van Nostrand Co., Inc. (Highly technical.)

Perkins, Gwen and Carroll: "Want Bird Close-Ups? Call them with Tape," *Popular Photography,* Vol. 67, No. 1, July, 1970, pp. 74f.

Rothschild, Norman: "What You've Always Wanted to Know About Close-Ups," *Popular Photography,* Vol. 68, No. 2, February, 1971, pp. 76f.

Scully, Ed and Herbert Keppler: "Fisheyes: Some are Better than Others," *Modern Photography,* Vol. 33, No. 4, April, 1969, pp. 68f.

Scully, Julia and Ed: "Portraits: From 20mm to 500mm," *Modern Photography,* Vol. 33, No. 4, April, 1969, pp. 76f.

Sussman, Aaron: *The Amateur Photographer's Handbook,* "All About the Lens," pp. 37–60. New York: Thomas Y. Crowell Co. 7th ed., 1968.

CHAPTER 11

Depth of Field

The importance of understanding depth of field, and how to use the principles involved, cannot be overstressed. The depth-of-field scale on camera or lens is so often ignored by the novice, yet the scale is a most valuable means for saving time, film, and pictures. Control of depth of field is definitely a tool for creativity. Best of all, the factors involved are simple to apply, especially if the lens has a well-marked scale.

WHAT IS DEPTH OF FIELD?

Depth of field is the depth or distance of the area between the point closest to and the point farthest from the camera in which the subject appears in acceptably sharp focus in the picture (Fig. 11-1).

Depth of field is sometimes mistakenly called depth of focus. Depth of focus refers to the distance in front of and behind the focal plane of the lens that gives acceptably sharp focus. In other words, depth of focus refers to an area within the camera rather than the subject of the picture (Fig. 11-2). The depth of focus is of concern to the photographer only if the manufacturer has failed in the construction of the camera to place the film plane properly to give sharp focus. The discussion of this chapter is concerned only with the areas of the subject that are or are not sharp in the picture.

The reader can demonstrate for himself, with his own eyes, the meaning of the definition of depth of field. The camera lens resembles the human eye in many ways, particularly in the variations of depth of field. The eye has a distinct advantage in its ability to refocus instantly as attention shifts. One must be observant to recognize the change. The camera lens is mechanically adjusted to change focus.

For the following experiment, read the whole set of instructions for each step before starting it.

1. Look at a line of printing on the upper one-third of this page. While concentrating on the printing, observe the indistinctness of lettering several inches above or below that line. Maintain the point of vision on the same line, and check the sharpness of objects

in the line of vision straight ahead of the book at about 5, 10, and 15 foot intervals.

2. Maintain the same position as in step 1, but look at an object 5 feet away. At the same time, consciously observe the depth of the area in front of and beyond the object that is sharp. How distinct is the book? The objects at 10 feet? At 15 feet?

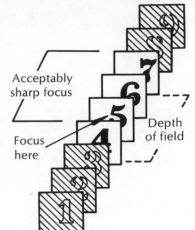

11-1 (Right) When the lens is focused on "5," cards "4" through "7" are in focus under the particular set of factors used for the drawing.

11-2 (Below) A comparison of the change in areas in focus (depth of field) when the subject is closer or farther from the camera lens as it would be in the picture. This is not a scale drawing.

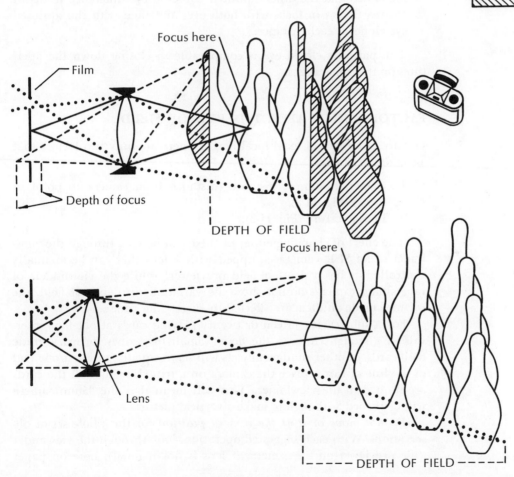

3. Continue with the same objects in the line of vision, and focus the eyes on an object at 10 feet. Note the depth of the area in focus. What has happened to the book?

4. Look out a window at a view that extends for some distance. Note the increase in the depth that appears in sharp focus, from perhaps thirty feet or so up to several miles.

If this experiment has been effectively done, it is evident to the reader that the depth of the area that is in acceptably sharp focus is quite shallow when the eyes are concentrated on a close object (the printing). The depth of the area of sharpness increases rapidly as the distance from the eyes to the subject is increased. The same is true on the camera lens. Proceed with step 5.

5. Use the same objects of steps 1, 2, and 3. Repeat steps 1 through 3, but this time look first with both eyes opened and then with one eye closed and the other squinted. Observe the difference in depth of area that is in focus with both eyes and then with the squinted eye alone, at each distance.

The partially closed eye is comparable to closing down the apertures on the camera lens.

FACTORS THAT AFFECT DEPTH OF FIELD

On any given lens of fixed focal length, there are only two factors that affect depth of field:

1. Camera-to-subject distance (distance from camera to point of focus) (Fig. 11-2).
2. Lens aperture (Fig. 11-3).

The effect of changing either of these can be seen through the viewfinder of an SLR camera equipped with a lens that can be manually controlled or has a depth-of-field previewer. While the viewfinders of rangefinder cameras do not show the variations in depth of field, the pictures made on them are affected in exactly the same way.

For a subject, lay fifteen or twenty playing cards at one-foot intervals in a straight line on the floor. (Small magazines, primary grade flash cards, or other similar subjects will serve equally well.) At one end of the line of cards, place the camera on a tripod, so that all the cards are framed in the viewfinder. This will mean that the 35mm camera will be turned as though to make a vertical picture.

Do not move or shift the camera position for the whole set of observations. With each suggested operation, look through the viewfinder (use previewer on the camera, if lens is not manual); note on paper

the number of cards in front of and the number behind the one focused upon that is in reasonably sharp focus:

With the lens at widest aperture:

1. Focus on a card at the nearest distance possible on the lens's focusing scale.
2. Focus on a card 4 feet from the camera.
3. Focus on a card 10 feet from the camera.
4. Focus on a card 15 feet from the camera.

11-3 A comparison of depth of field with change in lens aperture.

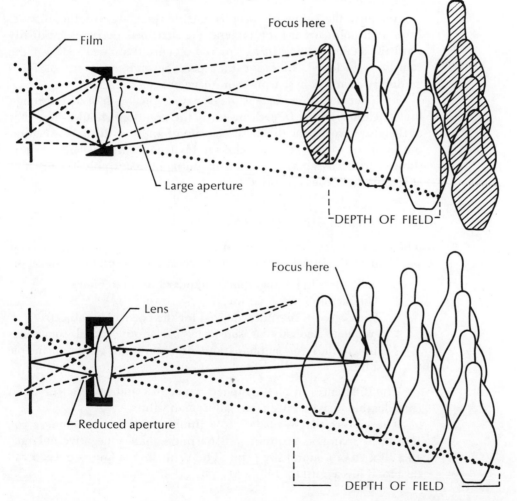

With the lens focused on a card 8 feet from the camera, note the number of cards before and the number after the point of focus that are sharp.

5. Open the lens to its widest aperture.
6. Change the aperture to $f/5.6$.
7. Close the lens to its smallest aperture, $f/16$ or $f/22$. If there is insufficient light to see the areas that are in or out of focus, open the lens to the first stop that will give sufficient light. Note the lens aperture with the other observations.

Depth of field is greater as distance from the camera-to-focused point is increased and as the lens aperture is closed down (Fig. 11-4). Obviously, then, the area in focus (depth of field) will be less as the lens is focused closer to the camera and as the lens diaphragm is opened wider.

Actually, the point of focus is the sharpest area of the picture. From that point toward the camera, the sharpness decreases gradually until the subject is indistinct or totally obscure if an area too near the camera is included. Likewise, the space beyond the point of focus gradually decreases in sharpness of image but not as rapidly.

Study the notations made while observing the depth of field through the SLR camera lens. In each instance, the notations should show that of the area in focus one-third was in front of and two-thirds was behind the point of focus. This principle holds true with any lens, on any subject, with any aperture, unless or until the focus point nears or is at infinity on the lens involved.

ACCEPTABLE SHARPNESS

There is no exact location behind or in front of the point of sharpest focus where the blur of out-of-focus becomes unacceptable because of:

1. Differences in photographers' standards or preferences.
2. The picture's potential use.
3. The degree of sharpness desired for the particular subject.
4. Frequent necessity of soft-focus backgrounds and sometimes foregrounds for emphasis and/or separation of the principle subject.

The differences in photographers' standards and preferences are at considerable variance, just as are all human values.

The picture that is made into a jumbo print for the family's collection of snapshots requires less sharpness than a negative enlarged to a 16 x 20 or a mural size print. The print that is fine as a 4 x 5 can be a total loss as an 11 x 14.

DEPTH OF FIELD
50mm LENS
Focused distances

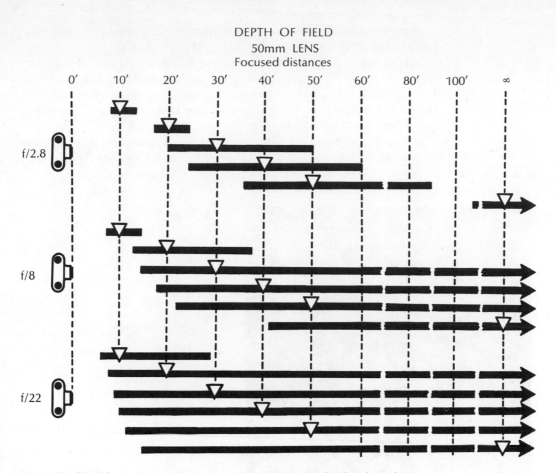

11-4 The black bar indicates the area in focus. Notice the bar breaks indicate an increase between distances in the vertical dotted lines.

More softness of image is tolerated on the projected color slide than in an enlarged print; still the degree of sharpness is very important. The larger the screen used, the greater the necessity of good definition.

Some subjects need the ultimate in sharpness. The character study is one example where it is desirable to show skin texture to the point that every pore and whisker is razor sharp. The average woman over twenty appreciates considerably less sharpness in her portrait. Most photographers prefer a sharp negative; then they may soften the focus in printing. Others buy special portrait lenses made to give a softer focus to minimize wrinkles and other skin flaws. In focusing, the eyes of people or animals always should be the sharpest part of the portrait.

Focus, with all subjects as with portraits, depends on the photographer's preference and what he is trying to portray.

Many times, it is effective to throw backgrounds out of focus in order to make the center of interest more important (Figs. 11-5,6). Occasionally, throwing the foreground out, also, or instead, can help the photograph express the purpose or idea best, though this technique is less popular (Figs. 11-7,8).

Controlling depth of field in all of these situations is simplified and quick with the depth-of-field scale that is on all better lenses and

11-5 Apache, the dog, separates well from the quite similar tonal values of the grass. Compare with Fig. 11-6.

11-6 The same subjects photographed with close areas in focus. It is more difficult to separate dog and grass.

11-7 (Above) The brush out of focus shows the animal legs better than had the growth been in focus. Taken with a 400mm lens. Notice the very narrow band of in-focus plants, both behind and in front of the subjects.

11-8 (Right) Below Athabaska Falls near Jasper, Alberta, Canada, maximum depth of field is required to get the small shrub and the more distant detail in acceptable focus.

cameras. For those cameras or lenses without a scale, many manufacturers include depth-of-field tables or charts in the operational leaflet that is packed with the camera. Photography supply stores have pocket size booklets with depth-of-field dials.

THE DEPTH-OF-FIELD SCALE

The depth-of-field scale is usually adjacent to the focusing scale on a camera or lens and is used in conjunction with the distance indications (Fig. 11-9). On most cameras, the lens's apertures are shown in a double sequence, with one set in reversed order, similar to a mirror image. Not all ƒ/stops may be shown, but lines will usually indicate those omitted (Fig. 11-10). On other cameras, two markers shift posi-

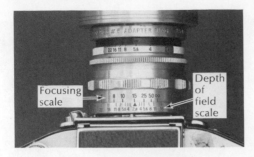

11-9 The depth of field scale is on a stationary portion of the lens adjacent to the rotating focusing scale.

tion as the aperture ring is turned (Fig. 11-11). On the Nikkor lenses, the lines are color coded to the color of the f/stop numbers on the aperture scale. The numbers on the depth-of-field scale are omitted.

To determine the area in acceptable focus at any given f/stop and focused distance, check on the footage between the two lines that lead from that aperture number or between the two movable markers (Figs. 11-9–11). A comparison of depth of field on two lenses of the same focal length may show variation.

Each focal length of lenses has a specific depth of field for any given combination of f/stop and focused distance. However, one lens maker may maintain more critical margins of safety than another. This is

11-10 On this 85mm lens, some f/stop numerals and even some of the lines are omitted. To read the depth of field at any f/stop with the camera focused at approximately 70 feet, follow the f/stop line through the distance scale. Read the near and far distances. At f/22, the near distance is about 35 feet, the far distance is at infinity. Estimate from the scale the near and far distances at f/8.

11-11 With the movable markers the diagonal shaded areas lead into the distance scale to indicate the depth in focus. With the f/2.8 setting the markers point to the line to follow.

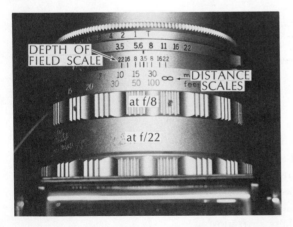

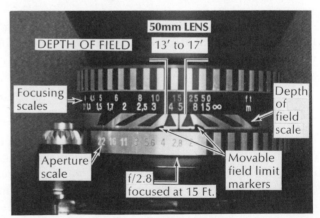

especially true of the producer of cameras and lenses that are usually purchased by professionals or advanced amateurs. The cameras used by the novice or casual snapshooter do not need this extra margin because, as indicated before, they are used for smaller-sized prints and projection at smaller magnifications. If one lens seems to give greater depth of field than another of the same focal length, the overall sharpness of the lens is less, so by comparison the softness of objects further from the point of focus is less obvious in the picture.

At any given combination of *f/stop* and *focused distance*:

1. The shorter the focal length of the lens, the greater is the depth of field. The wide-angle camera lens gives greater depth of field than does the normal lens. The wider the angle (shorter focal length), the more depth recorded (Figs. 11-12,13D).

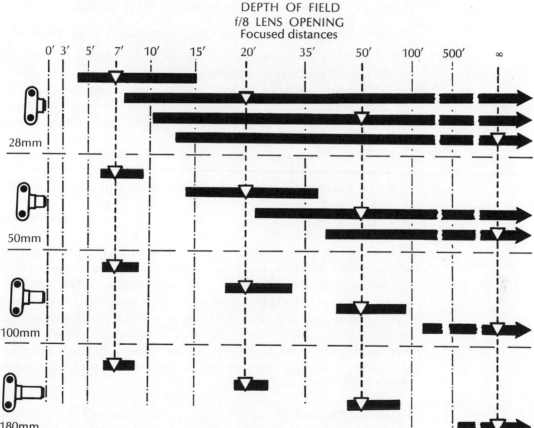

DEPTH OF FIELD
f/8 LENS OPENING
Focused distances

11-12 Note irregular distances on the columns to indicate focused footage. The horizontal bars give a comparison of depth of field on the various focal lengths of lenses all set at f/8.

2. The longer the focal length of the lens, the shorter is the depth of field. The telephoto camera lens has less depth of field than the normal lens. The longer the telephoto, the less depth recorded (Fig. 11-12).

When different focal lengths of lenses are used at the same f/stop to make images of identical size on the film, the depth of field is the same. The focused distance varies if the image proportions are equal.

The zoom lens owner must be aware that in varying the length of the lens the depth of field alters with each change in focal length. The differences are indicated on the depth-of-field scale of some lenses. Not all zoom lenses have such a scale. In these cases the photographer checks through the previewer to ascertain if depth of field is that desired.

WAYS TO UTILIZE THE DEPTH-OF-FIELD SCALE

There are five ways in which to use the depth of field scale. They are:

1. To check, then use or reject, the depth of field for a particular aperture and focused distance.
2. To secure maximum depth of field for a given aperture by hyperfocal distance focusing.
3. To prefocus for pictures near the camera (not close-ups with accessories) by zone focusing.
4. To secure maximum blurring of background by forefocusing, sometimes called selective focus.
5. To preset the camera for quick operation equivalent to a non-adjustable camera.

Choice of Depth of Field

As indicated in the previous chapter and as further explored in the next chapter, the same exposure can be accomplished with several combinations of shutter speeds and lens openings. When the photographer checks the depth-of-field scale and finds he gets a shallower depth of field than desired, he switches to a slower shutter speed and smaller aperture. In the reverse situation, if he finds the depth greater than needed, he shifts to a faster shutter speed and larger aperture. More often, compromise between the desired shutter speed and depth of field is the only solution.

Hyperfocal Distance

Many people automatically focus at infinity in taking a landscape. Subjects in the foreground that may be desirable as lead-in or to give perspective are either so soft focus or so far distant that neither goal

is accomplished. Using the smallest aperture of the lens helps but there is an additional, very effective method: hyperfocal distance focusing.

Maximum depth of field at any given aperture is accomplished by focusing at the hyperfocal distance for that f/stop. The simplest way to arrive at hyperfocal distance and check the depth of field is:

1. Decide on a tentative lens opening for the exposure.

2. Set the infinity symbol on the focusing ring at the f/stop mark on the depth-of-field scale (Fig. 11-13).

3. The point of focus or distance focused is the hyperfocal distance for that aperture (Fig. 11-13).

4. The nearest-to-the-camera point at which the subject is acceptably sharp is one-half of the focused distance. This is verified by checking the opposite side of the depth-of-field scale (Figs. 11-13,14).

If the tentative lens aperture does not yield sufficient depth of field, perhaps the lens can be closed down further. This requires a change in shutter speed. When less depth is required, a faster shutter speed with wider aperture is practical if advantageous for the subject. Setting the camera for hyperfocal distance has an added advantage. When a series of pictures is to be made at the same exposure settings, no additional focusing is necessary as long as objects are no closer to the camera than the near limit shown on the scale. The camera is operated as a simple, nonadjustable camera. All that needs to be done is frame for the best composition and trip the shutter release!

The photographer with a camera that has an overgenerous depth-of-field scale can still use the principles involved but may adjust to protect sharpness. He can conservatively set the infinity symbol one stop below the aperture actually used for the exposure. For example, if he is going to take the picture at f/16, set the infinity mark at f/11, to utilize hyperfocal distance at f/11, instead of f/16, and thus gain the extra margin of safety. Do not include anything closer than one-half the focused distance to maintain the margin of safety on near objects.

Zone Focusing

Often the time required to focus will cause the loss of the picture. To guard against this, especially on moving subjects, prefocus by zone focusing. If the subject may be or is confined to a given area or can be anticipated to move into a particular range, zone focusing is a practical way to be ready to make the picture at the opportune moment. To zone focus, decide on the appropriate aperture, then focus so that the near and far ranges of the depth of field include the distances within the confined area or range for the subject.

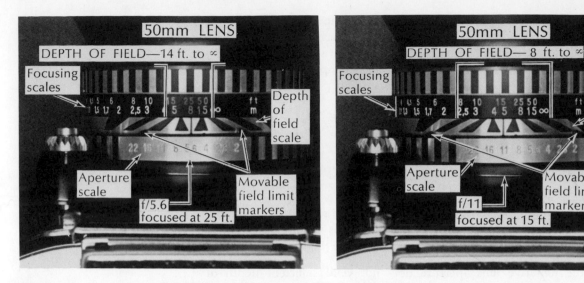

11-13A The camera focused at 25 feet at *f*/5.6 gives much more depth than in Fig. 11-11. The infinity mark is set at the *f*/stop used for hyperfocal distance. Compare on an adjustable lens the near distance when the focus mark or arrow is set at infinity.

11-13B Infinity set at the *f*/stop permits closer focus at *f*/11 than at *f*/5.6, with still greater depth of field. Compare depth on another lens with focus at infinity and at *f*/11.

Use either of two ways to arrive at the boundaries of a zone. Consider children playing in a sandbox that is about three feet across. The photographer finds the point from which it is most appropriate, in lighting and angle, to take the picture. He next focuses on the near boundary of the sandbox. Assume that it is 5 feet away. Focus on the far boundary. Assume it is 8 feet. Set the 8 feet of the focusing scale at the far mark of the *f*/stop to be used on the depth-of-field scale. Next, check the near *f*/stop to see if the 5 foot mark falls within the depth for that aperture. If so, no further focusing is necessary as long as the children stay in the sandbox and the photographer maintains his five feet from the near boundary of the box.

An alternative method of zone focusing is to estimate one-third of the distance into the sandbox and focus that spot sharply, then close down the lens manually or use the previewer to determine whether the depth of the whole box is sharp.

Should the children be standing around, rather than in, the sandbox, one stop smaller aperture may give the extra margin of safety needed for desired depth of field.

Forefocusing

Sometimes distracting backgrounds are all but obliterated by forefocusing. While this is often referred to as selective focus, it is a

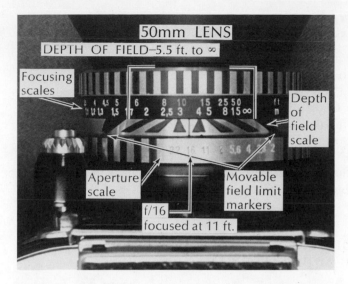

50mm LENS
DEPTH OF FIELD—5.5 ft. to ∞

Focusing scales

Depth of field scale

Aperture scale

Movable field limit markers

f/16 focused at 11 ft.

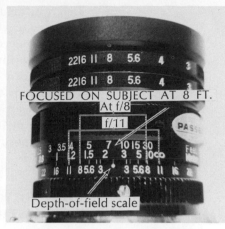

2216 11 8 5.6 4 3

2216 11 8 5.6 4 3

FOCUSED ON SUBJECT AT 8 FT.
At f/8
f/11

Depth-of-field scale

11-13C At f/22, the near distance of focus is much closer than any larger f/stop with hyperfocal focusing. Compare the hyperfocal distance on another lens with the depth of field when the lens is focused at infinity.

11-13D This is the depth-of-field scale on a 28mm lens set for hyperfocal distance at f/11. Compare the depth of field with Fig. 11-13B on the 50mm lens.

misnomer. Any time the camera's depth-of-field scale or the depth-of-field previewer is used in choosing depth of field, selective focus is exercised. In forefocusing, the camera-to-subject distance is established. That distance is set at the farthest f/stop mark on the depth-of-field scale. With the picture taken at this setting, the background will be soft focus to the extent that the aperture setting causes. It will not blur as rapidly or severely, of course, with an f/16 as with an f/2 diaphragm opening.

11-14 To determine the nearest distance of acceptable focus when focusing at hyperfocal distance (infinity mark on f/stop used) divide the focused distance in half.

HYPERFOCAL
DISTANCE

Infinity

Focused point

Depth of field

FOCUSING FOR CLOSE-UP PHOTOGRAPHY
WITH ACCESSORIES

Depth of field decreases rapidly as the camera is moved closer to the subject. On close-up work with accessories it can become extremely limited, indeed! Sometimes, it is 1/8 inch and even less, depending on the equipment being used, the f/stop, and the lens-to-subject distance.

To utilize most of the available depth of field, the photographer should apply that 1/3, 2/3 focusing principle. This is one of the most beneficial areas for its application. To do this, he focuses at a point one-third of the way into the desired depth. Then, with the smallest aperture possible, he will have taken every advantage for his close-up (Fig. 11-15).

CONTROL OF DEPTH OF FIELD ON THE
AUTOMATIC ADJUSTABLE CAMERA

For the automatic adjustable camera, some depth-of-field control is possible:

1. *If the lens apertures are manually adjusted.* This will force the camera to choose a different shutter speed but the different f/stop affects depth of field just as in the totally manual lens.
2. *If the shutter speeds are manually adjusted.* While shutter speeds have no direct control on depth of field, they do indi-

11-15A Photographed with bellows at smallest possible aperture, focused at one-third of the depth of the weed seed head, too much depth is recorded and makes the picture too confusing.

11-15B Focusing near the surface of the head with a stop less aperture reduced the depth of field to make a less busy, more interesting print. Maximum depth is not always best.

rectly, because this forces the camera to shift the lens aperture to a different diaphragm opening.

3. *If there is adjustable focus and a depth-of-field scale.* The camera operator can use several of the principles outlined in this chapter by his control of focusing, provided his camera will indicate to him the aperture the camera will use for the exposure.

When the photographer understands the effects of shutter speeds on the recorded images of various subjects, the relationship of the different lens apertures, and their effect on depth of field, he has the basis needed to choose the most appropriate exposure for his picture. The methods of determining exposure are explored in the following chapter.

REFERENCES FOR FURTHER READING

Kennedy, Cora Wright: "You Can Have It Both Ways" (split-field close-up attachment), *Popular Photography*, Vol. 67, No. 3, September, 1970, pp. 76f.

———"More About Those Two-Zone Lenses," *Popular Photography*, Vol. 67, No. 4, October, 1970, pp. 36f.

Mannheim, Andrew: "How Far Is Sharp?", "How Deep Can You Get?," *Modern Photography*, Vol. 34, No. 6, June, 1970, pp. 78f.

"Official Depth of Field Tables," *Modern Photography*, Vol. 25, No. 11, November, 1961, pp. 91f.

CHAPTER 12

Exposure

The effect of light on film is cumulative. The combination of shutter speed and lens aperture determines the exposure and in turn, the density of the negative, either black and white or color, and the color saturation of positive color film. The effects on the picture vary with the different shutter speeds and lens apertures. All of these facts have been explored in previous chapters. Now the question is to decide on the combination of shutter speed and aperture that will yield the desired picture.

METHODS OF CHOOSING EXPOSURE

Numerous methods can be used to decide on the exposure in a particular situation:

1. Instructions with the film.
2. Basic guide of exposure based on the film's speed.
3. Exposure dials and sliding scales.
4. Accurate, sensitive light meter.

The instructions with the film offer both a guide and a method of checking the light meter for accuracy. The printed instructions with the film are easy to understand and should be retained until the roll is fully exposed. In case the light meter is off or any unfamiliar problem arises, the information on the sheet of paper can be invaluable. It can serve as a reminder as to the kind of film in the camera, too.

The basic guide of exposure based on the film speed or ASA works in the limited situations covered. Between two hours after sunrise and two hours before sunset, the average *front-* and *sunlighted* scene can be satisfactorily exposed at $f/16$ for the fractional second of the shutter speed closest to the ASA of the film. For example, with an emulsion speed of 64, the exposure would be 1/60 second at $f/16$. The photographer can calculate other combinations that would give similar exposures or use an EVS table (Fig. 12-1). Similarly, a base for exposure of a film with an ASA of 25 would be 1/30 second at $f/16$; an ASA of 125 would be 1/125 second at $f/16$.

Actually, the intensity of sunlight varies from season to season and

EXPOSURE VALUE (EVS) TABLE LIGHT VALUE (LVS) SYSTEM

EV No.	f/2	f/2.8	f/4	f/5.6	f/8	f/11	f/16	f/22	f/32
2	1								
3	1/2	1							
4	1/4	1/2	1						
5	1/8	1/4	1/2	1					
7	1/15	1/8	1/4	1/2	1				
8	1/30	1/15	1/8	1/4	1/2	1			
9	1/60	1/30	1/15	1/8	1/4	1/2	1		
10	1/125	1/60	1/30	1/15	1/8	1/4	1/2	1	
11	1/250	1/125	1/60	1/30	1/15	1/8	1/4	1/2	1
12	1/500	1/250	1/125	1/60	1/30	1/15	1/8	1/4	1/2
13	1/1000	1/500	1/250	1/125	1/60	1/30	1/15	1/8	1/4
14		1/1000	1/500	1/250	1/125	1/60	1/30	1/15	1/8
15			1/1000	1/500	1/250	1/125	1/60	1/30	1/15
16				1/1000	1/500	1/250	1/125	1/60	1/30
17					1/1000	1/500	1/250	1/125	1/60
18						1/1000	1/500	1/250	1/125
19							1/1000	1/500	1/250
20								1/1000	1/500
21									1/1000

12-1 The EVS table disregards reciprocity failure. EVS is used effectively in several ways. Some cameras indicate exposure only by EVS or LVS numerals. With an exposure value of "14," the picture may be exposed at various setting combinations across the line from 1/1000 seconds at f/2.8 to ⅛ second at f/32.

from one geographical area to another, so that experience and/or records in a particular locale are valuable.

When the base exposure is used, then the following adjustments are made for these variations in subjects and/or lighting:

1. One stop *less* than basic exposure for a distant landscape and for light-colored objects.
2. One to two stops *less* than basic exposure for seascapes, snowscapes, and beach scenes.
3. One stop *more* than basic exposure for dark foregrounds, hazy day, and backlighting.
4. Two stops *more* than basic exposure for open shade.
5. Two stops *more* than basic exposure for heavy overcast.

Exposure dials and sliding scales for both daylight and night exposures are available at camera counters and through mail order. Each of these is general for a wide range of subjects so that the photographer should either bracket exposures on a one-time situation or plan for experimentation on problems that can be repeated if the pictures are definitely required.

An accurate, sensitive light meter appropriately used is the best of all methods to arrive at the most accurate exposure. The care and

kinds of light meters, and the techniques used to determine and apply the light meter readings are the concern of the balance of this chapter.

LIGHT METER CARE

Fingerprints, dust, sand, or debris of any kind on or in the light meter can cause false readings or malfunction. Especially, the area through which the light enters must be kept clean and unmarred.

Light meters with moving parts are particularly subject to shock from rough treatment or dropping. The all-transistorized light meter is much less subject to damage in this manner, which is one of its principal selling points.

Light meters must not be exposed to extremely humid conditions. Silica gel, recommended for cameras in warm, damp climates, can help preserve the light meter also. Repeated exposure to widely varied temperatures without opportunity to dry out from the resultant moisture condensation causes light meter deterioration, too. For instance, a light meter stored in a camper which is driven enough each day to warm everything to some extent in the camper, then allowed to get very cold on winter nights.

Light meters should not be exposed to strong light over too long a period of time. Hand-held meters without an activating switch should be in a closed case when not in use. Battery-powered light meters in the camera or out should be stored with the switch off. Strong light causes false readings. Usually, the light meter will return to normal if rested in total darkness for a reasonable time. The length of time depends on the intensity of the exposing light and the recovery ability of the individual meter.

PURPOSE OF THE LIGHT METER

A reliable, sensitive light meter is an invaluable aid to getting desired exposures, but it must be regarded as only an aid. The light meter does not have supernatural powers to interpret the photographer's requirements. He must know what he wants and use the light meter's information as a guide.

Since a light meter is used to achieve the desired exposure, and to prevent overexposure or underexposure, it is necessary to identify the effects of each on films.

Whether the film is negative or positive, the best exposure shows the amount of detail desired by the photographer in both the highlights and the shadows. Details may range from none in either the highlights or shadows for the very high contrast of only blacks and whites, to minute details for both the highlights and shadows in the

picture with a wide range of tones (Figs. 12-2,3). The method of taking the meter reading and its interpretation, plus the kind of film and its processing, determines the final results.

Negative films have more latitude than positive films. A greater degree of over- and underexposure can be tolerated and still achieve an acceptable print because of the extra step, which offers opportunity

Courtesy of Ponder and Best, Inc.

12-2 A high-contrast picture that would have been only in shades of black and white had a polarizing filter not been used to darken the sky just at sunset.

12-3 A wide range of tones from black through subtle shades of gray into pure whites.

Photographed by Violet Johnsen.

for some correction of exposure error. With color positive film, the exposure results are final when the shutter release is tripped, unless custom processing is employed or the photographer processes the film. The alterations in processing involve the whole roll and only certain color positive films allow these deviations with acceptable results.

The best quality prints are achieved when the exposure is appropriate for the film, the subject, and the lighting involved. Acceptable exposure may do for the emergency situation, but every photographer worthy of the name strives for the best exposure in every situation.

To identify and diagnose exposure problems, the photographer must remember that light gives a very different appearance on positive film than on negative film. If one works extensively with either type of film and then changes to the other, it can be confusing.

1. Overexposure on positive film causes the transparency to be too light, even clear, sometimes called "washed out" (Plate 1A).
2. Overexposure on negative film makes the negative too dense, even black, on extreme exposure (Plate 2A).
3. Underexposure on positive film produces a too dark, and when severe, even a black picture with no detail (Plate 1C).
4. Underexposure on negative film results in a thin and even a clear negative if the amount of light is too much curtailed (Plate 2C).

KINDS OF LIGHT METERS

Light meters are built into many cameras. Light meters that read the light from behind (or through) the lens (only on SLR's) may be built into the camera or be attachable as an interchangeable viewfinder and meter combination. Those meters that do read through the taking lens are indicated by the terms "TL" (through-lens), "TTL" (through-the-lens), or "BTL" (behind-the-lens) (Fig. 12-4).

Other cameras are provided with an accessory shoe where a meter may be attached or taken off at will. Some meters are a part of the viewfinder of the camera and may be exchanged for nonmetering viewfinders. Many light meters are made to be used separate from the camera and are termed hand-held meters. Within each of these types of meters are numerous other characteristics that vary with the equipment.

INCIDENT VERSUS REFLECTED LIGHT METERS

Reflected light meters measure the light reflected from the subject toward the camera. To take the reflected light reading, the meter is

12-4 Numerous locations and devices are used in through-the-lens metering.

pointed toward the subject and at *the same* angle *that the camera is pointed* (Fig. 12-5).

Incident light meters indicate the amount of light that falls on the subject from any source in a 180° arc. To take an *incident* light reading, *the meter is held near the subject* with the incident light collector *pointed toward the camera* (Fig. 12-6).

12-5A Point the reflector-type light meter receptor toward the subject. Notice the reflector placed to fill the shadowed areas.

12-5B A more accurate reading is obtained with a neutral gray test card held in the same plane as the subject with light striking the light receptor from the same direction as the subject. Still the white flower requires some compensation if detail is to be maintained.

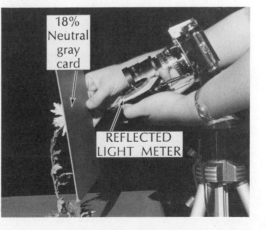

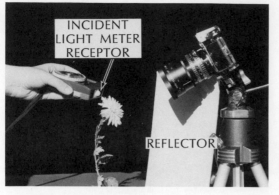

INCIDENT LIGHT METER RECEPTOR

REFLECTOR

12-6 Point the incident light meter receptor toward the camera from subject position to determine the light falling on the subject. To maintain detail in the white flower, a half-stop compensation may be required. The reflector fills the shadowed areas of the subject.

Many, though not all handheld meters are equipped to read either reflected or incident light. Most meters built in or attached to the camera read only reflected light. At least one BTL camera has provision for incident light reading; others may soon have this feature.

For an illustration of the differences in the two types of meters, explore readings that would be obtained with the same amount of light on a totally black cat, a gray cat, and a glistening clean white cat. (Textured black, gray, and white cardboard or fabric would serve equally well.) The incident light meter, correctly handled, gives the same reading on all the cats because it measures the amount of light falling on the subject. The reflected light meter provides very different readings, because the black absorbs light instead of reflecting it while the white reflects almost all of the light. If the meter indicates 1/25 of a second at $f/11$ on the white cat, the reading will be one full second at $f/11$ for the black cat. Twenty-five times as much light! The reading on the reflected light meter for the gray cat might show about 1/10 second at $f/11$ or two and a half times the light registered for the white cat. This reading will definitely hinge on the intensity of the gray cat's fur. What happens if each cat is photographed at the reading indicated on the reflected light meter? All the cats will appear about the same color or intensity as the gray cat! Light meters are calibrated to see a neutral gray for every color and/or intensity of light.

When the incident light readings are followed, there may be not quite enough detail in the black cat's and the white cat's fur. Opening up the lens to increase the exposure one-half to one stop on the black cat will bring in that detail. Closing down the lens the same amount to decrease exposure will hold detail for the white cat. Obviously, using the reflected light meter requires much more adjustment between lights and darks.

There are advantages and disadvantages in using either type of

light meter determined by the subject and the situation in which it is being photographed.

Professional movie makers must have their exposures consistent so that they can effectively match one frame with succeeding frames in the same locale and lighting circumstances, though the frames may have been taken several days or even months apart. Professional movie makers almost invariably rely on incident light meters. There is more variance among still photographers in their choice between these two types of light meters. To some extent, it depends on the photographer's experience with each type of meter reading as to which he prefers. Another factor is the kind and location of subject matter that he usually is photographing.

Advocates of the incident light meter point out that different colors and different intensities of each color reflect different amounts of light when illuminated with the same kind and intensity of light. The different colors give widely varying light meter readings with the reflected light meter. It is calibrated to render every color in the approximate intensity of a neutral gray test card. Therefore, if the major portion of the scene is very dark, the light meter may suggest an exposure that would give much lighter results than the subject. Similarly, if the scene is very light, such as snow, the reflected light meter may indicate an exposure that would give very dirty looking snow.

An incident light meter used correctly indicates exposures that produce more consistently the values of the original subject for those who use this type of meter effectively.

For the other side of this discussion, it is not always possible to reach the exact location of the subject. One example would be the wild animal that might be dangerous, skittish, or both. If the photographer is in the same light as the animal, he may turn his back to the animal (if safety is not a factor) take the exposure on his incident light meter, turn around, and take the picture of the animal. The exposure would likely be correct. What can be done about the zoo animal that is inside a glass enclosure with a sky light while the photographer is in a darkened passageway? The reflected light meter supplies the answer. There are many such problems for the photographer who works in uncontrolled situations. One method is to learn to handle both kinds of meters and use a convertible meter. Another way is to become proficient with the reflected light meter. It is used exclusively by many well-known and excellent photographers.

POWER FOR LIGHT METERS

Photoelectric meters have selenium cells powered by energy received from the light which moves an indicator on a calibrated scale. This

very reliable type has been in use for many years. Almost standard today is the cadmium sulfide (CdS) cell meters, powered by one or two button-type batteries that last two years or more. Quite new on the market are the all transistorized meters, battery powered, with no moving parts to jar out of adjustment. Tiny lights indicate over-, under- and correct exposure, rather than the floating needle or bar of other meters. The dials give the varying combinations that will give the same exposure.

Battery powered meters are sensitive in a lower range of light levels than the selenium cell meters. The degree of sensitivity depends somewhat on the price range of each type of power.

Each brand and model of meter has its peculiar method of operation. This is the time the booklet of directions that came with the meter must be studied. If the photographer is to use his meter effectively, he must understand its variations and their influence on the exposure readings.

Some meters have a booster for low light levels. The booster may be an extra light-gathering device, an opening that can be changed to allow a larger percentage of the light to strike the cell, or a combination of the two. The meter may require opening manually the particular area of the meter or merely using the power switch to bring different scales into position, at the same time increasing the sensitivity of the meter.

LIGHT METER ANGLE OF ACCEPTANCE

Another variation of meters is the area from which the reflected light is "read." Some read all the reflected light from a wide angle of acceptance (30° is average). Others have a more restricted angle or are made to adjust the angle of acceptance (as narrow as 1°) by means of attachments and/or settings. These are called, or can be converted to, spot meters, which are especially appropriate for use with telephoto lenses. Some hand meters have viewing windows similar to the camera viewfinder to indicate the subject that is covered by the meter.

On SLR through-the-lens meters, there are three different types in relation to the area from which the light is gathered for the reading:

1. The averaging meter picks up the light from several areas distributed over the entire frame, combines the total to register as an exposure combination of shutter speed and lens aperture.
2. The spot meter gathers the light from a small part of the scene, marked on the viewfinder screen, and from this indicates the exposure.
3. The center-loaded meter picks up the largest portion of light, sixty percent or more, from the center area and combines this

with the light collected from the balance of the frame, into an exposure.

Some cameras offer either spot or averaging meters at the flip of a switch to suit the photographer's needs. He must understand the use of each type to get consistently desired exposure.

LIGHT METER SCALES

At first glance, many meters seem to the novice to have a lot of meaningless, confusing numbers. Each is simple to interpret when one understands their purpose. The light meter could be compared to a miniature computer. When it is given certain information correctly, its series of numbers provides the answers. Like the computer, the answers can be only as accurate as the information fed into the meter.

First is the ASA scale and/or the DIN scale. These refer to the sensitivity of the film to light, called film speed. Corresponding letters indicate each scale and only one need be set. The DIN scale is consecutive numbers that may run from 1 to 45 or be less at either end (Fig. 12-7).

The f/stop or aperture scale is indicated by the same f/stop sequence found on most cameras. The scale may go further in the sequence and in some cases less. Between each stop will be dots or marks near the edge of the dial to indicate half stops (one dot) or third stops (two dots).

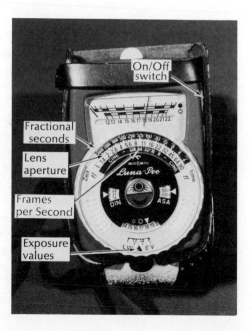

12-7 Most light meters clearly mark the different series of numerals.

Shutter speeds may be shown by fractions of a second or by whole numbers to indicate the fractional parts of a second. These are followed on the same scale by numerals of different size and/or color for the whole seconds, minutes, and even hours on some meters.

Other numbers may be under the floating needle or bar. These may indicate foot candles of light or be just a series of numbers. The one on which the needle stops may need to be set on a dial at an arrow or a mark. This then sets up the various exposure combinations on concentric dials that the meter computes for the given ASA and light level.

Some meters have a floating needle with a second floating device. When the two coincide or line up together, the concentric dials are in position to give the exposure combinations for that particular reading.

The EVS (Exposure Value System), sometimes called the LVS (Light Value System), is a series of consecutive numbers on meters. They usually range from 2 to 22 but they may start at 1 and go beyond 22. Each number represents a given exposure (Fig. 12-1). On some cameras this EVS number can be locked or coupled in; then, the apertures and shutter speeds may be shifted, but the same exposure values are maintained.

All light meters and EVS tables are compiled as though film reacts to a like amount of light regardless of the shutter time. For example, the reciprocal action of 1/250 second at $f/1.4$ would give identical results in density as 1 second at $f/22$. Strictly speaking, this is not true because of a phenomenon called reciprocity failure. This is of minimum concern for much photography but is important in some exacting situations, especially in professional color photography. Films vary widely in the shift that may occur in density and in color. Shutter speeds of 1/1000 second and faster, or of several seconds and longer, cause the most noticeable shift. Professional films are more subject to this shift.

Some light meters have a scale for use with movie (cine) photography. The scale indicates frames per second (fps). Shutter speeds vary with the fps, so if the movie photographer relies on the meter, he must use the scale in calculating f/stops. The fps indication will include some, if not all of these: 8, 16, 32, 64, 128.

Many light meters do not include all the scales listed in this section of this chapter.

Meters that are built into cameras have different indicators of meter readings inside the viewfinders. While one camera has only a colored warning flag for insufficient light for the camera to expose the film, another camera matches a floating needle into either a horizontal, inverted, or vertical "V", or into a reversed "C". Other cameras indicate an f/stop and/or shutter speed in the viewfinder in addition to the match needle mechanism.

HOW TO MAKE AN EXPOSURE READING

As has been suggested, the techniques used to make the meter reading affect the exposure that the meter indicates. Read the directions for the mechanical operation of the particular meter. Know how the meter is activated (switched on, if it is necessary), if the meter can lock in the reading or must be read while in position.

Many of the totally automatic cameras can be manipulated to some extent. In general, the procedures for making a meter reading are:

1. Set the film speed on the ASA or DIN scale. The 126 film cartridge sets the speed automatically on adjustable cameras that use this film size.

2. Determine where the light enters the meter. Be sure there is nothing in front of or over this area. Fingers of the operator or part of the camera or meter case are the most frequent offenders. Long hair can blow over the meters on cameras held at eye level while taking the reading. Any of these obstructions can produce false readings.

3. With the incident light meter, usually only one reading is necessary. If detail is desired in deep shadow and at the same time in brightly lighted areas, then separate readings may be required in both. Average the two readings for a compromise that will retain details in both highlights and shadows if they are within the latitude of the film.

 a. Hold the meter at subject position, the light-gathering globe or device pointed toward the camera (Fig. 12-6).

 b. When the photographer cannot get to the subject position, if *the light is of the same intensity at both subject and camera position,* he may measure the light by turning the meter's light collector in the same direction he would point it if he were at subject position. The reading will be the same.

 c. For the very light subject in which detail is desired, the exposure should be reduced by closing down the aperture 1/3 to 1/2 stop. For the very dark subject in which detail is necessary, open up 1/3 to 1/2 stop to increase the exposure.

4. With the reflected light meter, a number of procedures can be followed. Only simple, basic ones are explained here.

 a. The area of the meter that admits the light should always be aimed toward the subject from which the reading is being taken. Be sure light from a brighter source than the subject is not striking the area of light acceptance.

 b. For the averaging meter or the hand meter with a wide angle of acceptance, the overall reading of the scene may be acceptable. If it has a very light background but detail is desired in

the shadowed foreground, or if the situation is reversed, the photographer must move close to the principal subject to take the reading. Be sure not to read from an area in the meter's or the photographer's shadow except as noted later for snow scenes. If there is a wide range of dark and light areas that need detail, move in close and take readings from both areas. Choose an exposure midway between or decide which is the more important and favor that exposure. With the reflected light meter, to keep the exposure within approximate values of the very dark subject, the exposure should be reduced from $\frac{1}{2}$ to 1 full stop on color positive films, 1 to 2 stops in negative films. For the very light subject, such as snow, a meter reading taken from a shadow on the snow will give a better exposure. This will show texture if the direction of lighting is appropriate, but avoid dirty looking snow in the picture.

c. For sidelighting, the exposure needs to be increased $\frac{1}{2}$ stop (open the lens diaphragm) if the meter reading is not taken close to the subject.

d. With backlighting, the distant reading may need to be increased by 1 to 2 stops for all films to record detail in shadowed areas. The amount depends on the contrast in light. Closing one eye and squinting the other eye can help in evaluating the contrast. If the meter reading has been made close to the subject and is of average color intensity, this compensation will not be needed.

e. A reading taken from a 18% reflectance neutral test gray card is an excellent method of arriving at the best exposure. This works especially well for close-ups when the subject is small against a contrasting background and many other situations, too. This approaches the incident light meter reading, though not exactly. The light must strike the gray card from the same angle the light strikes the subject when viewed from camera position. Caution must be used so as not to read from the meter's shadow or let stronger light than is on the subject from camera position shine into the meter's light acceptance area.

f. With sunsets or sunrises, where the emphasis is on the sky area, the reading is made from the sky. This will cause the foreground subjects to go in silhouette, which is usually desirable. Closing down one stop more than the meter reading from the sky will increase the saturation of the sky's color on color positive films.

g. For night scenics, campfire, or other low light situations, the photographer must remember the light meter will indicate a

reading that results in a picture resembling a daylight exposure. The night scene is most effective if the nighttime atmosphere is retained in the picture. Compensation must be made if the light meter is to be used by underexposing one to two stops from the reading. Other methods are to utilize various tables or sliding scales and bracket the exposures. Not all meters will give the time exposures required for many night problems. Because of the darkness and reciprocity failure, differences in the bracketing are less, so wider variations in exposure are used at night.

While negative films are bracketed in one-stop intervals for daylight, nighttime exposures are varied at two or three stops. Positive color films are bracketed at one-third stops or one-half stops in daylight but at full-stop intervals for night scenes.

Some photographers favor double exposures. The first one is under normal by two stops or so at twilight followed by a time exposure after dark when street and building lights are burning. The camera is not moved in the meantime. This gives a brighter sky and also keeps the camera involved several hours for one picture. Many people much prefer the same scenes with the darker skies obtained in the darker hours with one exposure. Experimentation with both methods should help the reader decide his preference.

Night pictures without flash are interesting, usually with much more impact than the same view in daylight (Figs. 7-3,22; 12-8,9). Any speed film can be used when exposed appropriately for its ASA. Suggested exposures for a variety of situations are shown in Fig. 12-10.

5. Spot meters avoid the necessity of moving in close to the subject but can present real problems to the uninformed. Spot meters on cameras can cause the wrong exposure if the reading is not made correctly (Fig. 12-11).

 a. Locate the area of the frame in which the spot is situated. When making the reading, have this portion of the viewfinder on the subject from which the reading is to be made. Usually, to do this, the picture will not be framed as it is when the exposure is made.

 b. Choose the average reflectance subject, one that is not too dark nor too light, from which to take the reading. Aim the spot meter on the subject. The resulting exposure would be an average reading for that scene.

 c. A second method is to take the reading from the darkest area and another from the lightest subject in which detail is desired. An exposure midway between the two readings would be

12-8A The tunnel entrance in daytime offers little in picture interest.

12-8B A night view with the car taillights registered and some of the more unattractive areas in shadow is better.

12-9 A cityscape at night has much more sparkle than in day. Color film would add still different dimensions.

SUGGESTED EXPOSURES FOR PHOTOGRAPHY OF UNUSUAL SUBJECTS
(Difficult or impossible to make meter readings)

Film Speeds:	ASA 25-32	40-64	80-125	160-250	320-500	640-1000
Subjects:						
Amusement Parks at Night						
Ferris wheels and other similar rides*	8-f/8	8-f/11	8-f/16	8-f/22	8-f/32	4-f/32
Baseball, Night	NR**	1/30-f/2	1/60-f/2	1/60-f/2.8	1/125-f/2.8	1/125-f/4
Basketball, Artificial lights	NR**	1/30-f/1.4	1/30-f/2.8	1/60-f/2.8	1/125-f/2.8	1/125-f/4
Bridges, moderately lighted***	2 min.-f/11	2 min.-f/16	1 min-f/16	30-f/16	15-f/16	15-f/22
Christmas Lighting:						
****Indoor Christmas tree	2-f/11	2-f/16	1-f/16	1/2-f/16	1/4-f/16	1/8-f/16
Outdoor Christmas lights	25-f/4.5	12-f/4.5	6-f/4.5	6-f/9	3-f/9	3-f/18
Cityscapes	30-f/4	15-f/4	8-f/4	8-f/5.6	8-f/8	8-f/11
Fireworks# (Telephoto lens desirable)	f/5.6	f/8	f/11	f/16	f/22	f/32
Water fountains, floodlighted in color##	15-f/6.3	15-f/9	15-f/12.7	8-f/12.7	4-f/12.7	4-f/16
Gardens, Lighted	30-f/4.5	12-f/4.5	6-f/4.5	6-f/6.3	6-f/9	6-f/12.7
Ice Shows:						
Floodlighted	NR**	1/30-f/2.4	1/60-f/2.4	1/125-f/2.	1/125-f/2.8	1/250-f/2.8
White Spotlights:						
1 light (front lighted)	1/30-f/1.4	1/30-f/2	1/30-f/2.8	1/60-f/2.8	1/125-f/2.8	1/250-f/2.8
2 lights (front lighted)	1/30-f/2	1/60-f/2	1/125-f/2	1/125-f/2.8	1/125-f/4	1/250-f/4
4 lights (front lighted)	1/60-f/2	1/125-f/2	1/250-f/2	1/250-f/2.8	1/250-f/4	1/250-f/5.6
Lightning### (at night)	f/5.6	f/8	f/11	f/16	f/32	NR**

12-10 Basic exposures for night pictures. Bracket exposures to compensate for differences in light intensities. Keep a record to know the best exposure for a particular subject another time.

SUGGESTED EXPOSURES FOR PHOTOGRAPHY OF UNUSUAL SUBJECTS (Continued)
(Difficult or impossible to make meter readings)

Film Speeds:	ASA 25-32	40-64	80-125	160-250	320-500	640-1000
Moon (only), Full	1/60-f/4	1/125-f/4	1/250-f/4	1/250-f/5.6	1/250-f/8	1/250-f/11
Moon (Full) Lighted Landscape (Front Lighted)	30-f/1.7	15-f/1.7	15-f/2.4	15-f/3.4	15-f/4.9	15-f/6.9
Street Scenes####						
Brightly lighted	1/15-f/1.4	1/15-f/2	1/30-f/2	1/30-f/2.8-	1/60-f/2.8	1/60-f/4
Dimly lighted	15-f/2	8-f/2	8-f/2.8	8-f/4	8-f/5.6	8-f/8
TV Screen	NR**	1/30-f/1.8	1/30-f/2.8	1/30-f/4	1/30-f/5.6	1/30-f/8

All shutter times are in seconds except as indicated by "min."

* Several seconds shutter speed creates interesting patterns of color.

** Not recommended.

*** To register taillights of traffic vehicles, cover lens with black cardboard between waves of traffic. Count only the time lens is uncovered for exposure.

**** Double the guide number to use flash to show gifts around the tree if room is dark or dimly lighted.

Have camera on tripod, lock shutter open, cover lens with black cardboard until the small burst of light near ground. Uncover lens and follow (pan camera horizontally and vertically as needed) light as it ascends with the camera lens (viewfinder on rangefinder type cameras, sportsfinder on SLR's) for the big bursts. Multiple bursts can be exposed on one frame. Cover lens between bursts to reduce sky light registered.

With noncolored floodlights, use one-half the exposure.

With camera on tripod covering general area of lightning in the viewfinder, lock the shutter open. Several flashes may be exposed on one frame.

Use faster shutter speeds and wider lens apertures if stopping action is most important. Use slower shutter speeds and smaller lens apertures if depth of field is more important.

Films: Faster films stop action and give more depth of field because of smaller apertures that are possible. If subject isn't moving, any speed film can be used if appropriate exposure is used.

Low contrast films give more detail in both highlights and shadows. For color work, duplicating films are best if speed is not imperative.

Use tungsten color films for sodium vapor or incandescent (tungsten) lighting.

Use daylight color films for mercury or fluorescent lighting.

Bracket: Positive films at one-stop intervals, negative films at two- or three-stop intervals.

12-11A A picture taken with an averaging meter reading from camera position on a backlighted subject. The shadows are underexposed. Compare with Fig. 12-11B.

12-11B Exposed according to a properly made spot meter reading, from camera position, on Mary. Over one-stop difference from that on 12-11A. The detail in the shadows is much better.

average. When detail is more desirable in one area than another, the exposure should be shifted to compensate for this.

6. Many of the totally automatic cameras can be controlled to some extent.

 a. Move in close to the subject to take a meter reading. Depress the shutter release sufficiently to activate the meter but not to trip the shutter. Practice with the individual camera helps you to know the exact pressure necessary. Take the reading from the subject of average reflectance for the scene or from a gray card. Retain the pressure on the shutter release, move back into position, reframe the picture, and complete the pressure to trip the shutter release.

 b. For those cameras on which the film speed is set manually the exposure can be controlled by changing the ASA to fit that desired for the subject matter. Each next higher number in the film speed series represents a decrease in exposure of one-third stop. Each next smaller number increases the exposure by one-third stop. (Chapter 14, Films.)

 c. On some automatic cameras, the light meter can be "fooled" into giving up to 30 seconds exposure by holding back the light to the meter with a finger or black card over the light meter receptor while the shutter is opened.

7. The serious photographer will want to explore the more complicated but very effective exposure systems taught by the photographers Ansel Adams, Glen Fishback, and John Doscher. Each approaches the problem in a different manner. Adams and Doscher use the Weston Master meters for their methods and Fishback uses the Honeywell 1°/21° Spotmeter. All three men are noted for their excellent photography and teaching.

CHOOSING THE EXPOSURE COMBINATION

With the exposure reading registered on the meter, the problem now is to decide which combination of shutter speed and lens aperture will yield nearest to the desired results. Seldom are camera mechanics, film, light, and subject teamed so that there is only one possible and ideal combination. The choice, then, becomes a matter of compromise to decide on the best of the many possibilities. If the exposure should be EVS 14, which will be best: 1/1000 second at $f/4$, or 1/5 second at $f/32$, or somewhere in between? This is the test of the photographer's skill.

In summary, the photographer's decision on the f/stop and shutter speed combination depends on:

1. The subject and purpose for the finished picture.
 a. The best method of accenting the center of interest.
 b. The background and foreground material.
 c. Supporting elements.
2. The depth of field desired.
 a. Maximum depth at smallest aperture and/or with hyperfocal focusing, if applicable.
 b. Minimum depth with largest aperture and/or forefocusing.
3. Effect of the shutter speed on the picture.
 a. Movement, such as caused by wind, water action, subject mobility, or camera vibration.
 b. Degree of blur desired to give feeling of speed.
 c. Freezing of action or sharpness of the split instant of action.
 d. Long telephoto lenses accent any lack of steadiness of the camera.
4. Camera mechanics of the equipment being used.
 a. Maximum and minimum aperture of the lens.
 b. Shutter speeds available on the camera and with unlimited time exposures.
 c. Focal length of the lens.
 d. Critical aperture of the individual lens for extreme enlargements or extreme close-ups.

e. Steadiness of tripod, clamp pod, or other method of supporting the camera.

MULTIPLE EXPOSURE

Multiple exposures on the same frame of film offer interesting, creative results. There are unlimited possibilities in subject combinations. Different aspects of the same subject can be illustrated (Figs. 1-30, 2-19, 3-29, and 6-64—66). One can combine two or more subjects to show a relationship (Fig. 12-12).

On long exposures of several seconds, black paper can be held over the lens between exposures, or the lens cap can be used to cover the lens between exposures and the shutter left open without closing for the entire time.

Some cameras permit multiple exposure intentionally. A much larger percentage do not. A portion of those may be manipulated to

12-12 An underexposed travel poster superimposed with normal exposure of Judith (double exposure on one frame of film) provided a dreamlike image to portray the theme of period drama. Reproduced from a transparency by paper negative on regular black-and-white enlarging paper.

Photographed by Neil W. Momb.
Costume by Judith E. Jerde.

accomplish this feat by (1) tightening the film with the rewind lever, (2) holding in that position while pressing the rewind button, and (3) recocking the shutter with the film advance lever. This procedure is easiest to execute by the three-handed photographer, but those with two hands have done it successfully! Try the procedure with a practice roll of film or when just loading the camera while the camera back is open to be sure it works effectively without moving the film. Some cameras cause the next frame to be partially lost so it is good practice to cover the lens, trip the shutter, and plan on the loss unless the operator is sure of the mechanics. Watch out for torn sprocket holes.

Another problem in double exposure is calculation of the amount of light allotted for each time the shutter is opened. The particular technique and subject plus the desired results will determine the procedure.

The subjects are not overlapped in the illustrations cited in previous chapters and are taken against a black background. They were in sunshine in front of an open garage door for the first two illustrations and against black background paper with photoflood lamps in the third and fourth examples. Because the black does not register on the film, the standard exposure for the subject on one single exposure is given in each instance except the *rim-lighted silhouette,* which was underexposed three stops from a reading on the shadowed side of the face.

When images are overlapped or completely doubled (Fig. 12-12), the exposure is divided between the two shutter openings. A standard procedure is to underexpose two full stops each time the shutter is opened. However, if one subject is very light, it may be necessary to underexpose three full stops on that one. If a subject is especially dark, only one full stop underexposure may be best. As with so many areas in photography, no simple rule fits all situations. Experimentation is the answer.

If double exposures are impossible, combining negatives to make a print or sandwiching slides can give a somewhat similar effect. Negatives in which the subjects are to overlap should be underexposed. Positive films (slides) should be overexposed a full stop with average subjects. The very light or the very dark subject would need compensation accordingly.

Since existing light is not always sufficient for stopping action or getting the depth of field desired, the photographer often uses a flash lamp or gun for extra light during the exposure. Within limitations, this succeeds. There are techniques in using flash explained in the next chapter that often improve the results.

REFERENCES FOR FURTHER READING

Adams, Ansel: *The Negative,* Hastings-on-Hudson, New York, Morgan and Morgan, Inc., 1962.

Birnbaum, Hugh: "Basic Guide to Exposure," *Travel and Camera,* Vol. 33, No. 6, June, 1970, pp. 77f.

Draughon, Guy: "Incident-Light vs. Reflected-Light Readings," *Petersen's Photographic Magazine,* Vol. 1, No. 4, August, 1972, p. 36f.

Farber, Paul R.: "Shooting in Available Darkness," *Petersen's Photographic Magazine,* Vol. 1, No. 2, June, 1972, p. 16f.

Fishback, Glen: *The Glen Fishback Exposure System,* Sacramento, California, Glen Fishback School of Photography, 1969.

Flagg, Don: "The Case for the Hand-Held Exposure Meter," *Petersen's Photographic Magazine,* Vol. 1, No. 2, June, 1972, p. 50f.

Kennedy, Cora Wright: *Guide to Perfect Exposure,* New York, Amphoto, 4th ed., 1967.

———"One-Second Plus," *Popular Photography,* Vol. 71, No. 5, November, 1972, p. 90f.

Keppler, Herbert: "A Concise Guide to Aches and Pains of SLR Finders," *Modern Photography,* Vol. 35, No. 4, April, 1970, pp. 16f.

———"Can Eleven SLR Meters All Be Right?" *Modern Photography,* Vol. 33, No. 11, November, 1969, pp. 106f.

Kodak Color Dataguide, Rochester, New York, Eastman Kodak, 1971.

Life Library of Photography: *Light and Film,* "How to Expose for a Good Negative," New York, Time-Life Books, 1970, pp. 155f.

"Magnification and Exposure Scale with Each Lens on Your Bellows," *Modern Photography,* Vol. 27, No. 4, April, 1963, pp. 67f.

Mannheim, L. Andrew: "Close-up Exposure is Simple?" *Modern Photography,* Vol. 34, No. 3, March, 1970, pp. 78f.

Martin, Stephen P.: "Here's Your Night-Light Exposure Calculator," *Popular Photography,* Vol. 62, No. 4, April, 1968, pp. 116f.

———"Sunset Exposure Calculator," *Popular Photography,* Vol. 65, No. 3, September, 1969, p. 74.

Rothstein, Arthur: "Adjustments are Required for Long Exposures with Color Film," *U.S. Camera,* Vol. 30, No. 4, April, 1967, pp. 10f.

Ryon, Donald C.: "Shooting the Stars," *More Here's How* AE 83, Rochester, New York, Eastman Kodak, pp. 56f.

Stensvold, Mike: "Reciprocity Failure and How to Cope With It," *Petersen's Photographic Magazine,* Vol. 1, No. 7, November, 1972, p. 74f.

White, Minor: *Zone System Manual,* Hastings-on-Hudson, New York, Morgan and Morgan, Inc., 1965.

Yob, Parry C.: "Matte-Box Magic," *Petersen's Photographic Magazine,* Vol. 1, No. 6, October, 1972, p. 38f.

CHAPTER 13

Flash Photography

When additional light is necessary, the most frequently used source is flash. It is an easily transportable, compact, and relatively trouble-free supply of instant light of short duration.

There are two general types of flashguns in common use:

1. One that uses expendable flashbulbs, powered by a battery or a mechanical activator in the camera. Flashguns hold the bulb and battery and are attached to the camera (Fig. 13-1). Burning of finely shredded metal and/or gas inside the flashbulb furnishes the light. After use the lamp is then discarded.
2. The electronic flashgun, popularly called "strobe," is powered by batteries, by AC current, or by a choice of either. The same lamp is used repeatedly for thousands of flashes (Fig. 13-2).

Within each of these two general classes are variations in construction, in versatility, and in the results obtained with them which makes some flash attachments more appropriate for a particular purpose than others.

THE EXPENDABLE FLASH LAMP AND FLASHGUNS

The most popular expendable flashlamp at this time is, without doubt, the flashcube. It has four miniature flash lamps inside the familiar small, clear, plastic cube with built-in-reflectors back of each tiny blue lamp. It offers sufficient light for the average snapshooter, and is useful even in many situations by those who take their photography more seriously. The cubes are inserted into the top of cameras made specifically to use the cubes. Cubes that require no battery can not be used interchangeably with those that do require electrical power but must be used with particular cameras.

For other cameras, the batteries are inside the guns that are attached via the accessory shoe and a cord to the flash connection. Some cameras have the connection in the base of the shoe, referred to as "hot shoe." Flashguns may, also, be attached by metal brackets fastened to the camera at the tripod socket.

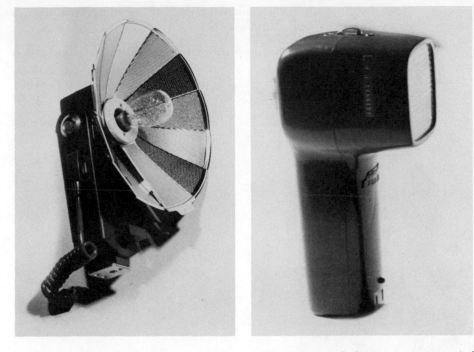

13-1 A versatile type of flashgun that uses expendable lamps.

13-2 Electronic flashguns come in varied shapes, sizes, and powers.

Photoflash batteries give better and longer service than the more common flashlight batteries. Some of these flashguns use the flashcubes while others use one of a number of other sizes and shapes of flash lamps. Adapters are available to permit smaller lamps to be used in guns that were made for lamps with larger bases of the same type.

Most, if not all, flashguns presently on the market for the expendable flash are powered with a BC (battery capacitor) pack that supplies the same amount of electrical charge to the lamp for the life of the battery. With the BC pack, when the battery is completely exhausted, the flash will not work at all. Until that time there is no weakening of the electrical charge to the lamp. The batteries used with a BC pack have a longer usable life than the batteries used with the gun without a BC pack. Those guns without the BC pack get a weaker charge as the batteries near exhaustion, so they do not always set the lamp off in time to expose the film while the shutter is open.

Many guns have a battery check switch that turns on a tiny light on the body of the gun to indicate if the battery is still operative. These battery-check signals are desirable.

Expendable flash lamp guns that do not use the cubes have a reflector. It is bowl shaped and may be:

1. Highly polished, chrome-finished metal to give maximum reflection.
2. Satin-finished smooth metal to provide softer light (Fig. 13-3).
3. Satin-finished, waffle-type, crimped-metal to break up the reflected light and produce a more diffused effect (Fig. 13-3).

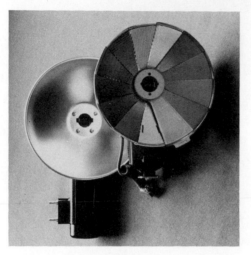

13-3 Left, a satin-finished reflector. Right, a satin-finished waffle type, crimped-metal, folding reflector.

Some reflectors are multiple leaves of metal that are folded together to make for more compact storage and/or eliminate the reflector (expressed as "bare bulb") when the flash is in use to give softer light effects (Fig. 13-4). The sizes of the reflectors vary from two to five or even six inches in diameter. This affects the amount of light reflected with any given size flash lamp.

Many flashguns have reflectors mounted so the lamp can tilt at varying angles to direct the light toward a certain section of the subject or to bounce the light from a surface to improve the quality of the flash picture (Fig. 13-4).

FLASH LAMPS

Expendable flash lamps vary in:

1. Size (Fig. 13-5).
2. Light intensity output.
3. Light duration.
4. Peaking time.
5. The spread of light over the period the lamp is burning.

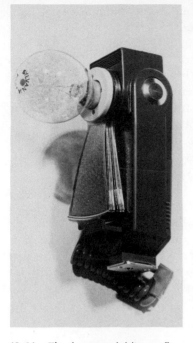

13-4A The fan-type folding reflector folded for a bare-bulb exposure for softer light effects.

13-4B The reflector tipped at 45° for bounce flash for less harsh lighting.

13-4C The reflector tipped straight up for bounce flash.

13-5 A few of the many types and kinds of flashlamps available.

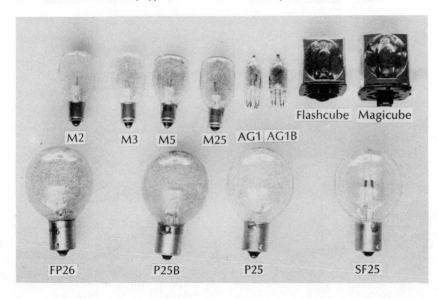

13-6 The strength of the light and its peak time plus the film speed and the camera's shutter speed determine the guide number furnished by the lamp manufacturer. Compare the peak and duration time of this lamp with the following graphs.

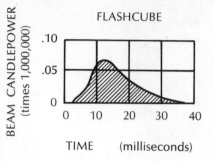

FLASHCUBE

The size of the lamp indicates to some extent the amount of light output and is measured in lumen seconds. Except for the comparison of lamps, via the graphs (Figs. 13-6–10), the photographer does not need to use this unit. The same is true of the duration of light which is shown as milliseconds of time. (It is interesting to know that a millisecond is approximately equivalent to the time it takes an automobile to travel one inch at sixty miles per hour.) Peaking time refers to the time it takes after the camera shutter is tripped for the light to reach its highest rate of light output. The spread of light over the period the lamp is burning is important to know to guide the choice of lamps to use with certain types of camera shutters.

A study of the graphs (Figs. 13-6–10) shows that there is considerable variation in light output and duration, peaking time, and the spread of the time the lamp is burning. Not all lamps can be used with all cameras. The shutter must be open during the time the lamp is burning in order to benefit from the flash (Fig. 13-11). To assure that this occurs, cameras are synchronized (commonly called synched) for given lamps. That is, the flash does not fire until the shutter has opened. The lamps that can be used with a particular camera are

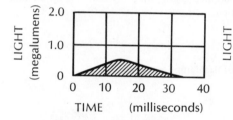

AG-1 and AG-3B

13-7 The lower profile indicates light will carry less distance than the flashcube.

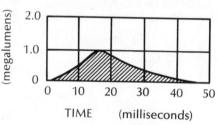

M3

13-8 Every type of lamp presents a different pattern. Each has its advantages.

13-9 The No. 5 is similar to the No. 25 lamp.

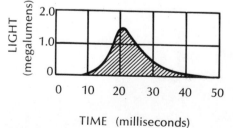

No. 5

13-10 The No. 6 is similar to the No. 26 lamp; both are used for focal-plane shutter cameras.

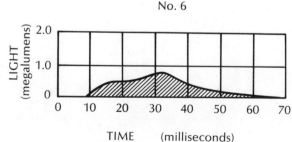

No. 6

LEAF-TYPE SHUTTER
SYNCHRONIZED

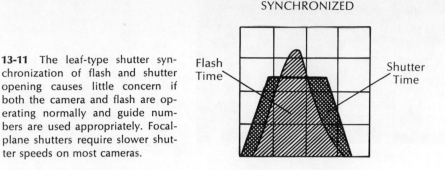

Flash
Time

Shutter
Time

13-11 The leaf-type shutter synchronization of flash and shutter opening causes little concern if both the camera and flash are operating normally and guide numbers are used appropriately. Focal-plane shutters require slower shutter speeds on most cameras.

listed in the operating manual for that camera. A check of the synchronization settings or outlets on the camera, compared with those required for the lamps, indicated by F or M, which are for medium fast peaking lamps; FP for focal plane shutter in combination with focal plane lamps; and X for some of the fastest peaking expendable lamps and electronic flash (Fig. 13-12). These settings may be indicated and set with a control on the side of the lens barrel, or the flash lamp connector cord may be attached at different sockets indicated by the letters (Fig. 13-13). It is important that the correct setting or connection be made for the exposure to be appropriate.

If the photographer is in doubt as to whether his camera is synched for a particular lamp, he can run a check. With the flash lamps in question, photograph a white surface flat and parallel to the film plane:

ELECTRONIC FLASH DURATION
(Time-Light Curve)

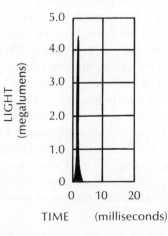

LIGHT (megalumens)

5.0
4.0
3.0
2.0
1.0
0

0 10 20

TIME (milliseconds)

13-12 The electronic flash requires an "X" setting on all cameras but shutter speeds cannot be faster than 1/30 on some focal-plane shutter cameras, or than 1/60 and 1/125 on others. Some have a special "X" setting on the shutter speed dial.

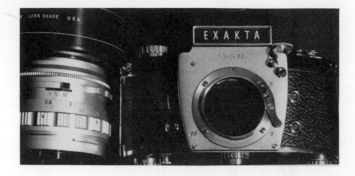

13-13 The lens (left) requires the small lever shifted to "X" for electronic flash and to "M" for most expendable flash lamps. The camera (right) requires the flashcord be inserted in the appropriate receptacle.

1. Direct the flash at the center of the area included in the picture. Use the guide numbers supplied with the lamps to determine the f/stop.

2. Make exposures at shutter speeds of 1/30, (1/25), 1/60 (1/50), and 1/125 (1/100) second and so on for as many shutter speeds as desired. The f/stop will be different for each shutter speed.

3. When the film is developed, the results should show even illumination over the whole frame if the camera is synched for the lamp and the particular shutter speed used.

Clear lamps are used for tungsten films, blue lamps for daylight films. "B" in the name of a flash bulb indicates it is blue. All flashcubes are blue. Either clear or blue may be used for black and white films.

ELECTRONIC FLASH

While the electronic flash is commonly termed "strobe," this is not strictly correct. Strobe should be and is the term applied to a stroboscopic lamp which flickers, that is, it lights and goes off in very rapid and regular sequence for tracing on film swift motion or action, such as a bullet discharged from a gun.

There was a time when electronic flashguns were so expensive, bulky, and heavy that they were practical only for the most frequent users. This is no longer true.

If the equipment is given appropriate care and properly used, the first investment in electronic flash is often the last and only expenditure unless it uses expendable batteries which need to be replaced. There are many budget-priced models of electronic flash available that are adequate and convenient. Some fit into the receptacle for battery-powered flashcubes.

The electronic flash is of much shorter duration than that from an

expendable flash lamp (Figs. 13-6–10, 12). The slowest electronic flashes are no more than 1/300 second (three and one-third milliseconds) and many are 1/1000 or 1/2000 (one millisecond and one-half millisecond). Some are many times faster than that. All electronic flashguns offer the advantage of freezing all but the swiftest action by the light source rather than by shutter speed.

Cameras are synchronized for electronic flash if they have an "X" setting. All except those with focal plane shutters are synched at all shutter speeds. Most focal plane shutters can be used at an exposure no faster than 1/60 second, a few at 1/125 second. If cameras with focal plane shutters can be used at faster speeds with electronic flash, this will be indicated in the camera's manual.

Determine if a camera is synched for electronic flash at any given speed. Without film in the camera, connect the electronic flashgun to the camera. Turn on the flashgun. With a piece of white paper on the table in front of the lens, watch through the open back of the camera and trip the shutter release. If a full circle of light can be seen as the gun is flashed, the camera is synched for electronic flash at the shutter speed used.

The electronic flash is nearly equivalent to sunlight in the color it produces on film, and is excellent with all daylight color and black and white films.

Power for the electronic flash may be by connection to AC current, by rechargeable nickel cadmium batteries, or by expendable batteries. Here, again, the photoflash (alkaline) batteries give better and longer service than the more common flashlight batteries. Expendable batteries are desirable if the flash is to be used in areas away from possible recharge on AC current or if the number of flashes per photographing session exceeds the charge on the cadmium batteries. Either of two sources of power can be utilized by some guns, others can use all three.

Features or variations in flash are in the time required for recycling, that is the time necessary for sufficient power to build in the capacitor to activate the flash. All electronic flashguns have a "ready" light that illuminates when the capacitor is recharged approximately 80%. This indicates the flash will go when tripped but it may not give a full-power flash at the instant. Another second or two, depending on the elapsed recycling time, may be required for the capacitor to reach full power.

Recycling time varies with the particular flash and the power source. On batteries, the recycling time will depend on the strength of the batteries. As they weaken, the recycling time lengthens. The same flashgun operating on AC current will recycle much more rapidly. There is wide variation in the number of flashes obtained on one battery charge, or with one set on expendable batteries.

Some electronic flash can vary the angle of coverage. Other guns can be set to flash at 1/4 or 1/2 power as well as full power. Light output varies with the individual models and brands.

There are many automatic electronic flashguns that give the necessary amount of light without any calculations when the controls are properly set. Do not expect the automatic electronic flash to know that extension tubes, extenders, filters, or bellows are attached to the camera. Compensation is necessary in these situations.

Divide the ASA by the exposure compensation to give a new exposure index number to set on the flash. For example, with a 2X extender, two full stops (exposure compensation of 4) adjustment must be made for correct exposure. With ASA 64 film

$$\frac{64}{4} = 16 = \text{compensated ASA}$$

An alternative is to set the flash on manual and open the camera lens two stops from that indicated by the dial or the guide number.

CARE OF THE ELECTRONIC FLASH

To get the best service from the electronic flash, it is important that it have certain care and attention. The amateur who uses the flashgun only occasionally should exercise the gun at regular two-week intervals. Repair men state that there is far more trouble with the electronic flash that is used only occasionally than with the ones used many times every day. It is not necessary to take pictures but each week, or at least once a month, the lamp should be flashed several times and the battery, if rechargeable, should be given a full recharge to keep it in top working condition. Do not flash too frequently in rapid succession. This can burn out the lamp. This hazard is not present in actual picture taking but can occur in the exercising procedure when the operator flashes it repeatedly as quickly as the ready light indicates the capacitor is charged. This is more rapid when the power source is AC current.

The electronic flash is installed in a very sturdy plastic case that presents no danger unless the gun is dropped or so severely abused that the case breaks open. Should this happen, **do not pick up the pieces with bare hands!** There is tremendous voltage developed in an electronic flash even when stored for long periods of time without use. This high voltage **will kill** if the gun is dismantled or broken. When or if it is necessary to pick up a broken electronic flash, use a well insulated tool such as a wood-handled shovel, to put the pieces into an insulated container. *Never attempt to repair* any electronic flash! Only a knowledgeable electronic technician can safely dismantle an electronic flash.

EXPOSURE CALCULATION FOR FLASH

Light diminishes rapidly as the distance from the light source increases. The light two feet from a light source is one-fourth as intense as it is at one foot. At three feet, the light is one-ninth as strong. It is desirable to control exposure of the film in some manner when using flash (Fig. 13-14).

The simple camera offers no control of lens aperture. Shutter speed is slowed to 1/30 second on some cameras with a flashcube inserted in the camera. The limitations on the kind or size of lamp that can be used on the simple camera control overexposure to some extent. This is true if the flash is moved no closer than is indicated on the instructions with the lamp for the kind of film used. Underexposure occurs when the photographer fails to recognize that the flashlamp normally used by the novice rarely carries farther than 20 feet for sufficient exposure on black and white films. Many lamps are totally ineffective beyond 10 feet on color films with fixed-aperture camera lenses.

Thousands and thousands of flash lamps and rolls of film are wasted every year at night and indoor performances because flash-to-subject distance is too great (Fig. 13-15). Incredible as it is, many a flashcube was burned in attempts to photograph the total eclipse of the moon. If pictures are obtained, it is from the existing or spot lights and the slowed shutter speed, not because of the flash on the camera. Another common mistake of the novice is to attempt to take a picture from a screen (TV, solarium, movie) with flash. If the light can give illumination at that distance, it simply erases the picture that was projected on the screen. On the automatic adjustable camera,

INVERSE SQUARE LAW

13-14 Light rays spread so the object catches less as the distance increases. Light intensity varies inversely with the square of the distance from the source.

13-15

a footage scale or dial may control aperture when the camera is set for flash. A check of the direction booklet with the camera should disclose whether this is true. If it does offer this control, the photographer sets the approximate footage on the scale. The aperture will control the exposure. Again, the construction of the camera will limit the particular kind of lamp that can be used.

GUIDE NUMBERS

For the manually adjustable camera, the necessary exposure is easily calculated with the guide numbers. These are provided by the manufacturer, printed on the lamp cartridges or accompanying instruction sheet. Film instruction sheets provide some flash information, too. The guide numbers were established by determining the best exposure for a given film ASA used with a particular shutter speed.

The guide number is the product of the f/stop number multiplied by the flash-to-subject distance in feet. The photographer then divides the guide number by the flash-to-subject distance in feet to arrive at the appropriate f/stop exposure number.

For illustration purposes, assume that the guide number is 80 for Kodachrome II (ASA 25) at 1/125 second shutter speed and given flash lamp. The subject is 10 feet from the flash, then:

80 divided by 10 is 8; f/8 is the correct aperture.

Were the subject 20 feet away, then 80/20 equals 4; f/4 is the appropriate lens opening.

Many flashguns have dials that indicate exposures when appropriately set. The dials on flashguns that use expendable lamps may be set with the film's ASA and flash lamp's guide numbers, then indicate

f/stops at various distances. The electronic flash, because of its one or two basic intensities, usually shows a point to set the film's ASA, then, the f/stop at the different distances can be easily read.

Several other available aids to determine exposures are revolving cardboard dials, sliding scales, and three-column scales on which a straight edge is laid from guide number to distance across the appropriate f/stop in that column. These are helpful for the nonmathematical individual.

Guide numbers are just that! Only guides! Experience soon alerts the photographer that there are variables which affect the pictures taken with flash. The ones most frequently encountered are:

1. A wide range of reflectance from the subject photographed causes loss of detail if the guide numbers are accepted as absolute. The guide number is established for the average reflectance subject, similar to that of a neutral gray test card. Very light or white subjects may need up to one stop less exposure. The dark or black object may need as much as one stop more than the average toned subject.

2. The surrounding area's reflectance can increase or decrease the light that may or may not bounce back onto the subject. For example, the very small bathroom with light walls, ceiling, and fixtures will yield much reflected light from the flash. The picture made at night in the deep woods with only dark greens, grays, and browns surrounding will absorb the light so that practically none will reflect from the surroundings. Compensation by less exposure will be needed in the bathroom, more exposure in the woods. In between the two extreme examples just outlined are those places where walls are white but twenty feet away, or are moderately reflective but very close to the subject.

3. The manner in which the lamp is held as it is flashed affects the amount of the light that strikes the subject. Guide numbers are established with the assumption that the flash is directed at the subject. Discerning photographers soon become aware that there are other ways of directing the flash that improve the quality of their pictures. These require a variance in guide numbers, too. This is discussed at length under "Techniques to Improve Flash Pictures."

4. The size and kind of reflectors on the flashgun affect the light output. Many lamp manufacturers provide different guide numbers to compensate for these variations.

The individual who takes many flash pictures may find it desirable to work out his own guide numbers for his particular equipment and

the various kinds of situations that he photographs most frequently. Color positive films, with their more limited latitude, are best to establish guide numbers because it is easier to determine more specifically the best exposure for the subject and particular techniques used. Careful records of focused distance, aperture, subject, surroundings, and the results are the basis for the guide numbers that can be established by either of two methods:

1. Check the results carefully on each picture taken by flash and determine the degree of over-, under-, or satisfactory exposure.

2. Set up the flash a given distance from a subject and bracket the exposures at one-half stop intervals either side of the manufacturer's recommendations for the number of pictures that the subject may require to get the ideal exposure.

When the most appropriate exposure is determined, multiply the flash-to-subject footage by the f/stop number used. This, then, is the guide number for the particular equipment, film ASA, and shutter speed used and the specific situation covered such as surroundings, subject, and method of directing the flash.

TECHNIQUES TO IMPROVE FLASH PICTURES

The only solution in some situations is the standard flash-on-camera shot. This seldom produces a quality photograph and commonly causes the following undesirable results:

1. Gives little or no modeling and no feeling of texture because of the flat, front lighting.
2. Provides harsh, unflattering flat front lighting.
3. Throws unattractive shadows on backgrounds.
4. Makes red eyes with color film and overly large highlights in eyes on black and white film in pictures of people or animals.
5. Overexposes the foreground while underexposing desirable background subjects that are further from the camera.

Numerous flash techniques reduce or eliminate these problems.

1. Taking the flash off the camera but still connected helps most of all. Six inches above the camera improves the picture; three feet up and to one side is better. More distance above the camera may be best but this depends on the flash-to-subject distance and the subject being photographed. Getting the flash off the camera lets the shadows drop lower behind the subjects, improves modeling, lessens the chance of red eyes, eyeglass flare (Fig. 13-16), and spreads the light better.

DIRECT FLASH

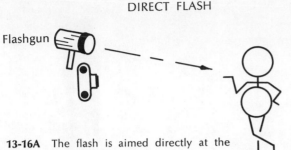

13-16A The flash is aimed directly at the subject.

13-16B Note eyeglass flare and white pupil of the eye when the subject looks directly at the camera. In color, the pupil would have been red.

No compensation in exposure is needed for taking the flash off the camera. It must be remembered, though, guide numbers are established on *flash-to-subject* distance, *not* camera-to-subject distance. If the subject and flash are stationary, the exposure will be the same whether camera-to-subject distance is three feet or fifteen feet.

 a. For the flashcube, extension flash units raise the cube from three to six inches (Fig. 13-17).

 b. Extension cords with appropriate terminals are available in both coiled and uncoiled types in several different lengths (Fig. 13-18). These are made of relatively light wire and must be treated with care to avoid the wire breaking. The flash extension cord should be kept in a hard case, such as a metal goggles case. *Never* toss flash cords into the bottom of the gadget bag if they are to work the next time.

 c. Extensions can be adapted easily. The coiled electric razor cord is an inexpensive solution. One prong on the male connection is filed narrower.

2. Bounce flash is an excellent technique to reduce contrast, produce better modeling, decrease or eliminate shadows on the background, and spread the light more evenly over a wider area (Figs. 13-19, 20). The gun with a tilting head can be used or the flashgun hand held off the camera. The exposure requires compensation. This usually is at least one stop. The more exact amount will depend on:

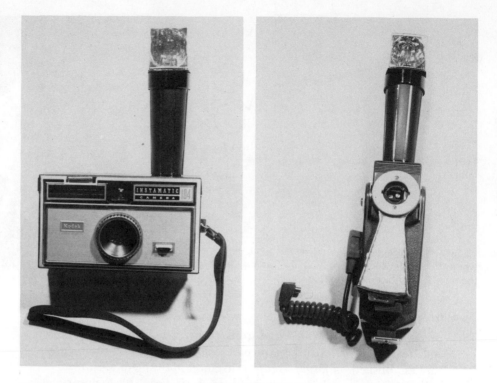

13-17A Flashcube extensions vary in height. Eastman Kodak offers plans to make one to get the flashcube off the camera at any distance desired.

13-17B Two flash units combined to get the cube still higher above the camera.

13-18A Extension flashcords come in many sizes and weights. These vary from nine inches to three feet, in straight and in coiled lines.

13-18B Stored in the sturdy metal goggles case, the cords are protected in the gadget bag from wire breakage.

Photographed by Neil W. Momb.
Costume by Judith E. Jerde.

13-18C Be cautious with the direction of flash off the camera. The flash was held to the right and just below the camera for this exposure.

13-18D Electronic flash was held to the left of camera position and just higher than the player's head.

13-18E Flash off camera aimed to put a hot spot on the travel poster but still illuminate the model. Flash was to the left and above camera position.

 a. The reflectance of the surface from which the flash is bounced. Though even a totally white surface will absorb some of the light, white and off-white surfaces are preferable because of their high reflectance. Light-colored surfaces other than white work well with black and white films but they give off-tints to pictures made on color film. Ceilings are favorites for bouncing surfaces.

 Light walls can be used. Some photographers use a corner wall by placing the subject in a corner. The subject must be far enough from the walls to prevent shadows on them. White umbrellas or the reflectors made on similar principles are effective for softening and diffusing light from flash. The flash is directed into the umbrella, which reflects onto the subject (Fig. 13-20).

 b. The distance from flash-to-bounce surface-to-subject will be the effective flash-to-subject distance to use to establish exposure (Plate 3).

3. An off-camera flash may be improved with reflectors or by the use of fill flash to reduce contrast, to fill shadows, and extend the light spread. Some electronic flashguns, called "slaves," are

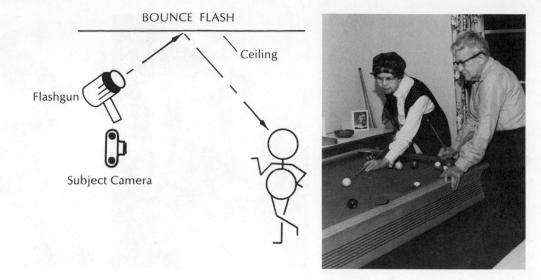

BOUNCE FLASH

Ceiling

Flashgun

Subject Camera

13-19A The flash directed at the ceiling provides softer, more natural light that is desirable for many subjects. An angle of 45° distributes the light nicely. Less than 45° creates unattractive shadows and much of the light is lost behind the subject.

13-19B Flash bounced from the ceiling from the right of the camera.

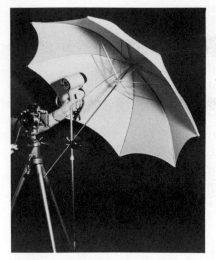

13-20 Another method of bouncing flash.

or can be equipped with an electric eye that trips the slave, causing it to flash instantaneously when the gun that is connected to the camera flashes. Multiple slaves can be set to cover wide areas.

4. Open flash is used to paint with light in dark areas. The tripod-mounted camera is set on "T" or on "B" with a locking cable release to hold the shutter open. The photographer then walks into the scene, flashing the gun without a connection to the camera, at fifteen-foot intervals, to light up extensive areas. If he keeps walking, his own image will not register on the film. When the painting has been completed, the camera shutter is closed.

5. Flash is used to reduce contrast and fill shadowed areas in daylight. Situations in which flash is especially effective in daylight is the indoor-outdoor picture and the back- or sidelighted pictures taken relatively close to the subject in bright sunlight (Figs. 13-21, 22).

 a. For the indoor-outdoor scene, the meter reading is taken for the outdoor view. The shutter speed chosen must be appropriate for the synchronization of the gun and/or lamp being used. Usually, maximum depth of field will be desired, so the slow shutter speed may be most desirable. The corres-

13-21A (Right) Fill flash in daylight lights up shadows in side or backlighting.

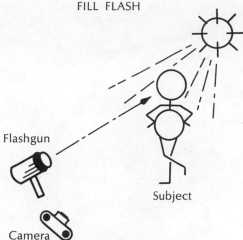

Flashgun

Subject

Camera

13-21B (Below, left) Note shadows in back-lighted subject.

13-21C (Below, right) Fill flash opens up the shadows without destroying the direction of lighting effect.

Photographed by Neil W. Momb.

Photographed by Neil W. Momb.

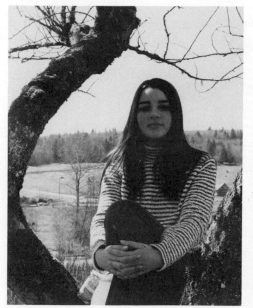

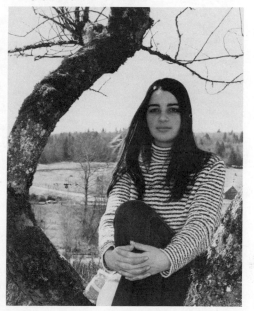

ponding *f*/stop number is divided into the guide number for the lamp to determine the lamp-to-subject distance. The flashgun and camera are placed accordingly and the picture taken.

b. For fill in daylight, the meter reading is made for the normal daylight scene. Again, the shutter speed must be one that

Photographed by Neil W. Momb.

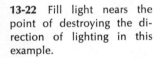

13-22 Fill light nears the point of destroying the direction of lighting in this example.

will work with the gun and/or lamp used. The fill flash is used to open up but not eliminate the shadows (Fig. 13-22). For this reason, in establishing the flash-to-subject distance, choose one-half to one stop smaller to divide into the guide number than the one actually used on the camera for the exposure. If, for example, the picture is taken at $f/11$ at 1/125 second, use $f/13$ or $f/16$ for the calculation to obtain the flash-to-subject distance. This will retain the direction of lighting effect but lessen contrast.

6. When it is necessary to use the gun so close that at the smallest aperture the picture will be overexposed, the exposure can be reduced with a man's white linen handkerchief wrapped or spread over the flashgun (Fig. 13-23). Handkerchiefs vary in the

13-23 The ten-inch working model was photographed with flash at two feet covered with two layers of a handkerchief.

amount of light screened so one should be tested and kept stored in a plastic bag with the flash for this use alone.

One layer of handkerchief normally reduces the exposure by two stops. For example, if the guide number is 90, the flash one foot from the subject, then the f/stop is f/90, which is seldom found on the more popular camera lenses. One layer of handkerchief reduces the aperture to f/45, two layers to f/22, which is found on many lenses. If this is still impractical for the equipment and situation, then a third layer will take it to f/11. Again, fabrics used in handkerchiefs vary in the amount of light they hold back. Any other white fabric can be used if the difference in exposure is known. The handkerchief also serves to diffuse the light to give a softer effect.

7. When it is desirable to spread the flash over considerable depth, the gun should be raised above the camera and aimed at an angle (Fig. 13-24). If the exposure is calculated for the back one-quarter of the depth and aimed at that distance, spill light will illuminate the closer subjects without overexposing as would happen with the flash and camera aimed at the same angle.

8. Bare bulb is a flash technique to spread and diffuse light for better modeling. With those guns that have removable or folding reflectors, the reflectors are not used. One stop at least is lost in the exposure so the lens aperture must be opened that amount or more.

9. To simulate lighting from the fireplace or a campfire, conceal the flash behind the flames or a shield in front of the fire. The flash is connected to the camera by a long extension cord.

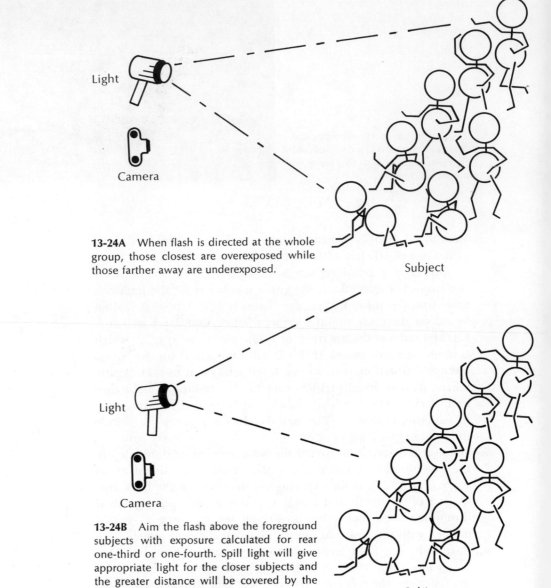

13-24A When flash is directed at the whole group, those closest are overexposed while those farther away are underexposed.

13-24B Aim the flash above the foreground subjects with exposure calculated for rear one-third or one-fourth. Spill light will give appropriate light for the closer subjects and the greater distance will be covered by the increased exposure allowed.

TROUBLESHOOTING FLASH FAILURES

Flashguns, like all other photographic equipment, benefit from careful handling. Problems that most frequently cause flash failures and their remedies are:

1. An oxidation film forms on the contact surface of the alkaline battery and/or the contact points in the gun or camera. To correct, rub the contact areas of the batteries with a firmly woven cloth to polish. The contact points in the gun or camera are easily damaged so they must be cleaned with more care, perhaps even by a competent repairman.

 The contact pads beneath the revolving flashcube mechanism become coated with the oxidation film in time. Extreme care must be used in polishing the pads to prevent damage. The knowledgeable repairman, again, may be the cheapest way.

 To reduce the formation of the oxidation film, the batteries should be removed from the camera and stored in the refrigerator during long periods of nonuse. Seldom are batteries exhausted from use. They deteriorate from age, which is slowed by refrigeration.

2. Intermittent flash firing usually is caused by the contact points within the camera becoming corroded to some extent from lack of use. Instead of continuing to shoot and missing exposure on most of the roll of film, it is better to remove the film, then trip the shutter repeatedly with the camera set to flash. This should be repeated dozens of times to wear through the film of corrosion. Usually, this procedure will polish the points sufficiently to remedy the problem.

3. Excessive oxidation occurs when moisture enters the areas of contact. A camera used in rain, mist, or snow, or exposed to rapid and repeated changes from extreme cold to warm areas causing moisture condensation may have this problem. Another common cause of excessive oxidation is the practice of misinformed photographers who dampen the contact points of the flash lamp before inserting it into the flash lamp holder. This should never be done! Moisture serves no good purpose inside any portion of a camera.

4. Contact springs within the camera may become weakened or broken from extensive use and provide no connection to the flash. A competent repairman is the only answer.

5. The flashgun may flash at the instant the lamp is inserted or the electronic flashgun is connected to the camera. This occurs in some cameras if the shutter is not cocked before the lamp is placed in the socket or recocked before the electronic flashgun can recycle. *Always* assume the flash may go off as soon as the lamp is inserted or the electronic gun connected. Hold the flash lamp gingerly as it is put in position and do not look directly at it as contact is made to avoid being burned and/or temporarily blinded.

Too often, flash is utilized for making a picture when the picture would have been far more effective without flash. The choice of films available today allows pictures by available light in very low levels. A study of the following chapter will help in the selection of the film to use in a particular situation.

REFERENCES FOR FURTHER READING

Farber, Paul: "Stop-Action Flash Photography with a Five-Cent Gadget," *Petersen's Photographic Magazine,* Vol. 1, No. 4, August, 1972, pp. 26f.

Gowland, Peter: *Peter Gowland's Guide to Electronic Flash,* New York, Amphoto, 1972.

Karsten, Kenneth: *The Science of Electronic Flash Photography,* New York, Amphoto, 1968.

Jacobs, Jr., Lou: *Electronic Flash,* New York, Amphoto, 1971.

Kennedy, Cora Wright: "Try Flash with an Available Light Look," *Popular Photography,* June, 1970, Vol. 66, No. 6, pp. 32f.

Martin, Stephen P.: "Flash Exposure Calculator," Activity Research and Development, Dept. P.Y., Box 85, Trumbull, Conn. 06611

Miller, David: "Unscrambling the Flash Mess," *Modern Photography,* Vol. 32, No. 11, November, 1968, pp. 116f.

Rothschild, Norman: "Flash: The Great Equalizer," *Popular Photography,* Vol. 71, No. 5, November, 1972, p. 108f.

CHAPTER 14

Films

To produce a good photograph, a most vital factor is the choice of film, its exposure, and subsequent development. Other factors related to the success of the picture are the care and storage of films. These areas have been presented to some extent in previous chapters and are explored further in this one.

CARE AND HANDLING OF FILM

Film is amazingly stable and durable when stored and handled appropriately, yet is very perishable when mistreated. To be sure that film is at its normal level of performance, follow these precautions:

1. Buy fresh dated film.
2. Keep film cool and dry before and after exposure and after processing.
3. Protect film from light, dust, and scratches at all times.

Reputable manufacturers stamp each carton of film with an expiration date which is the limit of their guarantee as to defects in manufacture. This date is an excellent guide to film freshness (Fig. 14-1).

Black and white film that is too old or has been subjected to extreme heat shows overall fog when developed. Fogged film reduces the contrast of the recorded image. Color film that has passed peak performance shows an unpleasant yellow-green tint and other color shifts are possible.

Humidity and/or heat cause rapid deterioration in film even before the expiration date. While film can be kept too dry, more often there is too much humidity. The manufacturer's airtight containers guard against moisture.

After the manufacturer's seal is broken, a packet of granulated silica gel stored with the film, either undeveloped or processed, all in a larger airtight plastic or glass container, solves the humidity problem. To keep the silica gel active, dehydrate it in a warm oven for several hours. Necessary frequency of dehydration depends on the severity of the humidity conditions.

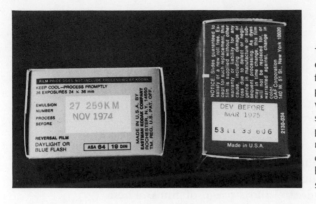

14-1 November 1974 and March 1975 are expiration dates for these two cartons of film. The emulsion number near the expiration date indicates all those cartons with the same number were made in the same batch. Emulsion lots in films or papers, like dye lots in fabrics and yarns, may show very slight variations. This is of little or no concern to most amateurs but is critical for advanced and professional photographers.

Both unexposed and exposed film, until it is processed, is best preserved by storage in a freezer below 0°F. The performance peak is retained indefinitely when film is kept frozen until a few hours before use. Film should warm at room temperature for three to four hours before opening the cartons. Storage in the fresh food compartment of the home refrigerator slows deterioration as compared with storage at normal room temperatures. Film from the refrigerator should warm at room temperature one to two hours before use. Film stored at 90°F or above would be suspect on stability long before the stamped expiration date.

Outdated film usually is sold at drastically reduced prices and can be a bargain if the film has not been overwarm at any time since its manufacture. One should be more cautious in buying outdated color film because it is considerably less stable than black and white film.

In hot climates, if possible, buy all films from the store that keeps the air conditioner operating seven days per week.

The traveler by air, train, or bus can pack his film in the middle of his luggage, letting the clothes on either side act as insulation (Fig. 14-2). Each morning, he should remove the film needed for the day,

14-2 Film packed in the middle of luggage of clothing has heat protection.

restore the film exposed the day before, and close the luggage until evening. Open it for the night to allow it to cool thoroughly and repeat the process each day. Even in very warm climates, film will be stable for several weeks by this method.

Travelers in foreign countries must protect their film from the hazard of X-ray inspection in going through customs by labeling the exterior of both sides of the luggage in large, legible lettering, "Unexposed (or Undeveloped) Film for Personal Use" (Fig. 14-3). Should there be more unexposed film than is allowed to be brought into the country, the owner can request the excess be sealed by the officials. When leaving the country, the duty on all unopened film will be refunded. For the countries that do limit film quantities, the longer rolls of 36-exposure or even 100-foot rolls carried in inexpensive daylight bulk-film loaders provide a legal method of carrying more film.

Reports at this writing indicate many airlines are utilizing X-ray on luggage to prevent sabotage and hijacking. If this practice is continued, pack the film in a special hand-carried case, also plainly labeled.

Processed film is subject to mildew in storage. In the early stages, use film cleaner to remove the mildew. If the emulsion has been damaged, there is no method that will restore the area. Both negatives and slides should be inspected at regular intervals for any sign of mildew. Control of humidity and temperature prevents mildew.

Slides can be commercially encased in clear plastic to protect them from mildew. The procedure is quite expensive if many transparencies are so protected.

The colors in transparencies fade if the processed film is exposed to strong light for too long a period of time. Most dangerous for slides is the ultraviolet light found in daylight and fluorescent lamps. Cool, dark storage in dusttight containers with low humidity assures the best possible stability. Project the slides every few months to subject them to the heat of a projector lamp for aid in the control of mildew.

14-3 The bright red letters of "unexposed" or "undeveloped" alert the inspector. Airport X-ray *does* fog film. Lead-lined bags are made that shield film.

Fingerprints on the emulsion of any film must be cleaned as soon as possible. The oils and acids of skin secretions will penetrate the emulsion in time and will ruin that portion of the film. Film cleaner is effective when used soon after the fingerprint is made.

Blow off dust and lint from film with the jeweler's plastic hand pump suggested in Chapter 1, Camera Care, for cleaning lenses and camera interiors. The magnetic brushes work well, too, when they are kept immaculately clean. Never brush across the fingers or hand because this transfers the acids and oils to the film via the brush.

FILM SELECTION

With the dozens of films on the market and the avalanche of advertising concerning them everywhere, it is certainly understandable that the novice photographer wonders, "Which film is really best?"

There is no one specific film that is best even though some photographers use one film exclusively and consider it the *only* film! It is the best film for that individual because:

1. He knows exactly the results to expect since he knows the film so very well, which allows maximum control and success.
2. The particular subjects he photographs are best portrayed on that film.
3. The kind and amount of light he uses is appropriate for the results he wants.
4. The film is best for the purpose or the way in which the picture is used.
5. He prefers the colors, the contrast, the grain, the latitude, the speed, or a combination of these characteristics of the film.

Other equally successful photographers prefer to use a variety of films, each to fit a particular purpose for the subject, the lighting, or the effect desired.

In order to decide which film may be the best choice, one should explore some of the characteristics of films and their potentials.

CLASSES OF FILMS

There are numerous methods of classifying films. Some are:

1. The shape or method of packaging for use.
2. Black and white or color.
3. Negative or positive.
4. Speed: slow, medium or fast.
5. Specialized uses: infrared, high-contrast copy, and Kodalith among many.

Classification by Packaging

In earlier chapters, the terms commonly used for classifying film as it is packaged were covered to some extent (Fig. 2-20). These are:

1. Roll film packaged with a paper backing. The 220 film for some 2¼ x 2¼ cameras has a paper leader but no paper backing on the film portion of the roll.
2. Cartridge pack for drop-in loading in the 126 size.
3. 35mm cassette film for cameras utilizing 35mm film.
4. Cut film in numerous sizes, used one piece at a time in film holders that allow specialized processing for each picture. Common sizes are 2¼ x 3¼, 4 x 5, 5 x 7 and 8 x 10 inches, used in cameras that employ film holders or film packs. These cameras have not been covered because seldom does the beginning photographer start with them.
5. Movie film in 8mm, Super 8, 16mm, and 35mm. Movie cameras and their specific techniques are not explored in this book, either.

Black and White or Color

Black and white or color films describe the end product. Black and white films yield results in shades of only one color. These range from very light (white) to very dark (black) in tone. Prints in other colors can be made from these by various methods but the original film is only in shades of gray.

Black and white films require only one layer of emulsion (Fig. 14-4).

Black and white films are further divided by their sensitivity to color; the ingredients included in the emulsion determine which colors. Films that are sensitive to all colors are termed panchromatic (or pan films for a shorter expression). Most of the popular black and white

BLACK AND WHITE FILM

14-4 A cross section of black and white film.

films sold at camera counters are panchromatic and need to be handled and processed in complete darkness. While sensitive to all colors, this does not mean they are sensitive to each color to the same degree. Color of light registering on the film can be altered by filters over the lens. (Chapter 15, Filters.)

Films that are sensitive to blues, greens and to some extent to yellow but not to red are termed orthochromatic. A red light can be used while developing or handling the ortho films. They are widely used in graphic arts work and for other specialized uses.

Color films, as the name implies, give pictures in color, more or less a duplication of the subject as the photographer saw it with his eyes. Films vary in their color rendition, however. The keys to some of these differences are explained in this and the following chapter.

Color films have three layers of emulsion, each sensitive to one specific color. The three colors are cyan, a blue-green; magenta, a bluish red; and yellow. With this combination, color films are sensitive to all colors. Films vary considerably in the rendition of individual colors. No color film will produce all colors exactly as they are, though all films on the market give pleasing renditions. Since everyone sees colors differently, a film that pleases one photographer very well may be completely unacceptable, or at least not pleasing, to another. Films are constantly being improved by the manufacturers so that comparisons that might be made here could no longer be valid for films on the market when this is read. For this reason, no comparison as to color rendition is made. The reader will want to explore the current differences when he is working with color film.

Negative Films

Negative films are made in both black and white and in color. On negative films the dark and light areas of the image are always the opposite of what they were in the subject. The original film used to take the picture is then utilized in making a print on a negative, emulsion-coated paper or other substance. Two negatives do make a positive in this case (Fig. 14-5). (Chapters 3, 4, 5, 6, Black and White Film Developing, Processing Color Film, Contact Print or Proof, and Enlarging.)

With negative color film, the colors are reversed in addition to the reversal of dark and light. Each color appears as its complement (Fig. 8-4B). Magenta in the subject is cyan in the negative, green is magenta, blue is yellow in films without a mask and vice versa. Many color-negative films have an all-over colored mask that distorts the reversed color. This is to simplify the filtering in making the positive print. The mask does make the negative more difficult to read for the un-trained eye. In the process of making the print, there is opportunity to

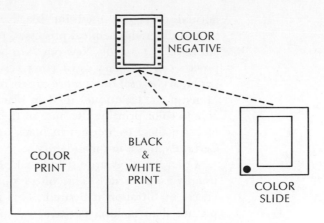

14-5 The color negative may yield any of the three but is most popularly used for the color print.

filter to gain different effects or to try to duplicate as nearly as possible the colors in the subject photographed. Different filtering causes the wide variance in colors obtained from the same negative in commercial color printing.

Negative color film can be identified by the word *color* in the name. Some of the ones on the market (listed alphabetically) are Ansco Color Print Film, Dynacolor, Ektacolor, and Kodacolor-X. These are color balanced for daylight and blue flash lamps. Filters over the lens are used to correct the light that reaches the film when this is desirable or required.

Negative color can be home-processed. Chemical kits are available. Control of chemical solution temperature is critical because this affects the colors. The process entails more steps chemically and more time than black and white on some of the processes. Other than these differences, it is really no more difficult than developing black and white films. (Chapter 4, Color Film Processing.)

Some photographers have negative color developed only commercially, then proof the roll in black and white prints in the home darkroom before having the choice exposures printed in color. This reduces the expense somewhat. The negatives can be printed on any black and white paper. Kodak's Panalure and GAF's Pan paper (P.P. 675-double weight and P.P. 763-single weight) are panchromatic papers made especially for black and white prints from color negatives. Because these papers are sensitive to all colors, it is necessary to have a special, very dark safelight filter or work in total darkness until the print is in the fixer.

This book does not cover color printing. It is becoming more and more popular in the home darkroom. Color printing is comparatively easy. One can achieve very fine work with the same equipment in the

normal darkroom used for black and white. There are available several different chemical processes, papers and varying equipment to aid in printing color. New ones are being announced frequently. Each process can give very satisfactory results. The supplies, chemicals and paper, are several times more expensive than those for black and white. Many of the techniques used in black and white printing are applicable to color printing. Because of the expense involved, it is less costly to learn these techniques in black and white, then progress to color. Certainly, this is not mandatory.

Color negatives are used to make color transparencies. This is done usually commercially and offers opportunities to change the color effects by filtration if desired. This procedure is more expensive per picture than making positive transparencies originally with positive color film. Special color print films are available to make slides from color negatives. High Speed Ektachrome processed in Kodak's C-22 chemicals works well.

Positive Films

Black and white negative films are processed to positives (transparency or slide) with special chemistry when this is desired. The pictures are mounted in cardboard, metal, plastic, or glass and viewed by rear illumination as in a projector. The picture is projected onto a screen. Kodak's Panatomic film or Direct Positive film is processed with the Eastman Direct Positive kit.

Positive color films can be identified by the suffix *chrome* in the name. Some presently on the market (alphabetically listed) are Agfachrome, Anscochrome, Dynachrome, Ektachrome, and Kodachrome.

Each of these require specific chemistry for processing. Dynachrome and Kodachrome have the dye couplers in the chemicals and must be processed under rigid controls in commercial processing plants. The other three films have the dye coupler incorporated in the emulsion and can be processed commercially or by the individual in his home.

Positive color films yield color transparencies, commonly called *slides,* on the original film used to take the picture. These are viewed by rear illumination as when projected on a screen; large audiences can observe or study a picture at the same time. This is not a process of printing on another surface.

Prints are made from slides (Fig. 14-6). Two common methods are used commercially. To obtain small prints, they are projected from the transparency onto a positive emulsion coated paper. For 5 x 7 and larger prints, the transparency is usually photographed on negative color film. This internegative is then projected in an enlarger and printed on negative emulsion coated paper. Positive film is termed a reversal film because it is first developed as a negative, reversed to a

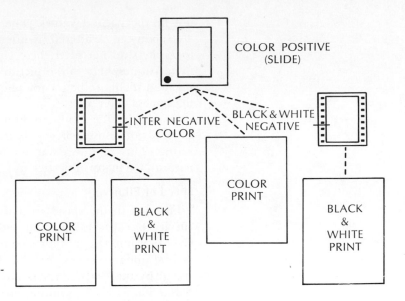

COLOR POSITIVE
(SLIDE)

INTER NEGATIVE
COLOR

BLACK & WHITE
NEGATIVE

COLOR
PRINT

BLACK
&
WHITE
PRINT

COLOR
PRINT

BLACK
&
WHITE
PRINT

14-6 The color positive slide may be utilized in all these ways.

positive, and redeveloped to get the color. The reversal step is done chemically with some processes. The reversal is accomplished by re-exposure to light, expressed as "second exposure" in other processing. (Chapter 4, Color Processing.)

Color of light varies widely and in turn affects the colors of the pictures made on color film. (Chapter 8, Light.) The negative film may be filtered in the printing process to correct for differences in the color temperatures of light. Positive films do not offer this alternative after the shutter is tripped. Filters over the lights, filters over the lens, or choice of film balanced for the light source are the only possibilities of color control of the resulting transparency. Filters for this purpose are explored further in the next chapter.

Color films are manufactured to a particular Kelvin rating. This, in simple terms, means that film to be used with tungsten light is made more sensitive to blue and less sensitive to red. Film to be used in daylight is made more sensitive to red and less sensitive to blue than is tungsten film. Most color films are made for daylight, balanced at or near 5500°K. Two kinds of films balanced for incandescent light (tungsten) are: Kodachrome II Professional Type A at 3400°K (photoflood lamps); and High Speed Ektachrome, Tungsten, at 3200°K (studio flood lamps).

While a daylight film is balanced for midday, it does not mean it is limited to use only during those hours. In fact, the color of light earlier and later in the day usually gives interest or mood to make the picture more effective than if taken at midday, even though colors will

not be the natural values. The off colors of early morning and late afternoon can be altered by filters to be natural. Many dedicated photographers do not filter these characteristic color tones but use them to add atmosphere to the picture. Early morning, late afternoon, evening, and night are better for photography. Midday is the time to stow the camera and rest!

Similarly, the tungsten film balanced for either the 3200°K or 3400°K can be used effectively in lighting situations with lower Kelvin rating. This produces warmer tones (more red and orange) than is natural. On many subjects, this is most effective and desirable.

Speed of Films

Films vary in the speed with which they respond to light. This sensitivity is expressed as film index, emulsion speed, exposure index (E. I.), or film speed. This characteristic of film has been indicated on several different scales. Two of those in use today are the ASA, established by the American Standards Association (now called the United States Standards Association) and the DIN scale advanced by Germany (Fig. I-4). Only the relationship between the numbers in the ASA scale are explored in this book.

The numbers in the ASA scale are in arithmetic progression so that when any number is doubled, the exposure will be decreased by one-half (a full f/stop). In reverse, when an ASA number is reduced by one-half the exposure is doubled or increased by a full stop.

On ASA scales on light meters, and/or cameras, only a portion of the possible numbers is shown. Those and the numerals represented by dots, lines, or indentations are standardized in increments of one-third f/stop differences in exposure. The settings include all the ASA ratings of popular films (Fig. 14-7).

Black and white films are classified as moderate, fast, and extra or super fast (Fig. 14-8). General characteristics of each speed classification are fairly standard but will vary with different photographers and pictures because of:

1. The ways the film is exposed: optimum, over or under.
2. The kind of developer used: standard, fine-grained; high, moderate, or low contrast.
3. The amount of development given: optimum, over or under.
4. The chemicals and water temperatures as the film is processed: consistent or widely fluctuating.
5. The degree of enlargement made: slight, medium, or extreme.
6. The kind of light in which the picture was made: color, direction, and contrast.

In general, the slow films have the finest grain, the best resolution or definition (the ability to reproduce fine detail), and moderate con-

A. Overexposed

B. Normally exposed

C. Underexposed

PLATES 2A-C. NEGATIVE COLOR FILM

A. Overexposed

B. Normally exposed

C. Underexposed

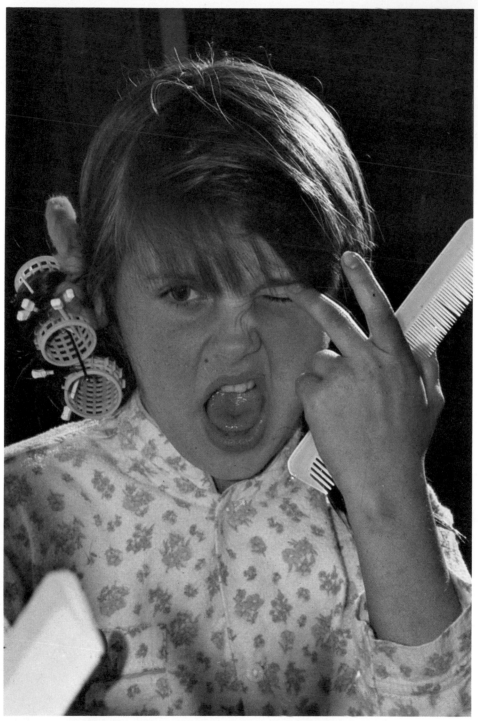

PLATE 3. A mirror reflection made with flash behind and above the subject. Notice the effective highlights.

PLATES 4A-C. While any of these three exposures bracketed at half-stops might be acceptable, one is best. Which?

A. *F*/13.5

B. *F*/16

C. *F*/19.6

Photographed by Neil W. Momb Costume by Judith E. Jerde

PLATE 5. This picture was made with Kodak's High Speed Infrared Aero Film.

PLATES 6A & B. Duplicating film, with less contrast, gives more detail in highlights and shadows.

B. Anscochrome 5470 Duplicating Film

A. Tungsten light with no filter

B. Tungsten light with an 80B filter

PLATES 7A-D. Daylight film was used in Plates A and B. Tungsten film was used in Plates C and D.

C. Daylight with no filter

D. Daylight with an 85B filter

A. Fluorescent light with no filter

B. Fluorescent light with an FLD filter

PLATES 8A-D. Daylight film was used in Plates A and B. Daylight film was used in Plates C and D.

C. Daylight with no filter

D. Daylight with a polarizing filter

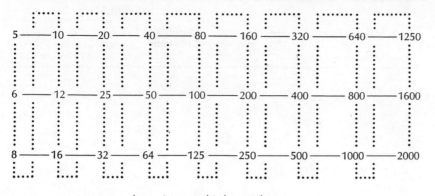

5 —— 10 —— 20 —— 40 —— 80 —— 160 —— 320 —— 640 —— 1250

6 —— 12 —— 25 —— 50 —— 100 —— 200 —— 400 —— 800 —— 1600

8 —— 16 —— 32 —— 64 —— 125 —— 250 —— 500 —— 1000 —— 2000

······· connects numerals to give one-third-stop change.
———— Connects numerals to give one-stop change.

14-7 Each preceding or succeeding number read vertically changes exposure by one-third stop. Any ASA number halved or doubled read horizontally changes exposure by one stop.
 To decrease exposure, multiply the ASA by the filter or compensation factor.
 To increase exposure, divide the ASA by the filter or compensation factor.
 Exposure is changed by inverse proportion to the multiplier or divisor.

trast. The medium speed films have medium grain, good resolution, and more contrast. The fast films have larger grain, somewhat lower resolution (but still very good), and more contrast. The superfast films have the largest grain, lowest resolution or definition, and highest contrast. It must be stressed again, these are only general statements. One photographer, because of his careful and knowledgeable handling of a film, may have finer grain, better definition, and more appropriate contrast with the fast film than another individual will have with the slow film. Even so, films do definitely vary in these qualities (Fig. 14-9).

Color films show somewhat the same variations in qualities found in the different speed ranges as do black and white (Fig. 14-10). In addition, there is variance in latitude and color rendition. The color variations have been discussed previously. The slow films have the finest grain, the lowest contrast, the best resolution, and the most latitude within a manufacturer's line. There is considerable difference in the same speeds for different film makers' products. The moderate speed films within a line may show a slight decline in each of these characteristics but are still of excellent quality. When the fastest speeds of films are involved, there is considerable increase in grain, increased contrast, lower resolution, and less latitude. When films are pushed, there may be some color shift, larger grain, and still more contrast and less lat-

BLACK AND WHITE FILMS
(Partial List)

Manufacturer and Film Name	ASA Exposure Index	Available in		
		Cartridge (Instamatic) 126	Cassette (35mm) 135	Roll Film (2¼ x 2¼) 120 and/or 620
Slow Speed / Very Fine Grain				
ADOX KB14	20		X	
R14	20			X
AGFA Isopan IF	40		X	X
KODAK Panatomic-X	32		X	120 only
ADOX KB17	40		X	
R17	40			X
ILFORD Pan F	50		X	
Medium Speed / Medium Fine Grain				
ADOX KB21	100		X	
R21	100			X
AGFA Isopan ISS	100		X	X
GAF 125 Black and White	125	X	X	120 only
ILFORD FP4	125		X	X
KODAK Plus-X Pan (PX)	125		X	120 only
Verichrome Pan (VP)	125	X		620 only
Fast Speed / Medium Grain				
AGFA Isopan ISU	400		X	X
ILFORD HP4	400		X	X
KODAK Tri-X Pan (TX)	400	X	X	X
GAF 500 Black and White	500		X	120 only
Very Fast Speed / Coarse Grain				
AGFA Isopan Record	1250		X	X
KODAK 2475 Recording Film			X	
Royal-X Pan (RX)	1250			120 only

14-8 The list does not include all of the popular films on the market.

itude. (Chapter 4, Processing Color Film.) However, these slight disadvantages are usually preferable to using flash and often get the picture where flash would be impossible.

USING THE ASA SCALE

There are several ways in which the photographer can utilize the ASA scale:

1. To correlate the film's sensitivity with the desired exposure.
 a. The film manufacturer's recommendation is certainly the most commonly used ASA setting. Photographers should check the instructions with each roll of film because the film makers change the sensitivity of films from time to time. The change always will be incorporated in the instructions except, perhaps, with the 126 size films.
 b. To adjust or compensate for a filter factor, see the following chapter for directions.
 c. To make adjustments for the variations in equipment or processing, the ASA is often adjusted to allow either more or less exposure. Seldom are lenses calibrated absolutely ac-

14-9 Tri-X exposed at ASA 2000 (normal is 400) with mercury vapor lights and developed in UFG. Grain is evident but images are very sharp and most acceptable.

COLOR POSITIVE (TRANSPARENCY) FILMS
(Partial List)

Manufacturer and Film Name	ASA Exposure Index	Available in		
		Cartridge (Instamatic) 126	Cassette (35mm) 135	Roll Film (2¼ x 2¼) 120 and/or 620
Slow Speed / Very Fine Grain				
KODAK				
Kodachrome II	25		X	
Kodachrome II Type A Professional	40		X	
Medium Speed / Medium Fine Grain				
AGFA				
Agfachrome	64	X	X	X
GAF				
64 Color Slide Film	64	X	X	120 only
KODAK				
Kodachrome-X	64	X	X	
Ektachrome-X	64	X	X	X
3M				
3M Brand Color Slide Film	50	X	X	
Fast Speed / Medium Grain				
GAF				
Anscochrome T/100	100		X	
KODAK				
High Speed Daylight Ektachrome	160	X	X	120 only
High Speed Tungsten Ektachrome	125		X	120 only
Very Fast Speed / Coarser Grain				
GAF				
200 Color Slide Film	200		X	
500 Color Slide Film	500		X	120 only
KODAK				
High Speed Daylight Ektachrome	400* (ESP)		X	120 only
High Speed Tungsten Ektachrome	320* (ESP)		X	120 only

*Ektachrome Special Processing

14-10A This list does not include all of the popular films on the market.

COLOR NEGATIVE FILMS

Manufacturer and Film Name	ASA Exposure Index	Available in		
		Cartridge (Instamatic) 126	Cassette (35mm) 135	Roll Film (2¼ x 2¼) 120 and/or 620
AGFA				
Agfacolor CNS	80	X	X	
GAF				
GAF Color Print Film	80	X	X	
KODAK				
Ektacolor Professional	100		X	120 and 220
Kodacolor-X	80	X	X	X
3M				
3M Brand Color Print Film	80	X	X	

14-10B Color negative films are used most commonly for prints.

curate, shutter speeds set exactly, or processing temperature and time without some slight variation. Usually, the differences balance out but if they do not, the photographer can utilize an ASA different from that recommended. This should be done by bracketing a wide variety of subjects under different light situations combined with careful records. If the choice is at variance with the meter reading on a large proportion of the pictures, perhaps a different ASA will give consistently better pictures. As an example, many photographers use Kodachrome II at 32, though it is rated by Eastman Kodak at 25. Other photographers use an ASA of 40 or even 50. Still, this is not the answer for all photographers. The idiosyncracies of the particular equipment, the kinds of subject, and the processing combined are the decisive factors. Many an individual has had a whole roll or several rolls of underexposed pictures by blindly following someone's recommendation to use a higher ASA without properly exploring it with his own equipment. When the study is properly made, if there is a difference of more than two-thirds of a stop, the photographer should review his methods of arriving at the exposures he makes and/or check his equipment for malfunction.

d. To control contrast, film can be exposed at a higher ASA (underexposed) and overdeveloped to increase contrast; a lower ASA (overexposed) with underdevelopment to de-

crease contrast. Careful exposure of a test roll along with detailed records in a given situation is the method of establishing the appropriate ASA.

2. To push film, use a higher ASA because of low light level, for more depth of field, to freeze action, or all three. Pushing film practically always compromises the picture quality to some extent, but it is often worth this sacrifice to have the other advantages. The resulting underexposure is compensated by more time in the developer or a different developer. If available, a faster film is the better answer to the problem. At this writing, Eastman Kodak processes High Speed Ektachrome Daylight at an ASA 400 if the film is sent into the laboratory in an ESP (Ektachrome Special Processing) envelope. High Speed Ektachrome, Tungsten (formerly, Type B), will be processed at ASA 320 if sent in the same kind of envelope. The envelope is available at camera counters at a slightly higher cost than regular processing. With home processing, the Daylight High Speed Ektachrome can be effectively pushed to ASA 800 with increased time in the developer. At this higher ASA, it is necessary to make very careful meter readings. The latitude is more limited but excellent results are obtained (Fig. 4-4).

3. To bracket exposures on either the manual or the automatic camera change the ASA to the next higher number or next lower number for a ⅓ stop decrease or increase, respectively, in exposure (Plates 4A-C). For a one-stop difference, as on negative film, double or halve the normal ASA. This is the only way that exposures can be bracketed on the totally automatic camera with the adjustable ASA scales. The method will not work on the cameras that set the ASA by the cartridge as occurs with the 126 film.

4. To compensate for bellows or extension tubes when making close-ups, determine the amount of increase required. Divide the film's normal ASA by the increase. This will give the appropriate ASA on the meter. Then, the reading is taken from a gray card or the subject. *Note:* This compensation *is not necessary* if the camera has a behind- or through-the-lens meter (BTL or TL). No compensation in exposure is required.

Specialized Films

There are numerous films for specialized uses. Probably the most commonly used of these are Kodalith, the high-contrast copy films, the infrared films, and the duplicating films. These can be and are used extensively in interesting, creative ways beyond the purposes for which they were intended.

Kodalith and the high-contrast copy films (black and white) are made specifically for copying printed matter or other materials where pure whites and blacks with no intermediate gray tones are desired. (Figs. 3-40, 8-39, and 12-2 are all made in Kodak's High Contrast Copy film.) With subject matter in lighting conditions that are suitable, these very high contrast films give exciting results. The special developers made for these films, or at least a high contrast one, heighten the effects.

Infrared black and white films are exposed with a dark red filter over the lens or with special infrared flash bulbs (Fig. 14-11). The film is sensitive to invisible infrared light rays with the filter or red flash. This film gives unusual effects in daylight, producing blue skies in very dark tones and the green of trees and grass registering white or light grays. This is an excellent film to give crisp lines in architectural pictures. It is effective for pseudo night scenes taken in daylight. Processing chemicals for infrared black and white films are the same as for regular films. Follow directions packed with the film.

Kodak's Ektachrome Infrared Aero film was developed for the military and later marketed for civilian use. Horticulturists use this film for scientific work also. It can be used with or without filters on all kinds of subjects to get unusual and largely unpredictable colors for the uninitiated (Plate 5). The film can be home processed. Many commercial processors will not process it.

Infrared film requires an adjustment in focus. Infrared rays are invisible. They come to focus differently from the visible rays. On many cameras there is an additional red dot, marked engraving, or

14-11A Infrared film yields white or light gray tones for greens, shows details in shadowed areas that are otherwise unrecordable on regular black and white film. Compare details with Fig. 14-11B.

14-11B Plus-X used a few weeks later with the same general lighting produced this record. Other subjects offer different possibilities.

"R" a short distance from the focusing mark. The subject is focused in on the camera as usual, the focused distance noted, and then that focused distance shifted to the red mark. The depth of field will vary because the actual focused distance depends on the amount of infrared light in the scene. Since this isn't measurable with the light meter, the smallest aperture possible gives maximum allowance for focus.

The duplicating films are available in 100-foot rolls for 35mm cameras and are quite inexpensive per frame, probably the cheapest of all color film. A 100-foot roll will make thirty 20-exposure rolls or twenty 36-exposure rolls. Some duplicating films, however, are thicker, so the cassettes may not hold full 36-exposure strips. These can be loaded in cassettes by the photographer in the darkroom or via a daylight loader. These films are effective for duplicating slides or transparencies projected onto a white matte screen or in a duplicator. (Figs. I-15–17.) This procedure gives an opportunity to change color tones by filtering, improve exposure, crop from very slightly to drastically, or combine two or more slides for creative effect.

Duplicating color films are superb for originals in night photography of cityscapes, garden light, or to copy colored illustration from printed material. The super low contrast of the duplicating film gives shadow detail while holding it in the highlights. The bright lights of city streets do not become flares, yet the dark areas will be registered in good definition (Plates 6A & B).

Duplicating cut films are effective for duplicating slides in larger format on the enlarger. Duplicating films require the same chemical processing as regular color transparency films of the same brand. Check directions with the film.

SUMMARY, SELECTION OF FILMS

A common mistake of novice photographers is to consult many photographers who do widely divergent kinds of work as to the *best* film. The beginner then proceeds to try each recommendation to determine who is right. The better approach would be to select a film and use it until he is well acquainted with its renditions under all conditions and methods of handling. Only then has he the background to judge quality and versatility of other films that he tries. As has been indicated, the kind of pictures he takes, the purpose for which they are used, and his personal preferences should dictate his final choice. Beyond these considerations, he will probably desire to use:

1. Slow films in intense lighting situations when he wants fine grain for extreme enlargements with normal contrast and good detail in both highlights and shadows.

2. A medium speed film for average lighting conditions, moderate-sized enlargements.
3. High speed films for low light levels or extremely fast action in moderate light levels and in low contrast lighting.
4. Tungsten color films for incandescent lighting, candle light, open flames, or sodium vapor light.
5. Daylight color films with blue flash, fluorescent light, mercury vapor, or neon signs.

To change the color of light striking the film, to alter the effect of certain colors on films, and to add drama to pictures, filters are often most effective. The following chapter provides guidance on when and how to use filters.

REFERENCES FOR FURTHER READING

Birnbaum, Hugh: "Fujichrome R100, Agfachrome 50S," *Camera 35,* Vol. 14, No. 6, October/November, 1970, pp. 28f.

Carroll, John S.: *Amphoto Black-and-White Processing Data Book,* New York, Amphoto, 1972.

Carroll, John S.: *Amphoto Color Film and Color Processing Data Book,* New York, Amphoto, 1972.

Draughon, Guy: "Infrared Color and Black and White," *Petersen's Photographic Magazine,* Vol. 1, No. 2, June, 1972, pp. 44f.

Farber, Paul: "Color Printing Made Hard," *Camera 35,* Vol. 14, No. 5, August/September, 1970, pp. 32f.

Life Library of Photography: *Color:* "Colors that Never Were," pp. 20f.; *Light and Film:* "The Evolution of Film," pp. 45f.; "How Film Works," pp. 121f.; "Fitting Film to the Picture," pp. 138f., 1971.

Scully, Ed: "Ektacolor vs. Kodacolor," *Modern Photography,* Vol. 34, No. 6, June, 1970, pp. 44f.

———— "35mm Films Compared," *Modern Photography,* Vol. 34, No. 10, October, 1970, pp. 82f.

CHAPTER 15

Filters

Filters are magical devices used for corrective, creative, and protective purposes. At least, they seem magical until one understands something of how they work. The photographer needs to know the effects that are achieved with specific filters, in various lighting situations and colors of subjects, and with particular films, if he is to get the results he wants and expects. It is important to know the adjustments in exposure needed for the light that is absorbed by the filters.

Actually, filters are pieces of more or less transparent material installed to cover the front or back of the camera lens or to cover the light source. There are many kinds of filters for photography. Only those most commonly used and particularly beneficial are covered in this chapter.

Before exploring specific filters and their effects, it is helpful to understand:

1. What materials are used for filters.
2. Where the filter is installed.
3. When exposure compensation is considered.
4. How exposure compensation is expressed.
5. How exposure compensation can be made.

FILTER MATERIALS

Filters are made of many materials. Optical-quality (transparent, distortion-free) glass filters are used extensively. The glass may be colored in the manufacturing process; or colored, optical-quality gelatin may be bonded between two very thin layers of glass. Some filters are coated as camera lenses are to prevent lens flare.

Most glass filters are mounted in a metal ring that screws into the front of the lens (Fig. 15-1); drops into an adapter ring that screws into or slips onto the front of the lens (Fig. 15-2); or drops into a retaining ring that is added to the adapter ring assembly (Fig. 15-3). Some glass filters are used at the rear of long telephoto lenses or dropped into a filter slot near the rear of such a lens. This arrangement saves the purchase of excessively large filters that are more expensive.

Glass filters, like camera lenses, must be treated with care if they are to continue to give good sharp images.

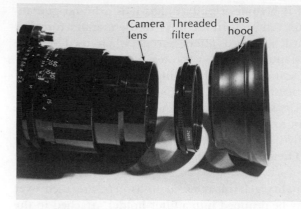

15-1 The screw-in filter requires less equipment but is not as versatile as the drop-in accessories for different size lenses.

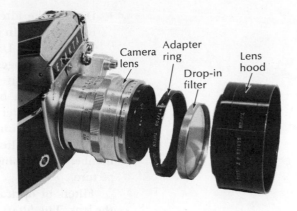

15-2 The series-sized drop-in filter is used with different size diameter lenses over a limited range by means of an adapter ring to fit each lens.

15-3 Multiple combinations of close-up lenses and/or filters can be assembled with either screw-in or drop-in filters. Additionally, step-up and step-down rings in series sizes are available.

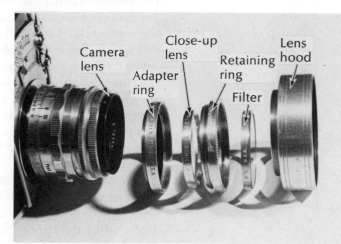

1. Store in clean, dustproof containers. If each filter is wrapped in a clean lens-cleaning tissue, there is protection from abrasion with any dust in the container. A tissue is available to give the filter a final brush before installation on the lens.

2. Handle by the rims to avoid fingerprints. They damage filters just as they do camera lenses.

3. Clean filters with lens tissues as outlined for the camera lens. (Chapter 1, Care and Handling of the Camera.)

4. Discard the filter if it becomes cloudy unless it is a brand guaranteed for life. In that event, return the filter to the manufacturer for replacement. Discard scratched filters except when used to give soft-focus images. Manufacturers' guarantees do not cover damage caused by mistreatment or careless handling.

Pictures must be focused through the glass filters, if possible, because they do alter focus slightly. When a filter or filters reduce the light in an SLR camera to the extent that it is difficult to focus, other lighter colored filters by the same makers may be substituted in equal number for focusing. Then the darker filter is put in place to take the picture.

Filters of optical-quality gelatin, referred to as *gels,* are used over the lens. The filters may be dropped into a filter holder attached to the front of the lens or attached by tape or rubber bands. The last two solutions are not kind to the filters! Gels are easily marred with scratches and fingerprints if not stored and handled gingerly. Metal, cardboard, or plastic frames help considerably to protect the gels. Gels can be purchased mounted or unmounted. While more fragile, gels are less expensive and if storage space or weight is a factor or if limited use is planned, they are the most practical. Gels provide a less expensive way to decide if the filter is effective for the subject. Gels are titled differently than glass filters.

When available and workable, filters are installed over the light source. In this case, there is no need for optical quality, so large sheets of gels used for stage lighting are utilized. They are available at display equipment and supply stores. Colored acetate or cellophane will serve in this manner, too, if the light source does not produce sufficient heat to melt or burn them.

A handkerchief over the light source will diffuse the light. Several layers of cheesecloth, frosted glass, or plastic are effective, also. If the light generates considerable heat, use a piece of fiberglass. The diffusers soften the light, which is a distinct aid in portraiture of women and children.

EXPOSURE COMPENSATION

When a light meter reading is taken at subject position, with filters installed on the light source, compensation in exposure is not required. A filter over a flash, electronic or expendable, or the filter on the camera lens used with flash, may require compensation in exposure. The amount depends on the specific filter.

Those photographers with BTL or TTL meters on their cameras theoretically do not have to be concerned with filter compensation unless flash is used. However, some meters do not give accurate readings

through some filters. To determine whether a given meter does read correctly through the particular filter, compare readings taken with and without the filter to the recommended exposure factor. An experimental picture is not amiss for checking. These two steps will help to avoid loss or lowered quality of an important picture in a critical situation through improper exposure.

For those *cameras without the BTL meters,* and/or readings on hand meters, the allowance for light absorption is expressed as a filter factor. This varies from filter to filter, from so small an amount that it is ignored to the equivalent of several *f*/stops (Fig. 15-4).

Compensation in exposure for the light reduction caused by the filter may be provided in one of several ways:

1. Change the ASA to give the correct compensation when numerous pictures are to be made with the same filter. For example: Divide the normal ASA by the filter factor for the new ASA and change it on the meter. Proceed to take meter reading normally. This method is definitely the simplest way for the individual picture and is the only method for the automatically adjustable camera. *Note:* Be sure to return to the normal ASA when the filter is removed.

2. Set for the individual picture (choose only one!):
 a. Open up the lens aperture the appropriate amount (Fig. 15-5).
 b. Slow down the shutter speed if the adjustment is in full stops: filter factors of 2, 4, or 8. Multiply the meter reading shutter speed by the filter factor to determine the new shutter speed. If the meter reading is *f*/11 at 1/125 second, a filter factor of 4 would give *f*/11 at 1/30 second as the corrected exposure.
 c. Slow down the shutter speed for a portion of the adjustment and open the aperture for the balance. For example: Without the filter, the meter indicates 1/250 second at *f*/5.6 and the filter factor is 2.5. Set the camera lens at *f*/5 and shutter speed at 1/125 second. The shutter speed compensated for the filter factor of 2, the aperture change for the additional 0.5.

It is important to get the best exposure because often the effect of the filter is lost with either over- or underexposure. This is true for either black and white or color; negative or positive film. With the higher filter factors, the picture can be totally lost with incorrect exposure.

FILTER CHOICE

With literally hundreds of different filters on the market, the beginning photographer is understandably confused as to which ones he needs or will use. The best policy, without doubt, is to wait until he is sure

Filter or Compensation Factor	Change in f/stops
1.5	⅔
2	1
2.5	1⅓
3	2⅔
4	2
5	2⅓
6	2⅔
8	3

15-4 Filter or compensation factors change exposure by the stops indicated. Full stops may be compensated by shutter speed changes if desired. Note: BTL or TL meters require no compensation.

The f/stop without the filter or accessory below:	When the compensation or filter factor is:								
	1.5	**2**	**2.5**	**3**	**4**	**5**	**6**	**8**	**10**
	See the corrected f/stop in the column below, opposite the normal f/stop at left.								
f/2	1.5								
f/2.2	1.8	1.5							
f/2.5	2.0	1.8	1.5						
f/2.8	2.2	4	1.8	1.5					
f/3.2	2.5	2.2	4	1.8	1.5				
f/3.5	2.8	2.5	2.2	4	1.8	1.5			
f/4	3.2	2.8	2.5	2.2	2	1.8	1.5		
f/4.5	3.5	3.2	2.8	2.5	2.2	2	1.8	1.5	
f/5	4	3.5	3.2	2.8	2.5	2.2	2	1.8	1.5
f/5.6	4.5	4	3.5	3.2	2.8	2.5	2.2	2	1.8
f/6.3	5	4.5	4	3.5	3.2	2.8	2.5	2.2	2
f/7	5.6	5	4.5	4	3.5	3.2	2.8	2.5	2.2
f/8	6.3	5.6	5	4.5	4	3.5	3.2	2.8	2.5
f/9	7	6.3	5.6	5	4.5	4	3.5	3.2	2.8
f/10	8	7	6.3	5.6	5	4.5	4	3.5	3.2
f/11	9	8	7	6.3	5.6	5	4.5	4	3.5
f/12.7	10	9	8	7	6.3	5.6	5	4.5	4
f/14	11	10	9	8	7	6.3	5.6	5	4.5
f/16	12.7	11	10	9	8	7	6.3	5.6	5
f/18	14	12.7	11	10	9	8	7	6.3	5.6
f/20	16	14	12.7	11	10	9	8	7	6.3
f/22	18	16	14	12.7	11	10	9	8	7
f/25	20	18	16	14	12.7	11	10	9	8
f/29	22	20	18	16	14	12.7	11	10	9
f/32	25	22	20	18	16	14	12.7	11	10

15-5 If it is difficult to do mental computation in change of f/stops in exposure compensation, use this table to find the nearest one-third stop. For example: If normal f/stop is f/8 (left column) and filter factor is 3, read down the column to the line opposite f/8 for the new compensated f/stop: f/4.5.

of the need for a particular filter for specific effects. Even the professional photographer seldom uses a full assortment.

Filters fall into three general classes. Those used with:

1. Both black and white and color films.
2. Black and white films, almost exclusively.
3. Color films, primarily.

The primary function of color filters is to change the color of light that exposes the film. In black and white photography, filters change the gray tone values of the colors in the subject and affect the contrast in the process. In color work, appropriate filters achieve more natural colors than would be produced with the light source.

Filters are used also to give unreal effects intentionally. Filters for black and white films are used by some color photographers for creative

abnormal effects. Likewise, the color film filters can be used on black and white films to gain effects in different values.

THE POLARIZING FILTER

A special filter, very effective for both black and white and color films, is the polarizing filter, sometimes called a screen. It is used in a very different manner from any of the other filters. When used appropriately, the polarizing filter improves the color film enthusiast's scenic pictures, slides or prints, more than any other filter made. It has many applications. The polarizing filter is one of the more expensive filters in any given size but is worth the cost in improved pictures. If one can afford, or wishes to carry no more than one filter, this one should be the choice.

A polarizing screen is neutral gray in color and could be mistaken for a neutral density filter. Neutral density filters, to be discussed later, do not substitute for a polarizing filter though the polarizing filter can be used instead of a neutral density.

The polarizing filter does not change the color of the subject but has magical effects on colors to make them more clear and dramatic. It is interesting but not necessary to understand just how the polarizing filter works for the photographer to make it function. Here is a simplified explanation:

All light rays travel as waves in a straight line. Unpolarized light rays vibrate in waves in many planes surrounding their course of travel (Fig. 15-6). When unpolarized light strikes a nonmetallic, flat surface it reflects in polarized light which vibrates in only one plane, parallel to that surface (Fig. 15-6). This causes a highlight, flare, or glare depending on its size and intensity. Highlights can add sparkle to a picture. Flares or glares produce overexposed areas that are usually

POLARIZATION

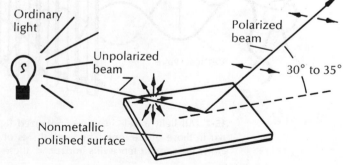

15-6 Unpolarized light vibrates in multiple planes around the axis, strikes a nonmetallic surface and reflects off in a polarized beam which vibrates in only one plane parallel to the surface, to cause a glare or flare.

most undesirable. They often hide the subject completely such as the fish in the pool with a glare of light from the water's surface. Flares of light from the painted surface of a car or its windshield are other examples.

The polarizing filter or screen, in effect, behaves much like a partially open Venetian blind that can be rotated as a unit so the light slits are positioned at any angle from horizontal to vertical. Both the blind and the screen will hold back light rays that vibrate in certain planes. Another way that explains the action of the filter is demonstrated in Fig. 15-7.

Two polarizing filters can demonstrate this characteristic. Hold the two filters, one in each hand, overlapping each other and watch through both as one is turned slowly a full quarter turn. There is a point at which almost all light is cut off. At this place, the screens are at right angles to each other (Fig. 15-8). When maximum light is transmitted, the screen grid lines are parallel.

The polarized light flares from a surface other than metal toward the camera at an angle of 30° to 35° are reduced or completely eliminated with the polarizing filter turned in the appropriate position (Fig. 15-8). The filter lets through only those light waves vibrating in the one direction. Light flares from a surface at lesser or greater angles than the 30° to 35° are diminished but in lesser amounts in either direction until there is no change at 0° and at 90°.

The polarizing filter is simple to use because one needs only to look through the filter to see whether it is having the effects desired. There is no calculating of angles of light source to the reflecting surface or from the reflective surface to the camera. The explanation of

POLARIZATION

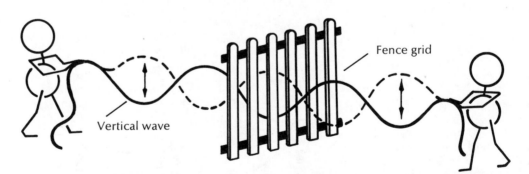

Fence grid

Vertical wave

15-7 All light travels in waves, polarized light only in one plane somewhat similar to those of the rope. The vertical slits of the fence "polarize" the rope. Were either the rope or fence slits horizontal, these rope waves would be stopped.

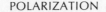

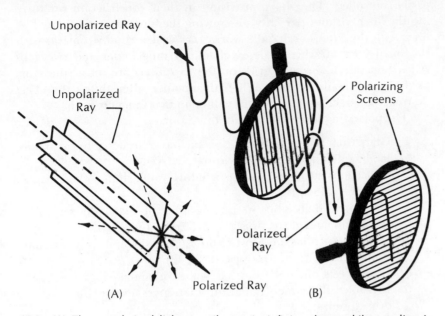

Unpolarized Ray

Unpolarized Ray

Polarizing Screens

Polarized Ray

Polarized Ray

(A)

(B)

15-8 (A) The unpolarized light ray vibrates in infinite planes while traveling in waves. (B) An unpolarized light ray enters the first polarizing screen, which polarizes the ray. As it strikes the second screen turned at right angles to the first, almost all light is blocked.

how the polarizing filter works has been included to alert the reader why it may work beautifully in one situation and not in another and as a point of interesting light behavior.

It is necessary to provide extra exposure if the filter is not being used with through-the-lens metering. Polarizing filters require from one to two f/stops of additional light depending on the filter (brands vary) and on the amount of light held back by the way it is turned. The maximum correction in a given situation occurs when the filter is turned to the darkest area. This much correction is not always best. The photographer must decide.

The filter can not be used on cameras that have only automatic metering control which is not through-the-lens unless the exposure can be compensated by the ASA setting. This eliminates all of those cameras which use 126 film unless they have TTL metering.

Polarizing filters may be purchased in series-sized, drop-in filters; as screw-in filters with threads to add another filter or a lens hood; and with an extension arm on one side to be used without or with a smaller

filter in adjusting the lens filter while on the camera. The drop-in filter is suitable with a single-lens reflex camera but the others are all more easily controlled. They have provision in their construction for turning the filter without partially unscrewing the filter from the lens. The filter with the extension handle works very well with any camera; with the small filter attached, it is excellent for rangefinder and twin-lens reflex cameras. The screen grids on the two filters are set at the same angle by the manufacturer. When the smaller filter shows the effect desired, the larger one on the lens will be in that same position.

The polarizing filters can reduce or eliminate:

1. Glare from nonmetallic surfaces such as from water in tide pools, large bodies of water, and painted surfaces.
2. Reflections such as in store windows, aquariums, glass display cases (Figs. 15-9, 10).
3. Unwanted highlights in photographs of glass, oil paintings, sculptures, and glossy finished surfaces of buildings.
4. Washed-out blue skies to provide strong sky and snow or cloud contrast in scenic views (Figs. 15-11, 12).
5. Haze effects but not from fog, smog, or smoke (Figs. 15-12, 13).
6. Invisible ultraviolet radiation that gives excess blue and/or overexposure.
7. Blue color tones from foliage, flowers, and other subjects.
8. Eyeglass flare from flash or other source.

In all of these situations, the effect of the polarizing filter is determined by the angle of view, angle of light, and angle rotation of the

15-9 This picture was made without a polarizing filter over the camera lens at the time Fig. 1-5 was made with a polarizing filter.

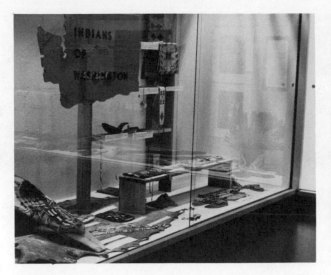

15-10A A museum showcase with multiple reflections from a right-angled case.

15-10B The same showcase from the same angle with a polarizing filter over the lens.

screen. There are a few other specific cautions and suggestions that are useful to know.

Underexposure without a filter reduces flares and glares but this subdues or completely loses detail in less intensely lighted areas to give excessive contrast. The polarizing screen allows normal contrast and color rendition while it reduces or eliminates the flares.

Reflections can add interest or even be a picture in themselves. The photographer must decide whether to eliminate or use them. With the reflections that need to be obliterated, the camera angle may have to be changed to succeed.

Oil paintings and other works of art present more difficult problems to subdue the highlights to a sufficient degree. Polarizing screens on the light sources rotated in a direction at right angle to the filter on the camera give added control.

The polarizing filter acts on polarized light from the sky to the greatest extent when the sun is shining at a 90° angle to an imaginary line between the subject and camera. Another way of remembering this is that the filter is most effective on sky areas with top or side lighting on the scene. When the sky appears darkest through the filter, the maximum correction is being accomplished in that situation. The polarizing filter is never amiss on the scenic unless it subdues highlights on water that is needed, reduces the depth of field too much because of exposure compensation, or cuts out haze that would serve a

Photographed by Jeff Gledhill.

15-11 This exposure was made without a polarizing filter from approximately the same angle and time of day (different season) as Fig. 7-3 was made with a polarizing filter.

15-12 Mount Si, Washington taken with a polarizing filter. Compare with Fig. 15-13 for haziness, contrast, and change in gray tones of the color swatches on the board at the left. To see their relatively true colors, check Plates 7B and 8B.

15-13 Taken with no filter over the camera lens.

purpose in the picture. Polarizing screens sometimes intensify rainbows beautifully; in another situation the rainbow may be completely erased. It's just a matter of angle!

The eyeglass flare on flash pictures can be controlled if a polarized plastic hood is slipped over the flash. The filter screen on the lens will need to be in its vertical position to gain the full effect. A filter factor of approximately 5× or 2⅓ stops in compensation is needed for this exposure. The polarizing plastic screen on the flash can be utilized to reduce flash exposure in flash-fill in daylight, too.

Two polarizing filters on the camera lens give unusual effects on waterfalls or water tumbling over rocks in bright sunlight. With the highlights subdued but not obscured, with a very slow shutter speed, an unusual visual effect is created. TTL metering is necessary for this project (Fig. 9-23).

NEUTRAL DENSITY FILTERS (ND)

As stated earlier, the polarizing filter and neutral density gray filters can be confused because of their similar appearance. They can be used interchangeably to reduce exposure with no effect on color values or contrast. There the resemblance ends. The sole purpose of ND filters is to reduce the exposure to achieve more limited depth of field or to use a slower shutter speed. These filters are utilized when it is necessary to make pictures with very fast film in sunlight or with flash close to the subject.

ND filters are made in ten different densities requiring from ½-stop compensation for the ND .1 that transmits 90% of the light to ND 1.0 needing 3¼ stops, which passes only 10% of the light. They are used in combination to gain further reduction.

FILTERS FOR BLACK AND WHITE FILM

There are three principal colors of filters utilized for black and white films: yellow, red, and green. These are made in multiple intensities ranging from light to dark. The light filters in each color change the tonal values least; the medium filters alter the gray tones more; and the dark filters give the most variance from normal. The black and white photographer may find it quite advantageous to have the medium intensity filter in each of these three colors. This definitely depends on the subjects he photographs and what he wants to accent.

The sole purpose of using a filter on black and white films is to alter tonal renditions:

1. To change contrast values.
2. To accent different areas of the subject.
3. To show details in areas that would otherwise be too light or too dark.
4. To separate colors and/or values that would normally photograph in the same or too similar gray tones.
5. To eliminate stains in certain colors in copy work, and acne or freckles in portraiture.

Choice of filters for a given subject depends on:

1. Color sensitivity of the film.
2. Subject's color and intensity.
3. Intensity of the filter.
4. Colors to be accented or subdued.
5. Tone to be darkened or lightened.
6. Filter factor as it affects depth of field and action, if any.

The filter absorbs some colors and transmits others. Those absorbed print darker and those transmitted print lighter, depending, also, on the color intensity in the subject and the filter. The color to which the film is most sensitive prints lighter than the color to which it is least sensitive. When in doubt as to whether a filter is needed and/ or which one, take pictures each way; study the results to be sure to get the best one possible and to understand what filters do.

On panchromatic film, the yellow filter absorbs blue, which darkens blue sky, and increases contrast, especially with clouds or snow on mountain tops in the black and white print (Figs. 15-13–15). The

YELLOW FILTER

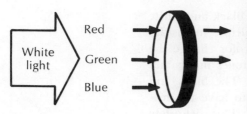

15-14 A yellow filter holds back the blue; the percentage depends on the intensity of the filter.

15-15 Taken with a medium yellow filter (compare with Fig. 15-13). Check sky and snow contrast and the gray tones of the color swatches on the left.

greens will print lighter; the degree depends on whether they are yellow-greens or blue-greens. Red will be lightened; the amount depends on whether it is an orange-red or a blue-red. The other colors of filters, while absorbing and transmitting different colors, have similar variations in the recording in gray tone values. See Figs. 15-16–21, 22 for colors absorbed and transmitted by each filter and some of the subjects for which each is appropriate.

Filters on black and white films, like any tool in photography, are a wonderfully creative and distinctive method of getting the picture but they can be overused, also. Experiment to know when filters improve the picture.

FILTERS FOR COLOR FILM

Filters used with color film change color rendition on the film to correct light source color, to achieve more natural color, or to create unnatural color for mood or effect.

There are several colors in multiple intensities available. Each has particular merit, yet it is doubtful whether the amateur photographer ever needs to invest in more than three or four filters for use with color films.

Many professional color photographers prefer to and do avoid all color filters. They make their pictures by the available light source, wait until the color of the light has changed to that desired, or use a film balanced at the appropriate Kelvin rating. Their reasoning is

RED FILTER

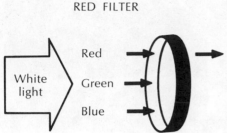

15-16 The red filter holds back green and blue light. The percentage of the green and blue light filtered depends on the intensity of the filter.

15-17 The medium red filter changes contrast more drastically than the yellow. The color swatches make dramatic changes. Compare with Figs. 15-13, 15.

GREEN FILTER

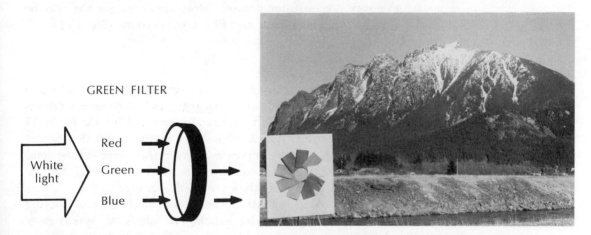

15-18 The green filter holds back red light. Again, the intensity of the filter affects the amount held back.

15-19 Mount Si and the color swatches exposed through a green filter. Compare with Figs. 15-13, 15, 17.

that they have paid for very fine craftsmanship and glass in expensive lenses and refuse to degrade the resolution and definition with additional glass, other than the polarizing filter.

There are times when the available light cannot provide the necessary quality of light. The filter offers a solution. The professional color photographer who uses filters a great deal may invest in the decamired system of filters which are made to be used singly or in combinations

15-20 An 85B filter (medium orange) normally used with color film gives still different gray tones. Compare with previous illustrations of the same subject.

15-21 An 80B filter (medium to dark blue) normally used with color films gives other intensities of gray. Compare with preceding filters' effects.

to achieve very precise color control. Most amateurs use the specific color filters for particular light and film combinations (Fig. 15-23).

WARMING FILTERS

Some photographers use clear glass filters over their lenses at all times to protect the lens from dust, sand, moisture, and fingerprints. Others use a skylight 1A, a haze or 2A, or an ultraviolet (UV) 15, 16, or 17 filter, which absorbs the invisible ultraviolet rays to warm the picture slightly and at the same time serves as a protective cover on the lens. None of these warming filters require exposure compensation. Seldom is there need to purchase more than one of this group.

Which one should it be? All of the filters are effective to varying degrees of warming in the order listed. The kinds of subject most frequently photographed, the light used, and the altitude at which the major pictures are taken will determine the choice. Subjects taken in shade with reflections from blue skies and green foliage need correction.

Though some are warmed by built-in reflectors or filters, ultraviolet (too cool) light is produced by many electronic flashguns. For those that are not corrected, a UV 16 filter (most popular) on the gun or on the camera lens prevents the white wedding gown and the cake from being baby blue in the pictures.

Scenic pictures made at high altitudes need far more correction for invisible ultraviolet light than do those made at sea level. Sometimes, the UV 17 is combined with the polarizing filter for extremely high altitudes.

FILTERS FOR BLACK AND WHITE PANACHROMATIC FILMS

Filter Number	Filter Color	Lightens	Darkens	Use with these subjects	Exposure compensation (filter) factor	
					Daylight	Tungsten
8	Yellow K2 (Medium yellow)	Yellow Yellow-red Greens	Blue Indigo Blue-greens	Increase contrast of blue sky with clouds; accentuate grain in yellowish woods.	2	1.5
11	Green 1	Greens Blues Indigo	Orange Red Purple Magenta	Portraits in daylight; for pleasing flesh tones; landscapes; dark flowers; for more detail in dark green foliage.	4	4
21	Orange (85b used with color film could be substituted)	Orange Yellow	Indigo Violet Blues	Marine views to darken blue water; accentuate grain in yellowish woods. Reduces acne and freckles.	5	4
25 A	Red 1	Red Yellow Orange Magenta	Green Blue-green Violet	Pseudo moonlight scene in daylight; to get dramatic sky and cloud effects in scenics; accentuate grain in dark woods. Eliminates some acne and freckles.	8	6
47	Dark Blue (80B used with color film could be substituted)	Blue Violet Indigo Blue-green	Yellow-green Yellow Orange Red	Emphasize haze and fog.	5	10
	Polarizer		Skies Sharpens image because reduces glare and hot spots.	Scenics, to reduce or eliminate reflections, glares and flares.	4	4

15-22

FILTERS FOR COLOR FILM

Filter number	Type of film	Color of filter	Kind of light	Filter (compensating factor)	Remarks
Sky 1A	Daylight	Slightly warm	Daylight	None	Reduces blue and adds warmth to all outdoor scenes. Good for subjects in shade.
Haze 1	Daylight	Slightly warm	Daylight	None	Reduces blue and adds warmth to all outdoor scenes. Good for subjects in shade.
UV 16	Daylight	Slightly warm	Daylight	None	May be used as haze filter. Reduces ultraviolet light in electronic flash and in high altitudes.
80B	Daylight	Blue	3400°K	2–4	Balances light for daylight film with the 3400°K lights.
85	Type A	Orange	Daylight, Electronic flash	1.5	Balances daylight and electronic flash light to type A (3400°K) films.
85B	Tungsten	Deep orange	Daylight	1.5	Balances daylight to tungsten (3200°K) films.
FL B	Tungsten	Magenta	Fluorescent	2	Converts fluorescent light to better balance.
FL D	Daylight	Magenta	Fluorescent	2	Converts fluorescent light to better balance.
Polarizing	All types	Neutral gray	All kinds	2.5–4	Darkens blue sky, water in marine scenes, reduces reflections, flares and unwanted glares when at correct angle.

15-23

FILTERS TO MATCH LIGHT TO FILM SENSITIVITY

As previously discussed, color films are balanced for light of a specific Kelvin rating. It isn't always possible to have lights and films that match. It is for these situations that color correction filters are made. There are numerous ones from which to choose. How does one decide?

One approach to the problem is to always use a daylight film and add an 80B (blue) filter to use with incandescent light (3400°K photoflood). The manufacturer of the Tiffen 80B filter recommends a filter factor of 4, which, in effect, reduces an ASA of 160 to 40, an ASA of 25 to 6. Film manufacturers suggest variously an increase of one to two stops in exposure (Fig. 15-23).

The photographer definitely needs to determine for himself the filter factor that he prefers. He should bracket and record a series of pictures and from the results decide on the filter factor or correction of meter reading needed for his particular equipment and taste. Even with the 80B filter, much incandescent lighting appears warm in pictures because of variations in degrees Kelvin of different wattage lamps, the amount of usage they have had and the power voltage fluctuations.

Sufficient depth of field and fast enough shutter speeds to get the picture needed are important problems with available incandescent light. When the 80B filter is used, there is considerable loss of film speed and the problems are intensified.

Another way is to use the faster Type A Kodachrome II Professional (ASA 40) or the High Speed Ektachrome Tungsten (ASA 125) balanced for tungsten. These films can be converted to daylight, when necessary, with salmon colored correction filters. Kodachrome II Type A requires an 85 (medium salmon) filter and Ektachrome Tungsten an 85B (deep salmon) filter to balance daylight (Plate 7D). These have a filter factor of 1.5, which is only 2/3 of a stop, reducing the ASA to 25 and 80, respectively. In most instances this is as fast or faster than the more commonly used daylight film. There will be a difference in color rendition. Some people prefer the tungsten films and use them exclusively by correcting with the filter for daylight.

The photographer who does not wish to stock a full assortment of filters needs to decide which method he prefers to match the film and light sensitivity and then buy one filter, either the 80B, the 85, or the 85B.

Pictures made with fluorescent and with mercury vapor light are probably best on daylight films but they do have an unpleasant green color. The tungsten film produces still more disagreeable blue tones. Tiffen Optical Company has developed filters for fluorescent light that also can improve pictures made with mercury vapor light (Plate 8B).

The FLD is for daylight films and the FLB is for tungsten films. The manufacturer suggests a compensation of 1 stop, or a filter factor of 2, for both FLD and FLB. Anyone doing extensive work with either of these light sources should have one or the other.

FILTERS FOR MOOD

Primarily, the discussion of this chapter is concerned with ways to balance or alter light sources for natural effects. There are procedures to give unnatural effects that heighten mood, background, and contrast choice. Filtering the picture to an overall tone can take it to the sublime or to the bizarre. The following are a few basic possibilities.

The pseudo moonlit landscape in color can be made in bright sunlight with an 80B filter combined with daylight film and underexposed two full stops. Tungsten film, unfiltered, produces similar results when underexposed in daylight. Infrared film paired with a dark red filter imitates the night scene in black and white.

Mood can be intensified in color by filtering to unnatural effects. Some possibilities would be a rosy glow for romance, a blue cast for mystery, orangey red for warmth, yellow for pollution, and lavender for delicacy. All abnormal filtering effects need to be chosen carefully to fit the subject and techniques used in the photography.

For bizarre effects, probably no other method compares to the almost unpredictable results of Kodak's Ektachrome Aero Infrared film when filtered with any strong color. It is weird, incomprehensible, and unaccountable to the uninitiated!

A soft-focus effect can be produced on either black and white or color films with a diffusing filter on the lens. Various models of etched glass filters are available. To obtain similar results, smear a glass filter with a tiny amount of vaseline. Apply it all over the glass of the filter or around the edges with a portion of the filter's center left clear. A difference in the extent of diffusion is obtained with each technique. *Note:* Be sure to clean the filter carefully and well before restoring it to its case.

Starlike rays are possible with the lights in night photography of cityscapes, lighted Christmas trees, and buildings decorated with lights. Some camera lenses produce these effects because of light flares within the lens any time lights are photographed. Other lenses show the flares only at certain apertures but all lenses can be equipped to make the star rays. Special filters are made for this. The photographer accomplishes similar results with a layer of gray screen such as the nylon insect screen in front of the camera lens (Fig. I-19).

FLARES FROM METAL

Flares and reflections from metal are reduced by spraying the surface with a clear matte acrylic finish. When the photography is finished some sprays will wash off with water if it is done within a few hours. Other sprays need a lacquer thinner to remove them.

When spraying is not practical, a booth or tent of white translucent plastic, glass, cheesecloth, or other thin fabric around the subject reduces the reflections. Lights should be outside the booth or tent. The camera lens should be inserted through or between sections of the tent.

CORRECTION OF TRANSPARENCIES

Overexposed, off-color, and underexposed transparencies can often be salvaged to make a more interesting picture than one taken conventionally. Contrary to the advice of many well-known and very knowledgeable photographers, it is not always best to toss all incorrectly exposed pictures in the circular file (wastebasket). For the poorly composed picture, the possibilities of cropping to another size and shape of mount were indicated in the chapter on composition. Also, there is hope for some of the other ailments!

For the overexposed, enclose gelatins, sandwich style, with the picture either in glass or the cardboard or metal mounts. The gels are precut in small squares in many colors and intensities and are available under the trade names of Addacolor and Tint-a-Slide.

The gelatins are flexible, easily scratched or fingerprinted and are definitely magnetic dust collectors. A firmer filter can be made of film. The overexposed sections of color film at the beginning of the 35mm rolls are tinted. They are enclosed with the processed slides and make firm filters as sturdy as the transparency. They must be protected from fingerprints or scratches by storing in a clean, dustfree container.

Ektachrome-X tails are perfect correction when mounted with a picture taken under fluorescent light without an FL filter on the lens. A whole roll can be unrolled in daylight then processed normally to obtain a supply.

Unexposed black and white film, fixed and washed, makes excellent neutral density filters to mount with color transparencies. Some black and white unexposed film has a very slight color tint but most are neutral gray. For the nondarkroom workers, send the unexposed film to the processor for "developing only." Mount slide-sized sections with the overexposed picture that is properly colored but needs more density.

Make filters for sandwiching with the slide by photographing a plain white matte surface lighted with colored gels over the light

source. Colored construction papers, instead of colored lights on white, work well, too. Avoid texture by focusing at infinity but working close to the paper. Normal, over- and underexposure give varying densities of filters. The cost per filter is less if one of the duplicating films is used. Home processing further reduces the expense.

MAKE CUSTOM HIGHLIGHT FILTERS

The photographer can make his own filters, to highlight a portion of a slide but to subdue another portion of the same slide. With color, cost is the same as for a regular transparency but the effect is "custom" and well worth it for many pictures.

These custom highlight filters are made in a number of ways. One method is to choose a foggy day:

1. Use a telephoto lens on the camera. Different length telephoto lenses give variation in the size of highlight areas.

2. Use daylight color film for colored filters, black and white films for neutral density filters. The black and white negatives then need contact printing or duplicating onto another negative film to give a positive.

3. Aim the camera toward the area where the sun is shining. It must be behind rather dense fog but so the light area is obvious. Never, *never* aim the camera at bright sun! There is danger of damage to the camera but worse yet, is damage that can be *permanent* to the *photographer's eyes!*

4. Focus the lens at its nearest distance to give the softest focus possible.

5. Expose frames 2, 3, and 4 stops over (open up the lens) the normal exposure to produce varied density of filters on positive films. Underexpose the same amount on negative films.

6. Put on any and all colored filters glass or gels, with the color film to obtain varying tints.

7. Shift the highlight area into different portions of the frame to provide a choice for the areas to be highlighted.

The same effects are obtained with a normal lens focused at infinity, aimed at backlighted tissue paper, placed at a two- or three-foot distance. The light source and choice of color film should match to predict the results.

With any of the procedures, try only two or three frames per roll until the results are those desired. Never do two or three rolls at a time until the outcome is predictable.

In exploring photography this far, concern has been with basic understanding of the camera, film, commonly used accessories and darkroom procedures to produce a well-composed interesting picture. Some of the worthwhile projects for enthusiastic photographers to pursue are suggested in the following chapter.

REFERENCES FOR FURTHER READING

Biggs, Ken: "Creative Filtration," *Petersen's Photographic Magazine,* Vol. 1, No. 4, August, 1972, pp. 20f.

Birnbaum, Hugh: "Do Filters Rob Resolution?" *Camera 35,* April/May, 1970, Vol. 14, No. 3, pp. 34f.

Draughon, Parry C.: "Fake It With Filters," *Petersen's Photographic Magazine,* Vol. 1, No. 5, pp. 26f.

Kennedy, Cora Wright: "Diffuse as You Like It," *Popular Photography,* Vol. 67, No. 1, July, 1970, pp. 26f.

Life Library of Photography: *Color,* "Capturing the Color of Light," pp. 12–50; *Light and Film,* "Adding Tones by Adding Light," pp. 174f; "Changing Tones with Filters," "Eliminating Tones with Filters," pp. 178, New York, Time-Life Books, 1970.

Rothschild, Norman: "The Filter That Drives Colors Wild," *Popular Photography,* Vol. 67, No. 2, August, 1970, pp. 84f.

Rothschild, Norman, and Cora Wright Kennedy: *Filter Guide for Color and Black-and-White,* New York, Amphoto, 3rd ed., 1971.

Scully, Ed: "B and W Filters Dead? Are You Kidding?" *Modern Photography,* Vol. 32, No. 12, December, 1968, pp. 40f.

——— "Charts Show What Filters Do," Vol. 32, No. 12, December, 1968, pp. 44f.

CHAPTER 16

Goals for Photography

By the time the reader has studied photography to this point, he may have developed attitudes and problems such as:

1. Excited; but his budget isn't sufficient to practice making pictures, to experiment, and to improve his skill.
2. Inspired; but needs more sophisticated equipment to make *good* pictures.
3. Fascinated; but feels extensive travel is necessary to make meaningful pictures.
4. Devoted and has invested a great deal of money and time in equipment and perfecting technique; but doesn't know what to do with the pictures.
5. Intrigued and determined to pursue photography further; but is in a quandary as to direction.

Each reader must explore to find his own individual solution if he is to maintain interest. A specific goal for the use of the pictures improves the end results and lends a real sense of accomplishment.

TO MEET THE COST OF SUPPLIES

Practice is imperative for proficiency in photography. For the limited budget, it can be *expensive,* even impossible. This problem has been hurdled in a number of ways.

One beginning photographer offered to do individual portraits of a Scout Troop for the parents' Christmas gift if the Troop would pay only the expenses. The pictures were planned for 5 x 7. For their part the Scouts sat for their portraits and constructed wood frames, covered them with free leather scraps from a glove factory. They used a wood-burning set to burn original design in the leather.

The photographer carefully photographed at least three exposures from which one was chosen for each Scout. Pictures of only five or six members were made each week to give opportunity to check and to correct any errors in lighting, posing technique, and exposures for the following sessions. The photographer gained much experience in portraiture and several commercial jobs from the Scout Troop venture.

Every organization offers opportunity for this kind of volunteer work and many will gamble the cost of film, developing, and printing for a beginner to photograph their activities. Some groups will pay more than the expense. Children and youth organizations, particularly, offer a wide scope in types of photography with their many and varied projects. Adult or children, it all adds up to challenge, practice and experience for the photographer.

TO MEET THE EXPENSE OF EQUIPMENT

While sophisticated equipment broadens the scope in kinds of photography, many *good* pictures are made with less expensive cameras. The photographer's ability to *see* and to *make* pictures determines the impact and interest, not the equipment used. Few cameras of any price range are utilized to their full potential.

Photographers have a universal urge to upgrade or add to their equipment for one purpose or another. Not everyone can do this without some method of collecting the original outlay or some monetary return on the investment. It may seem overwhelming, even impossible, at first look but it can and has been done many times.

Reasonably priced, well done, candid snapshots of friends, neighborhood children, pets or activities find a market among the subjects, parents, owners, and participants. These can be effectively done on the nonadjustable camera if print sizes are limited to those that retain sufficient sharpness of detail. Emphasis must be placed on the "well done" if the photographer is to get return business. Prints that meet this standard will sell successfully.

More specialized and profitable projects are possible with an adjustable camera, either the totally automatic or the automatic and/or manual. Effective portraits in 8 x 10 and larger, mounted or matted ready for display can be considered.

Dog or horse breeders pay very well for the outstanding picture of their animal. Besides good photography, this requires special study of technique to show the animal in the appropriate stance or instant of action to portray its best points. For the informed photographer who likes and appreciates animals, the potential in this field is unlimited.

The local fair or show with the animal in the show ring, especially as awards are presented to the winning entries, offers excellent opportunities for salable pictures.

Landscape architects, power companies, and lighting fixture retailers and wholesalers are good prospects for quantities of striking pictures of lighted gardens. The same scenes in daylight for a portion of the views are salable as a contrast. For the SLR owner, flower growers offer a potential market for color transparency close-ups of the

different varieties. These are used in slide shows extensively for garden clubs and other interested groups. Some are used for catalogs or color prints to aid in sale of the product.

Local newspapers may pay for newsworthy photographs of many types of subjects unless it is publicity for an organization or group of individuals. In that case, a by-line (credit to the photographer for taking the picture) is the most to expect unless the individuals or organization is willing to pay for the photographs.

Contracts for construction of sewers, roads, and buildings often specify that pictures must be made before, at regular intervals during and after construction is finished. They are termed progress shots. This is neither difficult nor taxing and offers substantial returns. Half frame and 35mm format is fine for this type of work. The photographer should understand problems of controlling contrast and be able to do time exposures on some construction. Careful records must be maintained for direction, camera position, and date of each exposure. Contractors, architects, engineering, and consulting firms can give leads to this type of work (Fig. 16-1).

One budding photographer took his first wedding with borrowed equipment. From that effort, numerous wedding jobs came his way until a chain reaction kept him booked each weekend for weddings for months ahead. Because of his limited overhead, expenses were below those of the professional studios. His moderate price produced a nice profit. Within a year, his returns from photography made it possible to drop another part-time job. During the same period he paid cash to upgrade his photographic equipment to the top of the line with accessories galore plus a home tape and stereo sound outfit of the same quality. He made outstanding wedding pictures because he gave the extra effort needed to produce quality work and operated in a business-like manner.

Procedures that help in establishing a wedding-picture business are:

1. Make up sample albums to show prospective customers: One each for the bride, the parents, and the proof album with definite prices made clear and the number of prints and sizes.

2. Collect one-half the cost of the bride's album of the initial order before any pictures are taken.

3. Require the bridal party to arrive one and one-half hours before the ceremony to make all formal pictures while everyone and the flowers are fresh.

4. Use only negative color film and tend to overexpose one full stop rather than risk underexposure. Negative format of $2\frac{1}{4}$ x $2\frac{1}{4}$ allows for cropping in either horizontal or vertical.

16-1A The interior required a time exposure for sufficient depth of field. Manipulation of the print during enlarging was necessary because of the wide variance in light intensity.

16-1B The directional signs were printed on translucent mylar with one side made for writing or drawing. The circle of mylar laid on the paper during exposure under the enlarger identified both date and direction.

5. Make two exposures on all important pictures to give a choice of facial expressions.

6. Keep camera on the tripod for all formal pictures. Only *time* exposures should be made during the ceremony. Some churches forbid any pictures in the sanctuary. Always check with the clergyman in charge for all church weddings.

7. Mount the electronic flash 10 to 12 feet high on a telescoping pole attached to a camera tripod to avoid eyeglass flare and red eye and to give good modeling. Hand hold flash above the camera on candid shots where the tripod is not practical.

8. Watch backgrounds for mergers, busyness, and/or possibilities of flash flare.

9. Use commercial developing and printing with proof prints in jumbo size.

10. Insert all acceptable proofs in an appropriate size proof album and deliver to the customer for selection of prints.

11. Collect the balance of money due when the final order is placed.

12. Carefully spot each print when the final print order returns from the processor. There are several kits available for this purpose. The same general techniques used in spotting black and white prints work well with color prints.

13. Assemble the order and deliver promptly.

The list of opportunities to earn money with the camera is endless but competitive. The keys to success are striving constantly toward improvement in quality and originality of work, and delivering at the earliest possible time. Do not be discouraged by failure of a particular sale or several sales but regard it as further practice and experience. Do not depend on this type of part-time work for living expenses until the volume has built sufficiently to warrant such a step.

To solicit photographic work of any kind, prepare a sample portfolio (a collection of top-quality photographs) of subjects similar to the kind of work that is desired by the prospect, to show potential customers. The most difficult part is to refrain from showing pictures of inferior work or including too many photographs. Five top-quality pictures are better than fifteen pictures, five of which are excellent and ten others that are mediocre. If only quality work is shown, the average photographer gains an enviable reputation.

IS TRAVEL NECESSARY?

A change of scenery is always welcome to understand and appreciate other areas, countries, and people; but, most certainly, travel is not

required to find subjects for the camera. Every home, garden, neighborhood, city, town, and country has hundreds of opportunities for meaningful pictures. Interesting pictures can be made everywhere and anywhere. People from other localities or countries see many things to photograph because everything is new. The photographer at home has a distinct advantage over the traveler because he may return to a subject repeatedly to make the pictures at the time of day or season of the year that gives choice lighting or the best point of development or maturity as with growing plants or animals.

The local camera club offers an opportunity to associate and work with other photographers to stimulate, expand, and improve techniques. A membership in the Photographic Society of America, either as an individual or as a camera club member, provides a wealth of information in many types of photography.

For the fortunate individual who is able to travel, photography offers an opportunity to relive each unique experience again and again. In the overwhelming rush of new experiences telescoped into a short period of time, much is forgotten without pictures. In fact, the photographer often sees details in his pictures that failed to register when he was there. This may not be true if he is unhurried and deliberate, a situation that rarely exists for the traveler.

WAYS TO USE PICTURES

For the photographer who has no desire to sell pictures yet enjoys making photographs, there comes a time when he wonders what justification he has to continue and interest begins to wane. The forewarned photographer does not wait until drawers, shelves, and even closets are overflowing with unused pictures.

Pictures serve no purpose unless they are displayed in some manner. Far more time, and usually more thought and energy is required to prepare a picture for display than it took to make the shot. Where and how can photographs be displayed? The field is unlimited!

First, explore some of the purposes for which pictures are displayed:

1. To create an appreciation of and an interest in or to emphasize:
 a. Beauty and a concern for nature or ecology, the world around.
 b. History of an area or of an era.
 c. Activities of an individual or a group, people, or animals.
 d. Need of proposed changes in a business, a community, institution, or country.
 e. Merchandise, products, or properties (advertising).
 f. Life of the people, flora and fauna of areas or regions.

2. To relax (therapeutic) or entertain:
 a. Family, relatives, or friends.
 b. Confined individuals and groups such as in children's, military, and mental hospitals; nursing and convalescent homes; correction or penal institutions.
 c. Organizations for people of all ages.
3. To educate, stimulate interest, or teach skills to:
 a. Children, youth and adults in schools, churches, and vocational training schools.
 b. Employees of merchandising, manufacturing, and business corporations.
 c. The general public.
4. To decorate and add interest to the photographer's room or home; to an institution or building interior.
5. To obtain critique or ratings as when work is submitted to art shows, salons, or magazines to compare the photographer's work with that of others.

Even record shots are interesting when the photography is done creatively. Ingenuity in selection and sequences of arrangement with variations from vertical to horizontal definitely add interest.

SLIDE SHOWS

Slide shows are a popular method of display. Guides for assembling a slide show are:

1. Plan for a short slide show for the first display. Twenty to forty slides make a good first effort. In gauging time for the show, most slides should be projected no less than six seconds and no more than fifteen seconds each, unless instruction is being given that requires longer to absorb the intended points. Ten to twelve seconds is average time per slide. Vary the times from slide to slide to avoid monotonous repetition of the rhythm of changing slides.

 Subsequent efforts may be longer. Fifty minutes is a universally accepted limit as maximum time for a slide show regardless of the quality of the pictures or commentary. Two twenty-five-minute shows with an intermission between is preferable. One show of thirty-five minutes may be best. The good showman stops while the audience wants more, not as they near or pass their limit of endurance. A return engagement is much more pleasant for all.

 If it is desirable to show more transparencies than can be comfortably shown in the desired time or to add variety to the usual presentation of slide shows in general, use two screens and two projectors. Carefully pair the pictures in regard to color tones,

composition, density and subject. Occasionally, one dark screen adds emphasis to the one shown. Mount black opaque paper in a cardboard mount to produce the black screen sequence. Change the dark screen from time to time. This is an excellent method for class or club slide show presentation.

This technique is effective with movies and slides combined with careful synchronization. The field is unlimited!

2. Establish a theme and plan a story line for the show. Decide whether it is to be an essay or a travelogue.

An essay covers only one subject. A travelogue shows a wide variety of areas including what is seen in traveling from one location to another. To further explain the difference, if the show covers only Death Valley, then it is an essay. If areas or subjects are shown of other parts of California, or perhaps Oregon or Nevada, the show is a travelogue. A show compiled on salmon spawning in rivers many miles apart would be an essay because even though various parts of the continent are shown, the presentation is confined to salmon spawning.

A trip to Europe might be divided into a travelogue covering the high points of the entire trip, and the other slides assembled into an essay on the architecture, the castles, the statues, the museums, or another facet covered extensively on the tour. From one extensive trip, or several short vacations, a whole series of essays is possible.

Plan for humor in every show in picture and/or commentary. Regardless of the seriousness of the story line, the attention of the viewer is sharpened on the weighty problem if his attention is diverted for an instant on an unexpected bit of lightness. Every good speaker follows this practice. The slide show benefits as well.

Humor may be inserted with no build up or it may be a continuous thread through the story.

For the incidental moment of humor, one picture with a definite direction (roadside sign, people, or scenic) related but not essential to the show may be projected upside down or reversed. This trick used more than once indicates carelessness by the showman. There are many other approaches that are more original for giving the light touch.

3. Inventory the entire selection of available pictures for the slide show. Project every one on the screen. Lay aside all that are mediocre or poor pictures. Do not destroy. They may be needed to fill in a hole in the story or may work well as composites for title slides or other purpose.

4. For transparencies, use several of the inexpensive commercial slide sorters on the market or improvise a slide sorter to view 100 or more at a time and arrange the sequence. (Appendix I, Section D.)

5. Choose three principal pictures, one for introduction to the subject of the show (not title pictures), one for the middle high point, and one for the climax. Build the show around the three pictures. All other pictures should continue and reinforce the theme to connect the three principal slides.

6. Select and arrange the sequence of pictures to tell the story. Avoid strong contrasts in density and in slide color. To go from a very light subject or low density slide to one that is dark makes the dark one seem underexposed. The light subject, such as a white flower that fills the frame, shown immediately following a night scene makes the flower appear overexposed when all the slides may have been of optimum density. In the same manner a transparency in predominantly bluer tones seems cooler when projected just after one with warm tones. The reverse process gives the opposite impression. Conceivably, this may be desirable but if not make the transition more gradual.

 Choose variety in long, medium, and close-up pictures but avoid the same sequence repeatedly in moving from one distance to another. To leave a lasting impression of excellent showmanship, choose above average pictures for the first five or six and conclude with an equal number of superb and pertinent ones.

7. When the sequence of the show is in order, project the whole group on the screen. Keep in mind the story line. Does each slide move the story onward? Edit mercilessly, the hardest part of all! If a less than perfect slide is required for transition or other reasons, carefully check for ways that the flaw can be corrected or improved by cropping, sandwiching with another transparency, or duplicating.

 Occasionally a much needed picture isn't available. The light, weather, or restrictive regulations prevented making a necessary or desirable exposure. A common practice is to buy slides offered for sale for back up. Because of difference in contrast, commercial slides are very apparent in the home show. A less expensive and more effective method is to purchase picture postcards in color or literature with colored photographs and copy these on slides with the camera at home. *This is illegal for any commercial venture*, without consent from those holding the copyright.

8. Write the commentary word for word, even if it is to be given live without notes. This crystallizes the thoughts to be expressed

and helps to avoid the pitfalls of so many poorly presented shows.

Provide an introduction in pictures or commentary that tells what, where and when; then, move into the explanation of how or why and work on to the climax and the conclusion. Do not let the show go on and on after it has been ended. Recognize the end and stop!

Hold commentary for each picture to no more than can be said in 15 seconds unless there is instruction in intricate processes. If this is true, it is better to present the material in two or three different pictures to provide relief from the same view for too long.

Give information not clearly visible in the picture. Research by the writer is invaluable and adds interest to the show. It isn't necessary to talk all the time each picture is being displayed. Some pictures should stand alone or, at most, have only a title.

Beware of repetitive phrases and redundant information unless needed to stress an exceptionally important point. Overworked phrases that are most evident in slide shows are, "This is," "Here is," or "That is." Very seldom are any of these needed if careful thought is applied to sentence structure.

Avoid flattering descriptive phrases. "This gorgeously lovely red rose . . ." is excess verbiage. If the flower was photographed properly, the viewer knows it was beautiful. If not well portrayed, no amount of words convinces him. Comment on the variety, its culture, the location or tell something of the history of the locale while the rose is on the screen.

Never apologize for a slide. Do not get involved with explaining photographic techniques. Only another photographer is interested in *how* the picture was taken.

If possible, include some of the sounds associated with the subject of a part of the slides. For example, the cry of seagulls on a waterfront scene, the cheering at the football game, the roar of a waterfall.

9. Tape the narration to assure the best presentation. This avoids the unplanned delays in the show, the problems of forgetting to explain important information, and gives a professional touch. If the photographer's diction or tone of voice on tape is not good, have someone other than the photographer read the script. Record in a conversational tone rather than as a reader. This may take practice.

Record the tape in as nearly a soundproof area as possible to avoid foreign or unwanted sounds. Do not project the slides at the same time because the noise of the projector detracts. Plan

and note the exact number of seconds for each picture, in the margin of the script along with an identification of the slide. Watch the second hand on a nonticking clock or have an assistant time for each slide change.

The speaker should tape only when well and rested. Weariness will be obvious in the voice.

10. Play narration tape and project slides together. Check for flaws. Retape or cut and splice tape if necessary.

11. Add background music when the narration tape is satisfactory. Choose music that fits the mood of the show. Avoid piano, voice and violin solos and familiar tunes because the viewer becomes involved with the music rather than the pictures and commentary. Fade the music in and out to maintain it as background only when the narrator speaks.

12. Prepare for each presentation. Preview the show each time to check if transparencies are clean, correctly inserted, and in proper order and that the tape is good and recorder functioning properly.

Have an extra projection lamp and know how to install it. Never move a projector while the lamp is hot. Use a clean handkerchief to handle the new lamp, when one is changed, to avoid fingerprints.

Never plug a projector into a drop cord because drop cords are not made to carry the 500 watts or more required for projectors. Set the projector on a steady support to avoid shake in the picture.

If projecting in less than a totally dark room, place the back of the screen toward the lightest area of the room. When the picture is larger than the screen, move the projector closer. For a too small picture move the projector farther from the screen.

Zoom lenses on the projector will fit the picture to the screen at various distances. If possible, have the projector in back of the audience.

When the top of the picture on the screen is wider than the bottom (keystoning), raise the projector to the middle of the screen (Fig. 16-2). On some portable screens, the top hooks over a notched rod so the screen is at an angle to compensate for the lower projector. If one vertical side of the picture is longer than the other, pull the long side of the screen toward the projector (Fig. 16-3).

With the automatic-focus projectors, the first slide is focused and theoretically there is no further focusing required. Sometimes there is a need for sharpening the focus but to prevent a seasick audience, beware of seesawing in and out.

16-2 The keystoned picture on a projection screen can be corrected if the projector is raised to a line perpendicular to the middle of the screen or if the screen is tipped forward at the top with something placed under the back leg on portable screens.

16-3 One side longer requires the long side of the screen pulled toward the projector. If the screen is immovable, place the projector directly in front of the center of the screen horizontally.

The satisfaction and knowledge gained from producing a miniature show challenges the photographer to longer and better productions.

PRINT DISPLAYS

The purpose of the display dictates whether a group of prints needs a unifying theme or whether each picture stands on its own merits. If it is for decoration, the picture needs no more than a title, if that. The display used to tell a story, educate, or stir interest in a particular field needs to be carefully correlated. The story line may be carried entirely by pictures or combined with captions.

As with the slide show, careful editing of prints and captions strengthens the presentation. Quality rather than quantity is the guide

for a print show. Variety in format and size increases interest. Why should every picture be 8 x 10, 11 x 14, or 16 x 20?

Salon exhibit rules limit the variety of mounting techniques that can be used. They are, in fact, quite rigid. Home, school, and institutional displays do not present these limitations. The photographer's imagination and determination are the only restrictions. Plan the mounting technique or frame to complement the picture, not to overwhelm it.

Shadow box mounts, raised mounts on a larger background, or a combination of the two are possibilities. Consider frames or mounts in which prints may be changed at will to provide variety with a minimum of fuss.

Not all photographic displays need be hung on the wall or framed and set on the dresser or piano. Ceiling or overhead mounted floating mobiles assembled on rectangular shaped flat mounts or cut-outs to the outlines of the subject offer a way to tell a story or to record an experience. Make two prints, one with the negative reversed (emulsion side up in the enlarger), so the prints on each side match perfectly on the shaped cut-outs. Balsa wood boxes in several shapes and sizes with pictures on each flat side are another variation possible for the mobile. The same type of boxes made of heavier wood or plastic are used for paper weights, book ends, or for conversation pieces on the coffee table or shelves.

A series of prints on mounting board joined together accordion style set on a furniture top add a decorative note. These might be panoramic views or just related subjects.

Experiment with varied methods of display to add interest and to increase the pleasure derived from photography.

DISPLAY IN NEWSPAPER AND MAGAZINE

One remunerative method of display is in newspapers and magazines. Certainly, this gives the widest base of display. There are basic guides that help in selling to this market; a few of the more pertinent ones are:

1. Submit the news photograph while it is still news and seasonal pictures at the appropriate time of the year.
 a. Daily city newspapers pay for many kinds of pictures that they use. They want the pictures to meet deadlines and would often prefer that the photographer give them the exposed film to develop and print. They then return negatives to the photographer. It isn't unusual for one of the national news agencies to pick up a picture to print. The photographer is paid by both or all agencies using the picture.

b. Seasonal pictures for magazines and Sunday supplements need to be submitted many months, at least six months, ahead of the time they may be published.

2. Black and white prints should be in 8 x 10 glossies (ferrotyped).

 a. To protect the print from possible damage in the mails or handling, mount it on mounting board. *Stamp or write the photographer's name and address on the back of each print.* If the print is unmounted, write the name back of the border to prevent creases on the picture.

 b. Attach captions typed on plain paper with tape on the back of the print and caption paper.

 c. Mail pictures flat in an appropriate size manila envelope or reinforced cardboard box.

 d. Several more views of a subject should be submitted than the magazine or newspaper is likely to use to provide a choice. A proof sheet may be submitted with one 8 x 10 enlargement for a magazine or newspaper's consideration. If they desire a different picture from the enlargement submitted, they notify the photographer.

3. Color transparencies are required by most publishers for any picture to be reproduced in color. Some publications limit their acceptances to one size, automatically refusing all others. This should be checked before submitting color.

 a. Print name and full address on each slide mount.

 b. Print caption on the mount or submit a typed caption sheet with the numbers on the mount keyed to the caption.

 c. Do not submit glass-mounted transparencies.

 d. The available acetate sheets, punched for a 3-ring binder, have twenty pockets for individual 35mm slides (Fig. 16-4). The acetate protects the slides, yet makes them available for quick appraisal over all or individually by projection.

 e. Support the acetate sheet with a piece of mounting board in the mailing envelope.

4. Furnish copies of signed model releases from and for all recognizable people in pictures sent to magazines. Parents or guardians must sign for minors to make the release valid. Releases are not required for politicians, public officers or stage, TV and movie personalities.

5. Enclose a self-addressed, stamped envelope for the return of prints or slides.

16-4 Cardboard-mounted slides in the pockets (appropriately sized) of acetate holders punched for loose-leaf notebook is an excellent method to submit slides to prospective customers. The holders are available at camera and at coin collectors' supply stores.

FIELDS FOR PHOTOGRAPHY

There are unlimited horizons to pursue in photography with literally hundreds of fields to explore, experiment, research, and invent. The one constant in photography is change.

Competition is present in all areas, yet photography offers financial and creative returns to every age. There is probably no other field of

work that can be and is pursued on as many levels with as much variation in kinds or sophistication of equipment, preparation in training, and differences in age of the participants. There are no mandatory retirement regulations for enjoyment or remuneration for photography, nor limitations on the age at which one can start his exploration of the field.

The only restrictions are the individual's own perseverance, originality, and technical know-how to carry out a project and find the market or to observe the need and supply it.

There are literally untold numbers of careers in which photography plays an important role or is a distinct aid. Dentistry, medicine, architecture, oceanography, engineering, astronomy, advertising, free-lance non-fiction writing, interior decoration, landscape architecture, and teaching are only a few of the professional fields that use photography extensively.

A portion of the numerous phases for specialization for the professional photographer are: portraiture, advertising, photojournalism, law enforcement, custom and/or commercial processing laboratory, medical laboratory, industrial, aerial, photogrammetry, graphic arts, military, free-lance, fashion, TV, and cinema.

No other field of work may offer the challenges; the chances for travel, adventure and/or danger in search of particular subjects; the need for originality and imagination; the associations with peoples of varied, interesting backgrounds; the rewards in both creative satisfaction and monetary returns for work well done; and the demand for self-discipline and irregular hours to meet deadlines.

Explore and inquire to decide if photography is to be a life career, a supplement to another career or profession, a source of income beyond the regular job, an interesting hobby or only a family record of activities. Each is a worthwhile goal.

This book, regardless of the field of the reader's interest in photography, is only a beginning. There are so many exciting and rewarding areas to investigate. Don't stop here! Explore! Explore! Explore!

REFERENCES FOR FURTHER READING

Ahlers, Arvel W., and Paul Webb: *How and Where to Sell your Pictures*, New York, Amphoto, 6th ed., 1965.

Arin, M. K.: *Successful Wedding Photography*, New York, Amphoto, 1966.

Bruns, Renee: "Look What Photography's Doing to Greeting Cards," *Popular Photography*, Vol. 67, No. 4, October, 1970, pp. 96f.

Cepnic, Dennis J.: "How to Deal with Editors like a Pro," *Popular Photography*, Vol. 67, No. 4, October, 1970, pp. 71f.

Chellis, Ken: "There's Money in the Air; Camera Can Pay for the Plane Ride," *Popular Photography*, Vol. 68, No. 2, February, 1971, pp. 81f.

Chernoff, George, and H. Sarbin: *Photography and the Law*, New York, Amphoto, 2nd ed., 1970.

Deschin, Jacob: *Photography in Your Future*, New York, Macmillan Company, 1965.

Dunn, Phoebe: "On Better Family Pictures," *Popular Photography*, Vol. 46, No. 12, December, 1959, pp. 64f.

Engh, Rohn: "Secrets of a Successful Free Lance, Another Day at the Mailbox," *Popular Photography*, Vol. 65, No. 3, September, 1969, pp. 71f.

Frey, Hank and Paul Tzimoulis: *Camera Below*, "The Complete Guide to the Art and Science of Underwater Photography," New York, Association Press, 1968.

Goldsmith, Arthur: "What You Need to Know about Model Releases," *Popular Photography*, Vol. 66, No. 2, February, 1970, pp. 58f.

———"The Economics of Free-Lancing," *Popular Photography*, Vol. 71, No. 5, November, 1972, p. 94f.

Hanningan, Ed: "The Photographer as Historian," *U.S. Camera*, Vol. 30, No. 4, April, 1967, pp. 16f.

Hyum, Walter: "What's a Picture Agency?" *U.S. Camera*, Vol. 30, No. 4, April, 1967, pp. 52f.

Kinney, Jean and Cle: *How to Tell a Living Story with Home Slides*, New York, Richards Rosen Press, 1964.

———*97 Special Effects for Your Home Slide Show*, New York, Richards Rosen Press, 1964.

Schroth, John F.: "How to Produce a Slide-Tape Talk," *The Fourth Here's How*, AE 85, Rochester, New York, Eastman Kodak, pp. 47f.

Sutton, David: "Where the Action Is: Protect Your Pictures," *Petersen's Photographic Magazine*, Vol. 1, No. 7, November, 1972, pp. 12f.

APPENDIXES

APPENDIX I HOW-TO

SECTION A

Score Transparency or Print
(10-point maximum)

Minimum points (for the photographer's effort)			1
Technically suitable for subject, mood or purpose of the picture:			
Exposure (shutter speed and aperture)	0	or	1
Focus and/or depth of field	0	or	1
Contrast	0	or	1
Direction and/or quality of light	0	or	1
Composition	0	to	2
Interest and impact	0	to	3
Total possible points			10

Score Transparency or Print
(5-point maximum)

Minimum points (for the photographer's effort)			1
Technically suitable for the subject, mood, or purpose of the picture: exposure, focus, contrast, and lighting	0	or	1
Excellent composition	0	or	1
Interesting subject, well presented	0	or	1
Impact such that the viewer wishes to look again	0	or	1
Total possible points			5

SECTION B

Convert to Another Scale

The scales most frequently desired to convert are shown graphically to simplify computation (Figs. I-1–4).

Convert ASA to DIN

Approximate Equivalents of ASA and DIN Scales

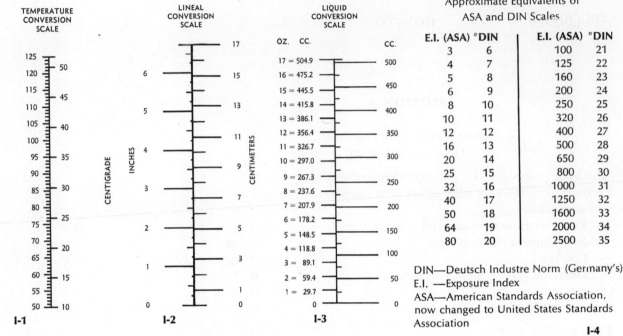

E.I. (ASA)	°DIN		E.I. (ASA)	°DIN
3	6		100	21
4	7		125	22
5	8		160	23
6	9		200	24
8	10		250	25
10	11		320	26
12	12		400	27
16	13		500	28
20	14		650	29
25	15		800	30
32	16		1000	31
40	17		1250	32
50	18		1600	33
64	19		2000	34
80	20		2500	35

DIN—Deutsch Industre Norm (Germany's)
E.I. —Exposure Index
ASA—American Standards Association, now changed to United States Standards Association

I-4

TEMPERATURE CONVERSION SCALE — FAHRENHEIT / CENTIGRADE — I-1

LINEAL CONVERSION SCALE — INCHES / CENTIMETERS — I-2

LIQUID CONVERSION SCALE — OZ. CC. — CC. — I-3

SECTION C

Mount a Photograph for Wall Display

Preparation of a print for wall display need be neither difficult nor expensive. The work must be done neatly and precisely if the photograph is to appear at its best. Before work is started, analyze and decide:

1. Will the print be most effective on a mount or in a mat?
2. Will a background in a color, in black, or in white add to the forcefulness of the photograph?
3. Is there need for the protection of a glass or plastic cover?
4. Does a frame add to, detract from, or offer needed protection?
5. How will the finished art be hung?

6. Will there be storage and/or transportation problems if and when the print is removed from display?

A print is mounted when attached to the surface of a board such as artist's mounting or illustration board, masonite, or other firm material. Print borders are cut off before the print is mounted, called bleeding the print. The mount may be the exact size of the print or may extend beyond the print to form a border or background that may be more effective (Fig. I-5).

I-5 To bleed a print, all white borders are cut off, as on the left. The print on the right is mounted with a border to separate the picture from the surrounding area.

A print is matted when an opening the approximate size of the print is cut in the board with considerable border left as a flat frame, then the board laid so the picture is visible through the cut-out area (Fig. I-6). The opening may just cover the edges of the picture to show no part of the white border of the print, or the print may be made with a wide border. Then the mat can be cut to show a very precise portion of the border around the print. The print will stay flatter if it is first mounted on another surface before it is matted (Fig. I-7).

Backgrounds formed by the mat or the mount and the area of display all contribute to the decision on whether black, white, or color is

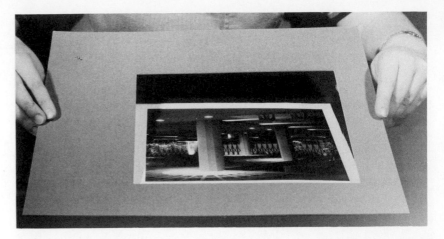

I-6 A print is matted when a cutout is made in the board with the picture fastened to the back.

I-7 Both of the prints were left with a portion of the white border showing to clearly separate the picture from the mat.

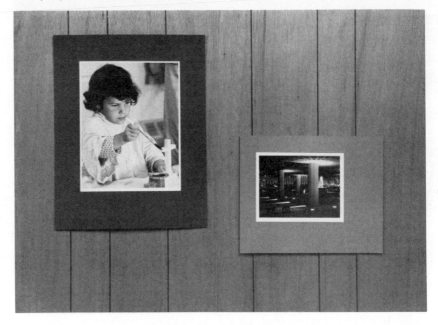

most effective. Experiment by laying the print on the various possible backgrounds. Black tends to dull pictures. White may give excessive contrast or tend to lighten the intensity of the colors in the color print. Taste and the existence of any governing rules for the display determine the final decision. There are no ready-made answers.

For exhibition in a damp, smoky, or dusty location, a glass or plastic cover protects the print's surface. This avoids the problem of viewers touching the picture surface, which leaves spots or fingerprints. Disadvantages of the glass or plastic are:

1. Glare produced as the picture is viewed from certain angles.
2. The heavier weight to handle and hang, which requires a stronger support.
3. The possibility of breakage that may damage the picture beyond use.
4. The chance of Newton rings or the emulsion sticking to the surface of the glass. This may cause the emulsion to pull off the paper when the picture and glass are separated at a later time.

Nonglare glass lessens but does not eliminate the glare. It does succeed in deadening the sparkle of the photograph, and nonglare glass is expensive! Plastic is lighter than glass but also has a glare problem.

Newton rings and the adhesion of the emulsion to the glass are avoided if the picture is matted to prevent contact. To substitute for the glass or plastic covering but still have protection, evenly coat the mounted and/or matted print with clear acrylic spray. The acrylic may be either matte or glossy. Both types give an added depth to the photograph. The glossy acrylic gives perhaps more than the matte though this is a matter of personal preference.

Spray the mat or mount at the same time to prevent smudges or grease spots from careless handling or accidents. The coated surface can be wiped with a damp cloth. In fact, the surface will resist a great deal of moisture. One set of acrylic-sprayed 11 x 14 prints were inadvertently strewn along a roadside over night in an especially heavy dew. When they were found the next day and wiped with a dry, absorbent towel, the emulsions were undamaged in any way. If the acrylic spray should become scratched, a whitish gray line is left. This is obliterated easily with another light spray of the acrylic.

In public showings, whether the print is framed is the prerogative of the exhibitor or the sponsoring organization. Home display gives wider possibilities. The most important concern must be that the frame complements and does not overwhelm the picture. A narrow frame of flat-finished black in wood or metal is favored by many photographers.

Shadow boxes can be improvised from the packing styrofoam

around typewriters and other office machines. Spraying lightly with an appropriate color produces both texture and color. Line the inside with a piece of fabric or paper. Display one large or several smaller prints mounted on lightweight boards. Glass-headed push pins hold them in place. To give dimensional effects, attach foam, balsa, or cork blocks behind the picture.

Two parallel strips of molding attached to a wall simplifies change of prints (Fig. I-8A). Metal, half oval molding attached to a wall with the same type reversed on the picture permits quick change (Fig. I-8B). Velcro mounted on the wall surface with its complement strip on the back of the picture is another method (Fig. I-8C).

The conventional method of screw eyes and wire on the frame with a nail or hook in the wall still works but offers less versatility for change of the display. Storage and weight are problems.

WALL DISPLAY

Picture

Wall

I-8 Three methods of picture display for quick and simple change of pictures. (a) Wood molding attached to the wall. Allow extra room at top for slipping in the print. (b) Metal half oval strips that lock. Wood strip on the wall at bottom of the print holds it away from the wall and vertical. (c) Velcro attached to back of picture with complement on the wall.

a b c

SUPPLIES AND EQUIPMENT TO MOUNT A PRINT

Now that the decisions have been made, the necessary supplies and equipment are collected and used.

1. Mounting board.
2. Cutting tools to cut mounts and mats.
3. Straight edge, preferably metal, if needed.
4. Adhesive and necessary tools to apply.
5. Frames, glass or plastic covers, if used.
6. Hanging devices.

Mount and Mat Board

Art supply stores sell mounting boards of various weights and colors in full sheets. Left-over scraps from their own picture-framing service are sold in bundles at nominal cost. These scraps are often quite large. The mount *back* can be any color when bleeding the print or when matting the picture. Pebble or heavily textured surfaces do not adhere well so if those boards are used, utilize the smooth back to attach to the print. Other mount materials used are sheets of aluminum, thin masonite, and plywood.

Some photographers use unexposed, but fully developed and processed, well washed, double weight print paper to mount prints. The back of the picture is glued to the back of the print paper so that the pull of the emulsion on one side is equalized by the pull of the other emulsion. This gives a flat print with minimum thickness and weight, which is economical both for storage space and mailing. Additional support board must be supplied in the mailing container, most certainly.

Mounts that extend beyond the edge of the print or are not covered by a mat must be chosen carefully, both in tone and color. Often suitable ones may be among the scrap board but do not economize and use inappropriate board just because it is on hand.

Proportions are very important with mats and with the mount that extends beyond the print. All borders can be the same width but more often the top and side borders are made equal; more is left below the picture than on either of the other three borders. There are no hard and fast rules but 2½″ is a good proportion for the top and sides with a 3″ border at the bottom. The opening in the mat and the picture is carefully centered horizontally and squared with the outside borders. Often, the print is not centered but if not, it must be far enough off center that it is obviously not an error in placement (Fig. I-7).

Cutting Tools

The kind of backing and/or mat material used determines the necessary tools for cutting. For the mounting board, a utility knife with the very heavy, razorlike blades that are replaced when dulled works well. A good metal straight edge with a couple of C-clamps holds the board and straight edge in place. Protect the mounting board from the metal straight edge with clean white paper if the mount extends for a border or if the board is used as a mat.

For the outside cuts, heavy bar paper cutters are suitable if they cut square and straight. The board may shift as the cutting bar is applied. Use appropriate saws with the masonite, plywood, or aluminum.

Wrap a piece of fine emery paper around a small block. Sand all edges lightly, especially the inside corners of the mats.

Adhesives

Several adhesives are used. Some of the newer ones have not been in use long enough to be sure of the effects with the passage of time.

For the temporary mount, rubber cement spread on one surface only at the very top of the back of the wide-bordered print that is matted works well. When it is time to change the picture, the mounting surface is pulled away from the picture, not the reverse. A hinge-type mount with tape works well, too, for temporary display.

For the permanent mount, rubber cement tends to yellow and loosen on the edges with time. If a permanent mount is the goal with rubber cement, spread evenly over both surfaces and set aside to dry until both feel dry to the touch. Align carefully and put the two glued surfaces in firm contact and especially on the edges. Rub with a soft cloth with considerable pressure over all the surface of the print.

The spray adhesives are convenient and quick to apply but it is too soon to be sure whether they will yellow or separate in time. If they are used, press and rub with a soft cloth over the surface of the print to be sure to form the best possible bond.

Dry mounting tissue, a heat-sensitive sheet that is laid between the print and the mount, is the most common and safest type of adhesive in the opinion of most photographers. Camera stores sell it in precut standard sized sheets. Some art stores can be inveigled into parting with the type they use which has a considerably heavier coating of adhesive. Art store mounting tissue is sold in bulk lengths.

A dry mounting press with thermostat control is the ideal method used to apply the tissue but is neither small nor cheap. The family laundry iron will do the job, though not as efficiently, if a mounting press is not available. The iron must have *no* steam. A steam iron may be used if there is *no* moisture in it.

A firm clean surface, not the padded ironing board, must be used for mounting. Set the iron on "wool'" for black and white prints, on "synthetics" for color prints. Lay a piece of *clean* wrapping paper or white paper larger than the print over it to keep the iron from touching the print emulsion in the mounting process. Iron this paper sheet first to be sure all moisture is removed before starting to mount or the emulsion may stick to the protective paper. Cut the sheet of dry mounting tissue to print size. Lay the tissue on the back of the print, touch the *tip* of the iron to the tissue and draw a line three or so inches long. This anchors the tissue in position on the back of the print.

Lay the mount on the table and align the print carefully into its proper place on the mounting board. Lay the protective paper over the print. Press momentarily at two corners with the iron. Check the alignment of the print. If properly placed, start at the center of the print to iron in ever widening circles to the edge of the picture. Keep

the iron moving to avoid a pressure image imprint of the iron's outline.

Turn the board over, with the wrapping paper between the table and print. Iron the back of the mount thoroughly. This prevents the mount warping as it cools. Now, go back to the front of the mount. Check for any bubbles or places the print may not be adhering. Press and rub with a soft cloth toward the outer edges of the print. If it still does not smooth down well, iron again (paper between!) and press with a weighted piece of masonite or other smooth flat surface, until the print and mount cool.

Masking tape secures the mounted print to the back of the mat if the mat is larger overall than the print mount.

Some photographers draw a black line in India ink around the border of the print. A black felt pen makes a good tool to blacken the cut edges of the flush mount. Don't let it slip!

The title of the picture is handwritten on the mount at the left and if appropriate, the photographer's name at the right immediately below the picture. Salons often rule out any prints with the photographer's name on the face of the mount or print. Now is the time to spray with acrylic. Two or three thin coats with drying periods between coats is far better than one heavy coat.

Assemble the prints in the frame, glass or plastic cover, or other method of display that has been chosen.

REFERENCES FOR FURTHER READING

Francekevich, Al: "How the Pros Mount Murals," *Popular Photography,* Vol. 67, No. 4, October, 1970, pp. 34f.

Vestal, David: "Mounting and Framing Prints," *Popular Photography,* Vol. 64, No. 6, June, 1969, pp. 94f.

Wolfman, Augustus: "Protective Coatings Will Prevent Your Prints from Getting Permanent Smudges," *Modern Photography,* Vol. 34, No. 6, June, 1970, pp. 52f.

Yarrows, Paul D.: "Print-finishing Techniques," *The Fourth Here's How,* AE-85, Rochester, Eastman Kodak, pp. 56f.

SECTION D

HOW TO MAKE

Make numerous items inexpensively to use to produce a better picture, to substitute for more expensive commercial equipment, or to improve the range of work possible with the ready-made accessories.

MAKE REFLECTORS

Improvise reflectors from inexpensive items. A white umbrella purchased at the local department store serves much less expensively than the umbrella-type reflectors made specifically for photography. The reflection is not quite as efficient but very good. Circles of aluminum tubing about one inch in diameter used singly or in combinations hold the umbrella on a light stand at the desired angle (Fig. I-9). Keep the umbrella clean for maximum reflection.

Use the umbrella between the light and the subject as a diffuser to soften contrast. The umbrella also serves its normal use as a shield from rain or sun for the photographer.

A white-fabric-covered hula hoop is a lightweight, multiple-use, easily laundered reflector. The smaller hoops are ideal for close-ups and the bigger ones for portrait work on larger subjects (Fig. I-10). White hoops are best for color work.

I-9 An ordinary white umbrella with the handle slipped through aluminum rings on a light stand serves as a reflector to soften light for portraits. A Lowell light unit holds a reflector flood which in turn holds the Lowell barn doors to prevent flares in the camera lens.

I-10 White plastic hula hoops are quickly converted to reflectors with a muslin cover with elastic in the hem.

Cut a circle four inches larger in diameter than the hoop, from the still firm areas of a worn, white bedsheet or other white fabric. Sew a ¾-inch hem around the edge. Insert ½-inch elastic in the hem.

Carry the fabric in a plastic bag until needed, then quickly assemble on the hoop to use either as a diffuser or as a reflector. When not em-

ployed by the photographer, the hoop alone serves as a device to help children work off excess energy on the photographic expedition.

Make a durable, flexible, lightweight reflector from a sheet of 2-ply bristol board (22 x 30) covered on one side with a sheet of paper-backed foil. The board, of 100% rag, does not disintegrate from moisture when used in wet grass, rain or snow. Silver foil is used for most subjects but gold foil gives nice skin tones for color portraits of people.

Assemble the reflector in the following steps:

1. Crumple the foil into a compact ball to form crinkles that will break up the reflections and avoid hot spots on the subject.

2. Smooth the foil back into a flat sheet.

3. Apply rubber cement evenly over one side of the board. Set aside to dry.

4. Spread rubber cement evenly over the paper backing on the foil and set aside to dry.

5. When both glue-covered surfaces feel dry to the touch, line up the edges carefully and spread the foil onto the board.

6. Write the photographer's name and address on the uncovered side of the board in large letters. Photograph this on the first frame of 35mm film to identify the roll in case it should be lost by the photographer or missent by the commercial processor.

7. Fold the board in half crosswise, roll it, and secure it with a rubber band around the tripod leg for storage and availability.

Utilize the foil side for maximum reflection, the white side for softer effects. This versatile reflector helps to photograph shadowed detail of arches without overexposing subjects beyond that are under more intense light. Curve the reflector for different intensity of reflection. A convex curve spreads the light over a wider area, the concave curve concentrates the reflected light in a smaller area.

GROUND LEVEL CAMERA SUPPORT

Make a camera support to photograph the small flower, mushroom, or insect within a few inches of the ground (Fig. I-11). Not all tripods have removable center posts that can be inserted upside down to put the camera lens in a snake's-eye-view position.

Materials needed for the ground-level camera support are:

1. Sturdy, tilt-top, camera-support head, available at camera stores and by mail order. The head should swivel 360° horizontally and 90° vertically.

2. A bolt with matching threads to fit the threaded hole in the

tripod support head and of appropriate length to extend through the wood base into the head.

3. Wood base of two layers of one-inch marine plywood or a section of 2 x 8 or 2 x 10 that is 10″ to 14″ long.
4. Metal luggage handle for a convenient carrying of the support.

Attach the support head with the bolt through a hole drilled three inches from the end and midway across the wood base. Secure the trunk handle to the opposite end of the base.

Those cameras with eye-level viewfinders are easier to focus and frame if they are equipped with a right-angle magnifier viewer, a supplementary accessory available at camera stores or supply houses. Waistlevel viewfinders do not require this aid.

GROUND LEVEL CAMERA SUPPORT

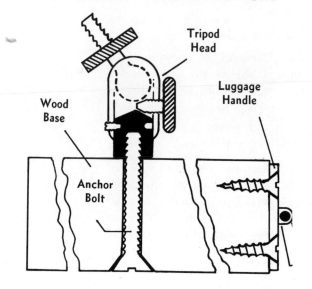

I-11 Cross section of the construction for ground-level photography. See text for material list and construction details.

GADGET APRON

(For women and girls only)

Gadget bags were invented by men! Women's shoulders are not built to support heavy bags. A gadget apron works well for a number of camera accessories (Fig. I-12). The gadget bag and unneeded equipment for a particular foray can be left in the automobile in that foam box *gadget bag* or at home.

GADGET APRON

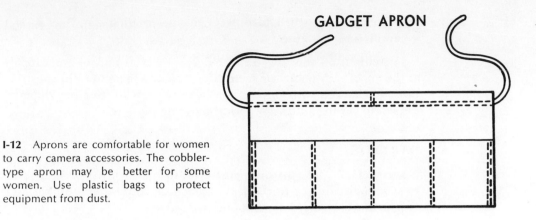

I-12 Aprons are comfortable for women to carry camera accessories. The cobbler-type apron may be better for some women. Use plastic bags to protect equipment from dust.

Gadget aprons are so inexpensive that one can afford one to match, blend, or contrast with each costume. One yard of fabric 36″ to 42″ wide with thread to match is required.

1. Cut or tear across the fabric from selvage to selvage into three pieces: 6″, 11″, and 19″.

2. Sew a 2½″ hem on the torn top edge of the 19″ piece and reinforce at each end by backstitching.

3. To make a casing for the ties, press a fold one inch from the top of the hem all the way across. Open up the fold and stitch the length of the crease mark and reinforce at each end with backstitching.

4. Sew a 1″ hem in the top of the 11″ piece.

5. Fold the 19″ piece selvage to selvage and press the fold. Open and fold each selvage to the center crease. Press the end folds. Repeat this same procedure with the 11″ piece.

6. Lay the right side of the 11″ piece to the wrong side of the 19″ piece along the torn edge of each. Match selvage to selvage and crease to crease.

7. Stitch a ⅝″ seam on the torn edges. Understitch the seam.

8. Fold the 11″ piece to the right side of the 19″ piece. Match pressed creases. Double stitch ⅛″ apart on the selvage edges to the top of the pocket sections. Double stitch the three pocket divisions on the pressed crease.

9. For the ties, cut or tear the 6″ piece in half, selvage to selvage. Seam the two strips together, on one end, right side to right side. Press the seam open. Fold the strip in half lengthwise and wrong side out. Press the fold. Stitch the seam at ⅝″ the full length. Turn the ties right side out. Press. Thread the ties into the casing of the apron. Match the crosswise seam of the ties to the center of the

apron and top stitch to prevent the ties pulling out. The gadget apron is ready to use.

Variations on this are to make deeper pockets and/or put zippers at the top of each pocket or each pair of pockets. The steps in construction are changed with zippers. Sew a storm flap in over the zippered pockets by sewing a tuck 1½″ wide above the zippers.

DARKBOX

No darkroom? Make an inexpensive substitute to load the film tank, to spool bulk film, or to check the camera operation mid-roll without fogging the film (Fig. I-13). Supplies needed are:

1. A solid corrugated cardboard box 15″ to 20″ wide, long and deep with covers that allow a 2″ margin to be retained on the top as light trap.
2. A second box just slightly longer in the length and width from which to cut a light tight lid to extend 2″ or 3″ below the top of the first box.
3. Electrician's black plastic tape.
4. A pair of black knit sleeve cuffs from a discarded garment with approximately 7″ of sleeve and lining still attached. Two or three layers of long black socks might be utilized instead.
5. Rubber cement or a white casein glue.
6. 15″ of ¼-inch elastic.

Steps in construction:

1. Cut the elastic in two equal pieces. Thread one inside and around the bottom of the cuff of each sleeve and sew the ends securely.
2. Paint the interior of both the box and the lid with the black, flat paint or line with black paper, to reduce reflections of any light

DARKBOX

I-13 The darkbox can be constructed of any light-tight material. It is less expensive and may be more convenient at home or school than the changing bag.

that may inadvertently enter the box. Tape all corners, cracks, and bends with the electrician's tape.

3. Cut a circle 5″ to 6″ in diameter, two or three inches up from the bottom on opposite ends of the box.

4. Glue the cut end of the sleeves around this circle. They may be sewn with heavy thread and darning needle or stapled into the hole if this is easier. Cover all holes made in the process with the black tape. To use the darkbox, lay tanks, film, and other equipment in the box through the top, put on the lid, and insert the hands through the cuffs for miniature darkroom operations.

A LIGHT BOX

A large light box is a delight for either the black and white photographer or the color slide enthusiast. The light box provides an excellent and consistent light source to read, compare, and sort negatives and is superb as a slide sorter. Light boxes are simple projects for the individual who is handy with tools. The size of the light box is never quite large enough but a capacity of 100 to 200 slides is normally sufficient. Probably the most convenient type of light box is one built into a table top. Materials needed are:

1. A sturdy table that can be altered.
2. A fluorescent light assembly appropriate for the size of the table.
3. Electrical cord, switch, and plug.
4. Lumber necessary to build the required supports beneath the table for the lights.
5. Opal glass or rigid translucent plastic to fit the opening in the table.

LIGHT BOX

I-14 Fluorescent lights are cooler but the long incandescent lamps can be substituted for a less expensive, lighter weight box if sufficient ventilation is provided for the extra heat. Excess heat ruins both negatives and slides.

Install the lights below the cut-out opening in the table top and cover with the glass or plastic flush with the top of the table.

If there is no suitable table for this kind of alteration, build the lights into a portable box covered with the opal glass or translucent plastic (Fig. I-14). Paint interior white or line with aluminum foil.

EMERGENCY OR TEMPORARY LIGHT BOXES

Should storage space, weight, or lack of tools prevent either of the previous solutions from being practical, there are make-do devices that work quite well. Some of these are:

1. Lay a fluorescent light horizontally on a flat surface. Glue or tape ¼″-square balsa wood strips horizontally 2½″ apart (to hold the slides) on a piece of translucent plastic that matches the length of the light fixture. Stand the plastic at a 45° angle, supported by triangles of plywood, heavy mounting board, or corrugated cardboard at each end and in the middle, if needed.
2. A glass-topped coffee table or end table with white paper or sheet laid below works well for a slide sorter. Shine light on the white paper with small lamps such as the low-intensity lights.
3. Support a storm window with the expandable dining room table or two tables of equal height. On top of the glass lay white tissue wrapping paper or lightweight translucent plastic sold by the foot or yard from rolls. Use table lamps set below for illumination.

SLIDE DUPLICATOR

Slide duplicating is easy. The equipment required can be quite simple or made more versatile with additional equipment that can be built. Basic requirements are:

1. A camera fitted with close-up equipment to give a 1:1 proportion. That is, the image is reproduced in the exact size. Equipment can be purchased to make it practical on the rangefinder-type camera. Cropping is possible with an SLR equipped with tubes or bellows. The greatest flexibility is obtained with the bellows, which permits infinite degrees of cropping.
2. A sturdy camera support. A tripod is practical (Figs. I-15, 16). A support that is more convenient to adjust and to crop as desired without danger of camera shift after it is focused is better (Fig. I-17).
3. A light for rear illumination. Daylight is used but the color of the light fluctuates widely to yield unpredictable results.

I-15 Scraps of mounting board stapled together provided this slide holder for duplicating. The electronic flash directed at the white side of a neutral gray test card (any *white* surface would serve) provides diffused light without opal glass. To predict exposure, standardize distances between flash and card, and card and slide. Bracket first experiments widely.

I-16 The taller upright piece is supported by a tight fit between the turned up triangles of the bottom board. Separate the two, upright and bottom, for flat storage.

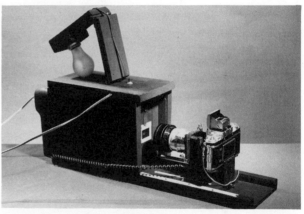

I-17A Scrap lumber and sheet aluminum made into a duplicator provide a sturdier, more versatile unit. The equipment is set for focusing. The lens is moved forward or backward with the sliding board on which the camera is mounted.

I-17B (Above right) The duplicating unit is ready for exposure. The flashgun is always placed against the bottom board of the unit to give consistent distance between gun and transparency.

I-17C (Right) Stage light gelatins can be used for filtering if desired. Optical quality is not necessary with filters between the light and the transparency. Different sizes of openings in extra slide holders provide possible duplication of different sized transparencies.

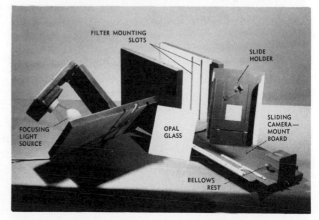

Shadows of clouds or highlights several miles away can register in out-of-focus shades that detract. A light with more controlled color and intensity gives better results. No. 211 or 212 enlarging lamps work well with tungsten-balanced films without filters. The electronic flash is the most predictable quality and quantity of light. A 85B filter will be required on tungsten-balanced films. Additional warming filters may be used.

The electronic flash needs to be at the same distance from the slide each time if predictable results are to be obtained. With either of the artificial light sources, a less intense (for less heat) light is used for focusing.

4. A piece of opal glass or translucent plastic to diffuse the light. This is mounted between the slide to be duplicated and the light source.

5. A film that gives pleasing result. GAF's 5470 duplicating film in 100-foot rolls is a favorite, inexpensive, tungsten-balanced 3200°K film that gives excellent results. Kodak's Kodachrome II, either the Daylight or the Type A Professional, is good when appropriately teamed or filtered to match the light source.

Do not expect any film to exactly duplicate either color or contrast. They can come very close. Additionally, there is the opportunity to increase the density on the overexposed slide or to decrease density on the underexposed transparency. Do not expect detail to register if there is none visible in the overexposed highlights. There is more possibility of capturing detail in the underexposed slide, though it will not be successful with too severe underexposure.

Filter to a different color rendition to increase mood or give a variety of effects from one original slide.

Filters may be inserted between the light and the transparency or fitted to the camera lens.

BORDERLESS EASEL

For maximum use of the paper and to have borderless prints that require little or no trimming make a borderless easel. They are inexpensive and simple. One easel serves for several sizes of prints. Select a relatively heavy piece of 5/8" or 1" plywood, two inches longer and wider than the largest piece of paper that is to be used on it. The weight is suggested to avoid the easel shifting unintentionally in use. Apply two coats of flat white or yellow paint. When dry, draw outlines of each of the standard size papers with black India ink or a black waterproof felt pen (Fig. I-18). Lay strips of pressure-sensitive tape coated with adhesive on both sides just inside the black lines on both

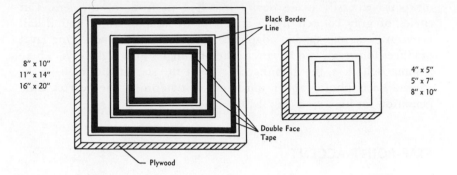

I-18 The outlines in black aid in placing the enlarging paper properly on the easel.

dimensions of each size. Do not overlap one strip with another at any point. Overlaps would produce uneven paper surface that might distort the image.

To use the easel, frame and focus the image within the appropriate black lines, then lay the paper in place within the same area. Press lightly on the tape areas of the outside dimensions of the paper to prevent its slipping. Expose the print, lift it off the easel starting on one narrow edge. Proceed as usual.

BEAN BAG SUPPORT FOR CAMERA AND LENS

When it isn't practical to carry a tripod or use a clamppod, a version of a bean bag may serve the purpose equally well or better. Make the bag of heavy fabric such as canvas or denim approximately 12″ square finished size. Insert a heavy zipper or strong drawstring the length of one dimension for an opening to fill and empty the bag.

To use, fill the bag two-thirds full with small beans, clean gravel, or even sand. Wheat, corn, or rice serve equally well. Lay the bag on top of the car (turn motor off), a rock, a log or bridge rail. Nest the camera and lens onto the top of the bag to hold it steady. This is effective for a long lens, much more so than a fragile tripod or many clamppods. The bean bag is an excellent device for the African Safari because the bag can be taken to the location empty, filled and used, and then the contents discarded until needed again. If filled with gritty or dusty materials, launder well before storing near any camera gear.

STAR PATTERNS

Lights in night exposures can be given a starlike appearance with an inexpensive, easily made device installed in front of the lens. Cut circles of gray colored nylon screen to fit adapter rings and install between two rings or one adapter ring and the lens hood. One layer produces four rays, two layers at different angles give eight rays. There is some light loss, the amount varies with the size of the mesh in the screen. Each photographer must test to determine the correct compensation for his screen (Fig. I-19).

STAR-POINT ACCENT

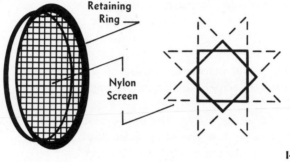

Retaining Ring

Nylon Screen

Four Points

Eight Points

I-19 Inexpensive filter to get starlike rays from highlights, especially in night scenes.

LEVEL THE CAMERA

Level the tripod-mounted camera accurately and rapidly (Fig. I-20). This is especially helpful with night photography and on mountain scenes.

Cut the ends from a small torpedo level available at hardware counters. Mount the level on a piece of stable metal that will extend over the tripod screw. Insert this metal between the camera and the tripod when the camera is attached to the tripod.

The level works for the vertical, the horizontal, and even a 45° picture if mounted as illustrated.

I-20A Inexpensive level to use with any camera and tripod combination.

I-20B Cut off the ends of a torpedo level and mount onto metal by glue or rivet. A hole in the metal fits over the tripod screw between the tripod plate and the camera.

REFERENCES FOR FURTHER READING

Edmund Scientific Co.: "How to Build" Booklets (on several pieces of photographic equipment. Catalog lists numerous items and ideas for photographic experiment and exploration), 600 Edscorp Bldg., Barrington, New Jersey 08007.

Englert, John F.: "Building a Photographic Blind for Nature Pictures," *More Here's How,* AE-83, Rochester, New York, Eastman Kodak, pp. 11f.

Farber, Paul: "Incident BTL Metering," *Camera 35,* Vol. 14, No. 3, April/May, 1970, pp. 10f.

Flower, Marvin S.: "The Print Wader," *Camera 35,* Vol. 16, No. 9, November, 1972, pp. 62f.

Floyd, Bill: "The Fantastic Floydmar Camera, The Pinnacle of Pinholery," *Petersen's Photographic Magazine,* Vol. 1, No. 5, September, 1972, pp. 42f.

Greenwald, Frank: "Superbag," *Camera 35,* Vol. 14, No. 5, August/September, 1970, pp. 54f.

Hobbs, Horace P., Jr.: "The Ultimate Gunstock," *Camera 35,* Vol. 14, No. 2, February/March, 1970, pp. 48f.

Lilley, Geoffrey: *Make Your Own Photo Equipment,* New York, The Macmillan Company, 1959.

"Make a Dry-Mount Photo Press" *Popular Science,* Vol. 198, No. 3, March, 1971, pp. 112f.

McGarry, Jerome T.; "Slide-Duplicating Techniques," *The Fourth Here's How,* AE-85, Eastman Kodak, Rochester, New York, pp. 26f.

Murray, David L.: "How to Build Your Own Slide Copier," *Petersen's Photographic Magazine,* Vol. 1, No. 6, October, 1972, pp. 66f.

Stock, Malcolm: "The Five Dollar Paper Safe," *Camera 35*, Vol. 14, No. 2, February/March, 1970, pp. 46f.

———"It's Only a Paper Sink," *Camera 35*, Vol. 13, No. 6, November, 1969, pp. 48f.

———"Pinarama," *Camera 35*, Vol. 13, No. 4, June/July, 1969, pp. 35f.

———"A Film Dryer for 35mm," *Camera 35*, Vol. 14, No. 1, January, 1970, pp. 55f.

Yob, Parry C.: "Build a Background Stand," *Petersen's Photographic Magazine,* Vol. 1, No. 4, August, 1972, pp. 42f.

———"How to Build Your Own Darkroom Timer," *Petersen's Photographic Magazine,* Vol. 1, No. 5, September, 1972, p. 31f.

SECTION E

CHOOSING EQUIPMENT

All enthusiastic photographers dream of equipment to meet every creative possibility and situation. Not everyone is able to afford such luxury. The problem is to select wisely to gain maximum convenience, versatility, and reliability with reasonable economy. Seldom are there magic answers. Each individual makes the decisions under the particular possibilities that are open. Areas to explore in analyzing the problems are:

1. Types or kinds of subjects to be photographed.
2. Ultimate use of the photographs.
3. Sophistication and control required vs. that desired.
4. Amount of money that wisely can be allotted to purchase the equipment.
 a. Cash on hand or over a period of time.
 b. Possible monetary return or savings to be made with the use of the equipment.
 c. Cost per picture or per roll for supplies and services such as film, chemicals, or commercial processing if it is to be utilized.
5. New vs. used equipment.
 a. Availability through legitimate channels.
 b. Opportunity for pretesting.
 c. Appreciation or depreciation potential in resale.
 d. Guarantees and repair service.
6. Sturdiness of construction to withstand the amount of use and/or abuse anticipated.
7. Weight and volume of portable equipment, storage and use-space for nonportable items.
8. Right price.

CHOOSING THE CAMERA

The photographer makes the picture; the camera is only a necessary tool. The most important factors for the buyer to consider are whether he knows or will learn how to use the flexibility and accessories available in the more sophisticated camera. If not, he should select the simplest to operate in the automatic adjustable camera that will meet his needs rather than prestige equipment. His pictures will probably be far better on the one that requires minimum attention to controls. The photographer who is deeply involved in photography has a more difficult decision. There are many fine cameras from which to choose.

The scuba diver must choose between the camera made especially for underwater work or use another camera in an underwater housing. The animal or bird photographer wants a camera with interchangeable lenses to enlarge the images. The size of his quarry, its timidity, or viciousness are additional factors to consider. The individual who photographs close-ups of insects, flowers, or other small subjects probably needs an SLR with BTL metering. Each field of work in photography presents this type of quandary to the buyer.

The manner in which the pictures are to be used must be taken into consideration. If they are to be sold or displayed in a particular way, the requirements of the market are other factors to be explored.

Additionally and most important is personal preferences that only the user can decide. One particular brand and model of camera may be ideal for one person but extremely awkward or almost unmanageable for another individual even though both do very similar types of work.

After deciding on the approximate price range, negative format, and type of camera, the buyer should investigate a number of cameras in the group on these points:

1. *Weight*: Does the camera seem overly heavy or too light as it is held in position to take pictures? Will it be too tiring to carry on photographic forays of the type anticipated?

2. *Shape and size*: Is the camera easily held in picture-taking position or does it feel as though it will slip from one's grasp? Does it seem bulky and awkward to hold? Is it so small that fingers easily overlap the lens, the light meter, the viewfinder without the operator being aware?

3. *Film-load mechanism*: Is it simple, relatively quick and sure as compared with other cameras in the same class?

4. *Location of controls*: Do the controls work easiest with the right hand or left hand? Is the photographer right-handed or left-handed? Are the controls easily manipulated with the particular dexterity and size of the operator's hands and fingers? To decide, operate repeatedly, each of these controls:

a. ASA dial.

b. Focusing ring or knob.

c. Aperture control.

d. Shutter speed dial.

e. Film advance.

f. Film rewind release and rewind mechanism. (Use a practice roll of film, load, advance to the end and rewind.)

g. Flash settings.

h. Delayed action shutter release (self-timer).

i. Marks, letters, and numbers. Are they easy to read in normal light? Readable in low light levels?

5. *Focusing screen*: Eyes and preferences vary. The choice for one person does not necessarily work well for the next photographer. With the multitude of focusing devices available, no one need use a type that is difficult. Do not assume that the focusing will become easier in time. Know the idiosyncrasies of the device before the purchase is made. None is perfect in all situations for everyone but some are much easier than others. Find the best one. Focus in low light levels, at different distances, and with different focal length lenses, if the camera uses interchangeable lenses, even if the other focal lengths are not to be purchased at this time. The operator's eyeglasses make additional differences that must be considered. The eyeglass wearer with extreme correction problems may prefer a waistlevel viewfinder.

6. *Light meter*: Is it built in, interchangeable, or behind the lens metering? Is the meter coupled to the controls, totally automatic, and/or manual? Is the meter spot, averaging, or center-loaded? Understand the advantages and disadvantages of each, then decide which is preferable. Will the meter give readings in low light levels?

7. *Depth of field scale*: Is it located to make for easy checking? Readable with a penlight for night photography? Are there sufficient lines or divisions to give sure readings?

8. *Accessories available*: Are those vital to the user's work or that may be desirable in the future made for the camera by its own manufacturer or by others? Are the accessories automatic and/or manual? Will they accomplish the needed results?

9. *Evaluation of the camera and lenses by test*: Quality tolerances are very close in all better brands of lenses, but most certainly, there are variances. Real bargains are available in some of the less expensive groups. The photographer should do his own lens test on the type of work for which he intends to use the equipment but prior to that investigate the tests by others. Extensive tests are run by the camera magazines on major equip-

ment and results are published throughout the year. Two of the present publications annually present a comprehensive compilation of the current models and the features of each. Excellent advice on tests, evaluation, and purchase of both new and used equipment are included.

To better understand the function of various features, study the following chapters of this book: Camera Operation, Understand the Camera, The Camera Lens, Depth of Field, Exposure, and Flash Photography. To know which features are desirable or required for certain fields of work, study books and magazines that deal with the particular type of picture making.

The prospective camera purchaser soon realizes that no one camera possesses *all* of the features he wants so compromise is required between the ones he values most and those that are acceptable.

CHOOSING CAMERA ACCESSORIES

As with the camera, accessories seldom possess all of the desired features in one piece of equipment but vital ones are necessary if it is to prove satisfactory.

1. Tripods.
 a. *Sturdiness*: The only purpose for a tripod is to hold the camera steady. If it fails this test, it is useless. Extend the legs to the maximum, press down on the tripod head with both hands, with a sideways pressure in all directions successively. Do the legs spring, sway, slip, or indicate a tendency to flex? Spindly, lightweight, flexible legs on tripods are fine when the tripod is being carried but of absolutely no value as a camera support. Diagonal bracing from the legs to center post give additional stabilization.
 b. *Leg extension locks*: Are they easy to operate with the particular size, strength, and dexterity of the photographer's hands? Is the lock positive? Do the legs maintain their positions as the tripod is lifted or moved from one area to another? It is frustrating and time-consuming to have to place each leg separately each time the tripod position is shifted a few inches or several feet. The leg connection to the tripod head wears with usage. The legs attached to the tripod head with bolts, lock washers, and nuts permit the leg action to be tightened when needed while those attached with rivets can not be so easily adjusted.
 c. *Camera angle adjustments*: Tripods universally permit a 360° horizontal rotation but they vary widely in the smoothness of this operation, the positiveness of the lock into posi-

tion, and the relative ease of release. If a movie camera is to be used, the pan (turn) must be super-smooth. The tripod should provide approximately 180° vertical swing with infinite positive lock position in that range. The 35mm camera owner needs a tripod with a hinged platform that releases easily and locks securely to permit quick shifting from vertical to horizontal format. The nonhinged platform can be utilized for vertical framing if the camera is placed crosswise of the platform; but this loses one control on tilt besides the danger in a few shifts of gradually unscrewing the camera from the tripod. Many a camera has been dropped with this technique. Square format cameras do not require shift from vertical to horizontal adjustment but it is more convenient when a camera with a waistlevel viewfinder is on a tripod at eyelevel height.

d. *Tripod platform and camera socket screw*: Some cameras have controls or moving parts that cannot be appropriately operated on some tripod platforms. The buyer should take the precaution of putting his camera on the tripod and operating the camera to be sure there is no problem in this area. The camera anchor screws on some tripods are so long they endanger the mechanism in the lower part of the camera. Too short an anchor screw gives insecure fastening. Measure the depth of the socket on the camera and the length of the screw when tightened at its maximum. An ordinary lead pencil marked with the thumbnail inserted the depth of the socket in the camera and serves as a measuring device. Grind or file the screw to shorten it, if the tripod is otherwise satisfactory. Be careful not to burr the threads when the screw is shortened.

e. *Height and weight*: Can the photographer stand erect and look in the viewfinder without extension of the center post? Utilize the center post primarily for fine adjustments in height. Extension for more than an inch or two lessens the camera's steadiness. Use the legs for all the height practical and the center post the least possible.

Can the camera be attached to the bottom of the center post or can the post be removed and inserted from the bottom to allow close to the ground work? This is desirable for copy work with the materials laid on the floor or tabletop and low level views.

Certainly, the weight of the tripod is an important element in its transportation and use but do not let this overpower the judgment on other features of greater importance.

2. Clamppod: These are practical for the traveler by train or air where the tripod weight may be prohibitive. A quick-release device on the clamppod decreases the time involved in adjusting the clamp to different thicknesses of stabilizing surfaces. Legs to set the tripod on a level surface and a large wood screw to insert into a plank or log are additional devices included in many clamppods. Utilize the clamppod as a chestpod, also, to steady the camera when the legs are placed against the chest with camera at eye level.

3. Cable release: Is it long enough to give protection from camera movement in tripping the shutter? A too short release without sufficient curve as it is tripped presents a hazard of movement of the camera almost as great as without the cable. Cloth-sheathed cables are less durable than metal-sheathed. The length of the "throw" of the tongue and the power required varies slightly from release to release. Take the camera and inter-changeable lenses (if the cable release socket is on the lens assembly) to test the release at the store to be sure the release works on the particular equipment for which it is purchased. The pneumatic type release used for the 15-, 20-, and 40-foot release should be tested for action.

4. Extenders or converters: Test the converter or extender before, if possible, or immediately after purchase because a particular one may not work correctly with an individual lens. Flares occur in some combinations. The flare most frequently seen is near the center of the picture that gives an overexposed area, often in the particular shape of the lens diaphragm. (Chapter 10, The Camera Lens.)

5. Tubes: When properly mounted, are the lens markings in a position to be easily read? Is the mount firm and secure? If the lens automation can be retained, this is desirable.

6. Bellows: Double-rail bellows decrease the danger of lens vibra-tions. The longer the bellows extension, the greater the magnifi-cation that can be gained. Some bellows offer swings and raising or lowering of the lens to correct perspective to some extent, similar to the tilts and swings offered in the large-format cameras.

 When fitted with a short-barrel lens, the bellows permit lens focus to infinity. A portion of the extension length of the bellows is lost for magnification with the short-barrel lens.

DARKROOM EQUIPMENT

Darkroom equipment, unlike cameras and accessories, depreciates more

slowly in value because of less wear and tear and fewer model changes. Often excellent values are available in second-hand equipment that has been carefully used and properly protected when not in operation. The purchase price of such equipment often is recouped entirely on resale after several years of active use. New or used, there are points to consider in choice of all such equipment.

1. Enlarger: Certainly a good, well-built, and well-cared-for enlarger is as good after ten years of use as the day it was purchased. Points to consider in choice of an enlarger are suitability of the particular model in question to the photographer's needs, ease of operation, and personal preferences. (Chapter 6, Enlarging.)

 a. *Negative size*: Determine the sizes that will be used with the enlarger. The largest negative determines the size to purchase. Larger negatives cannot be satisfactorily printed on smaller negative format enlargers. Smaller negatives may be printed on the larger format enlarger but the maximum size of the picture is less than is normal on the easel base unless the lens is changed for one of shorter focal length. A recessed lensboard is required on some enlargers for the shorter focal length lenses.

 To control the direction and spread of the light rays over the whole negative, some enlargers have condenser lenses. These are changed for specific negative sizes on some enlargers while others have only one set of condensers (universal) for all sizes of negatives that can be used on the particular equipment.

 b. *Type of illumination*: Cold light or incandescent? There is no danger of the negative popping from heat during projection with the cold light enlarger. It is less bright than the incandescent light, making it somewhat more difficult to focus the image on the easel. The cold light is left turned on at all times by many photographers so there is no loss or variation of light in the warming of the fluorescent tube. The exposure is made by shifting the red or orange filter mounted below the lens. The cold light is always used in a diffusion type enlarger, so there is a slight difference in sharpness of contrast. All diffusing enlargers require negatives of higher contrast than those used with the condenser enlarger for similar results in the print.

 The incandescent light may be in either the condenser or diffusion enlarger or a combination of the two types. There is some danger of negative popping during projection for focusing and exposure, unless glass is on both sides of the

negative. Shorter periods of projection or lower wattage lamps avoid the problem.

c. *Support post and adjustment controls*: Will the support post permit maximum enlargement on the easel or on the floor without interfering with a portion of the picture? The girder type support post or the enlarger with the head supported farther from the post horizontally avoids this difficulty. Most support posts can be turned to permit floor projection for oversize prints. Some enlarger heads rotate on the post to project on an opposite wall for still larger projection.

Is the support post well anchored, vibration-free, and capable of holding the head steady without becoming top heavy? Most enlargers need the baseboard clamped or weighted when the enlarger head is turned for floor projection. Is the raising and lowering mechanism infinite within the length of the support post with a positive lock stop or control with no back action? Is is easily released for further shift? Is the control handle wheel or knob easy to reach and to grasp?

d. *Focusing*: Is the control easy to find or reach in low light level, convenient in size, sure in its stops so that it will not slip as it becomes worn from use?

e. *The enlarger lens*: Besides the choice of appropriate focal length for the size of negative, is the lens sharp? Enlarger lenses are made for a flat field and for this reason usually give sharper images than can a camera lens attached to the enlarger. All enlarger lenses, however, vary somewhat in their ability to yield a sharp image. It is false economy to spend a lot of money for a camera that gives very sharp images and then use an economy enlarging lens. The value of the fine camera lens is lost! As with the camera lens, maximum sharpness is usually not at the widest or at the smallest aperture.

f. *Negative carriers*: Glass or glassless? Negatives are held flat with glass on both sides, especially important for long exposures required with extreme enlargements or very dense negatives. Glass carriers provide four extra surfaces to keep dust, scratch, and fingerprint free. Newton rings as the negative touches the glass are other hazards. Many photographers prefer glassless carriers despite their disadvantages.

g. Additional features that are valuable for some photographers but not desirable for others:

(i) Tilting negative carrier or tilting head permits correcting or exaggerating perspective.

(ii) Color filter drawer puts filters above the negative to prevent image degradation in focus. The filter drawer is best for color printing; most desirable, too, in contrast control by filters in black and white printing.

(iii) Extra long support posts to yield larger than normal pictures on the easel base.

(iv) Automatic focus regardless of magnification within the limits of the baseboard.

(v) Negative carriers that can be rotated horizontally for easy framing on the easel.

(vi) Sectional disassembly designed into the enlarger to permit compact storage or transport.

2. Timers: Can the timer be installed in the power line to the enlarger to turn the enlarger lamp on and off at precise and accurate times? This type gives the most accurate exposures. When setting for the shorter periods of exposure must the timer be turned beyond a certain setting and back to the proper time? This step is time-consuming and easily forgotten. Better timers do not require this procedure. Is there a switch to hold the light unlimited times for framing and focusing. This is a convenience. A foot-switch outlet helps in dodging or printing-in techniques but is not vital.

It is convenient and aids in remembering the previous exposure time if the pointer automatically returns to the same setting ready to be tripped again.

Enlarging timers measure units of time from one-tenth of a second up to an hour. The longer period timers with buzzers or bells are particularly good for film developing and print processing, both black and white and color.

As with all equipment, seldom are all desirable features on one piece of equipment. The purchaser must decide.

3. Stabilization processors: Is darkroom time limited or production requirements impossible? Darkroom space at a premium? Equipment could be only the enlarger and a stabilization processor. From the enlarging easel to an almost dry print the completion time is less than 10 seconds for a 3 x 5 to about 15 seconds for an 11 x 14.

The only other requirement is a flat surface to finish drying at room temperature for those prints that are needed for a comparatively short time. If archival permanence is required, the print is immersed in fixer for a normal period, washed, and treated the same as a tray-processed print. This last step can

be completed immediately when the print is rolled from the processor or at a later more convenient time up to six months or more with no loss in quality. Until the prints are washed, they should not be stored with washed prints.

The special concentrated chemicals are available ready-mixed in liquid form and require no dilution. Formulas have been published so the photographer can mix his own. Only two solutions are used, the activator and the stabilizer. The temperature range for use is 65° to 85°. Special papers with complementing chemicals in the emulsion are sold by several companies. Preparation and clean-up times for a printing session on the processor as compared with tray processing are greatly reduced.

The same manipulation techniques under the enlarger are used as with tray processing. There can be no variations in the developing as with tray processing. The processor, with a series of rollers spreads the activator evenly over the emulsion, then carries the print down into the stabilizer solution, and squeezes the solution from the print between exit rollers. Prints can be no shorter than five inches.

At present, Spiratone has a budget-priced machine. Others are made by Eastman Kodak and Fotorite. All three companies sell the paper and the chemicals, none of which are more expensive per print than for tray processing. The papers, machines, and chemicals are effective interchangeably. Kodak's Ektamatic SC (Selective Contrast) paper is compatible with the multicontrast filters. There are not so many contrast grades, tones, and surfaces available at this writing as in the tray processing papers. There is a product, Insta Print, sold by Peck Sales Company, North Hollywood, California 91605, that permits any black and white enlarging paper to be processed in the stabilization processors. The exposed paper is immersed in the Insta Print solution for 30 seconds, drained for 15 seconds, then put through the processor emulsion side down as with any stabilization paper. Approximately ninety per cent of the photographs in this book were printed on a Spiratone Stabilization Processor.

REFERENCES FOR FURTHER READING

"C/35 Tests," *Camera 35*, every issue.

Drukker, Leendert: "How to Choose a Projector Like an Expert," *Popular Photography*, Vol. 68, No. 1, January, 1971, pp. 104f.

Farber, Paul: "More Mix-Your-Own" (stabilizing processor chemicals), *Camera 35*, Vol. 14, No. 6, October/November, 1970, pp. 10f.

————"Pick-a-Peck of Panaceas" (for stabilization processor aids), *Camera 35*, Vol. 16, No. 2, March, 1972, p. 20.

————"The Best Optical Accessory: a Tripod," *Petersen's Photographic Magazine*, Vol. 1, No. 7, November, 1972, pp. 42f.

Feininger, Andreas: "Those Three Extra Legs . . . ," *Modern Photography*, Vol. 35, No. 2, February, 1971, pp. 52f.

"Lab Reports," *Popular Photography*, every issue.

Modern Photography and *Popular Photography* each publish annual listings of available equipment with a resumé for each.

"Modern Tests," *Modern Photography*, every issue.

Scully, Ed: "Can a Machine Like This Really Replace Tray Processing?" *Modern Photography*, Vol. 34, No. 11, November, 1970, pp. 82f.

APPENDIX II

Glossary of Photographic Terms

adapter ring A metal ring that screws into or slips over the front of a lens to hold a drop-in standard size filter (Series 4, 5, 6, 7, 8, or 9) or other accessories to the front of the lens.

adjustable reel Two wheel-like reels with continuous grooves on a spindle used in processing films. The ends spread apart on the spindle for wider film or move closer together for narrower film.

Agfachrome A color transparency film with an ASA of 50 made in Germany in one emulsion. Processing is prepaid with the purchase of the film but it can be home-processed with special chemical kits.

agitate Move or circulate the chemical solutions over the surface of films and papers. The container of films or papers with the solutions may be alternately tipped in opposite directions, the film reel turned in the tank, paper pushed and pulled by tongs or by hand. Gas is passed through the solutions in commercial automated equipment.

airbells Bubbles of air that form on the surface of film or paper. They prevent chemicals from getting onto the emulsion and cause inadequate washing of the paper and/or the emulsion. A sharp tap of the tank or tray on the table dislodges them.

Airsweep Brand name of clean sterile air in a pressurized can used to blow dust from any surface, and especially by photographers to clean cameras, negatives, negative carriers, slides, and lenses.

amateur photographer A photographer who does not make his living with photography though he may sell some pictures.

American Standards Association Former name of the United States Standards Association, an organization that establishes various scales of comparison, including the sensitivity of film emulsions, expressed for many years as the ASA rating of films but now renamed E. I. for Exposure Index.

angle of acceptance The angle of the area of image included in the light which enters the light meter.

angle of view The angle of coverage of a given focal length lens calculated on the area registered on the diagonal of the film frame.

Anscochrome Color transparency film made by General Aniline and Film Corporation (GAF). Made in four emulsions with E. I. of 64, 100, 200 and 500. May be home-processed with Anscochrome chemical kits.

aperture *See* lens aperture.

aperture ring Knurled ring used to regulate the aperture adjustments of a lens.

artificial light The glow produced by an electrically heated metal filament in a vacuum or gas-filled glass bulb, most common in the pear-shaped lamp used in home illumination. Oil or gas fueled lamps and lanterns are other examples of sources of artificial light.

automatic adjustable camera Lens apertures and shutter speeds have a range of adjustment which are controlled automatically by the camera's exposure meter and the light level of the area in the picture. It is possible to set some automatic adjustable cameras for manual control.

auto-focus An enlarger that shifts the bellows as the head is raised or lowered to give sharpest focus on the enlarger easel at all times. Auto-focus is used also on screen projectors in which the first slide is focused and an auto-focus device focuses the lens automatically for all subsequent transparencies.

automatic bellows Permits the lens to remain auto-

matic when separated from the camera body by the bellows. *See also* extension bellows.

automatic lens Used only on the single-lens reflex camera. The lens remains at widest aperture to frame and focus. When the shutter release is tripped, the iris diaphragm closes down to the preselected f/stop an instant before the shutter opens. When pressure on the release is stopped, the lens opens again to the widest aperture.

automatic tubes Permit the lens to be set and operated automatically when separated from the camera body by the tubes. *See also* extension tubes.

available light Existing light. Does not include any light added solely to make the picture.

averaging meter A light meter that measures the light from a broad area or from multiple spots over a wide expanse and gives each the same importance, thus averaging all areas.

background Area behind the principal subject or center of interest in a picture.

backlighting The principal light strikes the subject from behind and shines toward the camera. The shadow from the subject falls toward the camera position.

balance In picture composition, the symmetry of weight indicated by color or size of subjects in a picture pleasantly placed to invite attention to all areas but to accent the center of interest. In color of light, the combination of film sensitivity to color of the light that strikes the film to give natural results.

barebulb The flash lamp used without a reflector to give a softer, overall lighting effect in the picture. Compensation must be made for loss of light without the reflector.

barn doors Hinged shields attached to reflectors or reflector lamps to prevent the light striking in unwanted areas.

bellows *See* extension bellows.

bleach Spots, portions, or overall areas of the negative or print are reduced by chemical solutions to emphasize detail in darker areas, to reduce or eliminate detail in highlight areas, or to increase overall contrast.

bleed the print The process of trimming photographic prints to the image area.

blotter pad or book Device to dry prints between sheets of absorbent materials. Requires pressure to make print flat and longer time than other methods.

blotter roll A combination strip of blotter covered on one side with linen surface rolled up with another blotter and corrugated cardboard each the same size around a heavy cardboard core. Wet prints are placed face down on the linen surface and the roll secured with a string for the prints to dry.

borderless easel A device to hold the print paper flat and in place under the enlarger so there are no white borders on the print.

bounce flash Light from the flashgun directed at a light or white surface to bounce the softer light onto the subject. Photoflood light also can be bounced.

box camera A simple camera that provides little if any control or adjustment of shutter speed, lens aperture, or focus.

bracket or **bracketing** To take the same subject at multiple exposures. For daylight, one stop over and one stop under the standard or meter reading exposure for negative films; one-half stop over and one-half stop under standard or metered reading for positive films. Wider bracketing is sometimes used.

"B" setting Shutter speed setting which opens the shutter when the release is tripped and holds it open as long as the pressure is maintained on the release.

BTL Abbreviation of behind-the-lens, which refers to the meter situated behind the camera lens to take the exposure reading through the lens that takes the picture. Synonymous with TTL or TL.

burning-in *See* printing-in.

by-line Credit for the photograph given below the picture, as "Photo (or photograph) by —————." Credit may be noted elsewhere in the publication.

cable release A flexible shaft inside a sheath of woven cloth, metal, or plastic that permits the camera shutter to be released or tripped without touching the camera. Rubber or plastic tubing is utilized for pneumatic cable releases of extra length of ten to forty feet used especially for wildlife photography.

candid shots Unposed pictures of people and animals.

cartridge A lighttight plastic case around the 126 film that permits instant drop-in loading and automatically sets the film speed (E. I. or ASA) on the camera.

cassette A metal container with a felt-lined slit on one side fitted with a spool around which film without a paper backing is wound. A tail of the film extends through the slit to permit the film to be pulled from the cassette for loading and to pull the film across the film plane in the camera.

catch lights Reflection of light in the iris or pupil of the eye that gives sparkle. Only one catch light in each is preferable but not mandatory.

CdS meter A meter powered by one or more cadmium sulphide batteries used to measure light to determine appropriate exposures in particular situations with specific film speeds.

center of interest The most important area of a subject or picture.

center-weighted meter A TL meter which receives light from all of the area covered by the lens but gives more importance to the light from the central portion.

changing bag Zipper closed bag of two layers of black cloth (one rubberized) with two sleevelike openings for access of the operator's hands. The bag is used to load film in a daylight tank or to check malfunctioning film advance, whether and what film is in the camera without exposing film to light.

clamppod A device to stabilize the camera or other photographic equipment. The clamppod may be attached to a tree branch, table edge, window sill, car door, or other similar stable support with a thumbscrew clamp. A quick-release lever, small tripodlike legs, and a wood screw are supplementary supports that may be included.

cleared The unexposed emulsion and the anti-halation coating on the reverse side of the acetate base of the film are dissolved and/or neutralized by the fixer. When this is carried to completion the film loses its opaqueness and is "cleared."

click stops A specific position in the rotation of a control ring, knob, or lever that the "stop" is identified by an audible click and felt through the fingers of the operator. The stops are used on the shutter speed control at each shutter setting on the aperture ring at full and half stops.

close-up Picture made with the camera close to the subject so that it fills the frame, isolating it almost or entirely from the surroundings. The exact distance depends on the size of the subject, focal length of the lens, and the use of any supplementary accessories.

coated lens A lens that has a relatively transparent covering applied to the surface of the lens elements to reduce internal reflections.

cock the shutter To position the camera shutter ready to be tripped to make an exposure. With some cameras, this occurs when the film is advanced. With other cameras a lever is moved or a slide shifted.

cold light In an enlarger, a fluorescent circle light in an enlarger that generates less heat than an incandescent light, hence the term "cold" light.

color meter Measures the color content of light and indicates the correction, via filters, needed to balance the light to the sensitivity of the film for natural colors in the final pictures.

color positive Slide or transparency in the same light and color values as the subject if it has been properly exposed and processed.

color shift Variation from normal in color rendition from various causes: film has been overly warm; is outdated (beyond period manufacturer recommends); pushed (exposed at a higher ASA than recommended and compensated with more time in the developer during processing); or has been processed abnormally in some other manner.

color temperature Related to the warmth and the coolness of colors and measured in degrees Kelvin to indicate the color content of light.

compensation *See* exposure compensation.

component lens A lens built in detachable sections so that the front portion may be removed and another lens substituted to give shorter or longer focal length, such as wider angle of view (wide angle) or narrower angle of view (telephoto).

composite A combination of two or more pictures (slides or negatives) to get a different and creative effect. Negatives may or may not be sandwiched in the negative carrier for the print.

condenser enlarger Has glass lenses to control and direct the light rays in a very precise pattern that produces the sharpest image possible from the negative.

condensers Glass lenses in the enlarger head shaped to transmit light from the enlarger lamp in parallel rays evenly over the entire surface of the negative to yield sharp images on the print comparative to the negative.

contact print A positive print made with the paper exposed by light through the negative with the two laid together emulsion to emulsion. The print and negative are exactly the same size.

contamination The unintentional mixing of one chemical with another in dry or liquid form. The contaminated chemical is diluted, neutralized, or changed to make the chemical reaction unpredictable.

contrast The extremes of dark and light in the picture. The low-contrast black and white print has nothing very dark nor very light, with almost all middle gray tones. The high-contrast black and white

print has few if any middle grays, all black and whites. The color picture may or may not have contrast in dark and light (highlights and shadows) in color intensity, in hue complements, in tints and in color values.

converter *See* extender.

cool colors Colors with the blues and greens as principal hues.

cool-toned papers Print papers, contact and enlarging, that have slight color tints from a slightly cool white to a blue white.

cropping Eliminating a portion of the picture as it was originally made. Mats or mounts may hide a portion of the transparency. Prints are trimmed or only a portion of the negative is printed.

cropping L's A pair of L-shaped pieces of cardboard or mounting board used to lay over prints to determine desired cropping in further prints.

custom filters Made specifically for the particular situation for a distinct and original effect. May be used over the camera lens, over the light source, or sandwiched with the negative or with a transparency.

cyan A blue-green color.

darkroom Area from which all light is excluded while certain photographic operations are done. A safelight may be used for some procedures.

daylight tank Container for film and chemicals to process film. Must have the film loaded and tank capped in total darkness but then may be used in light to pour in and remove chemical solutions to develop or process the film.

definition The capability of a lens or film to reproduce sharply defined images of sharply defined subjects.

delayed shutter release A self-timer built into or attached to the camera to provide a time lapse of 10 to 20 seconds between the time the shutter is tripped and the time at which it opens. Permits the photographer to get in the picture or the camera to steady after any possible movement from the pressure on the release.

dense negative Overly dark negative indicates overexposure so that details in highlights of the subject are blocked up, which makes it difficult or impossible to print details in the highlights. Overdevelopment also can block highlights.

density The degree of translucence of processed or developed film. Too dense a negative has been overexposed, too dense a positive film has been underexposed. Insufficient density indicates the reverse **exposure.**

depth of field The distance between the point farthest from and the point nearest to the camera that appears in acceptably sharp focus in the picture.

depth of focus The distance within the camera between the point in front of and the point behind the focal plane of the lens that gives acceptably sharp focus. The film plane is within this area of tolerance but is not controllable in any way by the photographer.

depth-of-field scale Indicates the depth of field at different apertures and distances. The scale is on the camera or on the lens near the focusing scale or is indicated by pointers that slide along the focusing scale as the aperture ring is turned. Not all cameras or lenses have depth of field scales.

desiccant Absorbs moisture from surrounding air. Silica gel is a particular kind of desiccant packed with camera gear and films to protect against damage from excess moisture.

develop To bring the invisible latent image on exposed film or paper to a visible image with chemical solutions.

developer A combination of chemicals in solution that react with the chemicals in the film emulsion to make the latent image visible.

developing tank Any of many kinds and shapes of containers for films and chemical solutions used to develop film or print papers.

diffuser enlarger The rays of light from the enlarger lamp are diffused before they go through the negative by a sheet of ground glass. The nonparallel rays reduce visibility of dust spots and scratches and soften contrast on the print.

diffusing filter A more or less translucent material installed over the light source (cheesecloth, fibreglass, etched glass) to soften or reduce harshness of the light on the subject. A glass filter installed over the lens of the camera or the enlarger to diffuse the light either by minute grindings on the glass or by vaseline applied to glass to soften focus of the image. This reduces skin flaws or age lines.

dilution Reduction of a concentrated solution of chemicals by the addition of water.

DIN Abbreviation for Deutsche Industrie Norm, a German system used to rate the sensitivity of various films to light. The scale varies from but is comparable to the ASA or E. I. scales of the U.S.A.

distortion An appearance of abnormality in scale or spacing that may or may not be desirable. Unflattering distortion occurs when a camera is too close to a

subject or the focal length of the lens is excessively short or long. Creative use can have distortion add accent and interest.

dodging To hold back light from a portion or particular area of a picture as the print is exposed under the enlarger to retain detail in shadowed areas of the subject. The dodged areas receive less than the overall exposure.

dodging-tool Any device used to hold back light from certain areas by dodging during exposure of a print.

double exposure The procedure, intentional or not, of opening the shutter more than once on the same frame of film.

double-exposure control Mechanism within the camera that prevents the shutter being opened more than once on the same frame of film. Some cameras have a device that permits intentional double exposure.

double weight Refers to the thickness of print paper. Double weight is the thickest classification.

drop-in filters Filters mounted in a metal ring or without the metal that are dropped into standard-size adapter or retaining rings. Made in one of the standard size series 4, 5, 6, 7, 8, and 9.

dryer Method of drying prints that may vary from laying them face down on cheesecloth mounted on a wood frame, a blotter book or blotter roll to an expensive drum dryer with thermostat and speed control.

dry mount To attach a print to another surface with a sheet of heat-sensitive adhesive tissue between the print and the mount.

duplicating films Made especially to copy slides or transparencies, characterized by very low contrast to produce as nearly as possible the color values (with maximum detail in highlights and shadows) of the original.

easel Device to hold the print paper in a flat plane at the desired location.

E. I. *See* American Standards Association.

Ektachrome An Eastman Kodak color positive (transparency or slide) film, made in three regular emulsions: X (ASA 64), High Speed Daylight (ASA 160), and High Speed Tungsten (ASA 125). Infrared Aero Ektachrome is a specialized film. All may be home processed in E-4 chemicals.

Ektachrome Special Processing Extra time is required in the first developer when Ektachrome films are exposed at higher than normal exposure indexes.

Kodak will do this if the film is exposed as indicated and enclosed in (ESP) envelopes and sent to Eastman Kodak for processing: High Speed Ektachrome Daylight exposed at E. I. (ASA) 400, High Speed Ektachrome Tungsten exposed at E. I. (ASA) 320.

electronic flash Equipment that produces light when a pulse of electric current is passed across a gas-filled arc. The lamp is reused thousands of times. It is balanced for daylight film and is of much shorter duration than the expendable flash lamps that are used once and discarded.

emulsion Light-sensitive chemicals suspended in a gelatin base coated on one side of acetate sheets or paper. When the emulsion is exposed to light and then to treatment by suitable chemicals, an image becomes visible.

emulsion speed Rate at which a photosensitive emulsion reacts to light. Expressed as Exposure Index (E. I.).

enlarger Equipment which projects an image through a negative or positive onto print paper for a larger picture than the original negative or print.

enlarger lamp Source of light in the enlarger.

ESP *See* Ektachrome Special Processing.

EVS *See* Light Value System.

exhausted solution Chemical solutions that have been used to their limit of usefulness or that have deteriorated because of time lapse.

existing light Light that is normally available without the addition of supplementary lighting or flash specifically for picture taking.

exposed film Film that has been subjected to light.

exposure The light that strikes the film or paper emulsion controlled by the combination of lens aperture and time.

exposure compensation Allowance of extra exposure to compensate for light loss due to accessories such as tubes, bellows, and filters and for reciprocity failure. Those cameras with BTL or TTL meters need not compensate for close-up equipment or filters, but photographer should be aware of the cause of different exposure readings.

exposure index *See* American Standards Association.

exposure meter *See* light meter.

Exposure Value System (EVS) *See* Light Value System.

extender A supplementary lens inserted between the camera and another lens to extend the focal length for increased magnification of the subject on the film. Also termed converter.

extension bellows Accordion-folding tube-like section mounted on a rail inserted between the SLR 35mm camera and lens to permit infinite close-up focusing, within the limit of the length of the bellows.

extension tubes Sections of rings in varying widths to attach between the SLR camera and its lens to permit focusing on subjects closer to lens than is normally possible.

eye-level viewfinder Viewfinder on camera held close to the eye to frame and/or focus the subject.

Farmer's Reducer A combination of potassium ferricyanide crystals and hypo that is dissolved in water and used as an all-over reducer or as a spot bleach.

fast films Emulsions more highly sensitive to light than the average or medium speed films and thus higher E. I. (ASA) ratings.

fast lens A lens with a relatively large aperture at its widest opening in comparison to its focal length. Referred to as the speed of the lens.

ferrotyping Process of squeegeeing or rolling a glossy paper (only) print face down on a super smooth surface, usually chrome-plated metal, to make contact between the emulsion and chrome surface. The print is dried in this position to yield a glossy print.

fill flash Technique of using flash to brighten shadows with back- or sidelighting in daylight.

film A transparent acetate sheet coated on one side with photosensitive chemicals (the emulsion) suspended in a gelatin base. Additional protective coatings reduce danger of scratches and halation.

film cleaner Liquid solution used to clean films. Carbon tetrachloride is the most common ingredient and should be handled with extreme caution because it is a health hazard.

film plane The area or plane in which the film is held in position in the camera to make the exposure. The film plane is always in the same plane as the focal plane of the camera lens when focused at infinity.

film tank Any of many kinds and types of containers in which film is processed.

film clips Metal, plastic, or wood spring-loaded devices to hold drying film on a line or rod.

film weights Spring-loaded weights (lead insets) to clip on the bottom of a hung film strip to prevent curl as it dries.

filter A material (glass, plastic, cellophane, fiberglass, gelatin, or fabric) installed on the camera lens, over the light source, or above or below the enlarger lens to alter the color or density of light.

filter factor A number used to compute extra exposure. *See* compensation. The filter factor may be divided into the ASA for a new ASA to provide the extra exposure required; or the shutter speed may be multiplied by the factor if it is an even whole number such as 2, 4, 6, 8. BTL or TTL meters need make no compensation.

fish-eye lens Extremely short focal length lens that gives approximately 180° angle of view.

fixed aperture Permanent, nonadjustable lens opening set to the average picture taking situation with a moderate speed film.

fix or fixer A combination of chemicals used to fix the image on film or paper permanently. Commonly called hypo because one of the principal ingredients is a hyposulphite such as hyposulphite of soda (sodium thiosulphate).

flange An extra wheel-like ring that fits onto the spindle of the reel of an FR Special daylight load film developing tank to permit two 35mm 36-exposure rolls of film to be processed at one time.

flare A fogged, overexposed appearance in a picture caused by unwanted light striking the film. Occurs when film is loaded or unloaded from the camera, when film is loaded in the processing tank, or when the picture was exposed if light struck the lens directly from a bright source such as the sun, or a reflection from a shiny object. Lens hoods reduce the danger of flares.

flashcube A small plastic cube with a miniature flash lamp and tiny reflector on each of four sides. Usable only on cameras made for the specific type unless an adapter suitable for the particular camera is installed between the cube and camera.

flashgun A device that produces bright light of short duration by which film is exposed to make a picture.

flashing Overall or spot exposure of photosensitive papers without a negative between the light source and the paper. May be used to reduce effect of grain, to lower contrast, to darken or obliterate an unwanted highlight when the paper is exposed through the negative.

flashlamp Expendable glass and/or plastic lamp that is filled with highly combustible metal and/or gas that when fired burns brightly for a fraction of a second.

flat print Photographs with no intense blacks or stark whites with limited range of gray tones. May be

due to type of lighting when film was exposed, improper processing, fogged or outdated film or paper.

fluorescent lamp A light produced by electrical current through a long glass tube containing a fluorescent gas.

F-numbers A factor or fraction expressing the ratio of the lens aperture to the focal length of the lens. Synonymous with f/stop, iris diaphragm opening.

focal length The distance from the effective center of the lens to its focal plane.

focal plane The plane behind the lens at which light rays focus the image sharpest. The film should be in this plane when exposed.

focal-plane shutter Curtains of metal, cloth, or other material installed near the film plane in cameras to open and close for exposure of the film. The curtains are parted as they travel across the film plane (vertically or horizontally, never both). The width of the slit is determined by the shutter speed setting.

focus (*1*) The fidelity of the appearance of the subject in the camera's viewfinder, in the image on the film, or in the picture. (*2*) To lead the eye of the viewer to the center of interest with lines, real or imaginary; direction or contrast in lighting or with color.

focusing magnifier Device to magnify a small area of the projected image on the enlarging easel to aid focusing. Permits focus on the grain for sharpest possible image reproduction.

focusing ring or **knob** A knurled ring or knob that can be turned to move the lens forward and backward to alter film-to-lens distance to change the focus within limits.

focusing scale The numbers on the camera or the lens to indicate camera-to-subject distance, calibrated in feet and/or meters.

focusing screen A glass lens in the viewfinder of reflex cameras with one or more devices constructed in the lens to aid in determining at what position the lens gives the desired sharpness of image on film as shown in the viewfinder.

fogged Portion of the area or overall film or enlarging paper struck by undesired light.

forefocus Procedure of setting the camera-to-subject distance on the depth-of-field scale at the f/stop used for the exposure rather than at the focusing arrow or mark to throw the background out of focus or gain foreground depth.

foreground Area in front of the principal subject or center of interest in a picture.

format The outlines of the picture such as square, rectangular (vertical or horizontal), round, oval, or any other particular shape.

45° lighting The principal light falls on the subject from a 45° angle when viewed from camera position. It may be 45° frontlight or 45° backlight.

frame (*1*) Area included as it is viewed in the viewfinder and subsequently included in the picture. (*2*) Term used to designate a single, or in plural form, several negatives or transparencies. (*3*) Area within the easel arms under the enlarger.

frame counter Dial on the camera that indicates either the number of frames left on the roll of film or the number of frames that have been exposed.

free-lance The practice of photographing and then selling the resultant pictures or soliciting photographic assignments from many different businesses or individuals.

fresnel lens A series of concentric circles in the structural design of the lenses used for the focusing screen beyond the center focusing device and the ground glass collar as an additional aid to judge focus. SLR cameras may have this type screen.

frontlighting The principal light strikes the subject from the front as viewed from camera position. The light source is directed at the same angle, or nearly so, as the camera. Flash on camera or sun at photographer's back are two common examples.

FR Special Brand name of a daylight tank that will process all sizes of roll film and with insertion of an extra flange, will process two 36-exposure rolls of 35mm film.

f/stops Lens aperture diameter expressed as a ratio of the focal length of the lens.

full stop A change in aperture that doubles or halves the amount of light that reaches the film at a given shutter speed. Also used to denote the whole stop markings on the camera f/2.8, f/4, f/5.6, f/8, etc.

fuzzy Soft focus or blurry.

gadget bag A case used to store or transport the camera and accessories.

gel A thin sheet of transparent material used as a filter over the light source or camera lens to alter the picture in color, contrast or to separate or accent a particular area of the subject.

glossy or **glossy print** The emulsion of the print paper (contact and enlarging) with a shiny finish that is ferrotyped to a high sheen. *See also* ferrotyping.

graded papers Contact and enlarging papers manufactured to give different levels of contrast. Grade 2 is considered normal contrast in all lines. Below that number, the papers yield softer contrast. Numbers above 2 indicate progressively harder papers with higher contrast.

graduate A glass or plastic measuring container calibrated in ounces or cubic centimeters.

grain A sandy or mottled appearance caused by clumps of silver particles in the negative emulsion. Grain is accented with enlarging. The kind of film and the methods of developing affect the amount of visible grain.

ground glass High-quality glass screen finely etched on one side to aid in the adjustment of the camera lens to give a sharply focused image on the film.

guide number A numerical value given for a particular flash lamp or gun to aid in computing the correct exposure of film by flash. Guide number = flash-to-subject distance (in feet) times the f/stop number. To calculate exposure the guide number is divided by either the camera-to-subject distance or the aperture, whichever is known. The aperture is the known value in fill flash in daylight; the flash-to-subject distance in low light levels.

half-frame cameras Cameras that make negatives (18mm x 24mm), one-half the size of the 35mm camera negative (36mm x 24mm). Also called single-frame, because in the early days of 35mm cameras, the 24mm x 36mm was termed double frame. *See also* single-frame camera.

hand-held meter Light-measuring device that is held in the hand as opposed to one on or in the camera.

hard paper The "hard" indicates higher contrast. Hard print papers (contact and enlarging) yield a higher contrast print than a normal paper would with the same negative. Hard papers are graded as 3 through 6. The higher the number the harder the paper.

hardener Chemical used to toughen the emulsions on film or paper to resist damage in processing from scratches or abrasions. For black and white films and papers, hardener chemicals are added to the fixer. In color film processing a special solution may be used before or after the first developer.

haze filter A very slightly tinted orange layer of glass, plastic, or gelatin held in place over the front of the camera lens to reduce the effect of haze and to slightly warm the color of light that strikes the color film. Requires no compensation for light loss. Used, also, to protect the camera lens from dust, sand, fingerprints, and scratches during use.

high key A picture largely in light tones.

high-contrast copy film A graphic arts film that produces unusually high contrast, blacks and whites with few or no gray middle tones. Used by photographers for creative work.

high-contrast light Light that causes intense shadows.

high-contrast paper *See* hard paper.

highlights The lighter or white areas of a subject or a picture.

hypo Short terminology for a solution of chemicals, one of which is a hypo sulfite such as hyposulphite of soda (sodium thiosulphate), used to fix the developed image in the photographic emulsion and to clear the film of unexposed silver and anti-halation backing.

hypo elim, hypo clear Shorter terms for hypo eliminator or hypo clearing agent, which are chemical solutions used to neutralize the fixer (hypo) chemicals in film and paper emulsions and thereby shorten and improve efficiency of the wash that follows.

hyperfocal distance The closest focused point from the camera lens that records acceptable sharpness beyond one-half that distance to infinity to yield maximum depth of field for any given aperture on a given focal length lens. To find hyperfocal distance on the lens, set the infinity mark of the focusing scale opposite the aperture mark on the depth-of-field scale. The focused distance at this setting is the hyperfocal distance for that aperture. The area between one-half the focused distance and infinity within the angle of view of the lens will be acceptably sharp.

impact The characteristics of a picture that intrigue the viewer to continue to look and study. Personal preferences are important abstract factors.

incident light Light falling on the subject from any direction and any source.

incident-light meters Used to measure the light falling on the subject from 180° angle. The meter is held at subject position and pointed toward the camera.

infinity Photographically, infinity distance extends to the stars in the sky and beyond. The near limit at which infinity begins varies with the focal length of the lens.

infrared Invisible red light rays beyond the visible spectrum.

Infrared Aero Ektachrome Color film A film made by Eastman Kodak for the military originally, but now used in many fields for scientific and creative purposes. May be used with or without filters for images but requires filter for most specific scientific purposes. Can be home processed in E-4 chemicals.

infrared film Photographic emulsion sensitive to invisible infrared rays. Black and white infrared films require a red filter to become sensitive to the rays.

intensify To increase overall density of the negative by chemical action.

iris diaphragm The overlapping metal leaves that adjust the size of the lens apertures.

Jobo Tank Brand name of a daylight tank that processes two 36-exposure rolls of 35mm film at one time. The reel adjusts to any roll film size.

jumbo print Print on 3 x 5 or 3 x 3 paper from negatives of smaller format.

°Kelvin Measurement for the color content of light based on the color glow of metal at various degrees plus 273°F.

Kodalith film A high-contrast film manufactured by Eastman Kodak for use in graphic arts but also used extensively by photographers for creative effects.

Kodachrome Color transparency film made by Eastman Kodak and viewed by rear illumination. Made in three emulsions: II (ASA 25), Professional, Type A (ASA 40), and X (ASA 64). All require commercial processing.

lamp head The portion of the enlarger that contains the lamp.

landscape A picture of extensive areas of land that may or may not include rivers, mountains, fields, streams, forest animals, people, and buildings.

latent image An invisible image formed on the emulsion of film when it is exposed to light. The image becomes visible when the emulsion is treated with chemicals.

latitude The breadth of variation in tone intensity which a film or paper will register. This affects the range in exposure that will give an acceptable image or reproduction.

lead-in The visible or invisible lines, objects, or accents that direct the attention of the viewer to the center of interest in a picture.

leader The portion of film that extends through the slit of the 35mm cassette to aid in loading the film into the camera. The paper on roll film that pulls the film into position for exposure and protects the film from light.

leaf shutter Overlapping leaves of metal that pivot to open position to permit light to strike the film to make an image. The leaves are closed mechanically after the exposure.

lens One or more pieces of glass or plastic ground to a particular shape, polished and assembled to bring parallel light rays to a focal point.

lens aperture Opening in the mount or metal leaves behind or in front of the lens to control the amount of light that strikes the film. Aperture may be fixed, manually adjustable, or automatically adjustable.

lens barrel The metal tube or cylindrical housing in which the elements of the lens are mounted for proper alignment.

lens board The plate beneath the negative carrier and bellows of the enlarger that holds the projection (enlarger) lens in precise alignment.

lens cap or **cover** An opaque, usually black, cover for the lens that screws on or slips over the front of the lens for its protection from strong light, dust, scratches, and fingerprints.

lens cleaner A liquid sold in small plastic bottles to be used in cleaning lenses. Should be applied (one drop only) to a lens tissue which is used to clean the lens.

lens hood or **shade** A flared ring of metal, plastic, or rubber that screws into the camera lens or an adapter ring or slips over the front of the lens to prevent unwanted light (direct or reflected) from striking the lens and fogging the film during exposure.

lens speed The effective diameter of the lens aperture at its widest, expressed as a ratio to the focal length of the lens.

lens stops Lens apertures, diaphragm openings, and f/stops, named by the ratio of effective lens diameter to the focal length of the lens.

lens tissue A fine grade of thin, soft paper tissue made especially for cleaning lenses of cameras, binoculars, and microscopes.

light meter A device to measure light and by means of several scales indicate the correct exposure for films in the given situations.

Light Value System (LVS) A series of numerical values given one to each of the various combinations of shutter speeds and f/stops of equal value.

limitation The quality of a picture that confines the viewer's attention to the principal subject of interest.

lipstick brush Retractable brush in a container

similar to a lipstick case. The brush is used to clean dust from camera lenses and interiors, negatives, and slides.

logbook A booklet or listing of individual film exposures showing important data such as identification of the subject, the lens aperture, shutter speed, filters, light, or accessories used.

long shots Pictures made from considerable distance to relate the subject to the surroundings. The specific distance will depend on the size of the subject and the focal length of the lens.

low-contrast light Light from a source that spreads, diffuses, or reflects from surroundings to cause slight or no shadows.

low key A picture largely in dark tones.

low or **bottom lighting** The principal light on a subject comes from very low or below the subject as viewed from camera position.

LVS *See* Light Value System.

macrophotography Photographing small objects or subjects to yield an image on film at normal size 1:1 or magnified to several times larger than the subject.

magenta A blue red.

manual lens A camera lens with adjustable focus and aperture (shutter speed on those with the shutter in the lens) on SLR cameras that is set manually.

manually adjustable camera Focus, aperture of the lens, and shutter speeds of the camera are all adjustable and controlled manually by the photographer.

matte The surface finish of print papers that produce no gloss or shine on the finished print surface. Also, a frame of paper, board, or other material with a cut-out area which is laid over the picture so it is visible through the opening. The matte forms a border around the entire picture.

medium shots Pictures made from a moderate distance from the subject as contrasted with close-up and distance shots. The distance in each instance will depend on the size of the subject and focal length of the lens.

mercury vapor lamp A blue-white light produced by high voltage electrical current through a glass tube containing mercury vapor.

mergers Arrangement of elements in a picture so that subjects merge with background or foreground objects that may be unattractive or amusing.

microphotography Preserving records and documents on microfilm.

microprism Tiny prisms ground into the glass grid of a small circle of the focusing screen which is seen through the viewfinder of some SLR cameras. The prisms aid in fine focusing of the lens. With no image break-up the lens is focused at that subject distance.

millisecond One-thousandth of a second or approximately the time it takes a car to travel one inch at sixty miles per hour.

miniature cameras Common term for 35mm cameras.

mm Millimeters.

modeling The effect of light direction on the subject to show contours and texture.

montage Combination of two or more negatives or slides, each a portion to make one picture in which they blend, overlap, or physically relate to or join each other.

multiple contrast paper Print paper with special emulsion that yields varying contrast with filters of different colors between the light source and the paper.

mural Extra large photographs used primarily for wall decorations.

neck strap Fastened to the camera or other photographic gear to support or to carry the equipment around the neck of the photographer or his assistant.

negative A film or paper with photosensitive coating that has been exposed to light and processed to give a negative image in which the darks and lights of the subject are reversed. Colors are in their complements in color negatives.

negative carrier The device that holds the negative in a flat plane in the enlarger for projection in printing.

negative film Photosensitive emulsion on acetate backing that when exposed and processed (developed) yields an image in reverse value as compared to the subject. The darks are light, the lights are dark on negatives. With color negative films, the colors appear as their complements.

neutral density filter Neutral gray glass, plastic, or gelatin filter used over the light source or the camera lens to reduce the light reaching the film with no change of color or contrast. Used most frequently with very fast films in daylight.

neutral test gray card A card with a reflectance of 18% that is used as a control and to measure color and exposure.

Newton rings Image of concentric circles formed when glass and negative or glass and print emulsion

make absolute contact so *no* light is *between* the two surfaces.

nonautomatic bellows Requires the lens be set on nonautomatic (manual) when the bellows is in use. The camera and lens are disconnected.

nonautomatic tubes Do not permit using the lens set on automatic when separated from the camera by the tubes. Lens must be set on manual (nonautomatic).

normal lens A lens whose focal length is approximately equal to the diagonal of the individual negative.

novice photographer An individual just starting his study of photography.

off-color Wrong tones in color pictures, such as too warm (yellow, orange, red, or magenta) or too cool (blue, cyan, or green).

Omit The brand name of clean sterile air in a pressurized can. Omit is used to blow dust from any surface, especially by photographers to clean negatives, negative carriers, slides, and lenses.

opal glass A translucent, milky white glass.

optical quality Clear, distortion-free, as in quality glass, plastic, or gelatin filters.

optimum exposure The control of light that strikes the film, via aperture and shutter speed, that gives the exposure which most easily yields the best possible results in the final transparency or print.

orienting the picture The practice of including enough of the photographer's surroundings to indicate his location such as a portion of the boat railing when he is on a boat, a part of an airplane wing or engine pod on aerial shots.

outdated film Film that has not been exposed by the date the manufacturer has given to indicate the maximum time that can pass before the film will cease to yield predictable results.

out-of-focus Appearance in a picture or print of indistinct, fuzzy images up to complete obliteration of any discernible image or complete nullity.

overexposed The emulsion on film or paper has been subjected to more light than is desirable. The negative is too dense, reversal film is too light, and a print is too dark.

overdeveloped Undesirable result of film or prints processed in developer that is too warm, of too strong dilution, or for too long a time with excess agitation.

pan (*1*) Short for panchromatic, which indicates film's sensitivity to all colors. (*2*) Procedure of pivoting the camera, either handheld or on a tripod, to follow action of the subject.

Panatomic-X A relatively slow fine-grained negative black and white film manufactured by Eastman Kodak.

panchromatic Indicates film, paper, or other product is sensitive to all colors. Not all films and papers are sensitive to every color which permits the use of a specific color of light as a safelight.

panchromatic film *See* pan, panchromatic.

panning To follow action with the camera moved in a small arc parallel to the travel of the subject.

panorama Wider view than a wide-angle lens will take. Either a special camera is required or multiple views are taken with one camera, then the prints combined into a continuous strip.

paper negative Process of printing a negative image rather than the more common positive image on paper. Contact prints or enlargements can then be made from the paper negative to get a positive. This permits special touch-up techniques and creative procedures that are more difficult by other methods. The paper negative may be moderately enlarged, then enlarged still more in a large-format enlarger when the positive print is made. Another procedure is to enlarge the paper negative to its ultimate size and then contact print the positive image.

paper speed Print papers, like film, vary in their sensitivity to light. Contact papers are slower in their reaction than are enlarging papers but within each of these classes there are rapid, fast, moderate, and slower papers.

parallax The difference between the subject as the viewfinder shows and that the taking lens covers on rangefinder type and twin-lens reflex cameras at shorter camera-to-subject distances.

parallax correction The viewfinder frame within the camera shifts to correct for focusing on near subjects. Parallax correction is not effective with supplementary close-up equipment.

perspective The impression of size or scale gained by the larger close objects in comparison with more distant subjects of equal or greater size that are much smaller in the picture, which gives a feeling of greater depth.

photograms Pictures made without a camera by laying the subject on photosensitive emulsion, paper or film, and exposing it to light, developing and or pro-

cessing as a normal print. The enlarger lamp is often used as the light source but need not be.

photogrammetry Photographing surfaces or areas of the earth to map its contours. Most frequently done with aerial photography but is sometimes done from the ground.

photojournalist One whose vocation is a combination of photography and journalism.

photomicrography Photographing through a microscope so the image on the film is magnified many times normal size.

pinholes Small clear areas in the negative caused by dust or airbells on the emulsion that prevented developer from acting on areas of the film in processing.

plastic lighting Backlighting used on translucent objects.

polarizer Polarizing filter or screen.

polarizing filter A neutral gray special filter with a built-in grid that screens polarized light and thereby reduces or eliminates unwanted flares, glares, and reflections to improve many kinds and types of pictures. Effective screen for ultraviolet light and haze. Filter may be used with black and white or color film over camera lens or over the light source or both.

polarizing screen *See* polarizing filter.

portfolio A collection of a photographer's works.

portrait A characteristic image or likeness of a person, an animal (domestic or wild), or birds. Flower pictures are referred to as portraits in some instances.

positive The image on film or in which the lights and darks (highlights and shadows) and colors are in the same values or nearly so as the subject.

positive film Photosensitive emulsion on an acetate backing that when properly exposed and processed (developed) yields an image very similar to the subject in regard to highlights and shadows and color.

preflash Exposure by very limited amount of light prior to exposing for the picture. Technique is used for both film and paper to reduce contrast and/or grain.

Potassium Ferricyanide Orange-red crystals used in solution for overall and spot bleaching on prints and negatives.

projection print A photographic print with images larger than the original negative gained by projection in an enlarger.

preset lens On single-lens reflex cameras a device to preselect the chosen aperture, to leave the lens diaphragm open at its widest to focus and to frame the picture, then turn the aperture ring to the solid preset stop without looking at the scale just prior to tripping the shutter release.

pressure plate A sheet of metal or plastic which maintains pressure on the back of the film to keep it flat and in the proper plane for exposure.

primary colors Red, green, and blue, the three properties of white light.

printing-in The technique of giving more exposure to particular areas of a print under the enlarger or in contact printer to burn-in (or print-in) details in highlight areas of the subject. The areas printed-in receive more exposure than does the overall print.

print papers Photosensitive papers used to print images either by direct contact or projection in an enlarger.

process or processing To subject film to a succession of chemical solutions for controlled periods of time at appropriate temperatures with proper agitation and washing in clean water—all of which act on the emulsion to form visible images from latent images.

professional photographer An individual who makes his living with photography.

progress shots Pictures made at more or less regular intervals during construction of sewers, roads, buildings, or other procedures or activities.

projection scale Brand name of Kodak's acetate device with wedge-shaped sections of varying gray densities to use as a test strip in determining the best exposure times for any negative for print papers.

proof A print, the exact size of the negative or larger, used to determine whether to make more prints, enlarged prints or how to crop.

quality of light Refers to the color content of light which is measured in degrees Kelvin.

rangefinder camera Has a small window for framing and/or focusing the subject in a frame that is several times smaller than the negative and may not include exactly the area covered by the lens when the camera is close to the subject.

rangefinder viewfinder Use to focus the camera lens on rangefinder type cameras. May have a split image or a double image device to determine focus. When the subject appears in the viewfinder in line or as a single subject the lens is focused. May be purchased as a separate piece of equipment to be attached on top of a camera with no focusing device.

reciprocity The fact that photosensitive emulsions react the same to like amounts of light whether for longer periods of time at lower levels or for shorter periods of time at higher levels. This is the basis for EVS (LVS) tables and the f/stop and shutter speed combinations of light meters; *e.g.*, f/5.6 at 1/60 second will give the same exposure as f/4 at 1/125 second. Reciprocity tends to break down both in exposures and color rendition at very short and very long shutter speeds.

red eye Light from camera position (flash is the most usual source) strikes the retina (interior) of the eye, which reflects back to the film the color of the blood vessels. On black and white film the pupil of the eye abnormally registers white in the final picture.

reduction Process of using chemicals in solution to reduce the density of part or all of negative, print, or transparency.

reel A round wheel device with continuous grooves into which the film edges are fitted to prevent any portion of the film from touching so solutions can circulate. The tray for numerous projectors with individual slots for mounted slides or transparencies.

reflected-light meter A light meter that measures the light reflected from the subject to the meter (or camera). The meter is pointed toward the subject.

reflector Any device, artificial or existing, that reflects light from the source into shadowed areas. Artificial reflectors are placed or arranged especially for the picture-taking situation.

replenisher A combination of chemicals to keep developer and/or other chemicals at optimum working strength as they deteriorate from use.

resolution The degree to which a lens or a film can record (resolve) fine detail.

reticulation Caused by excessive swelling of emulsion so in the process of drying forms a reticulated or an all-over mosaic pattern of minute cracks. Too warm processing solutions are the most common cause.

retouch To reduce or eliminate unwanted details or to add shading to the negative before printing.

reversal film Emulsions that are changed during processing from a negative image to a positive image either by exposure to light midway or so in the processing or by chemical action.

reverse adapters A piece of equipment that inserts between the camera with the lens reversed front to back for photographing extreme close-ups.

rim lighting The halo effect around the subject when backlighting is used.

Rudolph nose Light spills over a shadowed face to highlight only the nose.

Sabattier effect *See* solarization.

safelight A light that can safely be used when handling photosensitive materials. It may be a special bulb, a special lamp, or a filter over a lamp but it must be of a color and intensity to which the emulsion is not sensitive.

salon A competitive exhibit of photographs solicited from a wide area. May include slides and prints, black and white and color. Limitations and/or classes may be set up as to subjects or techniques.

screw-in filters Filters made to screw into the front of the lens and to have other equipment such as a lens hood attached by the same method to the filter.

seascape A coastal or marine view of oceans, breakers, boats, beaches, or cliffs with water to suggest an area of or adjacent to the seas.

sediment Dregs found in chemical solutions from bits of emulsion and/or chemical precipitate that are prone to settle in the emulsion during film processing to cause undesirable spots in the picture.

selective focus Term commonly applied when the focus is adjusted to give minimum depth of field. The camera-to-subject distance is set at the f/stop (on depth-of-field scale) used for the exposure instead of the focusing mark or arrow. Check effect on previewer if the camera has one.

selenium-cell meter Light meter in which the light furnishes the electrical charge to activate the needle that indicates the light level or exposure.

self-timer Mechanical delayed-action shutter release.

semi-automatic lens Used on the single-lens reflex camera. Leaves the lens at widest aperture to frame and focus, closes down to the preselected f/stop when the shutter release is tripped, and remains at that aperture until *the lens* is recocked. *See also* automatic lens.

semi-matte paper A print paper with a slight gloss but not as intense as glossy paper.

sequence A series of two or more pictures to show progress or successive occurrences in a process or action.

series Standard-sized accessories that attach to the lens front with adapter and/or retaining rings. More common available series are 6, 7, 8, and 9 for adapter rings, step-up rings, retaining rings, filters, close-up lenses, and lens hoods.

short-barrel lens A relatively short lens mount with

longer focal length used with bellows or tubes to permit focusing on close-ups or to infinity. There is some loss in the effect of bellows extension as compared with the regular lens of the same focal length. There is the convenience of not taking bellows off and on to change from close work to infinity focus.

shortstop A dilute solution of acetic acid used to stop development of the image on film and paper emulsions.

shutter A device within the camera or the lens that opens to allow light to expose and form a latent image on the film when the release on the exterior of the camera is pressed. When set for timed intervals the shutter closes automatically when the preset time has elapsed. When set on "B", the shutter remains open as long as pressure is maintained on the release.

shutter release A device on the camera or the lens exterior that, when pressed, opens the shutter inside the camera or lens to permit light to strike the film to produce a latent image.

shutter speed The time the shutter is open to permit light from the subject of the photograph to strike the lens and form a latent image on the film. Time may range from 1/2000 of a second to several hours.

sidelighting Principal light strikes the subject from the side as viewed from camera position. Shadow falls to opposite side of subject.

silica gel A desiccant in the form of granulated crystals that absorbs moisture from surrounding air. Packed in small cloth packets with camera gear and films to protect from excess moisture. Crystals may be regenerated for reuse by drying in a warm oven for several hours.

single-frame camera Early name for today's half-frame camera when the 35mm was called a double-frame camera. *See also* half-frame cameras.

single-lens reflex camera Designed to frame and focus the picture in full negative size through the same lens that exposes the picture. Theoretically, includes only that visible in the viewfinder.

single weight Refers to the thickness of print papers. Single weight is the thinnest enlarging paper. Light weight is thinner in contact papers.

skylight filter Slightly orange-tinted glass, plastic, or gelatin held in place over the camera lens to reduce the blue in reflected skylight for pictures of subjects in shadow. Reduces the effect of haze in scenics and slightly warms the color of light that strikes the film. Used to protect the lens from dust, sand, and fingerprints. Requires no compensation for light loss.

slide A transparent positive photographic image that is viewed by rear illumination.

slow films Have emulsions less sensitive to light than average or medium speed films so have lower ASA or E. I. ratings.

slow paper Print paper with less sensitivity to light, thus requires greater exposure.

soft paper Print papers (contact and enlarging) that yield a lower contrast print than a normal paper would with the same negative and developer. Soft papers are graded 0 to 1 with 0 giving the softest contrast.

solarization Term commonly applied to the Sabattier effect. Procedure in which the exposed film or print is partially developed (approximately ¾ of normal), then exposed to light while in the developer, and the developing continued for the normal time. The process produces a picture that is a combination negative-positive image.

split image A focusing device ground into the center area of the focusing screen that appears to cut the vertical image in half and shift the halves out of alignment when out of focus. The image appears normal when the lens is in focus.

sportsfinders Wire or metal framing devices attached to the camera exterior to be used with fast-action sports at a distance.

spot bleaching A chemical agent applied to small areas on the print or negative to reduce or eliminate unwanted spots or lines.

spot meter A light meter that gathers the light from a very narrow angle of the overall view to indicate appropriate exposures.

spotting Special paints or stains used on prints to reduce or cover small areas of light or white caused by lint or dust on negative or glass negative carrier or unwanted highlights in the subject.

stains Unattractive off-color areas caused by insufficient chemical action that results from exhausted, insufficiently or incorrectly mixed chemicals, or failure to keep the print or film fully submerged for a sufficient time.

stirring rod Device used to mix chemical solutions.

stop (*1*) In darkroom processing: chemical solution (dilute acetic acid) that neutralizes the alkalis in developers to arrest development of the emulsion. (*2*) In composition of a picture: a crossline or bulk that stops and redirects the viewer's attention to prevent it from going out of the picture.

subdued light Shaded areas or light of less intensity than sunlight.

sub-miniature cameras Those cameras that make smaller negatives than the 35mm camera.

support post On an enlarger, the upright or cantilevered metal to which the lamp head, negative carrier, bellows, and enlarger lens are attached.

surface As referring to the emulsion side of print papers (contact and enlarging) indicates such as smooth, glossy finish that can be ferrotyped to a high gloss, a rough tweedy texture, a matte (non-shiny, fine-grained) finish, silk (fine-textured sheen) among many others.

synched Shortened term to denote the synchronization of shutter and flash to assure the flash is at its peak of light output while the camera shutter is open. Different flash lamps require varying settings on the camera.

telephoto lens A camera lens with a longer focal length than is considered a normal lens. The telephoto enlarges the image on the film as compared with the same subject taken from the same distance with a normal lens.

test strip A method of giving several different exposures on one piece of print paper to determine the best exposure time for a print with a particular negative.

thin negative Very light image on film that indicates insufficient exposure (or inadequate development) which produced a negative with insufficient detail in the shadowed areas of the subject.

thumb print A spot marked in the lower left-hand corner of the transparency (slide) *mount* with the picture viewed as it is to be on the screen. The spot indicates the position for the slide in the projector tray to give correct projection. The thumb print is an international marking required in salons and exhibits. A lead pencil eraser touched to a stamp pad and then the mount is a common method used.

timer Device to alert the operator that a preset time has elapsed so he can start or stop a procedure at the appropriate time. If the timer is installed in the power line, it automatically interrupts the power supply such as exposure under the enlarger.

time exposure Longer than one second exposure. On most cameras requires setting the shutter speed on T or B and opening the shutter, then closing it at the end of the desired exposure.

tone The color of contact or enlarging print paper such as cool white, warm white, cream, ivory, or neutral, plus others. Also, to change the color of a black and white print overall by processing in special chemicals.

tone-line process A procedure with graphic arts (high contrast) films that eliminates all intermediate gray tones, leaving only black and white lines somewhat similar to an etching.

toner Chemical solutions used to change the tone of prints in varying degrees.

tongs Stainless steel, plastic, or rubber-tipped bamboo formed to produce a spring to aid in picking up prints. The tongs are used to agitate prints in chemical solutions or to move the prints from tray to tray without getting chemicals on the hands.

toplighting Principal light source strikes from above the subject so that the shadow falls directly below.

transistorized meter Light meter with no moving mechanism that uses transistorized circuitry to indicate the correct exposure.

transparency A positive image on film that is viewed by rear illumination.

tripod A three-legged support to anchor or steady an object. Most widely used device utilized to hold the camera during exposure.

"T" setting On the camera, the "T" indicates the shutter opens when the release is tripped and remains open until the release is tripped a second time. Trip twice!

twin-lens reflex camera Has two lenses of equal focal length. One lens is used to focus and frame the picture in the same size as the negative; the other lens takes the picture. There may be a difference in what is seen and what the resulting picture includes with close camera-to-subject distances.

TTL or TL Abreviation of through-the-lens. Refers to meters on SLR cameras that "read" the light intensity through the lens used for taking the picture. Synonymous with **BTL**.

tubes *See* extension tubes.

underdeveloped Film or prints processed in developer that is too cool, of incorrect dilution, exhausted solution, or for too short a time.

underexposed Not enough light reached the emulsion. With positive film emulsion, the image is too dark; with negative film emulsion, the picture is too light. With enlarging papers the picture is too light.

unexposed Photosensitive paper or films that have not been affected by light.

unipod One-legged support for a camera to minimize the chance of any up-and-down movement.

variable close-up lens Accessory lens that attaches to the front of a regular lens to focus closer to the camera than is otherwise possible to record a larger image on the film. The variable close-up lens has infinite magnification within its limits. Usable on the SLR only.

variable contrast filters Colored gelatins inserted between the light and the variable contrast paper during exposure in the enlarger to alter the contrast of the print.

variable contrast paper When the appropriate filter is inserted between the light of the enlarger and the paper during projection of the negative, the contrast of the resultant print can be changed equivalent to several grades of regular paper. Without the filters, the paper will yield normal contrast with a normal contrast negative and developer.

Verichrome Pan Film A medium speed black and white film made by Eastman Kodak.

viewfinder A device on or in the camera that frames approximately or exactly the area reproduced by the camera lens on the film format.

vignette (vin-yet') A process by which an area surrounding the principal subject is held back by dodging to let it shade off into white or to print-in or burn-in the edges very dark so there is no visible detail at outer edges. Also, a term applied to darkened corners of a picture caused by faulty lens construction, too small filters, or lens hoods.

waist-level viewfinder Device for framing and focusing the picture designed to be held at waistlevel. All better waist-level viewfinders have a magnifier to permit the camera to be held close to the eye but one still looks down into the viewfinder rather than straight ahead as with an eye-level viewfinder.

warm colors Colors with reds and yellows as principal hues.

warming filters Glass, plastic, or gelatin filters slightly tinted a creamy or orange color used to reduce the effect of invisible ultraviolet light, reflections from blue skies, or to give warmer skin tones.

warm-toned papers Print papers, contact and enlarging, that have color tints from slightly warm to creamy whites and ivory.

wash Procedure of rinsing film or prints with water to reduce or eliminate unwanted chemicals.

washer Device to shift prints without damage to give a thorough rinse in the wash to reduce and eliminate chemicals and thus prevent print deterioration with age.

water spots Chemical residue left when drops of water have adhered to the film-base surface and dried.

weight As refers to the photographic print papers (contact and enlarging) indicates thickness of the individual sheets. Classes are lightweight, single weight, double weight, and medium weight.

wetting agent *See* wetting solution.

wetting solution Used for a last rinse in processing and developing film to avoid water spots caused by drops of water that adhere to the film's surface and dry, leaving a chemical residue.

wide-angle lens A lens of shorter focal length than the approximate diagonal of the negative taken with the camera.

zone focusing Using the depth-of-field scale, the lens is focused to maintain acceptable sharpness at the nearest and the farthest distance required for a number of subjects in a given range at a particular aperture. The lens is not refocused nor the aperture changed for each picture.

zoom lens A lens with infinite adjustment of its focal length within the built-in limitations.

Index

Abnormal filtering, 364
Acceptable sharpness of image, 270-273
Accessories, choosing for the camera, 411-413
Accessory shoe, 286, 304
Acetic acid, 108
Acrylic spray
 glossy
 print and mount protection, 391, 395
 matte
 print and mount protection, 391, 395
 reflection reduction from metal, 365
Action photography, 186-188, 239-242
Activating switch of light meter, 284
Activator, 417
Adams, Ansel, 300
Adapter ring
 assembly, 346, 347
 close-up lens holder, 259
 filter holder, 346, 347
 star pattern filter holder, 406
Addacolor, 94, 365
Additive system, 206
Adhesives, preparing prints for display, 394, 395
Adjustable camera, 28-31, 202, 248, 225-281
Adjustable easel, 125, 126
Adjustable reels, 45
Adjusting temperature of chemicals, 59
Adox black and white films, 338
Agfachrome, 79, 82, 334, 340
Agfacolor, 341
Agfa black and white films, 338
Agfa Brovira paper, 103, 106
Agfa positive (slide) films, 340
Agitation
 film tank, 59-62, 71, 72, 90
 print, 112, 134-136, 144, 146
Airbells, 131
Air bubbles, 60
Airsweep, 131
Alkaline batteries, 311
All-over fog (black and white negatives), 73
Aluminum reflector, 397
American Standards Association, 336
 see also ASA
Angle of acceptance of light meters, 390
Angle of coverage of electronic flashguns, 312

Angle of subject in print, 149-151
Angle of view of lenses, 256
Anscochrome, 33, 79-82, 340
Aperture
 of camera lens, 248-254
 critical, 253, 254, 300
 effect on depth of field, see Depth of field
 with infrared film, 344
 scale, 31
 of enlarger lens, 132, 135, 141, 151
 when easel is tipped, 151
Apron
 gadget, 398-400
 plastic, 46, 48
 rubber, 46, 48
Artificial light, 202
ASA of film, 42, 43, 336-341
ASA scale on camera, 42, 43, 66, 90-92, 235
 compensation for filter factor, 337, 339, 341, 353
 contrast control, 341, 342
 conversion to DIN, 388
 exposure compensation, 339, 341, 342
 exposure control, 299
 extra film speed, 342
 filter compensation, 362, 363
 relation to exposure, 339, 341
Automatically adjustable camera, 28-31, 202, 243, 249, 280-1, 293, 299, 313
Automatic bellows, 263
Automatic cameras, see Automatically adjustable camera
Automatic focus on enlarger, 416
Automatic lens, 90, 254, 255
Automatic tubes, 262
Available light, 202
Averaging light meter, 290, 291

"B" settings, 66, 91, 240, 243
 with the automatic lens, 255
Background in pictures, 43, 195-197, 300, 302
 altering, 195-197
Backlighted subject, reflected light meter reading of, 294
Backlighting, 208-211, 220-221
 advantages, 220
 problems with, 220
 solutions to problems with, 220, 221
Balance of color film
 in daylight, 335, 336
 in incandescent light, 335, 336
 color of light with film, 208
Balance in composition, 169, 174, 175

Bare bulb flash
 equipment, 306, 307
 exposure calculation, 323
Barn doors, 221
Bas-relief, 163, 164
Basic guide to exposure, 282, 283
Batteries
 alkaline, 311
 checking of, 305
 exhausted, 90
 for electronic flashguns, 311
 nickel cadmium, 311
 photoflash, 305
 storage of, 90, 325
Battery capacitor, 305
Bean bag support, camera and lens, 405
Bellows
 close-up equipment, 262-264
 compensation
 for automatic flashgun, 312
 via ASA scale, 337, 339, 341
 duplicating, 402-404
 enlarger, 125
Between-the-lens shutter, 237
Bizarre effects with filtering, 364
Black and white film
 classification, 331
 contrast control
 with filters, 357-359, 361
 with processing, 71, 72
 emulsion, 102, 110, 331
 filter effects
 color separation, 357-361
 color values, 357
 contrast, 357-359, 361
 panchromatic, 331, 332
 orthochromatic, 332, 343
 speed, 336-338
Black and white print
 analysis of problems, 114, 115, 138-155
 attaching caption, submission to publications, 381
 bleaching, 155-160
 chemicals to process, 107-109
 equipment to process, 105-107
 ferrotype, 120
 spotting, 160-162
Black lines on print, 140
Bleaching, 154-160
Bleeding a print, 389
Blotter book, 107
Blotter roll, 107, 108, 119, 120
 for camera interior, 18
 for lens, 18
 plastic, 92
Blue flashlamps, 310
Blower

Boosters on light meters, 290
Borderless easel, 126, 404, 405
Bottles
 brown glass, 46-50, 58, 59, 79
 plastic, 46-50, 58, 59, 79
Bounce flash, 215, 317-319, 396
Box camera adjustments, 27, 28, 243
Bracketing exposures, 295, 297, 341, 342
 ASA scale control, 337, 341, 342
 color positive films, 294, 295
 negative films, 294, 295
 on automatic cameras, 342
 on non-automatic cameras, 337,
 341, 342
Bristol board reflector, 397
Brown or yellow stains
 on negatives, 69
 on prints, 115, 135, 158, 160
Brush
 cleaning lens, 19
 cleaning negatives, 131
 print bleaching tool, 156,
 spotting prints, 160, 161 159
BTL or TTL metering, 262, 263, 286, 288
 close-up photography, 262, 263,
 409
 with filters, 348, 349, 356
Bulk film, 53, 344, 366, 404
 daylight loader, 344, 404
Burning in print, 115, 132, 142-144
 tools for, 132, 142, 144

Cable release, 32, 37, 243, 245, 263, 413
Cadmium (nickel) batteries, 311
Cameras
 accessories, see Camera accessories
 available, 410
 choosing, 411-413
 adjustable, 28-31, 202, 225-281
 ASA scale, 42, 43, 235, 337
 automatic adjustable, 28-31, 202,
 225-281
 care, see Camera care
 choosing, 408-411
 common parts, 27
 controls, 409, 410
 degree of adjustability, 27-31
 focusing devices, 232-235
 focusing screens of, choosing, 410
 interchangeable lenses for single
 lens reflex, 255-258
 half-frame, 225
 handholding, 32-36
 kinds or classifications, 27-31
 lens, 13, see also Camera lens
 miniature, 225
 operation, 27-44
 press, 227

 rangefinder, 227, 231, 255
 shutters, 236-245
 single-frame, 225
 subminiature, 225
 support, 32-34
 bean bag, 405
 ground level, 397, 398
 tripod, 32-34, 300, 402, 403
 synchronized for flash, 308
 2¼" x 2¼", 255
 2¼" x 3¼", 226
 view, 27
 viewing systems, 227
Camera accessories
 bellows, 262-264, 312, 413
 cable release, 32, 37, 243, 245, 413
 extender or converter, 258, 259, 413
 filters, 346-364
 interchangeable lenses, 255-258
 reverse adapter, 258, 264
 right-angle magnifier, 398
 tubes, 262-264, 312, 413
Camera angle, portraiture, 200
Camera care, 13-18, 20-23
 theft prevention, 23-5
Camera lens, 30, 31, 246-265
 adjustable, 248-253
 angle of view, 256
 aperture settings, 30, 31, 249-254
 depth of field effect, 268-270
 automation, 254, 255
 "B" settings, 240, 243, 255
 care of, 13, 18
 close-up, 259-262
 color-corrected, 247
 construction, 13, 246, 247
 control of light, 248-254
 converters, 258, 259
 critical aperture, 253, 254
 diaphragm openings, 30, 31, 249
 evaluation tests, 247, 410
 extenders, 258, 259, 410, 411
 F/number, 249
 F/stop, 30, 31, 249-254, 277-279
 fast, 249-253
 fish-eye, 193, 255-257
 fixed aperture, 251
 focal length, 240, 247-251, 300
 effect on depth of field, 274-
 276
 choice of, 258
 interchangeable, 255-258
 macro, 258
 normal, 255-257
 on non-adjustable cameras, 248
 preset, 254
 semi-automatic, 254
 speed of, 249-253

 stops, 249-254, 341
 "T" setting with the automatic
 lens, 254, 255
 telephoto, 255-258, 263
 35mm camera, 255-258
 wide-angle, 255-258
 zoom, 256
Camera operation, 27-44
Camera repair, 18, 20, 26
Camera support, 32, 38, 300, 397, 398,
 402, 403, 405
Campfire, reflected light meter reading
 for, 294, 295
Candle light
 film choice for, 345
 picture by, 204
Caption submissions to publications
 black and white prints, 381
 transparencies, 381
Care and handling
 of camera, 13-26
 of chemical solutions, 49-51, 80,
 109
 of electronic flashguns, 312
 of film, 51, 73, 74, 81, 93, 94,
 327-330
 of filters, 346-348
 of flash extension cords, 318
 of light meters, 284
 of negatives, 73-76
 of transparencies, 81, 95
Cassette, 35mm
 loading camera, 38, 40, 41, 67, 90,
 91
 reuse, 53
Center of interest in composition, 169-
 178
Center-loaded light meter, 290, 291
Centigrade, conversion scale to Fahren-
 heit, 388
Centimeters, conversion scale to inches,
 388
Changing bag, 46, 49, 79
 substitute for, 400, 401
Cheesecloth tent, to subdue metal
 flares, 365
Chemicals
 for black and white films, 46, 48,
 49
 for black and white print, 99, 107,
 128
 mixing
 for black and white films,
 49-51
 for black and white prints, 109
 for color film, 80
Chemical kits
 color slide film processing, 79

color negative processing, 78
Chemical solutions
 developer for black and white films, 46, 48, 49, 61-63, 71-73
 developer for black and white prints, 99, 107-109, 113, 115, 128, 129, 134, 136
 fixer (hypo) for black and white film, 46, 49, 50, 61-63, 69
 fixer for black and white prints, 99, 107-109, 112, 113, 135, 137
 hypo neutralizer for black and white print, 107, 118
 hypo neutralizer for films, 46, 49, 50, 62-64
 Pakasol for black and white glossies, 120
 shortstop for black and white print, 107-110
 wetting solution for film, 49, 59, 63, 64
Choosing equipment, 408-417
 bellows, 262-264, 413
 cable release, 37, 38, 413
 camera, 27-31, 225-264, 409-411
 clamppod, 34, 413
 darkroom, 45-48, 97-107, 122-127, 413-417
 enlarger, 122-125, 414-416
 extenders or converters, 258, 259, 413
 problems to analyze, 408
 stabilization processor, 416, 417
 timers, 106, 107, 126, 127, 416
 tripod, 34, 411, 412
 tubes, 262-264, 413
Clamppod, 34, 300, 413
Classification of film
 black and white or color, 330-332
 color sensitivity, 330-332
 negative or positive, 330, 332-336
 negative size, 330-344
 by packaging, 38, 330, 331
 specialized uses, 330, 342-344
 speed, 330
Clear flashlamps, 310
Cleared film, 49
Click stops, 254
Clock or timer, 46, 48, 126, 127, 416
Close-up equipment
 bellows, 262-264, 402-404, 413
 choosing, 241, 258-264, 413
 tubes, 262-264, 413
Close-up focusing, 280
Close-up lenses, 231, 258-264, 413
 exposure compensation, 261, 262
 one-half, 262, 263
Close-up photography

bellows exposure compensation, 263
BTL metering, 262-264, 409
critical aperture, 300
equipment, see Close-up equipment
exposure compensation, close-up lenses, 261, 262
exposure control with flash, 322, 323
SLR camera, 259, 261, 262, 402-404, 409
tubes, exposure compensation, 263
with bellows, 262-264, 402-404
with flash, 322, 323
with normal lens, 189, 191
with tubes, 262-264, 413
Coated filters, 346
Cold light enlarger, 123, 124
Color
 complements, 198, 207
 of light, 203-209
Color balance, 204, 208, 362-364
 of electronic flashgun, 311, 360, 362
Color-corrected lenses, 247
Color film
 emulsion sensitivity, 206, 208, 332, 335, 358-364
 fogged, 91, 327, 329
 negative, 78, 332-334, 341
 speed, 337, 339-341
 ultraviolet ray correction, 354, 360, 362
Color filters
 effects on black and white films, 357-361
 effects on color film, 359, 360, 362-364
Color filter drawer, 416
Color negative, proofs in black and white, 333
Color negative film defects, 78
Color positive films, 78-95, 285, 286, 294, 295, 335-337, 340
 defects, 90-94
Color printing, 79, 333, 334, 416
Color rendition, 204-208, 335, 363, 364
Color reversal film defects, 90-94
Color sensitivity of black and white film, 331, 332
Color shift, 81, 82, 328, 337, 342
Color temperature meter, 207
Color temperature of light, 206-208, 335
Color transparencies, enemies of, 81, 95, 329, 330
Color variances in lenses, 247

Commentary for slide show, 376-378
Compensating factor
 automatic electronic flash, 312
 with bellows, 262, 263
 with converter, 258
 with extender, 258
 with filters, 348, 349, 353, 360-364
 with tubes, 262, 263
Compensation
 for bare bulb flash, 323
 for combining slides, 302
 for incident light meter reading
 dark subjects, 288, 293
 light subjects, 288, 293
 for reflected light meter, night scenes, 295
 for reverse adapter, 264
 for star pattern screen, 406
Composites, 163, 302, 344
Composition, 169-201
 arrangement of subjects, 175-178
 balance, 175-178
 center of interest, 169-187
 cropping, 94, 95, 189, 193
 curved lines, 179, 181
 definition, 169
 diagonal lines, 179
 foregrounds and backgrounds, 43, 195, 196
 format influence, 187
 horizontal lines, 179, 184
 lead-in lines, 172, 180, 181
 mergers, 195, 197
 moving-in close, 189, 194
 "N" for reference points, 171, 172
 perspective, 195-197
 portraiture, 198-201
 repetition of line, design, color, 189
 reversing the picture, 172, 173, 184
 space for subject to move, 186-188
 thirds, 171
 variety and contrast, 198
 vertical lines, 179
 zigzag lines, 179, 180
Condenser enlarger, 123, 124
Contact points, flash connections, 325
Contact print, 97-121
Contact print proofers, 99, 100
Contract printers, 101, 102
Contact proof, 97-121
Contrast
 choice of paper grade, 102, 105, 128, 129
 for black and white film, 357, 359-361
 of film

black and white, 66, 71-73, 336-337, 341-343, 351
high, 285
in papers, 103, 105, 146-148
in prints, 159-60
unsatisfactory, on prints, 102-105, 128, 129, 146-152
variances in lenses, 247
Contrast control
black and white film, 163, 164, 336, 338, 341-343
on prints with filters, 127, 129, 146, 147
underexposure, 341, 352
Control of image with the enlarger (size and perspective), 132, 149-151, 416
Converters, 258, 259, 312, 413
choosing, 413
exposure compensation, 258, 259, 312
magnification, 258, 259
Conversion scale
film speeds (ASA-DIN), 388
lineal (inches-centimeters), 388
liquid (ounces-cubic centimeters), 388
temperature (Fahrenheit-Centigrade), 388
Critical aperture, 253, 254, 300
in duplicating, 344, 402
Cropping
in printing the picture, 130, 131, 138, 139, 189, 193
the transparency (slide), 89, 94, 189, 191, 193, 344, 402
Curved lines in composition, 179, 180
Cutting tools, mats and mounts for prints, 392, 393

Dark lines on the print, 140
Dark subjects, reflected light meter reading of, 294
Darkbox
construction, 400, 401
use, 400, 401
Darkroom, 46, 51, 79, 129, 130, 400, 401
substitutes, 46, 51, 79, 129, 130, 400, 401
Darkroom equipment, choosing, 413-417
Daylight film loader, 329, 344
Daylight films, 333, 335, 340, 341, 362-364
Daylight tank
film developing in, 45, 46, 51, 53-63
plastic, 45, 55-57, 60, 61
stainless steel, 45, 53, 59-61

Defects
in black and white negatives, 66-73
in contact prints, 112-14
in enlarged prints, see Evaluate the print
in transparency (slide), 90-95
Definition
of camera lens, 253, 256, 258, 264, 358-9
with filters, 358, 359
of negative, 66, 336, 337
required sharpness, 271
°Kelvin, 206-208, 335, 336, 358, 362, 363
°Kelvin rating
daylight color film, 335, 362, 363
tungsten color film, 335, 336, 362, 363
°Kelvin table, 206
DeHypo washer, 107
Delayed action shutter, 216, 243-245
Density correction in transparencies (slides), 93, 94, 365, 366
Depth of field, 266-281, 300
acceptable sharpness of image, 270-273
choice of, 276
in close-ups, 260, 262, 280
control on automatic adjustable cameras, 280, 281
definition, 266
effect of camera-to-subject distance, 267-271
effect of lens aperture, 268-270
effect of lens focal length, 274-276
factors that affect, 267-270
forefocusing, 278-279
hyperfocal distance focusing, 276, 279
indoor-outdoor scene, 320, 321
infrared film, 344
maximum for close-ups, 280
reduction with some filters, 363
with zoom lens, 276
zone focusing, 277, 278
Depth of field scale on camera lens, 266, 273, 274, 410
utilization, 276-279
Depth of focus, definition, 266
Desiccant, 20
Design, repetition of, 189
Developer
for black and white films, 48, 49
for films, one-shot, 49
for papers
cool-toned, 129
warm-toned, 129
for prints, 99, 107, 108, 129

Developing films, 58-63
summary of steps, 63, 64
Developing the test strip, 134-137
Diaphragm, 125
Diaphragm opening, 279
Diffused light, 348
Diffuser
for light sources, 348
for softening lines, in printing, 151, 152
white umbrella, 396
Diffusing camera filter, 364
Diffusing enlarger, 124, 125
Diffusion materials, 203
DIN, 336
conversion to ASA, 388
DIN scale, 235, 291, 293
Direct Positive Film, 334
Direction of lighting, 208-224
backlighting, 208, 220-221
factors to consider in choice, 224
front lighting, 208, 212, 215, 216
low or bottom lighting, 212, 223, 224
side lighting, 208, 217-219
top lighting, 212, 221
Display
mount
print, 165, 167, 388-395
slide, 81, 83-87
preparation
print, 165, 167, 379-381, 388-395
slide show, 95, 374-379
Distortion
camera too close, 191-194
lens construction, 247
on the easel, 164
related to focal length, 256, 257
Dodging, 115, 132, 142, 143, 154
tools, 142, 143
Doscher, John, 300
Double exposures, 295, 301, 302
Double exposure prevention bypass, 301, 302
Double weight paper, 102, 118, 138
Drop-in filters, 346, 347
Dry mounting tissue, 394, 395
Dry the print, 118-121, 138
Duplicating films
composites, 344
for original exposures, 344
processing, 344
transparency filters, 366
Duplicating slides, 344, 404
Duplicator, 344
construction, for transparency duplication, 402-404

Dynachrome, 344

E-3 processing kit, 79-82
E-4, 79-82
Easel, 122, 125, 126, 404, 405
 adjustable, 126
 borderless, 404, 405
 frame the picture, 132
 kinds of, 125, 126
 titling, 149-151
Eastman Direct Positive kit, 334
Editing
 prints for display, 372, 379, 380
 slide show, 375, 376
Effective lens diameter, 248
80B filter
 black and white film, 360, 361
 color film, 362-364
85 filter, color film, 362, 363
85B filter
 black and white film, 360, 361
 color film, 362, 363, 404
 duplicating film, 404
18% reflectance gray card, reflected
 light meter reading, 294
Electricity static marks on film, 16, 17
Ektachrome, 79-82, 334, 340, 342
Ektachrome Infrared Aero Film, 343,
 344
Ektachrome-X, 94, 365
Ektacolor, 341
Electronic flash
 angle of coverage, 312
 camera settings with, 245
 capacitor, 311
 color balance, 311
 flash duration, 310, 311
 for duplicating light, 403, 404
 power sources, 311
 recycling time, 311
 repair, 312
 synchronization, 311
 with plane shutters, shutter speed,
 311
Emulsion side
 identification of
 on glossy paper, 110
 on negatives, 102, 110, 131
 on semi-matte and matte pa-
 pers, 110
 of enlarging paper, 132-135, 138
 of negatives
 cleaning, 131, 135
 position in contact printing,
 102
 of print paper, in processing, 112,
 115, 135
Enlarged print, degree of sharpness re-

quired, 247
Enlarger
 choosing, 123-125, 414-416
 condensers, 148
 focal length of lens, for negative
 size, 125
 focusing lens, 132
 glass negative carriers, Newton
 rings, 415
 image size, 123, 132
 negative carriers
 glass, 125, 415
 glassless, 125, 415
 operation, 123
 red filter, 133
 types, 124, 125
Enlarging equipment, 122-127
Enlarging lamp, for duplicating light,
 404
Enlarging papers, 102, 103, 105, 128, 129
 orthochromatic, 165
 panchromatic, 165, 333
Equipment for enlarging, 122-127
Equipment
 how to choose, 408-417
 how to make, 396-407
Equipment to process
 black and white film, 45-48
 color positive film, 79, 80
 the print, 105-107
ESP, 342
Etched squares in camera viewfinder,
 231
Evaluation of the print, 138-160
EVS (Exposure Value System), 282, 283
 exposure combination, 300, 301
 scale on light meter, 292
Existing light, 202
Expendable flash lamps, 245, 304-310
Expiration date on film cartons, 328
Exposure, 282-303
 automatic flashgun compensation,
 312
 "B" setting, 240, 243
 basic guide, 282, 283
 calculation with flash, 313
 compensation with close-up lenses,
 259, 261, 262
 compensation with extenders or
 converters, 258, 259
 compensation, with light or dark
 subjects, 293
 double, 26, 38, 61, 153, 295, 301-
 302
 EVS or LVS, 282, 283
 filter compensation, 348, 350
 importance with filter, 349-350
 low light problems, 297, 298

methods of choosing, 282
 multiple, 26, 38, 61, 153, 295, 301,
 302
 "T" setting, 240, 243
 tubes and bellows compensation,
 263
Exposure control
 ASA scale, 299, 337-342
 automatic adjustable cameras, 299
 flashlamp, 313, 314
 neutral density filters, 356, 357
Exposure dials, 283
Exposure indicator, 232
Exposure index, 336
Exposure reading
 how to make, 293-302
 incident light meter, 288, 289, 293
 light subjects, 288, 294
 low light situations, 294, 295
 night scenics, 294, 295
 reflected light meter, 288, 294-5
 side lighting, 294
 snow, 288, 294
Exposure systems, 300
Exposure, time, 239, 243
Exposure time, enlarging, test strip, 133,
 134
Extenders, 258, 259
 automatic flashgun compensation,
 312
 choosing, 413
 exposure compensation, 258, 259
 magnification, 258, 259
Extension cords off camera flash, 317-
 319
Extension tubes, automatic flash, com-
 pensation, 312
Extreme cold
 effects of
 on camera shutters, 16
 on film, 16, 17
 protection for camera, 16, 17

"F" setting, 245, 309
Fahrenheit, conversion to Centigrade,
 388
Farmer's Reducer, 72, 157
Fast films
 black and white, 336-338
 color, 337, 338-340
File negatives, 73-76
Fill light, 218, 219, 220, 224, 320-322
Film
 black and white
 color sensitivity, 331, 332, 343
 357
 fogged, 327, 329
 kinds, 331, 332, 343

bulk, 53, 344, 366, 404
care and handling, 51, 63, 73, 74, 81, 93, 94, 131, 327-330
classification, 330-334, 336-344
dated, 73, 93, 94, 327, 328
duplicating
for originals, 344
processing, 344
expiration date, 327, 328
exposed, 44
fast, 336-338, 340, 345
fogged, 67, 73, 91, 327, 329
freezer storage, 94, 327, 328
fresh, 73, 93, 94, 327, 328
medium (moderate) speed, 336-338, 340, 345
negative, 78, 332-334
100-foot rolls, 53, 344, 366, 404
outdated, 73, 93, 94, 327, 328
protection
from fingerprints, 51, 74, 81, 131, 330
from X-ray fogging, 329
from humidity, 76, 95, 327
reciprocity of, 283, 292
refrigerator storage, 94, 327, 328
removal from camera, 40, 42, 44
slow, 338-340
static electric flash, 16, 17
Film advance, 39, 41, 44, 410
Film cleaner, 68, 92, 330, 131
Film clips, 48, 63
Film developer
FR's X-100, 49
GAF's Hyfinol, 49
Kodak's D-76, 49
Kodak's HC110, 49
Film developing daylight tanks, 45
Film latitude, 285, 293, 337, 339
Film load the camera
cartridges, 38, 39
roll film, 39, 40
35mm cassettes, 40-42
Film-load mechanism, 409
Film plane, 246, 247, 262
Film processing
black and white, 48, 49, 336
color, 79, 80, 337, 341, 342
Film processing chemicals, amount required, 58
Film reels, loading, 51-58
Film resolution, 336, 337
Film selection, 330-345
Film sizes, 225
Film speed, 336-342
black and white, 336-338
conversion scale (ASA-DIN), 388
loss with filters, 362, 363

Film storage, 15, 22, 95, 327-329
Film tank loading, 51-58
Film weights, 46, 48
Filter, 261, 262
balance light sources, 404
exposure compensation for, 348-350
focusing through, 348
polarizing, 285, 351-356
red, on enlarger, 133
Filter drawer, 416
Filter factor, 343, 349, 350, 362, 363
adjust ASA scale, 349
aperture and shutter speed change, 349-350
80B filter, 362, 363
Filter slot, 346
Filtering, abnormal, for mood, 343, 364
Filters, 253, 335, 347-367
abnormal effects, 343, 364
automatic flashgun compensation, 312
black and white film, 357, 361
black and white printing, contrast control, 127, 129, 146-150
BTL meters, 348, 357, 358, 349
care and handling, 346-348
choice, 349-364
classifications, 350
clear glass, 20
cloudy, 348
coated, 346
color film, 358-360, 362-364
color printing, 332, 333
compensation, ASA scale, 337, 339, 341
contrast control, 127
creative effect, 404
drop-in, 346, 347
duplicating, 344
focusing through, 348
function, 350
gels, 348
haze, 20
highlight, 366
make, 364
materials in, 346, 348
mood, on color film, 364
multi-contrast, 127, 129, 146-150
neutral density, 351, 356, 357
optical quality, 346, 348
portraiture, 200
retaining rings, 346
scratched, 348
screw-in, 346, 347
series sizes, assembly, 346, 347
skylight, 20
slide correction, 365

storage, 346, 347
TTL meters, 348, 349
warming for color film, 360, 362
Fingerprints
on displayed prints, 391
on film, 51, 73, 74, 81, 131, 330
on filters, 347, 348
on lens, 13, 19
on negatives, 74
on slides, 81
Fireplace, simulated lighting by flash, 323
Fishback, Glen, 300
Fish-eye lens, 255-257
Fixed-aperture camera, flashlamp, exposure control, 27, 28, 43, 313
Fixed aperture lens, 27, 28, 251
Fixer
for black and white films, 49, 61, 62, 69
for prints, 99, 107, 108, 110, 115
in bleaching, 156-159
time for print in single bath, 115
time for print in two baths, 115
Flare, 67, 91, 212, 215-217, 219, 220-222, 351-355
Flares from metal, subduing, 365
Flash
battery care, 323
blue, film choice for, 345
bounce, 215
exposure compensation, 317-319
tilting head gun, 317-319
close-ups, exposure calculation, 322, 324
covering depth
exposure calculation, 323, 324
gun angle, 323, 324
diffusing light, bare bulb, 323
duration
electronic, 304, 310, 311
flashlamps, 308
fill, in sunlight, 319, 320
exposure calculation, 321, 322
front lighting, 212
indoor-outdoor scene, calculating exposure, 320, 321
off camera, 317-320
synchronization, 320, 321
Flashcube, 304
Flashgun, 245, 304
flash prematurely, 325
with tilting head, 317-319
Flashlamps
expendable, 245, 304-310
light duration, 306
light intensity output, 306

lumen seconds, 308
milliseconds, 308, 311
peaking time, 306
size, 306
Flash bulb, 243
Flash failures, 324-326
Flash-fill, filter for, 356
Flash photography, 304-326
 automatic flashgun compensation,
 312
 blue lamps, 310
 bounce flash, 306, 307
 clear lamps, 310
 electronic, 245, 304, 310-312
 exposure calculation, 313-316
 F setting, 245, 309
 flash duration
 electronic, 310, 311
 flashcube, 307, 308
 flashlamps, 308
 flashing prematurely, 325
 FP setting, 245, 309
 guide numbers, 310
 M outlet, 245, 309
 strobe, 310
 X outlet, 245, 309, 311
Flash pictures, techniques to improve,
 316-323
Flash settings on camera, 245, 309
Flash synchronization
 electronic flashgun test, 311
 flashlamp test, 309, 310
Flashing, in printing, 154-156
FLB filter, 362-364
FLD filter, 362-364
Floor projection, enlarger, 415
Fluorescent light
 filters for, 362-364
 green cast in slides, 93, 94
 light box, 401, 402
Focal length of camera lenses, 247-251
 choice, 256-258
 effects on action, 240
 effect on choice of shutter speeds,
 300
 effect on depth of field, 274
Focal plane, 247
Focal-plane shutter, 237
 with electronic flash, 311
 with flashlamps, 309, 310
Focus of camera lens, definition, 256
 definition affected, 13, 18, 248,
 253, 258-9, 264, 274
Focusing the camera lens, 232-235, 410
 adjustable automatic cameras, 281,
 410
 adjustable cameras, 28-31, 44, 232-
 235, 410

close-ups, 261, 262, 280
devices, 232-235, 410
filters, 348
infrared film, 343, 344
nearest distance, 191
red R, mark or dot, 344
Focusing the enlarger lens, 132, 416
Fogged black and white film, 66-68,
 327, 329
Fogged color film, 90, 91, 327, 329
Fogged film from X-ray, 329
Fogged negatives, 66-68
Fogged photo-sensitive papers, 110, 111
Foot-candles, 203
Forefocusing, 278, 279, 300
Foreground, composition, 195, 196, 300
Format in composition, 186
Forty-five degree lighting, 212
FP flash lamps, 309
FP (focal plane shutter), synched for
 flash, 309
"FP" setting, 245, 309
Fps, scale on light meters, 292
FR Special, 45
Frame the picture
 camera viewfinder, 27, 43, 187-
 189, 201
 close-up lenses, 260-262
 enlarger easel, 132
Frames for print display, 388, 391, 395
Freckles on black and white film, 357,
 358, 361
Freezer storage for film, 94, 327, 328
Freezing action, 238-240, 300
Fresh film, 73, 93, 94, 327, 328
Fresnel lens, 233, 234
Front lighting, 208-216
 advantages, 212, 215
 problems with, 215
 solutions to problems, 215, 216
FR's X-100, 49
F/stops, 30
 camera lens, 30, 249-254
 camera light meters, 292
 flashlamps, 310
 in close-ups, 322, 323
 on enlarger lens, 125, 132, 135
F/stop and shutter speed combination,
 252, 300, 301
F/stop relationship, 249-253
F/stop scale on light meters, 291
Full stops, 252, 253, 294, 298, 302, 312,
 337, 342
Funnel, plastic, 46, 48

Gadget apron for women, 398-400
GAF Anscochrome, 79
GAF Color Print Film, 78, 341

GAF 5470 Duplicating Film, 404
GAF Hyfinol, 49
GAF 125 Black and White Film, 338
GAF Pan Paper, 333
Gelatins, transparency improvement,
 365
Gels, filter, 348
Gem-mounts and Gem-Masks Co., 89
Glare, 351-355
Glass covers for prints, 388, 391, 395
Glass mounting 35mm slides, 86, 87
Glass negative carriers, enlargers, 125
 Newton rings, 415
Glass, non glare, 391
Glassine envelopes, 74, 75
Glassless negative carrier, enlargers,
 125, 415
Glossies, black and white pictures, 120
 for publication submission, 381
Glossy paper, 102, 110
Gloves for handling films, 51, 74, 81
Goals for photography, 368-383
Grain
 black and white negatives, 70, 71
 fast films, 336-340
 medium speed films, 336-340
 slow films, 336-340
GraLab, 126, 127
Graphic arts, 332
Green cast, slides, see Transparency de-
 fects
Green filter, black and white film, 357-
 361
Ground glass collar, 232
Ground level camera support, 397, 398
Guide numbers, 310, 316
 exposure control, flash, 314-316
 tests for accuracy, 315, 316
 variables, 315
Guides
 to composition, 169
 to sell pictures, 380-382
 to slide show assembly, 375-378
 to wedding photography, 370-372
Half-frame cameras, 225
Hand blower, 18, 92, 130
Hand holding the camera steady, 34-38
Handkerchief
 diffuser on flashgun, 322, 323
 to reduce exposure on flash, in
 close-ups, 322, 323
Handling films, 51, 63, 73, 74, 81, 93, 94,
 131, 327-330
Hangers for film, 48, 63
Hanging devices for prints, 392
Haze filter
 protection for lens, 20
 warming, 360, 362

Heindl Masks 'N' Mounts, 94
High contrast (black and white negative), 71, 72
High Contrast Copy Film, 71, 285, 343
High contrast developer, 71, 72, 343
High contrast light, 71, 72, 203, 217, 220
High contrast paper, 72, 102-105, 148
High contrast subject, 71
High Speed Ektachrome, 334, 342, 363
High Speed Ektachrome Tungsten, 334, 340
Highlight, 142, 284, 293, 351
Highlight detail, 64, 284, 344
Highlight filters, custom, 366
Horizontal lines in composition, 179
How to choose
 cable release, 37, 38, 413
 camera, 409-11
 camera lens, 247, 410-11
 clamppod, 34, 413
 darkroom equipment, 413-417
 enlarger, 414-16
 enlarger lens, 125, 415
 equipment, 408-417
 extenders or converters, 258, 259, 413
 focusing screens, 232-34, 410
 stabilization processor, 416, 417
 timers, 48, 105-107, 123, 126, 127, 416
 tripod, 34, 411, 412
 tubes, 262, 413
How to make
 borderless easel, 404, 405
 camera support, 397-98, 405
 darkbox, 400, 401
 dodging tools, 142
 double exposure, 301, 302
 gadget apron, 399, 400
 level for tripod and camera, 406, 407
 light box, 401, 402
 proof sheet, 97-100, 116-118
 reflectors, 396, 397
 slide duplicator, 402-404
 star pattern filter, 406
How to score print and transparency, 387
Hula hoop diffuser and reflector, 396-397
Humidity, effect on film, 95, 327
Humor in slide show, 375
Hyperfocal distance focusing, 276, 279, 300
Hypo (fixer), 49, 99, 107, 108, 110, 156, 159
Hypo Clearing Agent, 62, 63
Hypo Clearing Solution, 49

Hypo Eliminator, 46, 49
Hypo neutralizer, 46, 49
 film bath time, 62
 print bath time, 118

Ice chest (styrofoam) for camera gear, 22, 24
Ice show, suggested exposures, 297
Ilford black and white film, 338
Incandescent light, 123, 204-206, 335, 345, 362, 263
Inches, conversion scale to centimeters, 388
Incident light, 203
Incident light meter, 286-289
 how to make reading, 293
Incident vs. reflected light meter, 286-289
Indexing
 negatives, 73-76
 slides, 95
Indoor-outdoor scene exposure calculation, 320, 321
Infinity, 234, 248, 258, 276. 277, 279
Infrared Aero film, 343, 344, 364
Infrared Film, 343, 344, 364
 black and white with red filter, 364
 focusing the camera, 343, 345
Insurance, 23
Intensity of light, 287, 203
 film choice for, 344, 345
Interchangeable lenses, 237, 255-259
Internal reflections in lens, 13, 247
Internegative, 334
Iris diaphragm openings, 249

Jeweler's hand blower, 18, 130, 131
Jobo, 45

Kelvin ratings, 206-208, 335, 336, 358, 362, 363
 color films, 335, 336, 358, 362, 363
 light, 206-208
Keystoned image, 378, 379
Kodabromide paper, 140
Kodachromes, 79, 334, 335, 340, 341, 362, 363, 404
Kodachrome II, duplicating, 404
Kodacolor, 78, 341
Kodak black and white films, 338
Kodak C-22, 78
Kodak Dektol, 146
Kodak Direct Positive film, 334
Kodak Direct Positive Film Kit, 334
Kodak D-76, 49
Kodak E-4, 79-82
Kodak E-3, 79-82
Kodak Ektachrome, 79, 80, 82, 94, 335,

340, 344, 363
Kodak Ektachrome Infrared Aero film, 343, 344, 364
Kodak HC110, 49
Kodak Panalure paper, 333
Kodak Panatomic film, 334, 338
Kodak Polycontrast Filters, 127, 147, 149
Kodak Projection scale, 110, 112, 127, 132-3
Kodalith, 342, 343

Labels for chemical solution bottles, 50
Lamp head, 123, 124
Latent image
 developing, 27
 on film, 27
Latitude of film, 285, 293, 337, 339
Laundry iron for mounting prints, 394-395
Leader
 roll film, 39, 41
 35mm film, 40, 41
Lead-in lines, 180, 181
Leaf shutter, 237
Lens
 camera
 automatic, 254, 255
 automatic with "T" setting, 254, 255
 color-corrected, 247
 diaphragm openings, 30, 31, 125, 249
 fast, 249-253, 258, 259
 fish-eye, 193, 255-257
 fixed aperture, 251
 focal length for portraits, 258
 focal length for wildlife, 258
 interchangeable, 255-258
 macro, 258
 materials in, 13, 246
 normal, 255-257
 one-half stops, 253
 preset, 254
 semi-automatic, 254
 telephoto, 240-1, 255-258, 263
 wide-angle, 240-1, 255-258
 zoom, 256
 critical apertures, 253, 254
 enlarger
 diaphragm openings, 125, 132, 135, 151
 focal length, 125
 focus, 132
 f/stops, 125, 132, 135, 151
 evaluation tests, 247, 410
 f/number, 30, 31, 249-254, 277-279
 focal length, 240, 247-251, 300

effect on action, 240
effect on depth of field, 274-276
effect on image size, 256
light control, 125, 248-254
plastic, 15
protection, 13
Lens aperture,
 camera, 30, 31, 90, 91, 249-254, 300, 323
 enlarger, 125, 132, 135, 151
Lens coatings, 13, 247
Lens construction, 13, 246, 247
Lens extenders, 258, 259, 410, 411
Lens flare, 67, 91, 212, 217, 219-222
Lens hood, 67, 91, 219-223, 261
Lens quality, 125, 247, 410
Lens speed, 249-253, 258, 259
 loss with extender or converter, 258, 259
 loss with filters, 348, 349, 353, 356, 360, 363, 364
 loss with reverse adapter, 264
Lens tissue, 18, 152, 347
Lensboard on the enlarger, 141
Lenses
 close-up, 231, 258
 color-corrected, 247
 color variances, 247
 contrast variances, 247
Level, photography aid, 406, 407
Light, 203-224
 available, 202
 back, 67, 91, 208, 209, 212, 220, 221, 320-322
 bare bulb, 216, 306, 307, 323
 bounce flash, 215, 317-319, 396
 candle, 204, 206, 345
 characteristics, 203-208
 color, 203-209
 color temperature, 206-208
 contrast, 203
 diffused, 348
 diffusion, 203
 direction of, 208-224
 film choice for, 344-45
 flat, 204
 fluorescent, 93, 94
 film choice, 345
 filter for, 362
 front, 208-216
 high-key, 204
 incandescent, 93, 204
 film choice for, 345
 filter choice for, 362-364
 intensity, 203, 293
 low or bottom, 208, 212, 223, 224
 low-key, 204

mercury vapor, 203, 205, 362, 364
 film choice for, 345
 filter for, 362-364
modeling, 212, 215, 217
polarized, 351-353
side, 67, 91, 208-211, 217, 218, 320-322
sodium vapor, 204
 film choice for, 345
sources, 202
spectral colors, 204, 205
top, 67, 91, 208-211, 221-223
tungsten, 93
 film choice for, 345
 filter choice for, 362-364
unpolarized, 351-353
waves, 351-353
Lighting
 back, 67, 91, 208, 209, 212, 220, 221, 320-322
 front, 208-216
 low or bottom, 208, 212, 223, 224
 plastic, 220
 side, 67, 91, 208-211, 217, 218
 top, 67, 91, 208-211, 221-223
Light areas (black and white negatives), 70
Light box, 376, 401-402
Light collector on light meter, 293
Light flecks (black and white negatives), 68, 69
Light intensity
 falloff with distance, 313
 on enlarger easel, 132, 150
 of enlarger lamp, 132
Light meter, 66, 90, 203, 282-302
 accessory shoe, 286
 activating switch, 284, 293
 angle of acceptance, 290
 aperture scale, 291
 ASA scale, 42, 43, 66, 90-92, 235, 291
 averaging, 290, 291, 410
 battery-powered, 284, 289, 290
 booster, 290
 BTL or TL, 258, 259, 262, 263, 286, 290, 291, 348-49
 cadmium sulphide (CdS) cell, 290
 camera, choosing, 286-292, 410
 care, 284
 center-loaded, 290, 291, 410
 DIN scale, 235, 291, 388
 EVS scale, 282, 283, 292
 false readings, causes, 293
 foot candles of light, 292
 fps scale, 292
 f/stop scale, 291
 handheld, 42, 66, 286, 287

incident, how to make reading, 293
incident light, 286-289
incident vs. reflected, 286-289
infrared rays, 344
kinds, 286-292
LVS scale, 282, 283, 292
photoelectric, 289, 290
power, 289, 290
purpose of use, 203, 283, 284
reciprocity failure, 283, 292
reflected light, 286-289
selenium cell, 289, 290
spot, 290, 291, 410
transistorized, 284
TTL, 259, 262-63, 286, 290, 291, 348-349
Light meter receptor, 299
Light meter scales, 291, 292
Light meter viewing windows, 290
Light spread, flashlamps, 305-308
Light stand attachment for white umbrella, 397
Light subjects, reflected light meter reading, 294
Lineal scale, conversion (inches-centimeter), 388
Lines, composition, 179-186
Lint, dust, sand (camera care), 14, 15
Liquid measurement, conversion scale (ounces-cubic centimeters), 388
Loading film in camera, 38-42, 66, 67, 90, 91
Loading film in developing tank, 51-58, 66, 67, 90, 91
Loading film on reels
 rotating top flange, 55, 56, 69
 stainless steel, 53-55, 69
 stationary flanges, 57, 69
Logbook notations to make, 44
Low or bottom lighting, 223-224
Low contrast black and white negative, 72, 73
Low contrast paper, 103-105
Low contrast print, 147, 163
Low light, reflected light meter reading, 294, 295
Lowell barn doors, 221
Lowell light units, 221
Lumen seconds, 308
LVS (Light Value System), 282, 283
LVS scale on light meter, 292

M, flash setting, 309
Macro lens, 258
Macrophotography, 259-264
Magazines, selling pictures to, 380-382
Magnification of images, 258-265

close-up lenses, 259-262
converters, 258-259
extenders, 258, 259
Magnifier
focusing on enlarger easel, 127
right-angle for camera viewfinders, 397
Mailing pictures, 381
Manually adjustable cameras, 31, 235-245, 314
Marbles, 46, 48
Masking tape labels
chemical solution bottles. 50
loaded film tank, 58
Mat
border proportions, 393
picture (print) display, 388-395
Mat board slide holders for duplicating, 402, 403
Match needle, light meter in camera, 292
Materials
borderless easel, 404, 405
camera support, 397-98, 405
darkbox, 400, 401
duplicator, 402-404
gadget apron, 398-400
level between camera and tripod, 406, 407
light box, 401, 402
reflectors, 396, 397
star pattern filter, 406
Maximum depth of field, 277
Medium speed films
black and white, 336-338
color, 337, 339-341
Mercury vapor light, 204, 205, 345, 363-364
Mergers, 195, 197
Metal, flares and glares from, 365
Meter
color temperature, 207
light, see Light meter
Methods of choosing exposure, 282-284
Microphotography, defined, 265
Microprism, 234
Mildew
film, storage, 329
negative storage, 72-76
slide storage, 95
Millisecond, 308
Mixing chemicals
black and white films, 49-51
do's and don'ts, 50
Mobiles for print display, 380
Model releases, 381
Modeling, 212, 215, 217

Montage, 162
Mood, filters on color film, 364
Moonlight, pseudo in daylight, 364
Mosaic pattern
black and white negatives, 72, 73
color slides, 94
Mottled prints, 143, 146
Mounting a photograph, 380, 381, 388-395
supplies and equipment, 392-395
Mounting press, 394
Mounting slides, 81, 83-89
cardboard, 83-86
glass, 86-89
Mounting tissue, dry, 394, 395
Mounts, 35mm slides, 86, 89, 94
Multiple contrast papers, 129
Multiple exposures, 38, 61, 153
bypass double exposure prevention, 301, 302
Music background for slide shows, 378
Mystery filter for mood, 364

"N" composition, 171, 172
Narration for slide shows, 377, 378
Natural light, 202
Nature photographer, camera choice, 258, 409
Negative (black and white) inspection, 64-73
Negative (black and white) defects, 66-73
Negative carrier, 123-125, 415
glass, 125, 415
glassless, 125, 415
tilting, 149, 416
Negative color film, 78, 332-334
identification in name, 333
processing, 78, 333
Negative density, black and white, 64
effects on print exposure, 110, 115-118, 132
Negative filing, 73-76
Negative films, 78, 285, 286, 332-334
latitude, 285, 286
underexposure, 66, 70, 284-286
Negative indexing, 73-76
Negative paper, 155, 164-166
Negative popping, 140, 141
Negative storage, 73-76
Negatives, combined or composite, 74, 163, 302
Neutral density filters, 351, 356, 357
slide correction, 365
Neutral gray test card, 287, 294, 403
Newspapers, selling pictures to, 380-382
Newton rings

enlarger, glass carriers, 415
glass-covered prints, 391
Nickel cadmium batteries, 311
Night photography, film for, 344
Night pictures, suggested exposures, 295-298
Night scenes, reflected light meter readings, 294, 295
Non-adjustable camera, 27, 28, 243, 276, 277
Non-adjustable camera lens, 90, 246, 248
Nonglare glass, 391
Normal contrast paper, 103-105, 128, 129
Normal lens, 255-257
Nylon hose
for texture, 152, 153
soften lines, 151, 152
Nylon screen, star pattern filter, 406

One stop, 30, 125, 251, 252, 336, 337, 350
One-half stops, 253, 254, 288, 292, 298, 316, 337
One-third stops, 253, 292, 337, 341, 342
126 film cartridge, 38, 52, 342
Opal glass, diffuser in duplicating, 403, 404
Opaque blotches (black and white negatives), 69, 70
Open flash, 320
Opening cartridge film, 52
Opening 35mm film cassettes, 52, 53
Optical quality filters, 346, 348
Orange filter, black and white film, 360, 361
Orientation in composition, 195, 198
Orthochromatic film, 332
Orthochromatic paper, 165
Ounces, conversion to cubic centimeters, 388
Outdated film, 73, 93, 94, 327, 328
Out-of-focus areas, slides, 70, 93
Overexposed negatives, 66
Overexposed slide, correction, 404
Overexposed slides, 90-91, 95
Overexposure effects on film, 284-286
Overexposure
composites, 302
slides combined, 302
with flashlamp on simple camera, 313
Oxidation, flash connections, 325

Painting with flash, 320
Pakasol, 120
Panchromatic (pan) film, 331, 332

filter effects on, 357
Panchromatic papers, 165, 333
Panning the camera, 188, 189, 239, 242
Papers (photo-sensitive)
 classifications, 102, 128
 glossy, 102, 107, 115, 135
 hard, 103-105
 multiple contrast, 129, 146-150
 normal contrast, 103-105, 128, 129
 orthochromatic, 165
 semi-matte and matte, 102, 107, 110
 soft, 103-106
 variable contrast, 129, 146-150
Paper emulsion identification, 102, 110
Paper negative, 155, 164-166
Paper negative from slides, 164, 165
Paper speed, 102, 132
Paper weights, 380
Parallax, 229-231
Parallax correction, 231
 with close-up lenses, 260
Pawn shops, 23
Perspective control, enlarger, 149, 416
Perspective in composition, 195-197
Photoelectric meters, 289, 290
Photoflash batteries, 305
Photo Flo, 157
Photograms, 164, 165
Photograph mounting, 388-392
Photographer
 attitudes, 368
 money needs
 equipment, 368-372
 supplies, 368-369
 picture uses, 373-382
 problems, 368
 travel, 368, 372, 373
Photographic bookends, 380
Photographic mobiles, 380
Photographic paper weights, 380
Photographing, filters for different situations, 354-356
Photography
 careers, 383
 fields to pursue, 382, 383
 professions that use, 381
 worthwhile goals, 383
Photomicrography, definition, 265
Photo-sensitive papers, 102, 103-107, 110, 115, 128, 129, 135, 146-150, 333
Picture display
 newspaper and magazines, 380-382
 preparation, 374-380, 388-395
 purposes, 373, 374
 slide show, 374-378
Picture sale opportunities, 368-372

Pinholes (negatives), 69
Plastic apron, 46
Plastic bags, camera protection, 19, 24
Plastic covers for prints, 388, 391, 395
Plastic funnel, 46, 48
Plastic handblower, 18, 92, 130, 330
Plastic lighting, 220
Plastic stirring paddle, 46, 47
Plastic tape labels for camera and accessories, 23
Polarized light, 351-353
Polarizing filters, 195, 285, 351-356
Polarizing screen, 351
Polyester film tape, 86
Portfolio, selection, 167, 372
Portraits, 198-201
 attractive and unattractive features, 200
 camera angle, 200
 center of interest, 198
 effects of direction of light, 212, 215-218, 220, 222, 223
 filters for, 200
 room to look, 198
 softening lines, 151, 152
 techniques that aid, 200, 201
Positive color film processing, 78-81, 334-335
Positive film
 black and white, 334
 overexposure, 90, 91, 284-286
 underexposure, 91, 92, 284-286
Potassium Ferricyanide, 156-160
Pouring solutions
 in and out of plastic tanks, 59-63
 in and out of stainless steel tanks, 59-62
Power for light meters, 289, 290
Preflash, 325
Preset lens, 254
Press cameras, 227
Press, mounting, 394
Pressure plate
 corrosion, 18
 protection, 18
Print
 bleeding, 389
 burning in, 142-144
 contrast correction, 146-150
 dodging, 142
 hanging device, 392
 how to score, 387
 mottled, 143, 146
 subject at wrong angle, 149-151
 streaked, 144, 146
 vignetted, 148
 washing, 138
Print bath time

developer, 110, 112
 fixer (hypo), 112
 hypo neutralizer, 118
 shortstop, 112
Print display
 for decoration, 379
 editing, 379, 380
 mounts and mounting, 380, 388-395
 purpose, 379
 salon exhibit rules, 380
 storyline, 379
 theme, 379
Print dryer, kinds, 107, 108, 119, 120
Print frame, 97, 99, 102
Print proofers, 99, 100
Print title, 395
Print tone, 128, 129
Print washer, kinds, 106, 107
Procedure for enlarging, 131-138
Process the print, 134-137
Processed film, storage protection, 329
Processing
 black and white negative film, 58-64
 black and white positive film, 334
 color negative film, 78
 color positive film, 78-81
 duplicating films, 344
Projection scale, Kodak's, 110, 132, 133
Projector, slide, 378
 auto-focus, 378
 lamp, 378
 lens, 378
Projector screen
 keystone image, 378, 379
 position, 378
Proof, 97-121
Proof printing negatives with different densities, 115-118
Pseudo moonlight in daylight, 343, 364
Pushing film (color positive), 81, 82, 342

Quality
 camera lenses, 125, 247, 410
 enlarger lenses, 125

Rangefinder cameras, 231
 with close-up lenses, 261
Reciprocity failure, 283, 292
Record slide-show narration, 377, 378
Recycling time, electronic flashguns, 311
Red focusing mark or dot, 344
Red eye, 215, 216
Red filter
 on camera, with black and white film, 357-361

on enlarger, 133
Red safelight, 332
Reels
 film holders for developing film, 45, 46
 plastic rotating, 45, 46, 55, 56
 plastic stationary, 45, 46, 57
 stainless steel, 45, 46, 53-55
Reflected light, effects of, 203
Reflected light meter, 286-289
 how to make reading, 293-295, 299, 300
Reflected light meter reading
 average scene, 294
 backlighted subject, 294
 campfire, 294, 295
 dark subjects, 294
 18% reflectance gray card, 294
 light subjects, 294
 low-light situations, 294, 295
 night scenics, 294, 295
 side lighting, 294
 snow scenes, 294
Reflector, 71, 218, 219, 221
 bristol board and aluminum, 397
 flashlamp, 306, 315
 hula hoop, covered, 396
 how to make, 396, 397
 white umbrella, 218, 219, 319, 321, 396
Refrigerator storage
 batteries, 90, 325
 film, 327, 328
Release shutter, 13, 16, 27, 36, 37, 44
Repetition of line, design, color (composition), 189
Replenisher for black and white developers, 49
Retaining ring
 close-up lens holder, 259
 filter holder, 346, 347
 star pattern filter holder, 406
Reticulation
 black and white negatives, 72, 73
 color slides, 94
Retouching negatives, 155
Reuse of cassettes, 53
Reversal in color film processing, 79, 80, 94
Reversal film, 334, 335
 defects, see Transparency defects
Reversal process, color positive film, 79, 80
Reverse adapter
 close-up equipment, 258
 variable magnification, 265
Reversing positive film, 79, 80, 334, 335
Right-angle magnifier viewfinder, 398

Romance, filter for effect, 364
Rubber apron, 46, 48
Rubber cement, 394
Rudolph nose, 222, 223
Rules of composition, 169

Sabattier effect, 163
Safelight, 99, 105, 110, 132
 orthochromatic film, 332
 panchromatic film, 333
 red, 332
Salon exhibit rules, 380
Salt water bath, camera, 20-22
Scales, light meters, 291-293
Scene, average, reflected light meter reading, 294
Scoring print or transparency, 387
Scratches on negative, 140, 141
Screw-in close-up lens, 259
Screw-in filters, 346, 347
Scuba diver, camera choice, 409
Seasonal pictures, selling, 381
Sectional disassembly, enlarger, 416
Sediment in chemical solutions, 58
Selenium cells in light meters, 289, 290
Self-timer, 216, 243, 245
Selling pictures, 368-372
 news deadlines, 380-381
 newspaper and magazines, 380-382
 seasonal, 381
Semi-automatic lens, 254
Semi-matte paper, 102, 110
Series sizes
 of drop-in close-up lenses, 259, 260
 of drop-in filters, 346, 347
Shadow detail, 64, 285, 344
Sharpness of image, 66, 125, 247, 248
Shortstop, 107, 108, 112, 113
Shutter
 between-the-lens, 237
 cock, 42, 44, 237, 243, 325
 delayed action, 216, 243-245
 focal plane, 237, 309, 311
 leaf, 237
 self-timer, 216, 243, 245
 speeds, 28-31, 33, 43, 44, 90, 91, 236-245, 258, 300, 363
Shutter action
 "B" setting, 243
 "T" setting, 243
 timed settings, 236-245
 "V" setting, 216, 243, 245
Shutter release, delayed, 216, 243-245
Shutter settings, 28-31, 33, 43, 90, 91, 236-245, 258, 300, 363
Shutter speeds

cine, fps on light meters, 292
 for action, 188, 189, 238-241
 for hand-holding camera, 33
 indicators on camera light meters, 292
 indoor-outdoor scene, 320, 321
 light meter scales, 292
 on non-adjustable cameras, 43
Sidelighting, 208-211, 217-219
 advantages, 217
 problems with, 217-219
 reflected light meter reading, 294
 solutions to the problems with, 217-219
Silhouette, rim-lighted, 153, 157, 302
Silica gel, 20, 284, 327
Simple camera, control of shutter speed, 313
Single-frame cameras, 225
Single-lens reflex cameras, 227, 237, 261, 262, 286, 290
 shutter types, 237
 with bellows, 262, 263
 with BTL meters, 286, 288, 348, 349, 353
 with close-up lenses, 259, 261, 262, 409
 with converter, 258, 259
 with extenders, 258, 259
 with interchanegable lenses, 256
 with TL meters, 286, 288, 348, 349, 353
 with tubes, 262, 263
 with vari-close-up lens, 259, 260
 with zoom lens, 226
Skylight filter, 20, 360, 362
Slides (transparencies)
 combined (composite), 95, 302
 indexing, 95
 storage, 95, 329
Slide defects, see Transparency defects
Slide duplicator, 402-404
Slide holder, duplicating, 402-404
Slide masks, 86, 89, 94
Slide mounting
 cardboard, 83-86
 glass, 86-89
Slide mounts, kinds, 83
Slide projector, 378
Slide show
 background music, 378
 commentary, 376, 377, 378
 editing pictures, 375, 376
 essay, 373
 humor, 375
 picture sequence, 376
 presentation, 378, 379
 projector, see Slide projector

purpose, 95, 373, 374
story line, 375, 376
tape narration, 377, 378
theme selection, 375
travelogue, 373
Slow films, 336-341
black and white, 336-338
color, 336, 337, 340
SLR cameras, see Single-lens reflex camera
Snow scene, reflected light meter reading, 294
Sodium vapor lights, 204, 345
Soft edges on the print, 138
Soft-focus effects, filters for, 364
Solarization of prints, 162, 163
Space for subject to see or move, 186-188, 198
Specialized films, 342-344
Ektachrome Infrared Aero, 343, 344, 364
High Contrast Copy Film, 71, 285, 343
Kodalith, 342, 343
Spectral colors of light, 204, 205
Speed of camera lens, 249-253, 258
Speeds of camera shutters, 29, 30, 43, 44, 90, 91, 236-245, 300, 363
Speed classification
black and white film, 336-338
color film, 337, 339-341
Speed of film
color negative, 341
color positive, 337, 339, 340
Speed of photo-sensitive papers
contact, 102
enlarging, 128
Speed of subject action, 239-241
Spill light, flash for depth, 323, 324
Split complements, color, 207
Split-image rangefinder, 232, 233
Spool, take-up, 39
Spot meter, 232, 290, 291, 255, 299, 300
exposure reading, 295, 299
Spot Off, 156
Spot seal, 84, 85
Spotone, 156, 161, 162
Spotting colors, 161
Spotting techniques, print, 160-162
Spray for prints and mounts
glossy acrylic, 391, 395
matte acrylic, 391, 395
Sprocket holes, 41
images of, 92
torn, 302
Sprocket wheels, 41
Squeegee
film, 48

print, 120
Stabilization processor, 416, 417
Stabilizers, 416
Stains
bleaching prints, 158
eliminate or reduce, black and white film, 357, 361
film, 69, 70
print, 115, 135, 138
Star rays, 364, 406
Static electricity marks on film, 16, 17
Stirring paddle, plastic, 46, 47
Stop
composition, 180-182
exposure, 43, 283, 288, 292-295, 302, 314-317, 321-323, 336, 337, 341, 342, 349, 350, 353, 356, 357, 363
full, 30, 125, 251-253, 294, 298, 302, 312, 337, 342, 350
lens aperture, 30, 31, 43, 132, 249, 250-254, 258, 274, 279, 283, 310, 312, 314-317, 321, 323, 336, 337, 350, 353, 356, 357, 363
one-half, 253, 254, 292, 298, 316, 337
one-third, 253, 292, 337, 341, 342
Storage
batteries, 90, 325
chemical solutions, 47-48, 79-80
color films, 93, 94
film, 93, 94, 327-330
negatives, 73-76
processed film, 329
slides, 95
transparencies, 95
Storyline
print display, 379
slide show, 375-377
Strobe, 310
Styrofoam ice chest, 22, 24, 25, 398
Sub-miniature cameras, 225
Substitutes, light box, 402
Subtractive system, 206
Supplies and equipment
making, 142, 396-407
to develop film, 45-49, 78-80
to enlarge a negative, 122-129
to make contact prints, 97-108
to mount a print, 392
to mount transparencies (slides), 81, 83-89
to prepare a print for display, 392
Synchronization of flash, 308, 311, 320, 321

"T" settings, 240, 243
with automatic lens, 254, 255

Tape, masking
for loaded film tank label, 58
for solution bottle labels, 50
Polyester film for glass mounting slides, 86-89, 94
Telephoto lens, 189, 191, 255-258, 263, 300, 405
Temperature
conversion scale (Fahrenheit-Centigrade), 388
developing
black and white films, 58, 59
black and white prints, 130, 146
color film, 71, 80, 93, 94
effect on films, 15, 22, 59, 71-73, 80
Tent, metal glare prevention, 365
Tessina, 225
Test print, 135
too dark, causes, 112, 114, 135
too light, causes, 114, 115, 135
Test strip, 132-134
exposure time, 133, 134
Texture screens, 152, 153
Tiffen Optical Company, 363
Tilting negative carrier, 416
Time, for test strip, 133, 134
Time exposure, 90, 240, 243, 300
Time-O-Lite, 126, 127
Timer, 99, 105, 106, 107, 123, 126, 127, 133
automatic, on enlarger power, 133
kinds, 99, 105, 106, 107, 126, 127
use, 99, 105, 106, 107, 126, 127
Tint-a-slide, 94, 365
Tissue, dry mounting, 394, 395
Title, print, 395
Theft, 23, 25-26
Theft prevention, 23-26
Theme
print display, 379
slide show, 375
Thermometer, 46, 94, 105, 123
dial, 46
stainless steel shank, 46
Thirds, in composition, 171
35mm film cassette, 38, 40-42
3M Color Print Film, 341
Through-the-lens metering, 258, 259, 262, 263, 286, 290, 291, 348, 349
Thumbprint, 86
TLR cameras, 227, 260
TTL or BTL light meter, 286
with bellows, 262, 263
with extender or converter, 259
with filters, 348, 349
with tubes, 262, 263

Tonal range, black and white print, 285
Tonal renditions, filter effects, black and white, 357, 361
Tone-line prints, 163
Tones
 paper, 128, 129
 printing papers, 161
 spotting colors, 161
Toners, 128, 129
Tongs
 kinds, 99, 106
 reasons for use, 99, 105, 106
 use of, 99, 106
Toplighting, 208-211, 221-223
 advantages, 221, 222
 problems with, 222
 solutions to the problems with, 222, 223
Torpedo level, 406, 407
Transistorized light meter, 284
Translucent plastic tent, metal glare prevention, 365
Transparencies
 cropping, 344
 films, 334
 identifying, 381
 indexing, 95
 mailing to newspapers, magazines, 381
 storage, 95
Transparencies (slides) combined, 302
Transparency
 color correction, 365, 366
 density correction, 365
 how to score, 387
Transparency defects, 89-95
Transparency sharpness, 247
Travelers' film protection
 duty, 329
 heat, 328, 329
 humidity, 327
 X-ray, 329
Travelogue, slide show, 373
Trays
 arrangement for processing prints, 109, 130
 kinds and sizes, 99, 105, 123, 126
Tripod, 24, 34, 245, 260, 261, 300, 402-404
 camera angle adjustments, 411, 412
 choosing, 411-412
 height and weight, 412
 leg extension locks, 411
 sturdiness, 411

Troubleshooting flash failures, 324-326
Tubes
 choosing, 262, 413
 compensation, 263
 ASA scale, 337, 339, 341
Tubes and bellows, 262-264
Tungsten films, 93, 362-364
Tungsten lights, film choice for, 93, 345
Twin-lens reflex cameras, 227, 260
2¼″ x 3¼″ cameras, 226, 227
2¼″ x 2¼″ cameras, 226

UFG developer, 339
Ultraviolet filter, color film, 93, 360, 362
Ultraviolet light
 fading of color prints, 329
 in electronic flash, filter correction, 93, 360, 362
Umbrella
 attaching to light stand, 396
 diffuser, 396
 reflector, 218, 219, 319, 321, 396
Underexposed negatives, 68-69
Underexposed slides, 91-92
Underexposure, 284
 correction (duplicating), 404
 rim-lighted silhouette, 302
 with flashlamp and simple camera, 313
Underwater photography, camera choice, 409
Unicolor kit, 78
Unipod, 34
Unpolarized light, 351-353
UV (ultraviolet) filter, 93, 360, 362

Variable close-up lens, 259, 260
Variable contrast filters, 129, 146-148
Variable contrast papers, 127, 129, 146-150
Variable magnification with reverse adapter, 264
Variety in composition, 198
Vaseline, to diminish negative scratches, 140, 141
Vertical line in composition, 179
Vibration
 damage to camera, 13
 of enlarger, 141
Vibrator tool for marking equipment, 23
Viewfinder, 27, 36, 37, 227-235, 286, 398
 cropping, 94
 etched squares, 231
 exposure indicator, 232

eye-level, 227-229
 methods to handhold camera, 36, 37
 right-angle viewer, 398
focus devices, 232-235
information in, 231, 232
interchangeable, 227
parallax correction, 231
sportsfinder, 229
spot meter, 232
waistlevel, 227
 holding the camera, 36, 37
wire-frame, 229
Viewing system on cameras
 rangefinder, 227
 reflex, 227
 simple, 227
 single-lens-reflex, 227
 twin-lens-reflex, 227
Viewing windows, light meters, 290
Vignetter, commercial, 154, 155
Vignetting
 on enlarger, 154, 155
 print, 148
 subdue unwanted details, 154, 155
Voltage fluctuations, 363

Warming filters, color film, 360, 362
Warped mount prevention, 84
Wash, film, 63
Washer for prints, 99, 105, 106, 107
Washing the print, 118, 138
Water spots, removing from negative, 131
Wetting solution
 for black and white film, 49
 for spotting, 157
White lines on print, 140, 141
White umbrella reflector, attaching to light stand, 396
Wide-angle lens, 255-258

X, flash setting, 245, 309, 311
X-ray, danger to film, 329

Yankee tank, 45
Yellow filter, black and white film, 357, 361

Zigzag lines in composition, 179, 180
Zone focusing, 277, 278
Zoom lens, 256
 depth of field with, 276